There are those who think the proudest title in the communications profession is: ''Working News Photographer.''

This book is dedicated to the men and women who bear — or have borne — that title.

Cal Olson
Editor

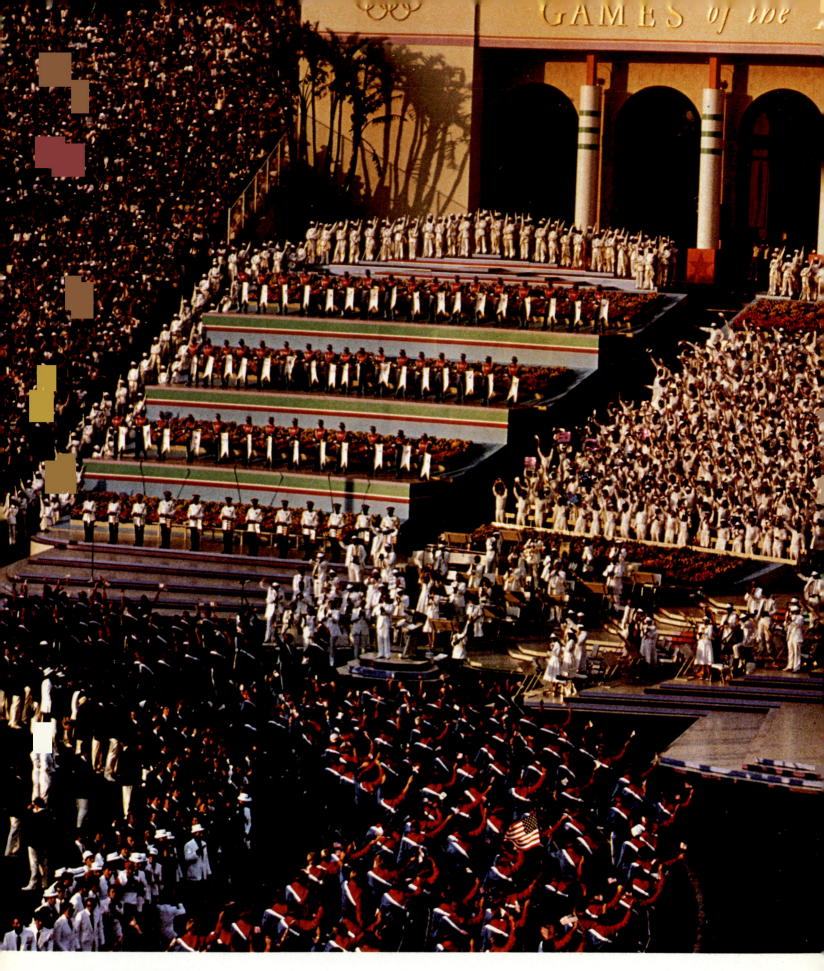

the best of

Photojournalism / 10

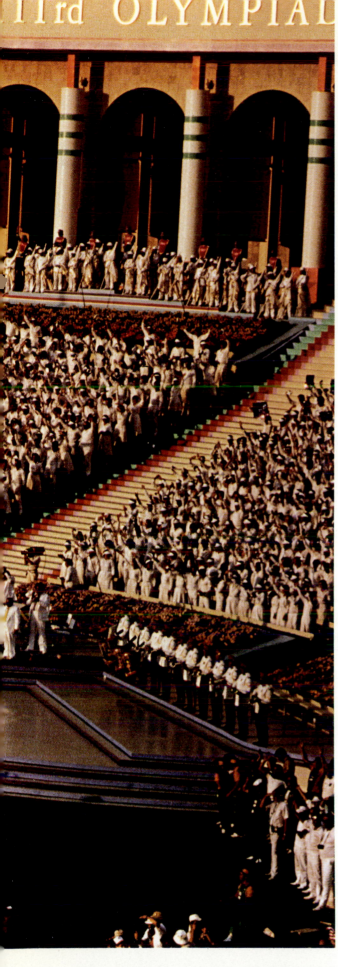

IIrd OLYMPIAD

An annual based on the 42nd Pictures of the Year competition sponsored by the National Press Photographers Association and the University of Missouri School of Journalism, supported by a grant to the University from Canon U.S.A., Inc.

Cal Olson, editor
Joanne Olson, assistant
Ken Kobre, photojournalism
 director, School of Journalism,
 University of Missouri

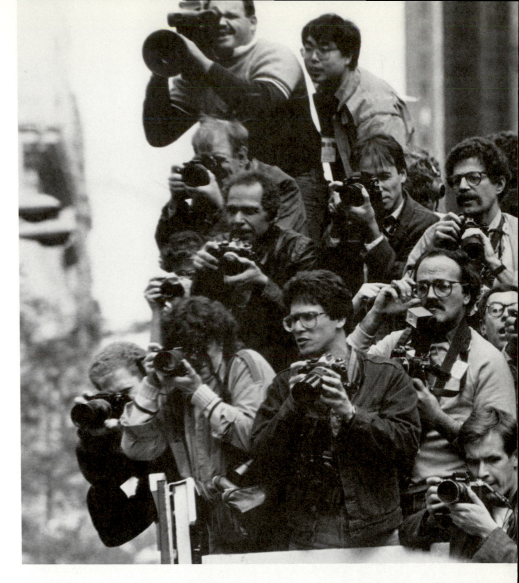

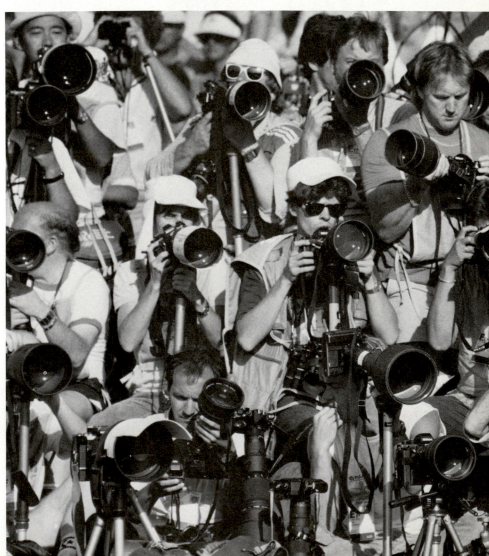

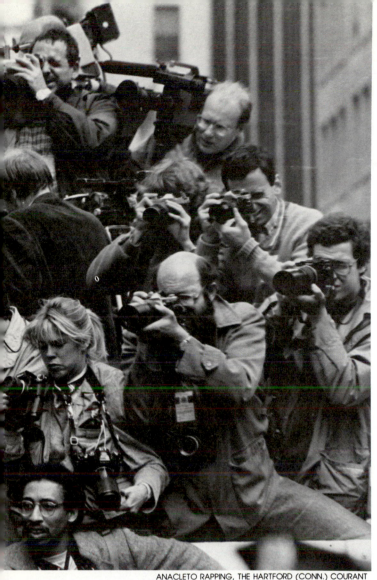

ANACLETO RAPPING, THE HARTFORD (CONN.) COURANT

LEH-CHYUN LIN, THE WORLD JOURNAL (FLUSHING, N.Y.)

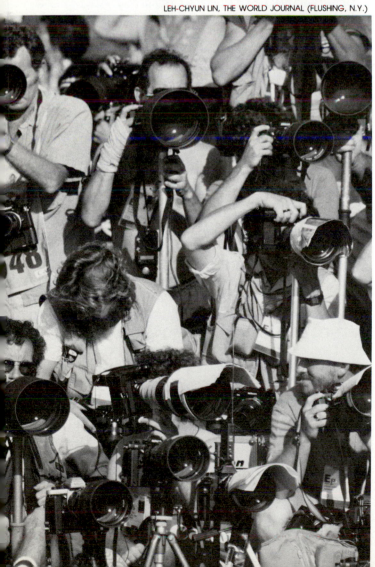

Contents

A SURFEIT OF SHOOTERS: The top two news events of 1984 brought photographers out in unprecedented numbers. Left above, these news photographers covered an appearance of Democratic presidential nominee Walter Mondale at a Columbus Day parade in New York City. Left below, a small portion of the finish line photo pack at a track event at the Olympic Games in Los Angeles.

FRONT COVER: Scaffolding enfolds the Statue of Liberty during a $39 million restoration project. (See Page 118.) Photograph by David L. Ryan, The Boston (Mass.) Globe.

REAR COVER: A striking miner stripped off his clothes, then surrenders to law officers. (See Page 107.) The photograph is by David H. Schreiber, Tucson (Ariz.) Citizen.

PRECEDING PAGE: The spectacular opening ceremonies of the Games of the 23rd Olympiad in Los Angeles. Photo by Bill Frakes of The Miami (Fla.) Herald.

A golden year for photographers

1984 was the Year of the Photojournalist, a
year when the nation went for the gold both
politically and athletically, a year whose news
events will be recalled primarily through the
photographic images by which those news
events were reported.

Politics dominated the entire year, as the
nation's quadrennial absorption in the
presidential campaign provided the big
continuing news story. Then the midsummer
counterpoint of the Olympic Games in Los
Angeles put a golden glow to the news
photographers' product.

But the presidential campaign set the tone for
1984 news reportage. The Democrats set a
precedent when Walter Mondale selected
Geraldine Ferraro as his vice presidential
running mate — the first woman ever on a
major party's presidential ticket.

But President Reagan, running for re-election,
sounded a note of pride, prosperity, and
patriotism that was exactly in tune with the
nation's experience at the Olympic Games.

Those games: the Associated Press called them
"a study in gold for U.S. athletes," who won 83
gold medals and 174 total medals in 16 days
of competition which drew 5.6 million
spectators and several thousand news
photographers.

Like the presidential campaign, the Olympic
Games were a local story for photographers
who produced brilliant picture reportage under
what can best be described as difficult
conditions.

Not all of 1984's news stories were golden,
however. In Africa, photographers recorded
the grim facts of a spreading famine that
claimed at least 300,000 lives in Ethiopia alone.

Photojournalists were on hand to record the
aftermath when two Sikh security guards
assassinated India's Prime Minister Indira Gandhi
late in October. In San Ysidro, Calif., a man
walked into a McDonald's restaurant with three
guns and a sack full of bullets. When he finished
shooting, he had killed 21 persons.

Beyond the tone-setting stories, 1984 produced
a welter of news events: Bill Schroeder's
amazing recovery after doctors successfully
implanted an artificial heart in his body; the
scandal of Miss America and those nude
photos; the bombing of the U.S. embassy
annex in Beirut; the soaring success of singer
Michael Jackson; the Statue of Liberty's face
(and body) lift; the creeping financial crisis
among Midwestern farmers at a time when
most of the American economy was making
strong recovery (unemployment down, inflation
blocked); the agony and ecstasy of the
Chicago Cubs' progress toward the World
Series; the no-nonsense approach to that
Series by the Detroit Tigers (who beat the
Cubs-beating San Diego Padres) And more . . .

* * * *

Just as the presidential political campaign
topped the nation's 1984 news events, so also
does it lead "The Best of Photojournalism/10."

The campaign resulted, as Newsweek
Magazine reported, in "a smashing, 49-state
re-election victory that sent Ronald Reagan
back to the White House and left disconsolate
Democrats to ponder their party's future.

"Walter Mondale, far behind in the polls from
June to November, never really had a chance;
after weathering the Reagan deluge with his
history-making running mate, he retired from
politics for good. Sen. Gary Hart's appeal to
the yuppies missed the mark in Campaign '84,
but he seemed ready to take aim in '88 —
and the Rev. Jesse Jackson, on the move from
Havana to Syria to San Francisco, promised the
Rainbow next time . . ."

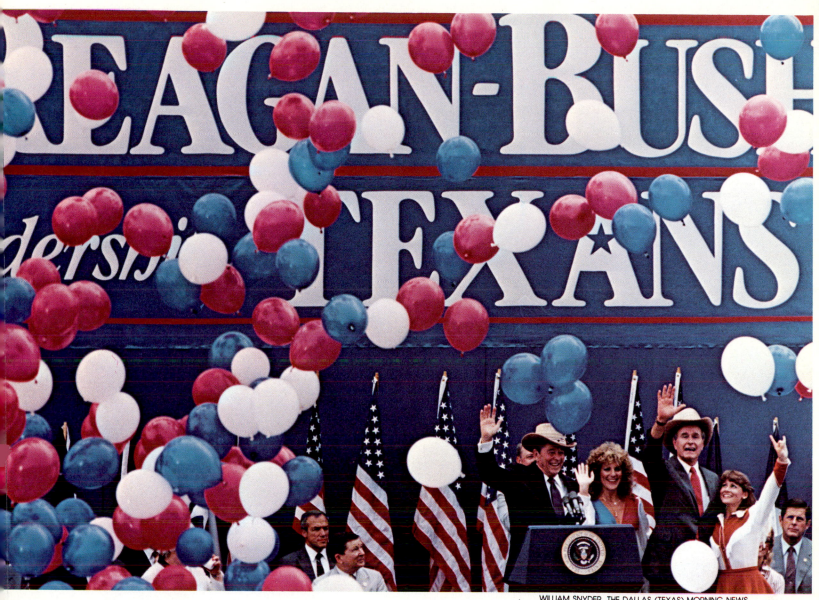

WILLIAM SNYDER, THE DALLAS (TEXAS) MORNING NEWS

BARBARA RIES, USA TODAY

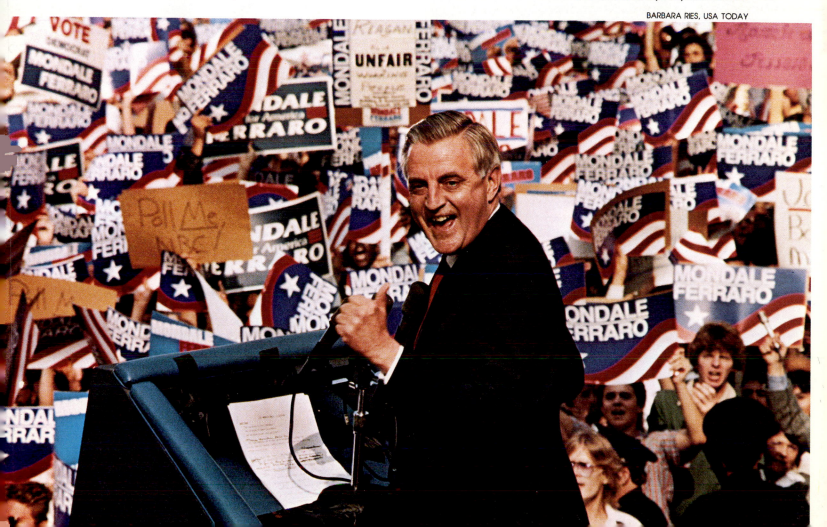

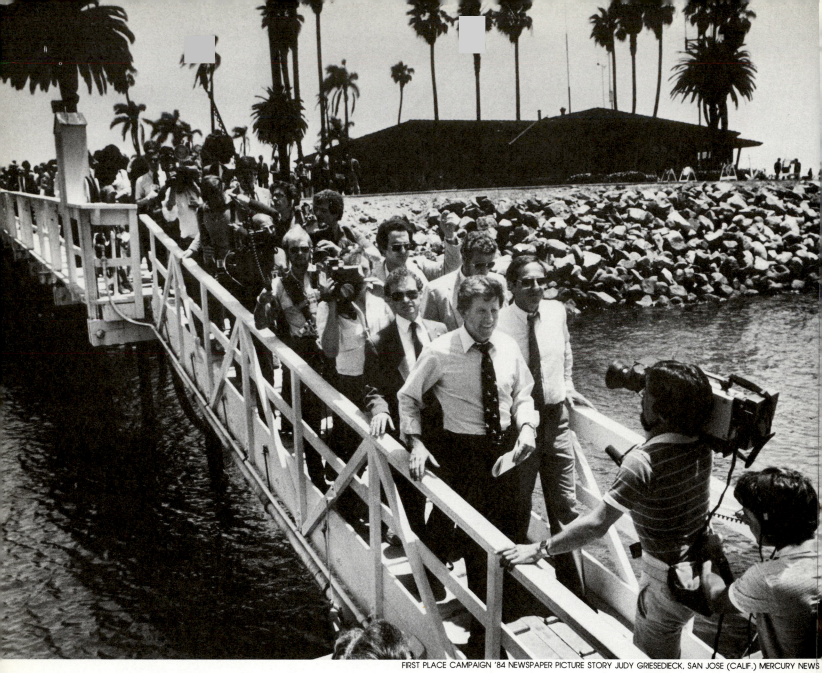

Above, Sen. Gary Hart campaigned early, long — and unsuccessfully — for the Democratic presidential nomination. Here he heads across a bridge to tour a Navy ship in San Diego. Says Photographer Judy Griesedieck, ''He learned to use (the media) to spread his image of 'new ideas' . . . but it wasn't enough.''

Right, Hart and daughter Andrea on the beach near Monterey, Calif. Reported the Rocky Mountain News: ''For Hart, life in pursuit of the presidency has become a race between campaign appearances and photo opportunities designed to enhance his image.''

Campaign '84

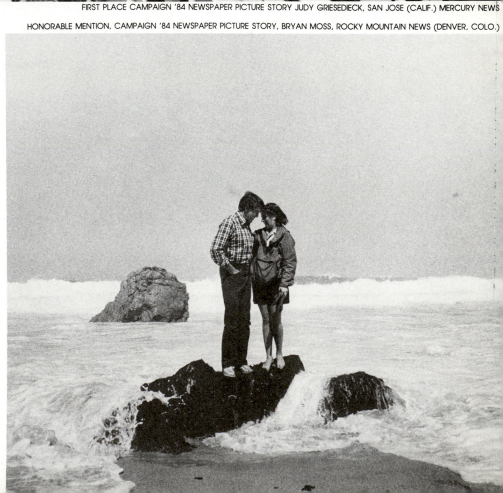

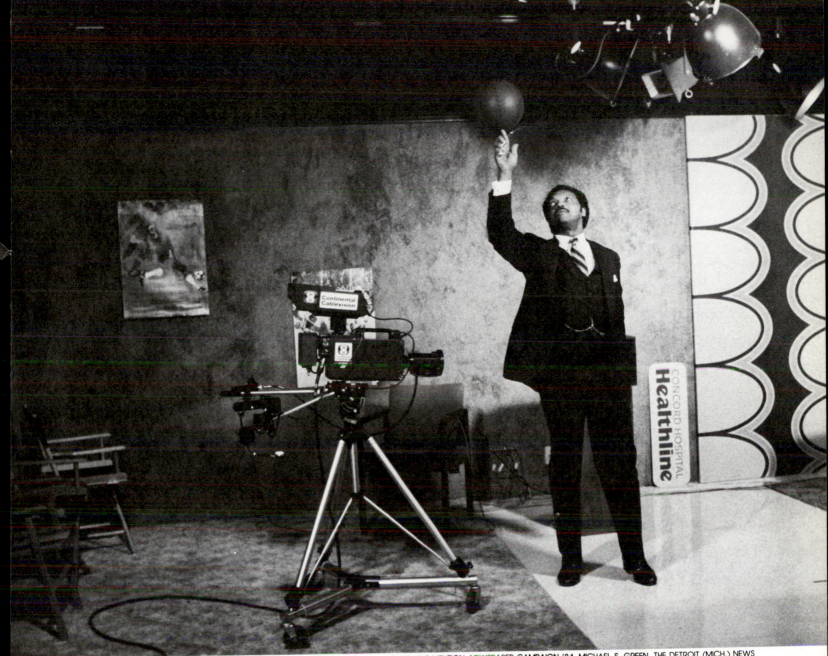

Jesse Jackson mounted an active campaign, but never gained the national momentum to win either the top spot or the vice presidential nomination. Above, he kills time in a Concord, N.H., TV station spinning a basketball he found on the set.

Right, Jackson gets applause, a smile, and cheers from a delegate after his speech at the National Convention.

Far right, running up the steps to his plane, Jackson gives the victory sign to supporters at the airport in Anniston, Ala.

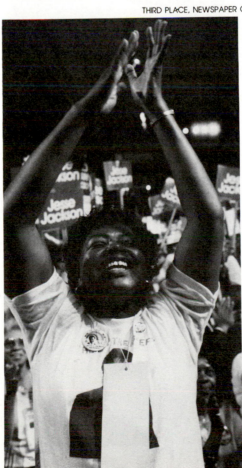

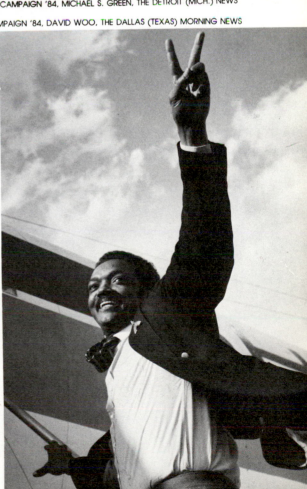

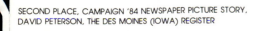

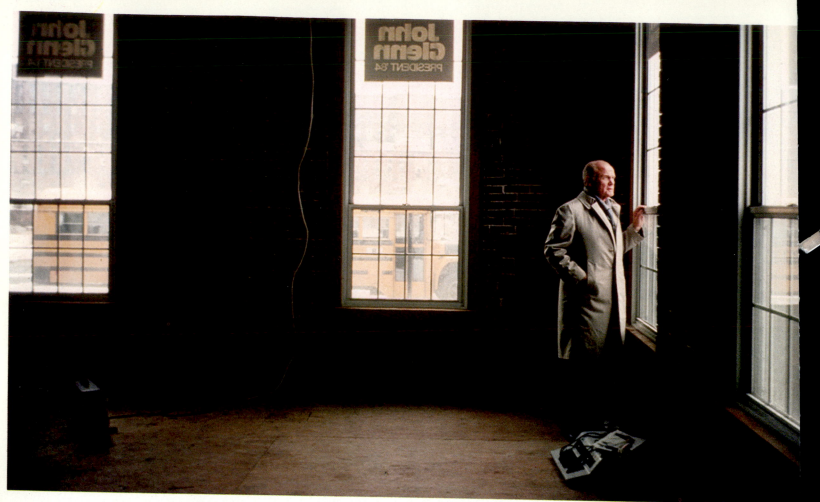

Campaign '84

Above, another unsuccessful Democratic presidential hopeful, Sen. John Glenn, stands alone in his Manchester, N.H., headquarters.

Below, Jesse Jackson peers out the window of his campaign plane.

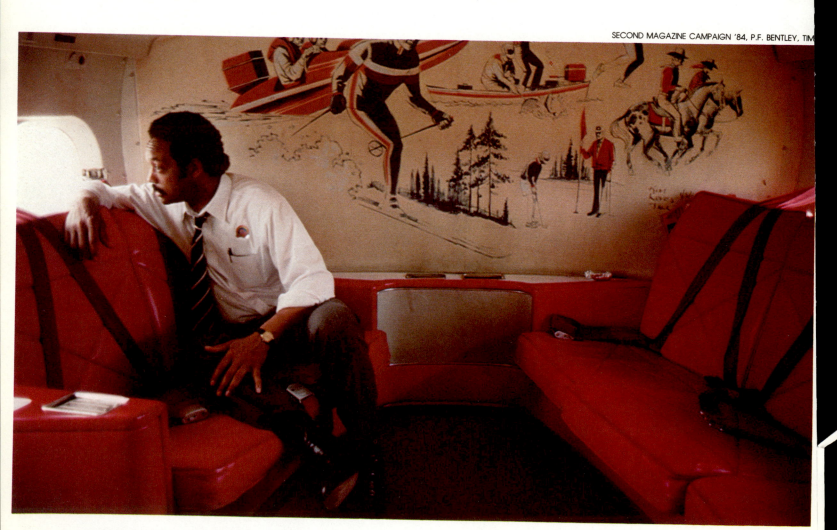

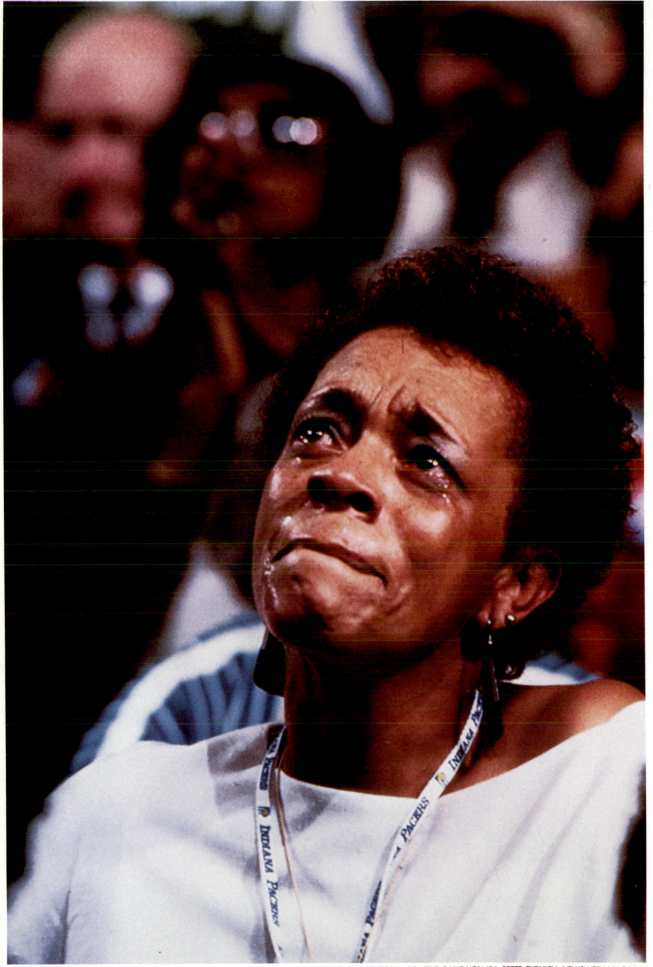

Photographer Pete Turner calls them
"teardrops of pride" — shed by a supporter
of Jesse Jackson after his defeat at the
Democratic convention.

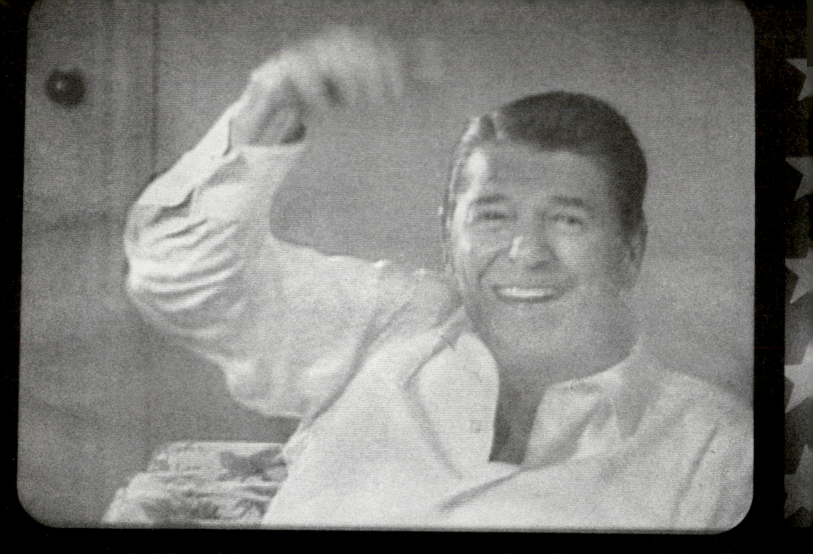

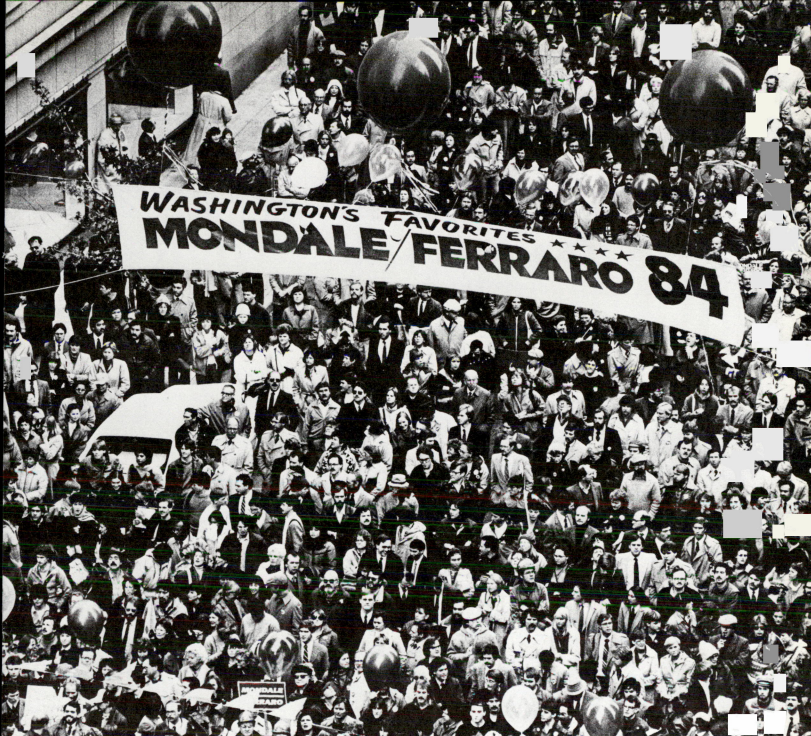

WASHINGTON'S FAVORITES MONDALE/FERRARO 84

COLE PORTER, THE SEATTLE (WASH.) TIMES

Above, in Seattle, Wash., candidate Walter Mondale draws a crowd of thousands during a brief visit in the final days of the campaign.

Campaign '84

Left, President Ronald Reagan waves from his hotel room and Nancy Reagan, from the platform at the National Republican Convention, waves back.

LEFT, ANTHONY SUAU, THE DENVER (COLO.) POST

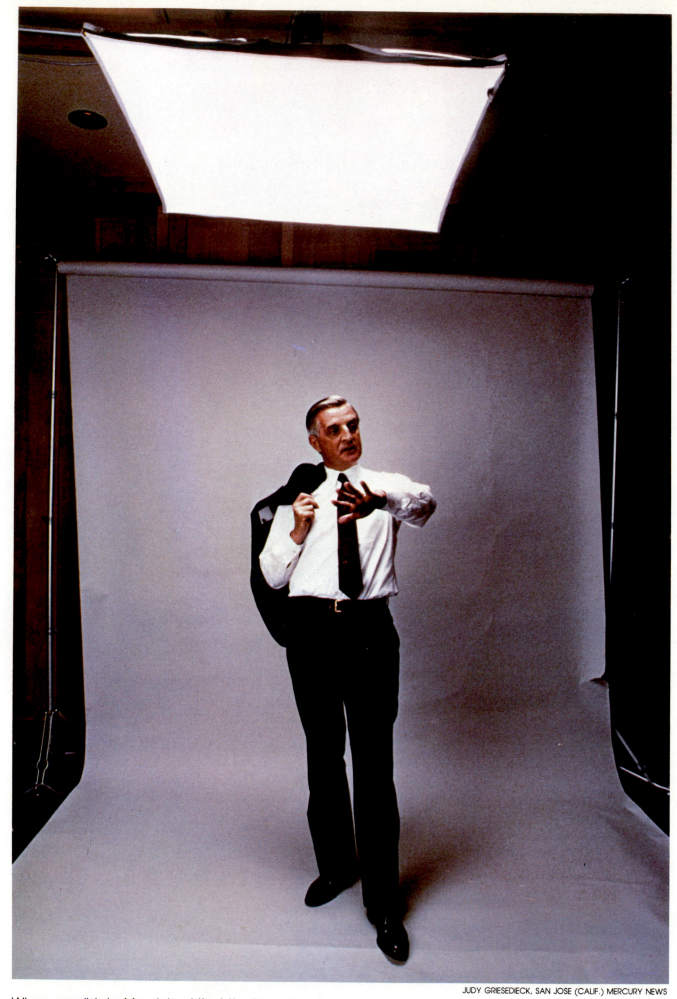

When candidate Mondale visited the board room at
the San Jose (Calif.) Mercury News, Photographer
Judy Griesedieck trotted out the seamless paper.

Campaign '84

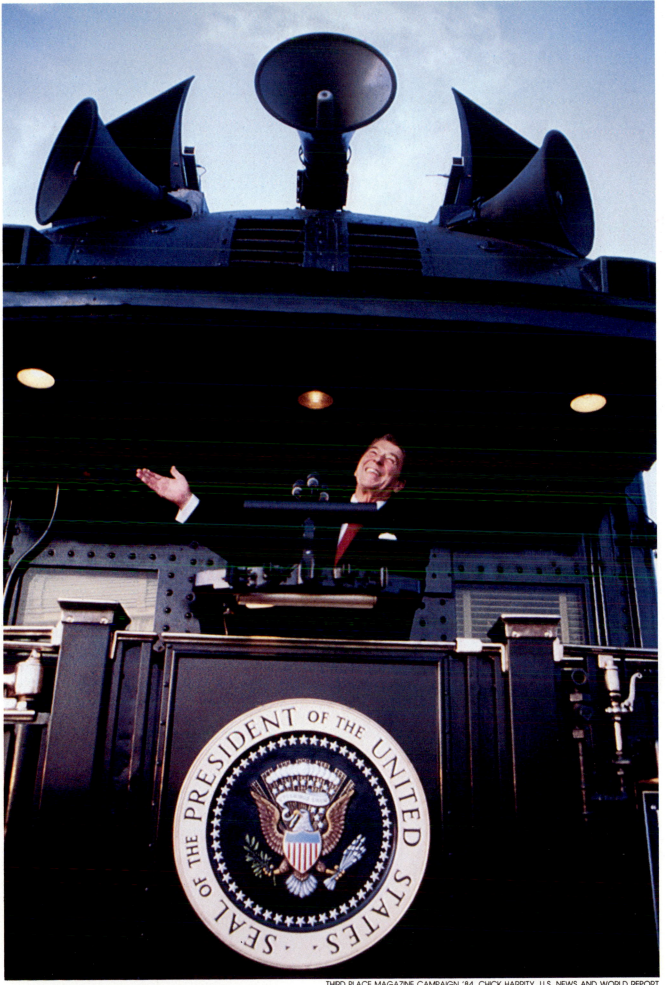

THIRD PLACE MAGAZINE CAMPAIGN '84, CHICK HARRITY, U.S. NEWS AND WORLD REPORT

President Reagan waves from the back of his campaign train during a swing through Ohio.

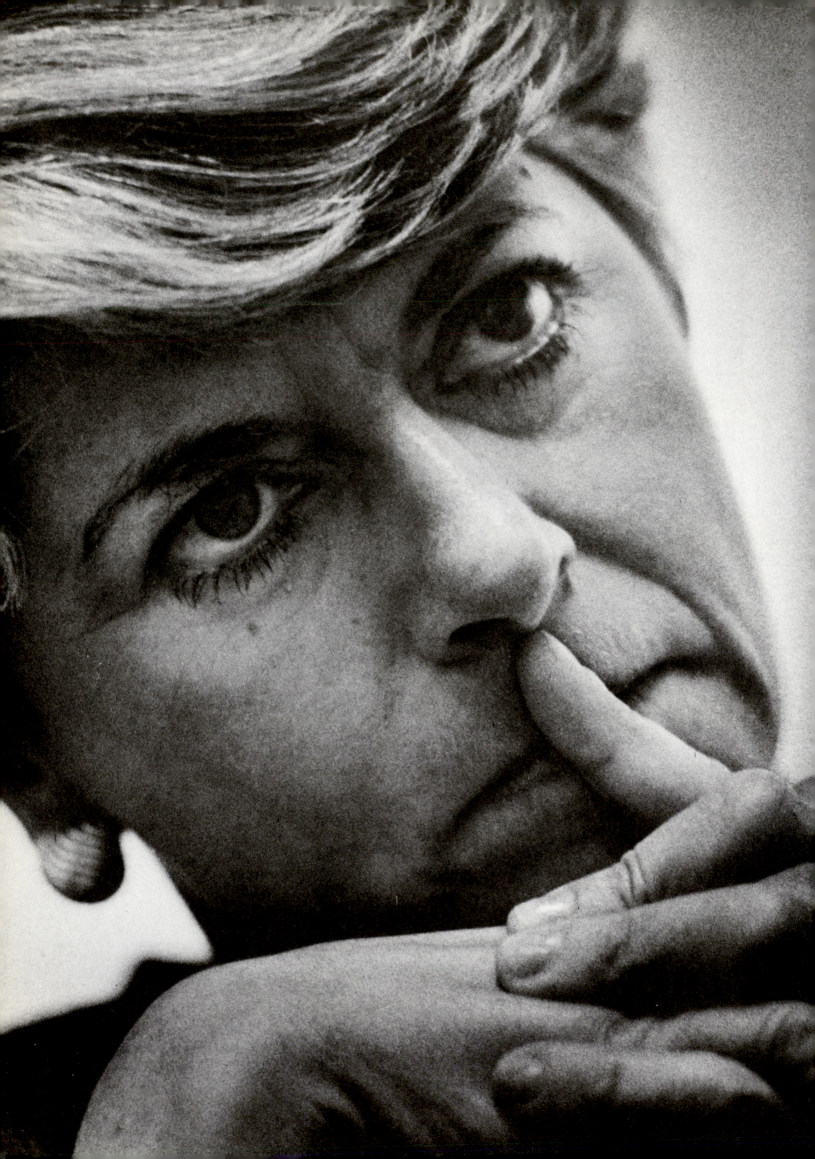

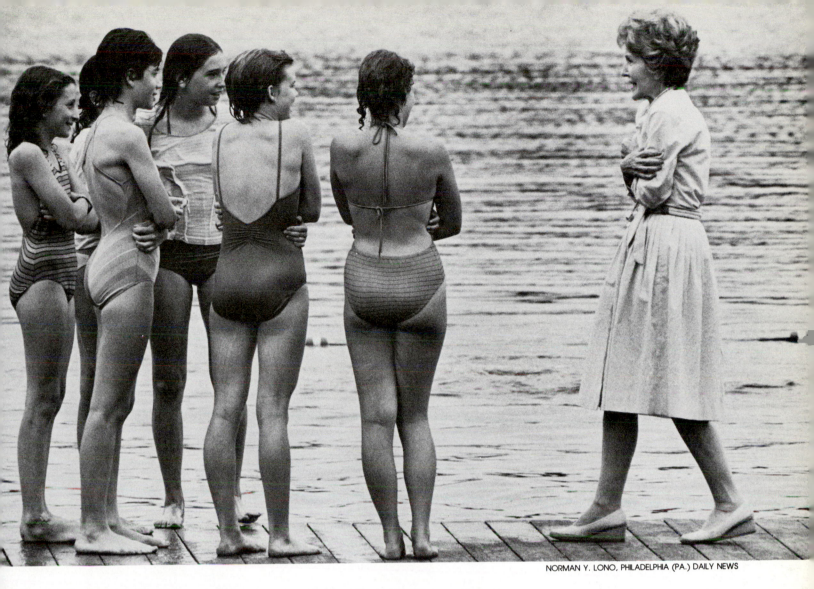

NORMAN Y. LONO, PHILADELPHIA (PA.) DAILY NEWS

Campaign '84

bove, on the campaign trail for her
usband, Nancy Reagan imitates chilly
mmer camp kids at East Coast camp she
erself attended as a youngster.

ft, Democrats made history when they
ominated a woman as their vice
esidential candidate. Here Geraldine
erraro considers a reporter's question during
campaign stop in Pennsylvania's Lehigh
alley.

N FISHER, THE MORNING CALL (ALLENTOWN, PA.)

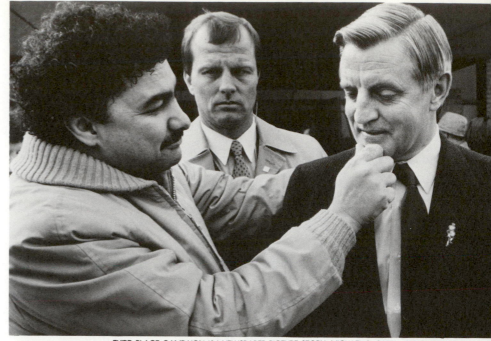

Right, in Detroit, Mich., for the state's Democratic caucus on St. Patrick's Day, Mondale is confronted by a supporter who chucks the candidate on the chin, kisses him on the cheek, and receives a less than enthusiastic response.

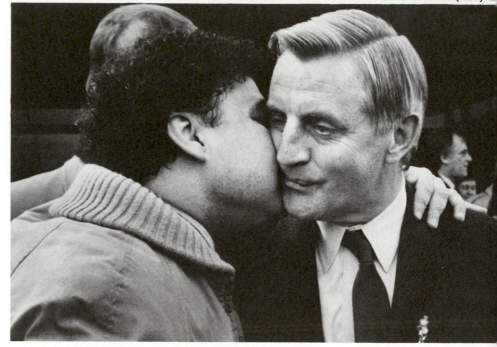

Campaign '84

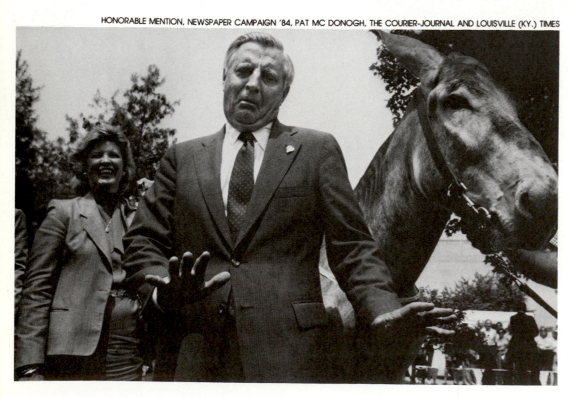

Left, Mondale hams it up to show hi distaste at the thought of riding a mule at the Kentucky State Fair. That's Kentucky's Gov. Martha Layn Collins laughing in the background.

NORMAN Y. LONO, PHILADELPHIA (PA.) DAILY NEWS

Campaign '84

bove, on the campaign trail for her
usband, Nancy Reagan imitates chilly
ummer camp kids at East Coast camp she
erself attended as a youngster.

eft, Democrats made history when they
ominated a woman as their vice
residential candidate. Here Geraldine
erraro considers a reporter's question during
 campaign stop in Pennsylvania's Lehigh
alley.

ON FISHER, THE MORNING CALL (ALLENTOWN, PA.)

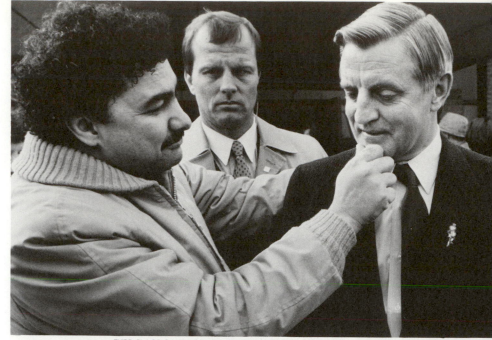

Right, in Detroit, Mich., for the state's Democratic caucus on St. Patrick's Day, Mondale is confronted by a supporter who chucks the candidate on the chin, kisses him on the cheek, and receives a less than enthusiastic response.

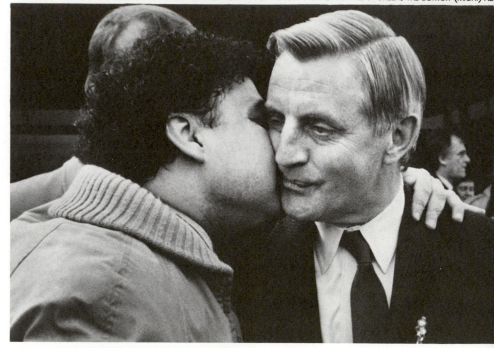

Campaign '84

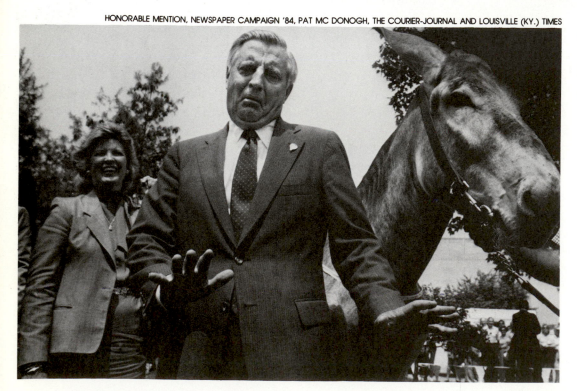

Left, Mondale hams it up to show h distaste at the thought of riding a mule at the Kentucky State Fair. That's Kentucky's Gov. Martha Layn Collins laughing in the background.

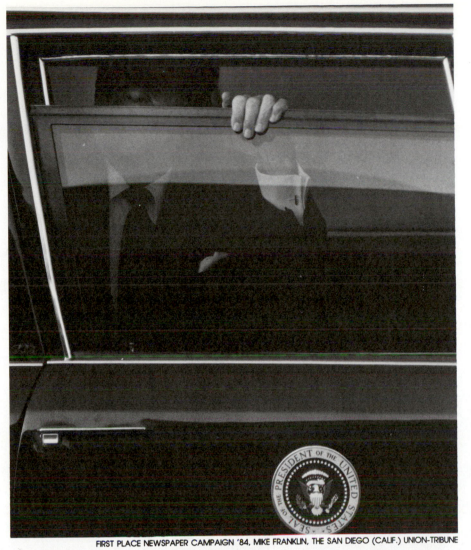

Left, Photographer Mike Franklin's first chance to photograph President Reagan came the day before the election at a campaign stop in San Diego, Calif. He made this exposure when the president rolled down a limousine window to hear what a woman was shouting.

Below, when Vice President George Bush campaigned at the University of Missouri in Columbia, he found a crowd of nearly 400 agricultural students — and three bovine observers.

FIRST PLACE NEWSPAPER CAMPAIGN '84, MIKE FRANKLIN, THE SAN DIEGO (CALIF.) UNION-TRIBUNE

SECOND PLACE NEWSPAPER CAMPAIGN '4, JIM CURLEY, COLUMBIA (MO.) DAILY TRIBUNE

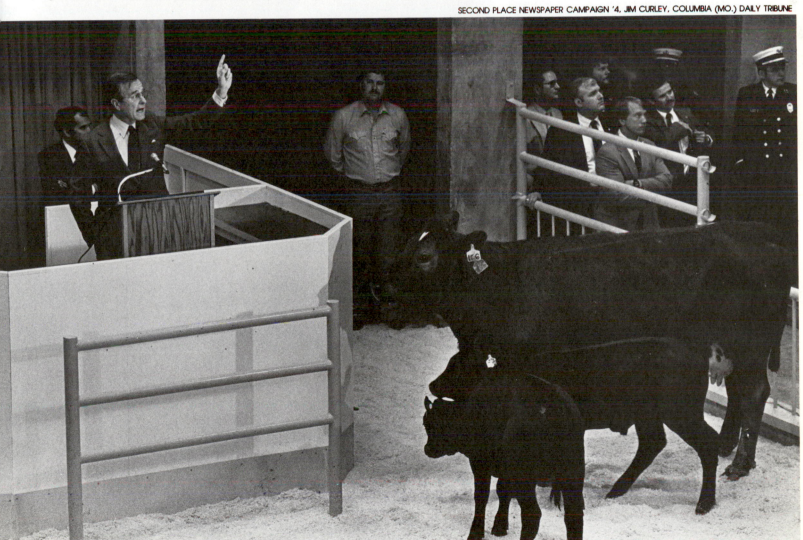

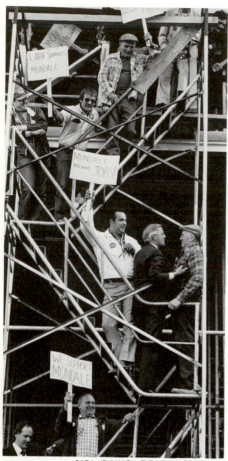

SARA KRULWICH, THE NEW YORK TIMES

Above, campaigning during the New Jersey primary race, Mondale climbs onto scaffolding in Jersey City to greet supporters.

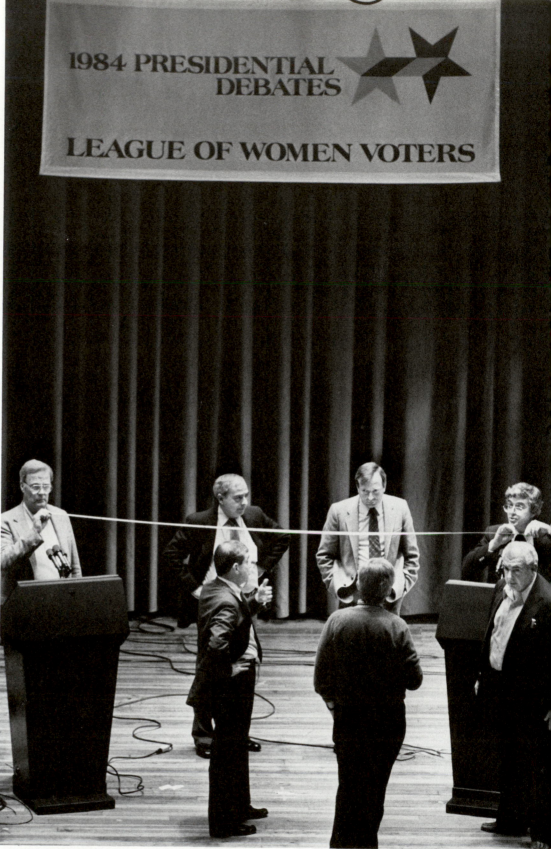

PATRICK J. SULLIVAN, THE KANSAS CITY (MO.) STAR/TIME

Campaign '84

Above, staffers for the two candidates carefully measure distances and camera angles before the second debate in Kansas City, Mo. It took about an hour to get things just right.

Right, aftermath of the first debate in Philadelphia, Pa. Although the Democratic contender was generally considered the winner of the session, it would appear this Mondale supporter had a premonition of the coming Reagan landslide.

TOM GRALISH, THE PHILADELPHIA (PA.) INQUIRER

'The toughest one yet . . .'

The agony of a starving people burst on a world's consciousness when news outlets began reporting the food crisis in Ethiopia late in 1984. And a photographer for The Boston (Mass.) Globe was among the first newsmen to detail the extent of the problem.

As a result, the stark, graphic and gripping photographic reportage of photographer Stan Grossfeld brought him the Canon Photo Essayist Award.

Grossfeld, who won the 1984 Pulitzer Prize for his photographic coverage of war-torn Lebanon, was sent to Ethiopia late in 1984 with Globe reporter Colin Nickerson. Their two-week tour of Ethiopia produced electrifying reportage of the crisis in that African nation.

On his return to the United States, Grossfeld was the subject of a feature story written by reporter Naedine Hazell for his home town paper, The News-Journal in Rockland, N.Y. Here are excerpts:

"The (Ethiopian experience) was everything I hate all wrapped up in one miserable assignment" . . . a series of great highs and lows that changed him not only physically — he lost 15 pounds — but emotionally as well.

"There were times when I couldn't even talk to anyone . . . There were things so disgusting I couldn't even make pictures. I'd go to my tent and stare at the canvas . . .

"Sometimes I almost wished they would throw rocks at me. But they wanted me to take pictures . . .

"This was the toughest one yet. It will take quite a while to get over it. I want to go home"

Grossfeld's entry for the Canon Photo Essayist Award contained only 12 photographic prints. Two months after he was named Canon Photo Essayist, Grossfeld's Ethiopian photographs won one of two 1985 Pulitzer Prizes for feature photography.

Grossfeld, 33, is chief photographer for The Boston Globe, which he joined in 1975.

Right, Ethiopian mother and child, only two of 22,000 refugees in a facility that was built for 5,000, wait for food in Wad Sharafin Camp. The child died later the same day. Grossfeld's photograph has been called "Ethiopian Madonna and Child."

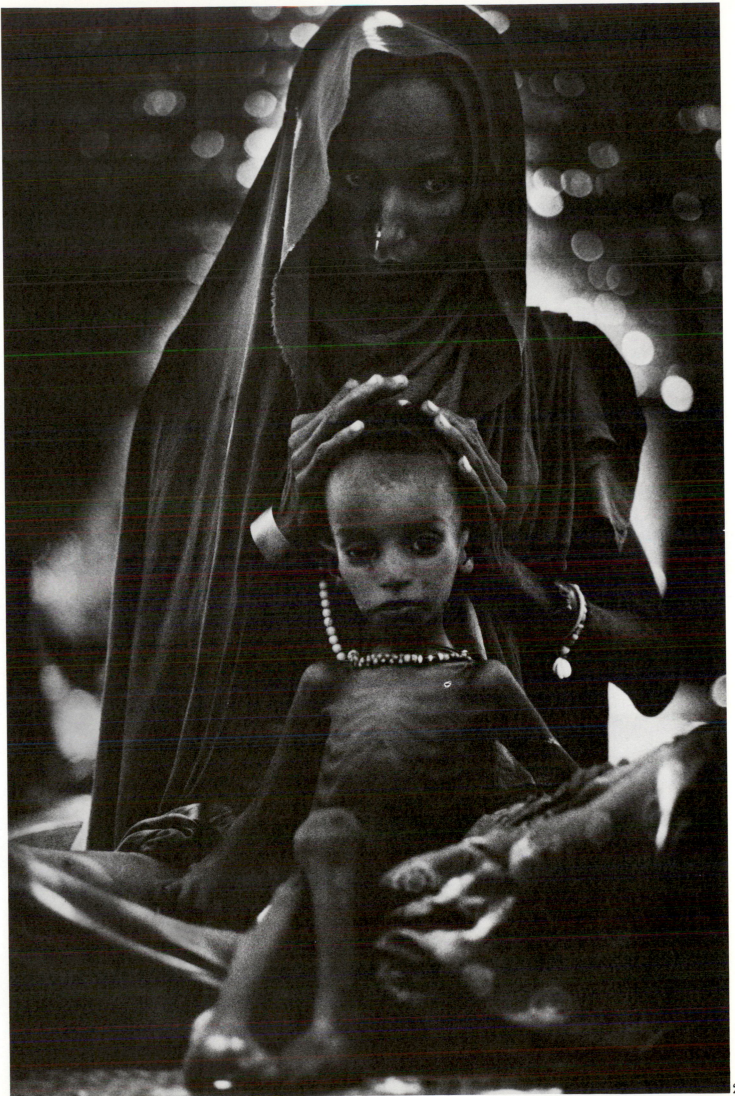

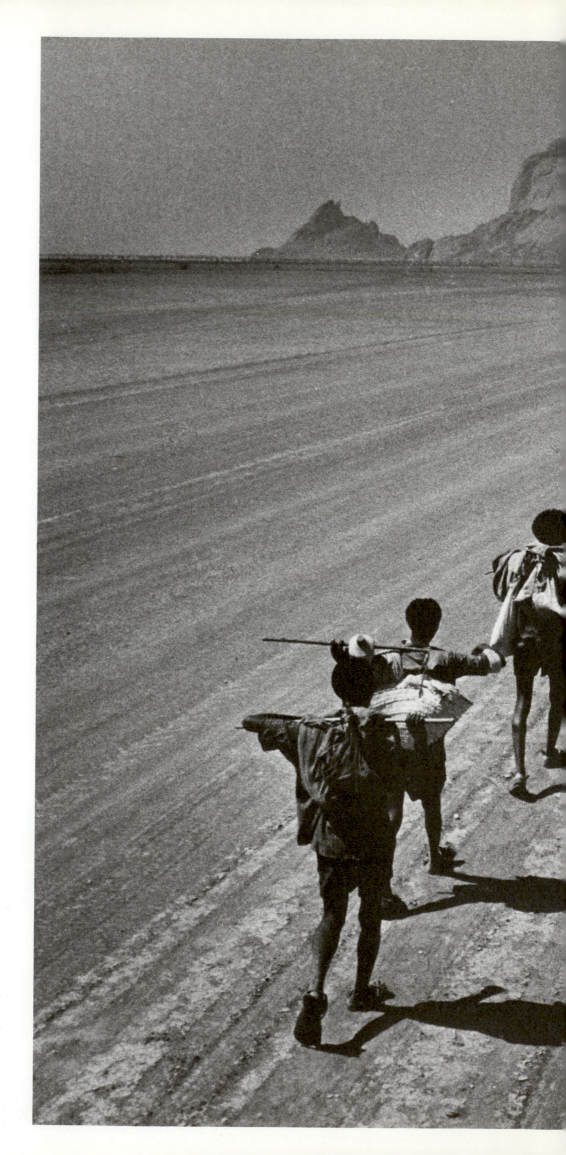

Canon Essay

Refugees on a nine-day, 180-mile hike into Sudan from Ethiopia.

24

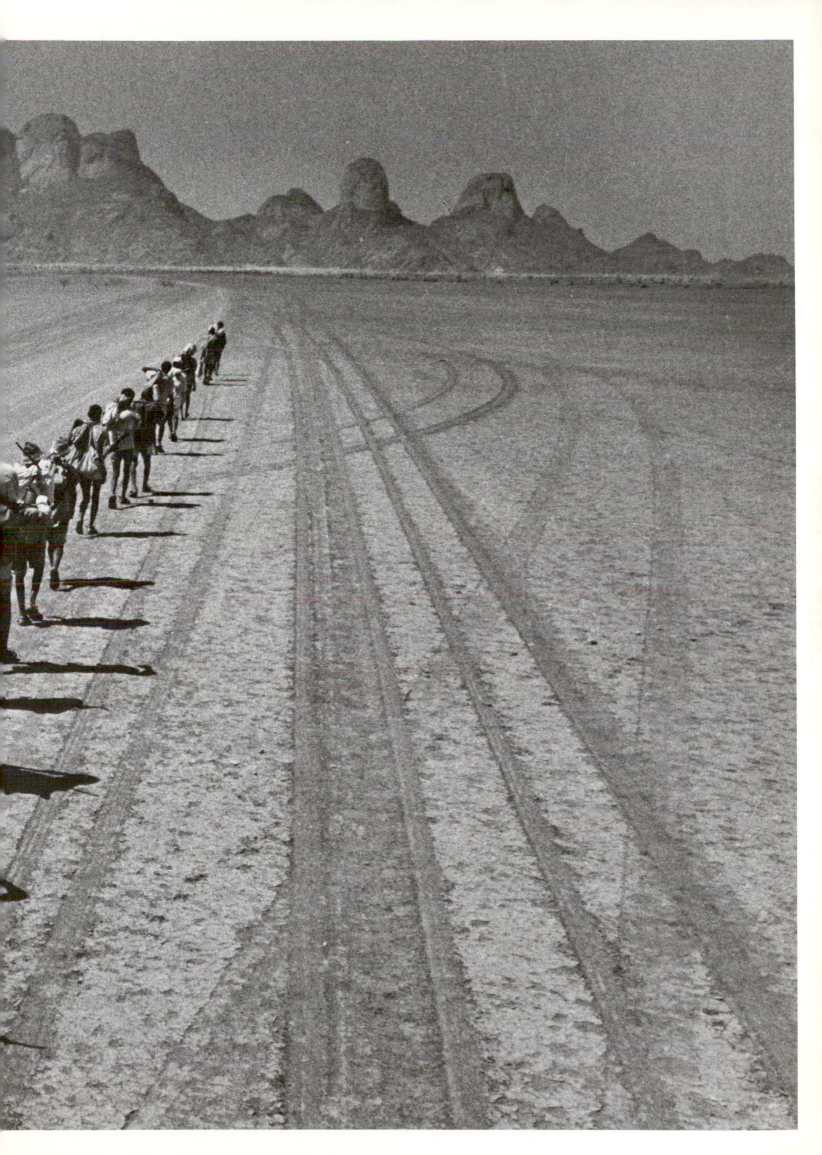

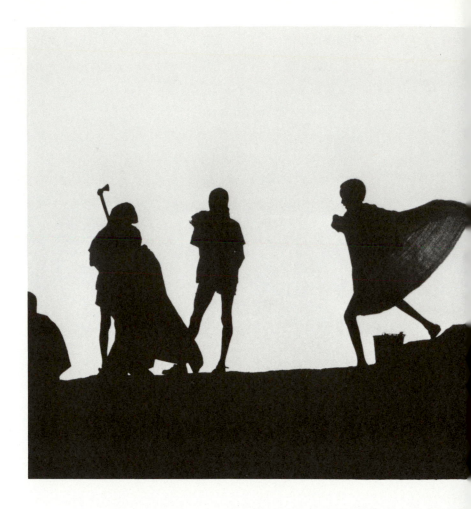

Ethiopians line up at sundown in Tigray Province for the long overnight march towards the Sudanese border.

Canon Essay

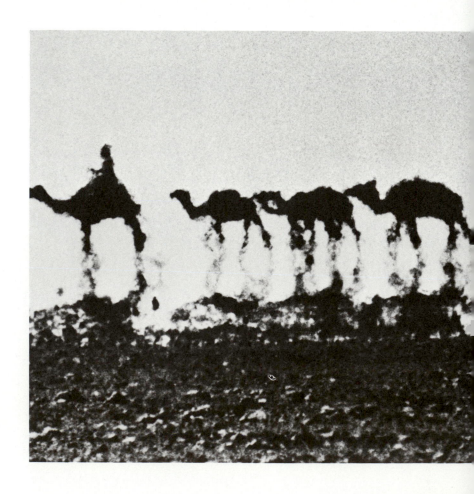

A camel caravan heads into Sudan from Eritrea Province.

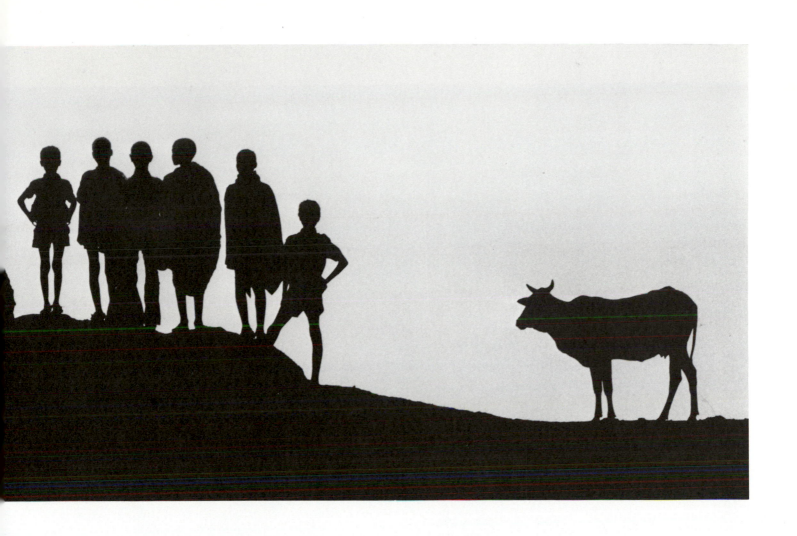

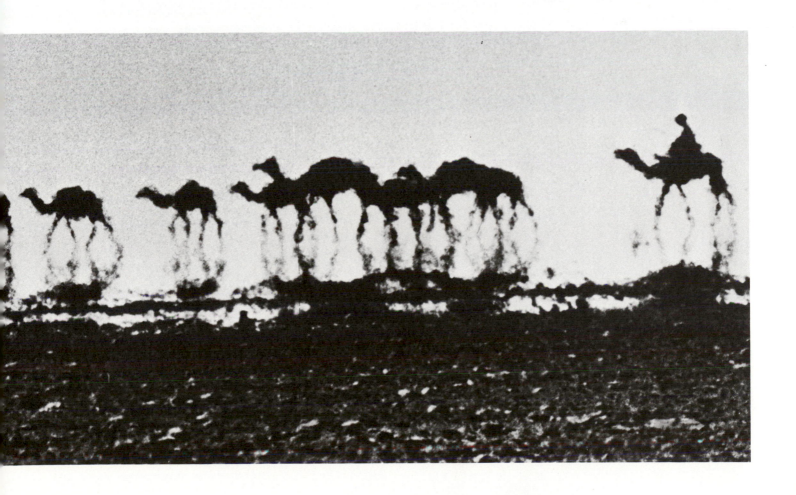

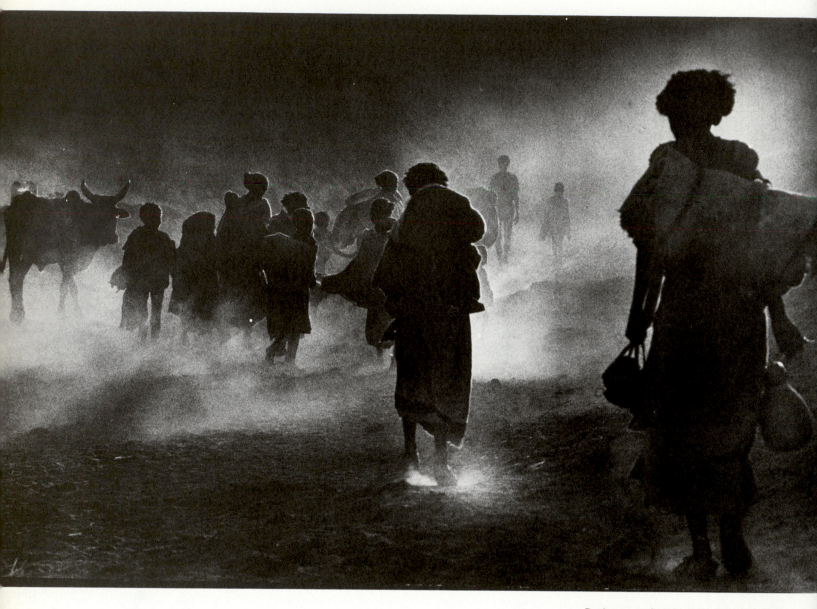

Refugees fleeing to food relief camps in Sudan move down a dry riverbed in Tigray Province, Ethiopia.

Right, Berhamy, an Ethiopian refugee sips water from a dish after giving birth at Zele Zele in Tigray Province.

Canon Essay

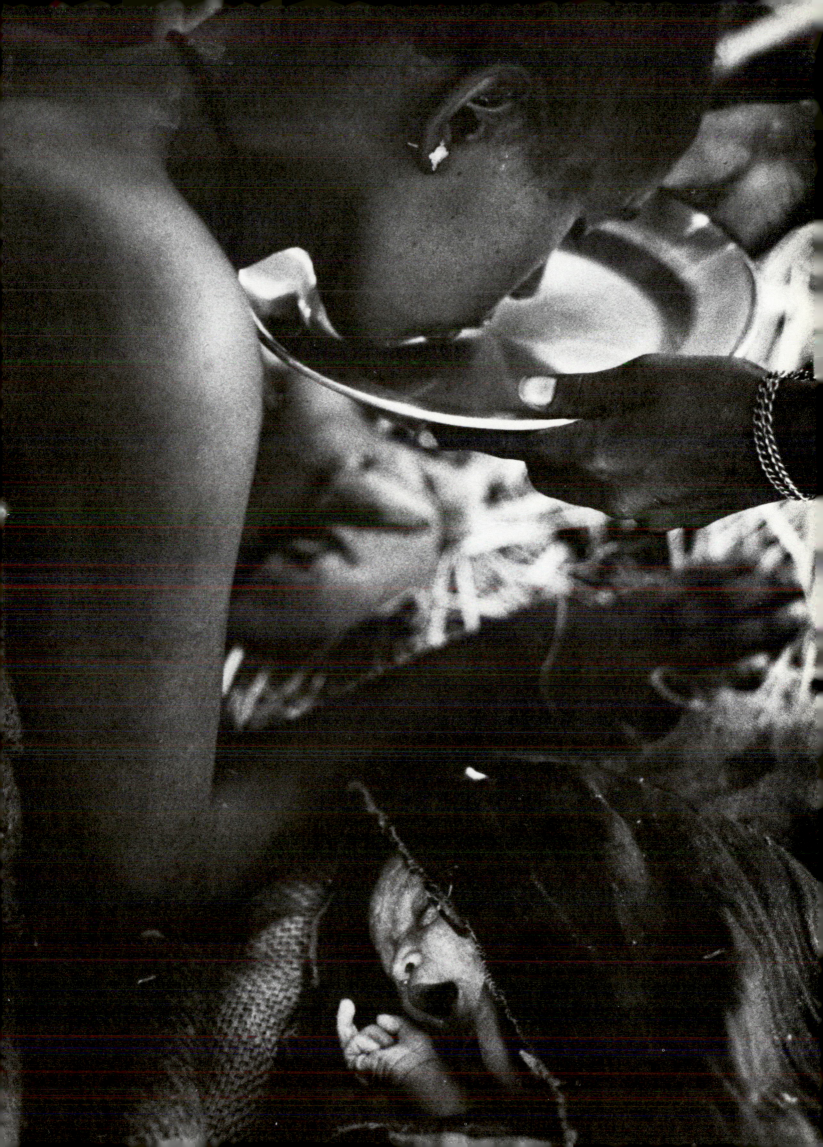

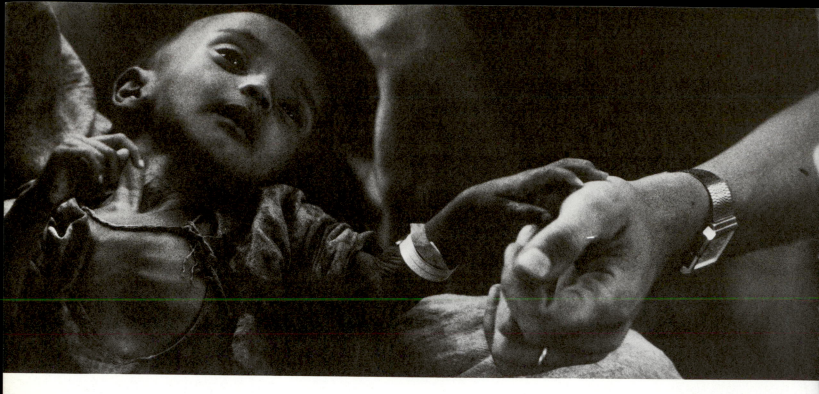

Above, an Oxfam doctor holds the hand of an emaciated baby.

Below, a youngster is so hungry he licks the flour from an empty burlap bag as he waits in line for food.

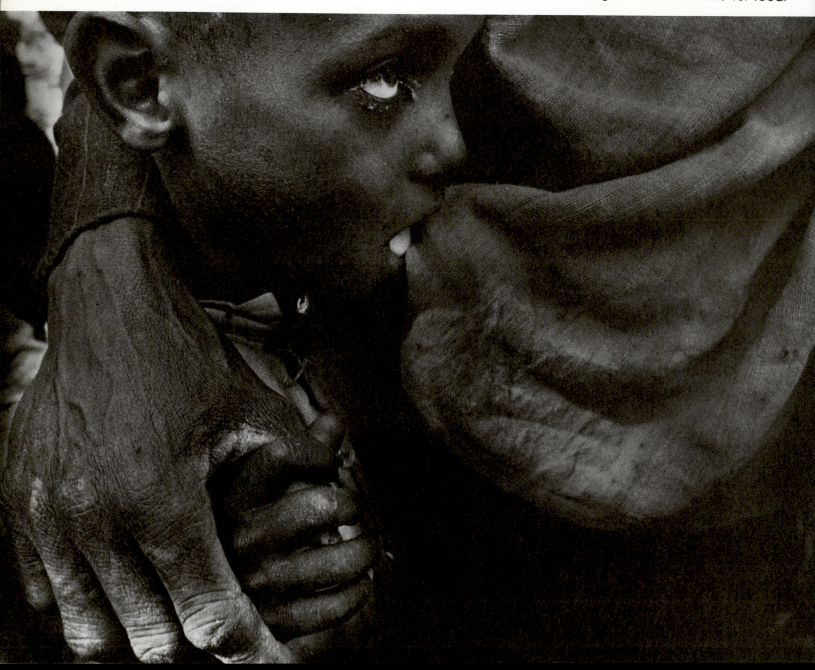

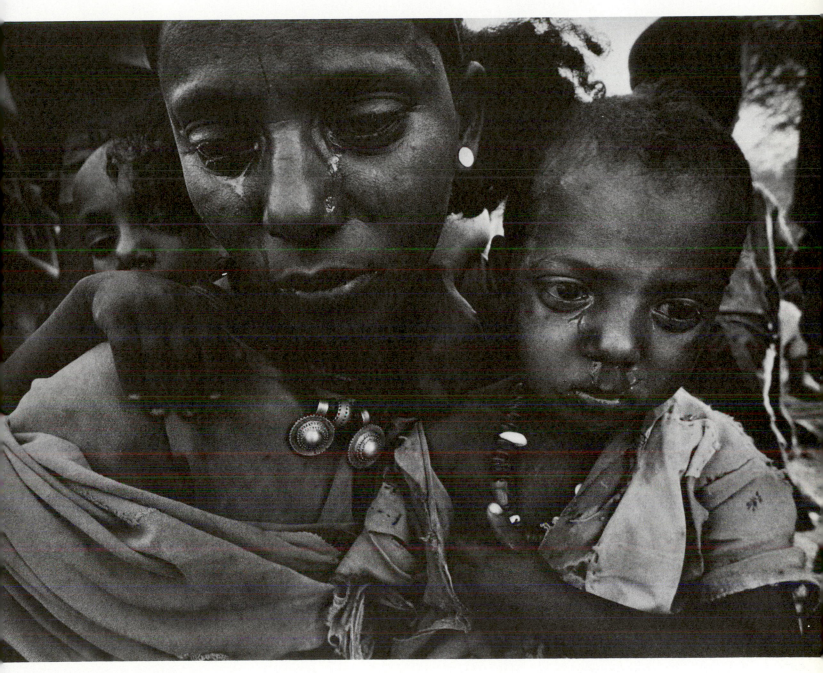

Near the Gash River in Tigray Province, a woman and her son are told there is no room for them on a convoy heading to Sudan.

Canon Essay

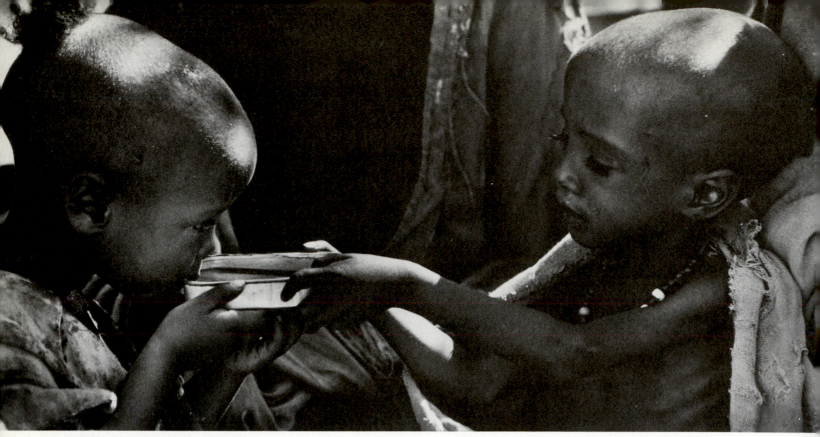

Canon Essay

Above, children reach for a sardine can of murky water at the Tukulababa refugee camp.

Below, a child who is too weak to brush away the flies rests on his mother at a transient camp in Zele Zele.

Right, a guerrilla from the Tigray People's Liberation Front crosses the dry Gash River in Tigray Province.

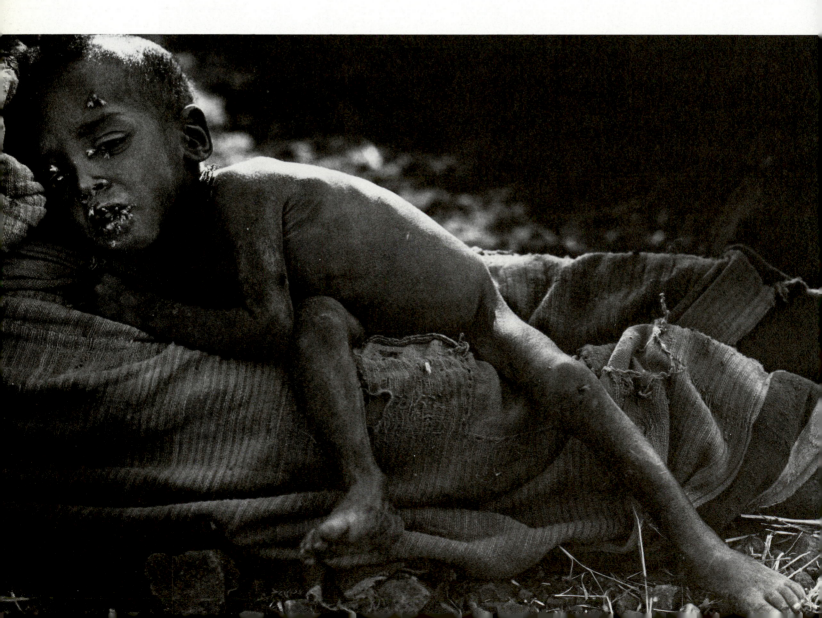

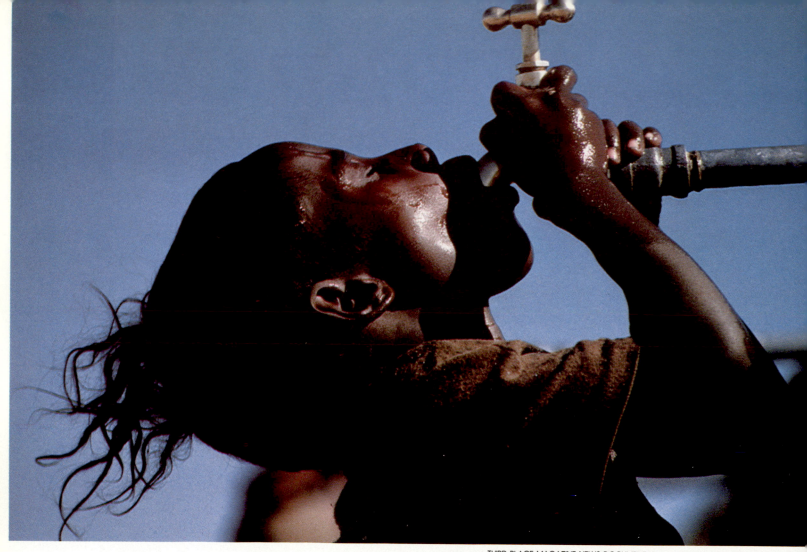

Above, an Ethiopian child sucks on a faucet for a few rare and precious drops of water.

Below, a young victim of famine in Ethiopia sits in the classic pose of despair.

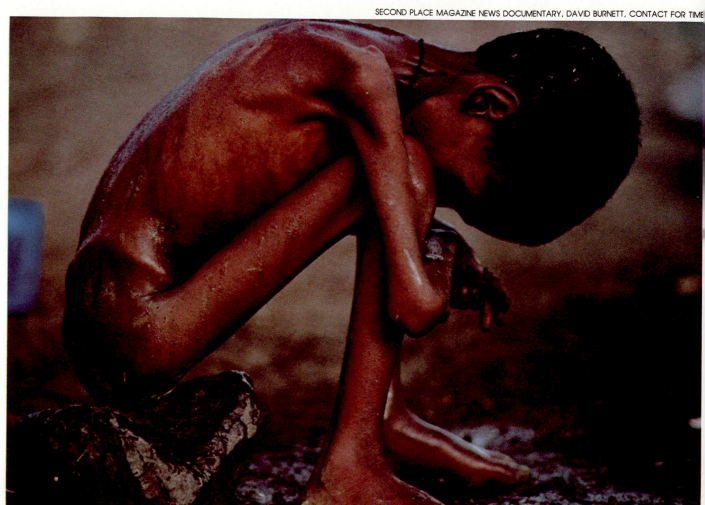

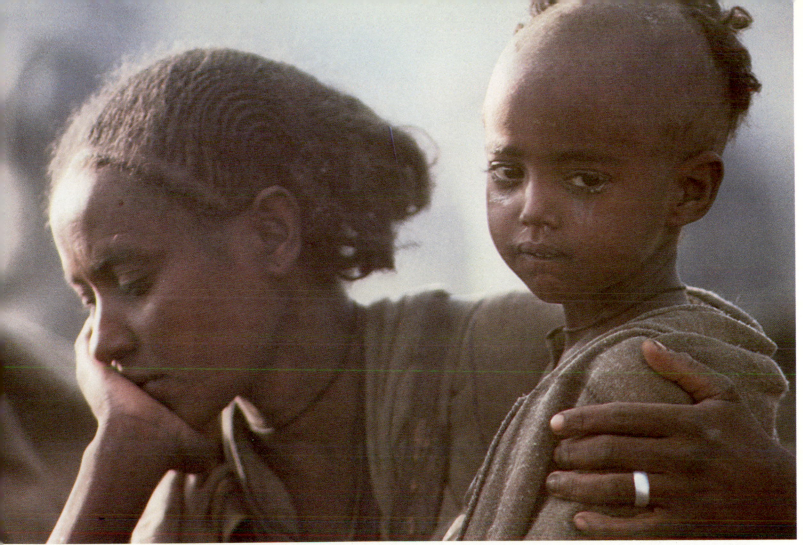

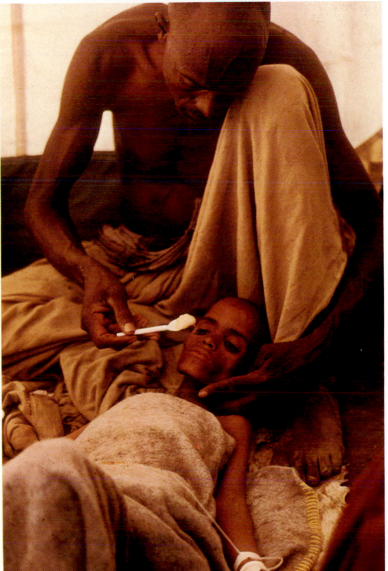

Above, mother and child outside a camp for the victims of the famine in Ethiopia.

Left, a father feeds his son, who died later that day. Said Photographer John Isaac, 'The children had forgotten how to eat.''

Right, hundreds of fans without tickets line gates outside the Los Angeles coliseum to catch a glimpse of the Games' opening ceremonies. Said Photographer Karen T. Borchers, "They settled for the sound of fans cheering and music playing."

'Radiant days'

It was a summer of superlatives, of high adventure and national pride, as Americans absorbed themselves in the 1984 Summer Olympic Games at Los Angeles.

The Associated Press reported the stark statistics: "With such athletically powerful nations as the Soviet Union, East Germany and Cuba staying away, U.S. athletes won 83 gold medals and 174 total medals in 16 days of competition, which drew 5.6 million spectators and were watched on worldwide television."

Newsweek Magazine assessed the Games: "The Olympians were America's darlings and, in the midst of Campaign '84, the nation paused to celebrate itself.'

Time Magazine's conclusion: "Those radiant days."

For photojournalists, the '84 Summer Olympics were a joy and a despair: the biggest story of most photographers' careers and one of the most frustrating. But photographers reported the Games in brilliant detail; if the Games were of championship caliber, so was the photographic coverage.

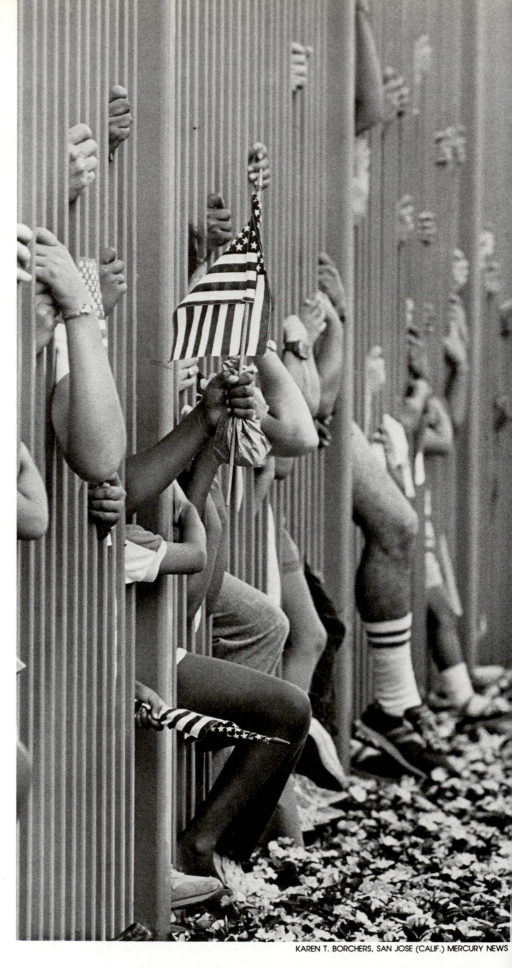

KAREN T. BORCHERS, SAN JOSE (CALIF.) MERCURY NEWS

Right, all across the country, Americans cheered bearers of the Olympic torch. Here Chicago Bears running back Walter Payton carries the torch out of the Daley Center in Chicago.

BOB RINGHAM, CHICAGO (ILL.) SUN-TIMES

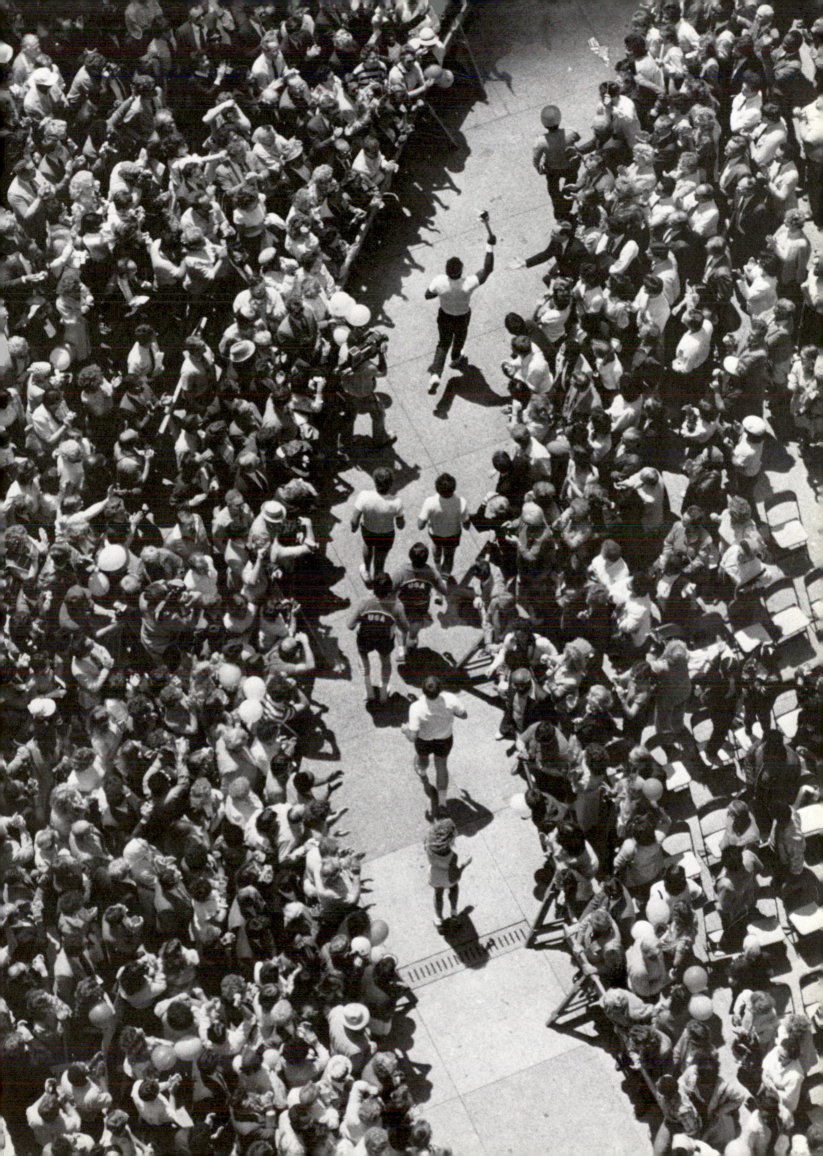

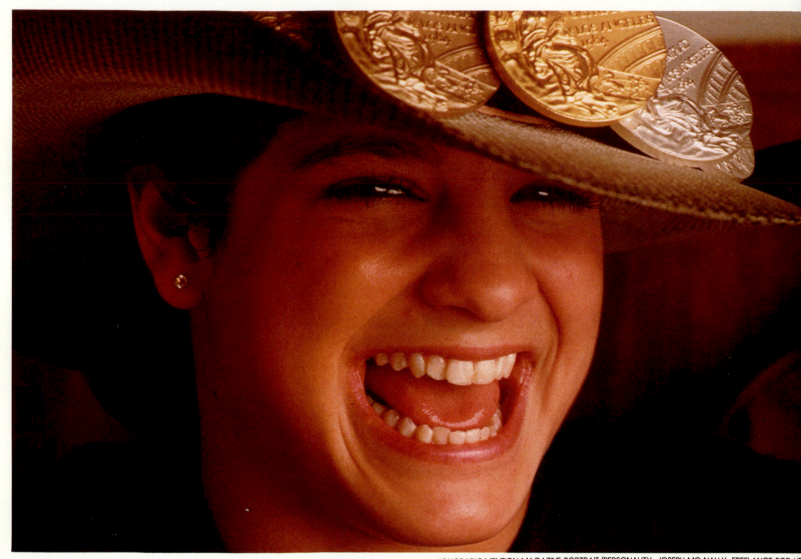

HONORABLE MENTION MAGAZINE PORTRAIT/PERSONALITY, JOSEPH MC NALLY, FREELANCE FOR LIF

Golden girl

If there was one Olympian whom Americans took to the hearts, it was Mary Lou Retton, the Golden Girl of international gymnastics.

Reported Time Magazine, ''When Mary Lou needed two 10s in her last events, and nailed them both to win, her final dismount was an enduring image of the Games' perfect execution and victorious exuberance.''

The 92-pound 16-year-old wound up with one gold medal, two silvers and two bronzes. And Sports Illustrate named her Sportswoman of the Year.

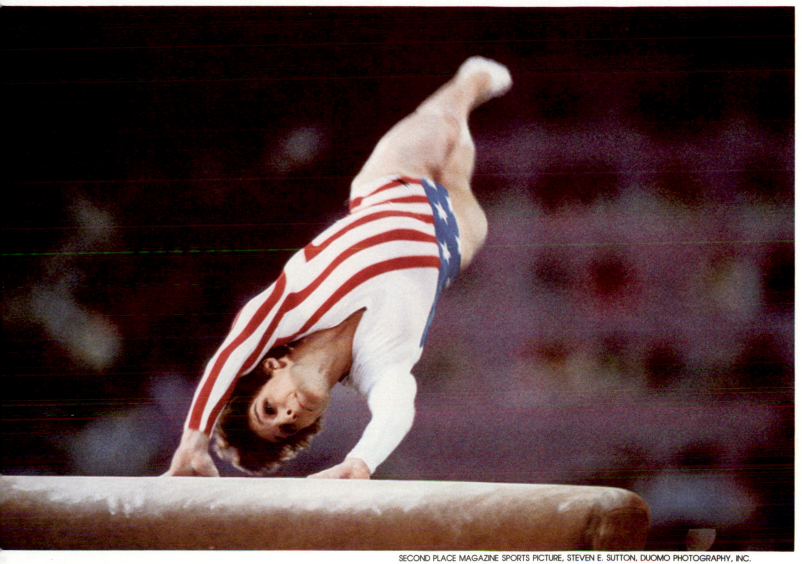

SECOND PLACE MAGAZINE SPORTS PICTURE, STEVEN E. SUTTON, DUOMO PHOTOGRAPHY, INC.

Retton's gold medal came only after
perfect scores of 10 in both the floor
exercises and (above) the vault.

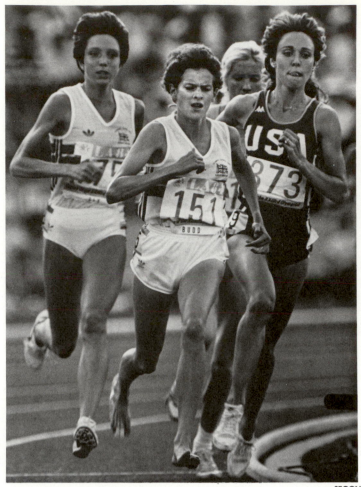

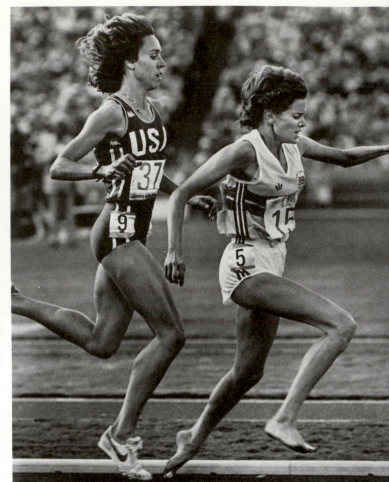

Mary Decker's fall

A series of photographs by Photographer Bruce Chambers of the Long Beach (Calif.) Press-Telegram captured one of the most emotional events of the Summer Olympics. Reported the Press-Telegram:

"The first four laps of the first Olympic 3,000 meters for women — and the first meeting between world champion Mary Decker of the U.S. (373) and the South African-turned-British teenager, Zola Budd (151) — had progressed rather uneventfully until Budd found herself in the disadvantaged position of running to the outside of Decker on the turn . . . Budd, who runs with an awkward style, seemed to be trying to get inside (top left).

"The tangle of legs and feet that victimized Decker, who writhed in pain on the infield grass, and villainized Budd, who had to endure the boos of a pro-American crowd for 3½ more laps,

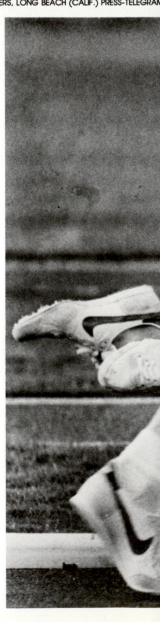

was not without warning. The two bumped legs earlier.

"Then they bumped again. As Decker brought her right leg forward (second from left), her rising knee hit the back of Budd's left leg, causing it to splay sharply to the left.

"Struggling to keep her balance, Budd staggered into Decker's path. Decker chopped her stride, avoiding Budd's bare feet with her right foot. But Decker's left foot came down on Budd's left heel, her spiked shoe scraping a two-inch cut into the Briton's exposed skin, and the American began to fall (third from left).

"In desperation, Decker reached for anything for support but all she grasped was the paper number pinned to Budd's back. She took it with her (fourth from left) to the turf as Budd skipped out of trouble . . . As the rest of the field ran past Decker broke into tears."

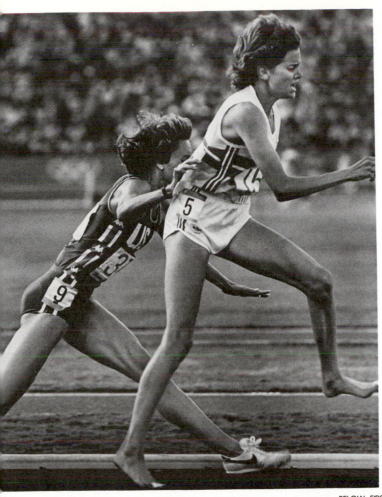
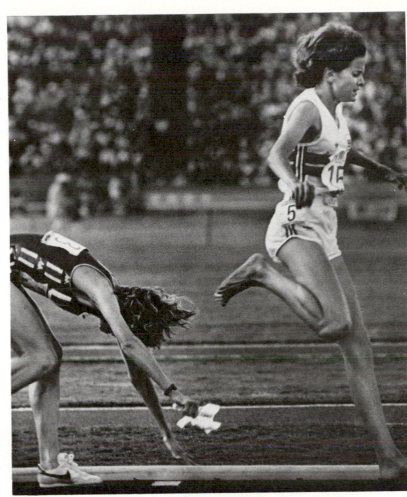

BELOW, FIRST PLACE NEWSPAPER SPORTS ACTION, BRUCE CHAMBERS, LONG BEACH (CALIF.) PRESS-TELEGRAM

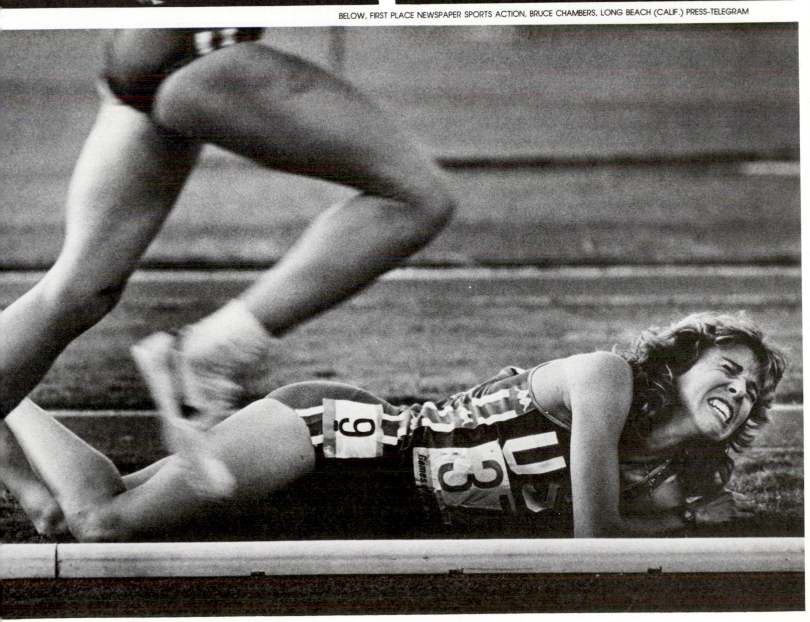

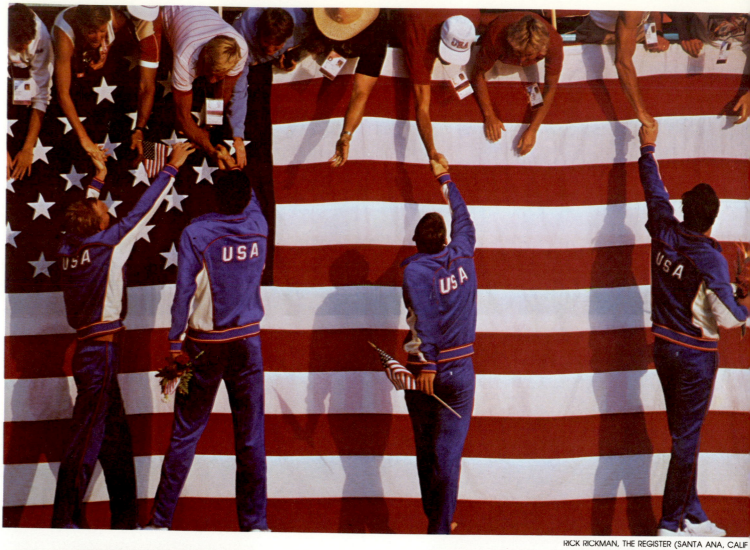

BRIAN SMITH, THE REGISTER (SANTA ANA, CALIF.)

RICK RICKMAN, THE REGISTER (SANTA ANA, CALIF

BRIAN SMITH, THE REGISTER (SANTA ANA, CALIF

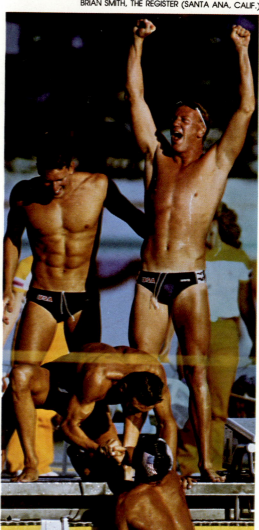

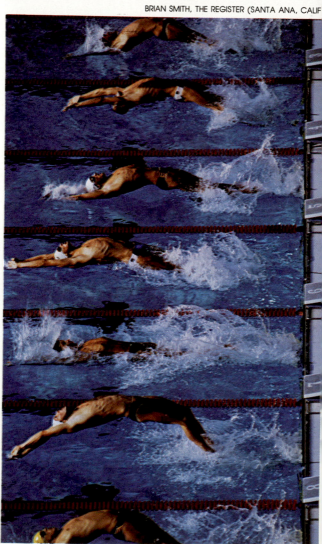

Above, members of U.S. men's relay team receive warm welcome from team members and relatives after winning their second gold medal.

Left, Michael Heath (left) and David Larson rejoice as Jeff Float congratulates Bruce Hayes on the U.S. men's relay team's victory in the 4x200 freestyle relay — a surprise win.

Right, swimmers leave the blocks at the start of the men's 100 meter backstroke.

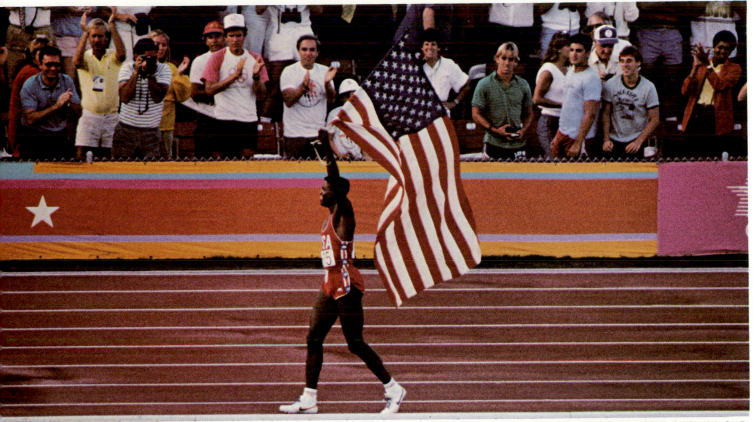

RICK RICKMAN, THE REGISTER (SANTA ANA, CALIF.)

Above, sprinter Carl Lewis takes the American flag around a victory lap after winning his second of four gold medals.

Below, Olympic gymnast Tracy Talavera performs her routine on the uneven bars. Photographers Rick Rickman and Brian Smith were among three Register photographers whose Olympic coverage was awarded the 1984 Pulitzer Prize for spot news photography.

RICK RICKMAN, THE REGISTER (SANTA ANA, CALIF.)

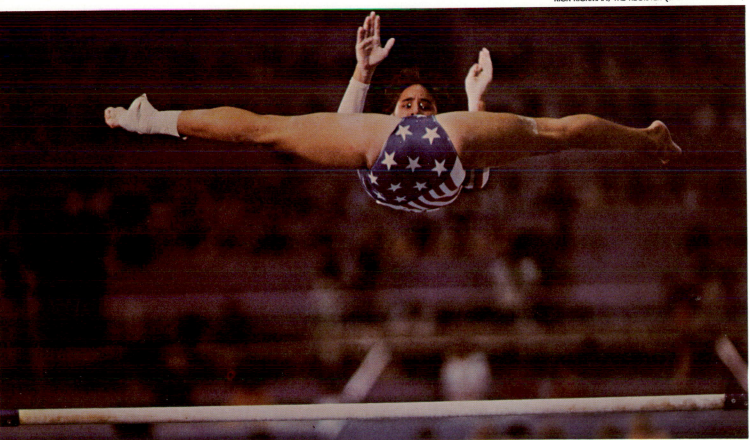

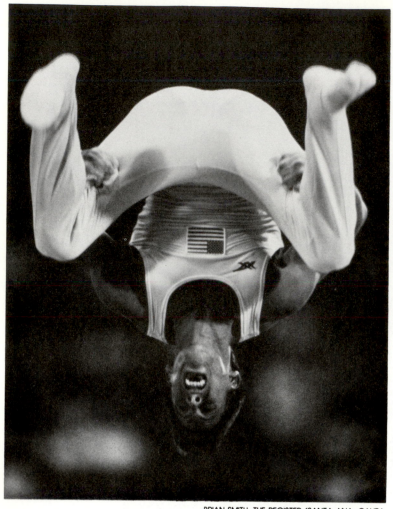

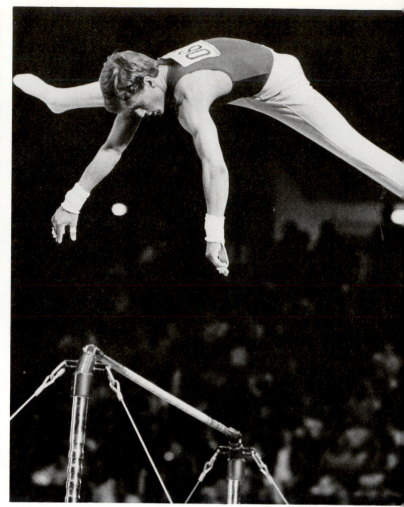

Above, gymnast Tim Dagget spins through the dismount of his routine on the rings. His 10 helped lead the United States team to the gold.

Below, Phil Cahoy of the University of Nebraska competes for a spot on the U.S. Olympic gymnastics team in Jacksonville, Fla.

Above, Peter Vidmar in action on the uneven bar — a perfect 10 in a silver medal performance for best overall men's gymnastic performance.

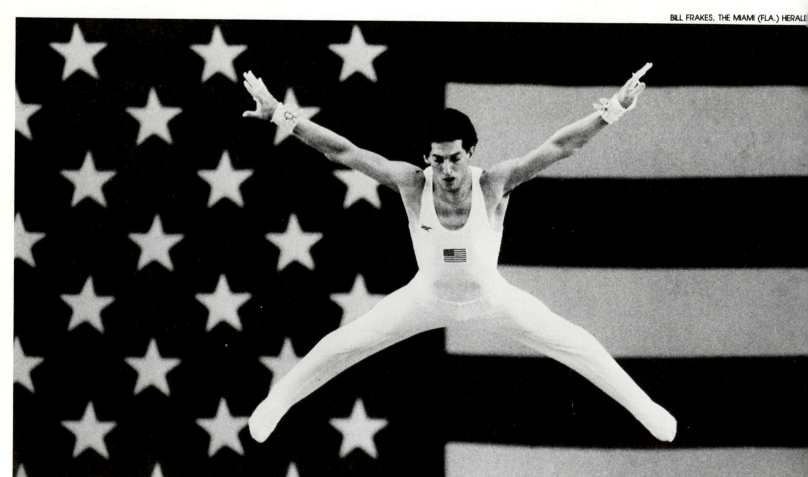

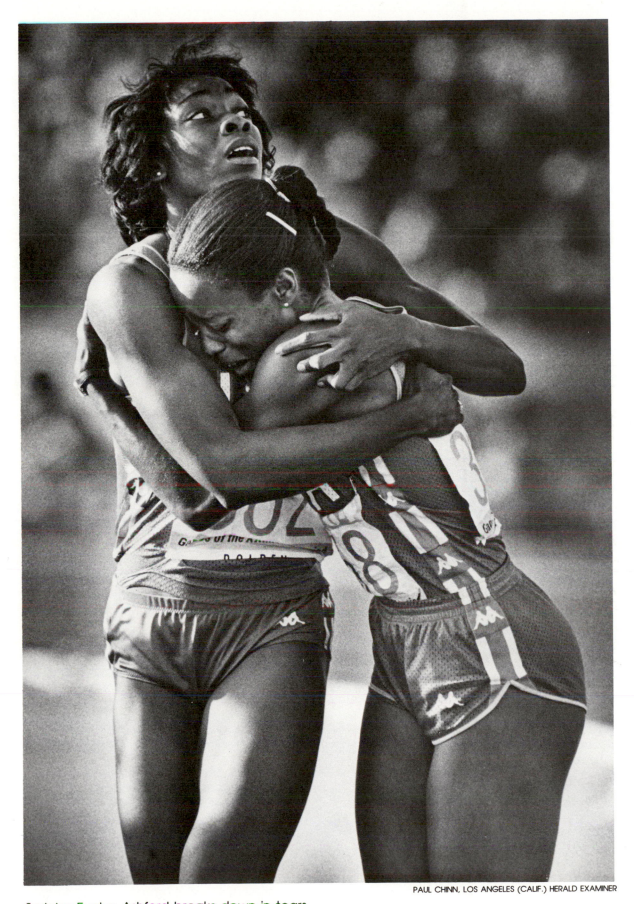

Sprinter Evelyn Ashford breaks down in tears in the arms of teammate Jeanette Bolden after winning the gold medal in the women's 100 meter run. Ashford's winning time (10.97 seconds) broke the old Olympic record of 11.01.

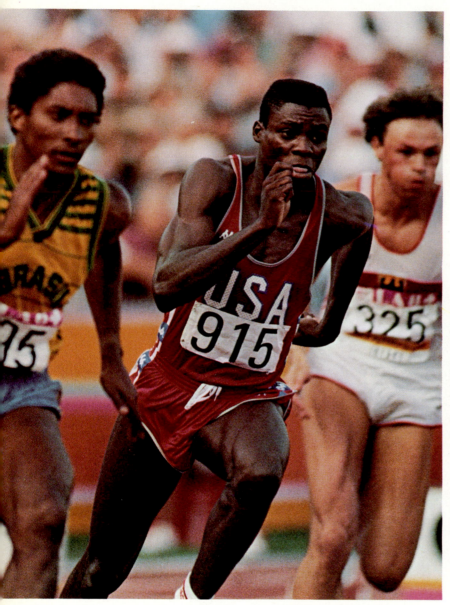

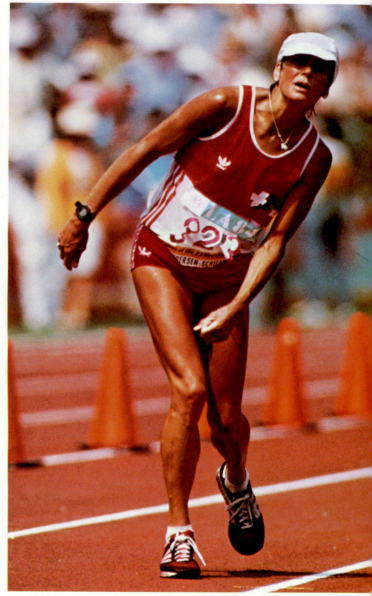

Above, U.S. runner Carl Lewis heads for the finish line — and a gold medal — in the 200-meter event. His time of 19.80 seconds set a new Olympic record.

Above, agonizing climax to the women's marathon came when Switzerland's Gabriel Anderson-Schiess staggered into the stadium to complete two laps and finish the race. Although suffering from exhaustion and near heat prostration, Schiess refused aid, which would have disqualified her. Still, track officials came under criticism for not stopping the indomitable runner.

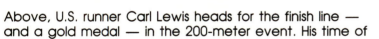

Right, U.S. cyclist Steve Hegg waves an American flag a an enthusiastic crowd after winning a gold medal in the 4,000 meter individual pursuit.

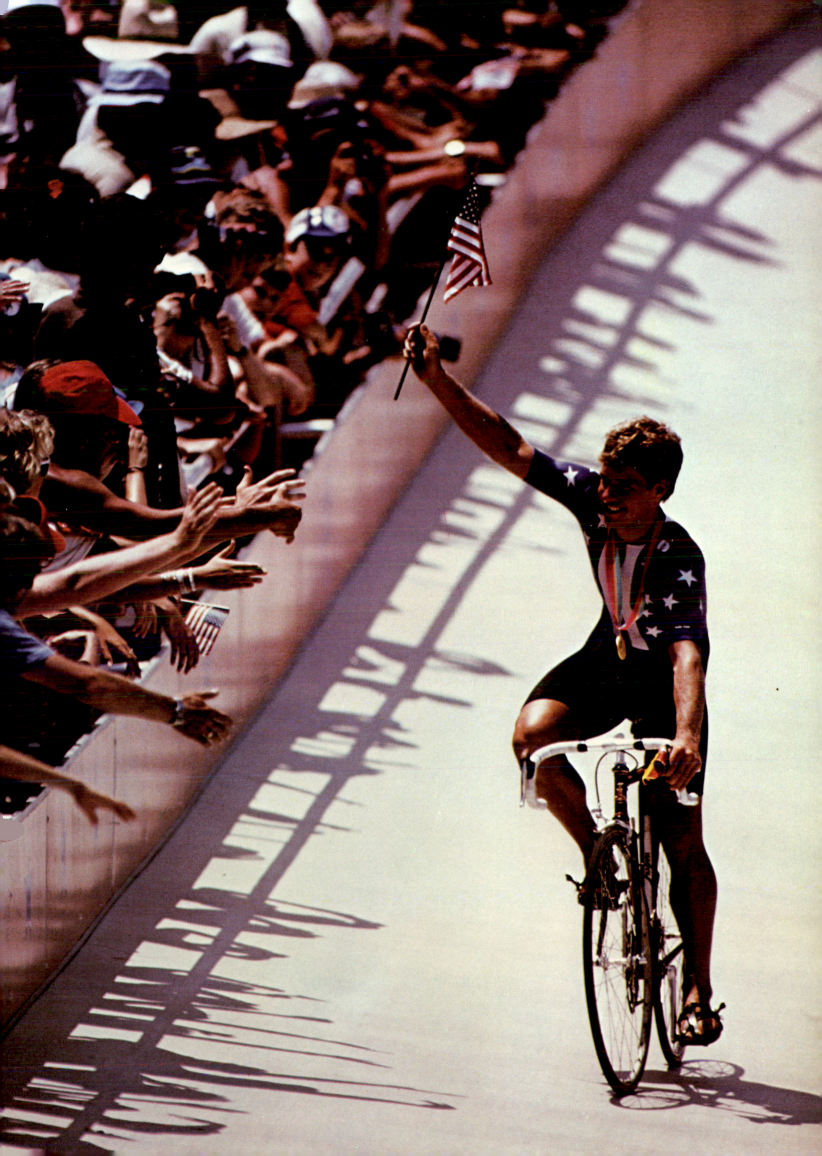

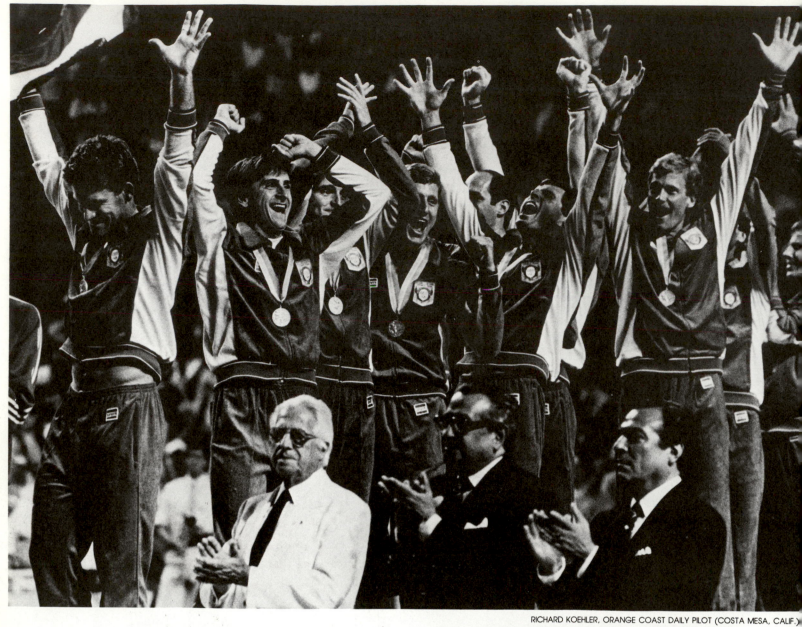

Above, it was joy unrestrained when members of the U.S. men's volleyball team received their gold medals. Their elation came after they defeated Brazil in three straight games.

Right, America's Joan Benoit raises her arms in victory after winning the first women's marathon at the Summer Games.

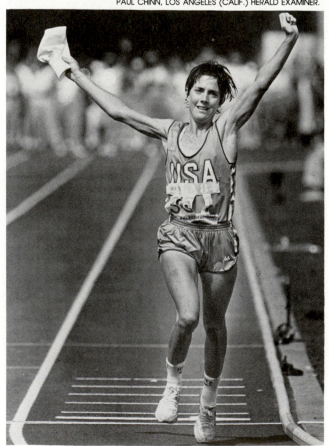

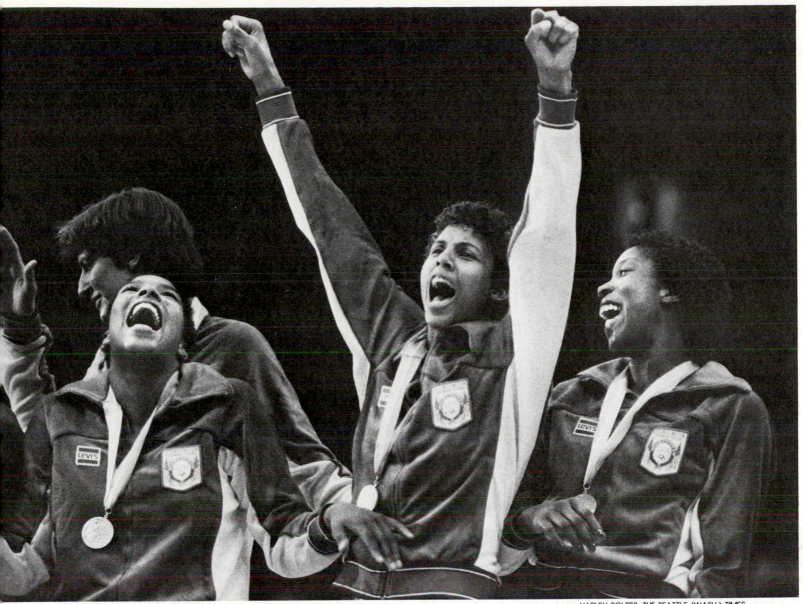

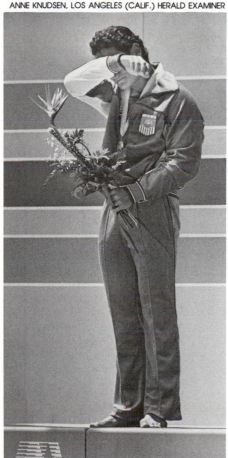

Above, another golden celebration, this one involving members of the U.S. women's basketball team after downing South Korea by 30 points.

Left, those are tears of joy hidden by U.S. diver Greg Louganis after taking the second of two gold medals, this one in the platform diving competition.

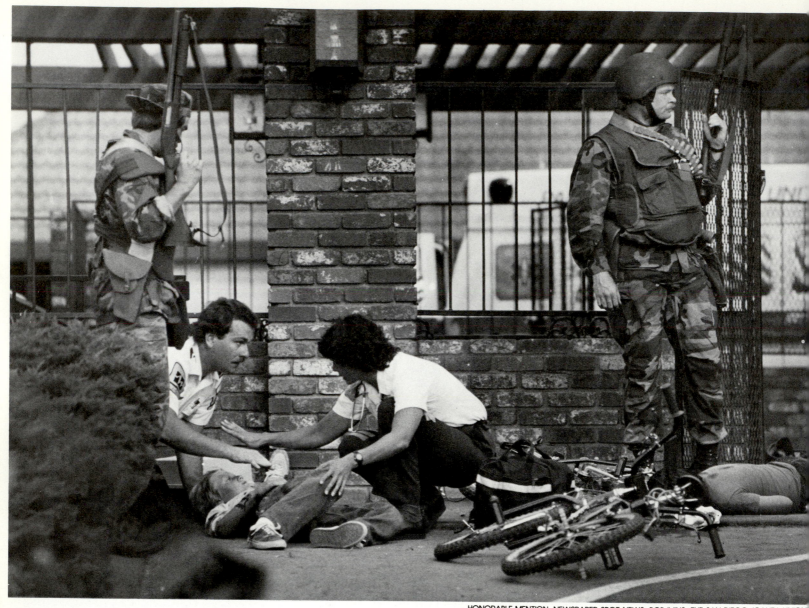

Above, San Diego police SWAT officers stand guard while paramedics attend to a young survivor, Joshua Coleman. He stayed alive by feigning death. But his two friends were killed.

Massacre at McDonald's

Late afternoon in mid-July: half a hundred people were enjoying themselves in a McDonald's restaurant in San Ysidro, Calif. An unemployed security guard, James Huberty, came on the scene with a pistol, shotgun and a semi-automatic rifle.

He began shooting, reported LIFE Magazine, "anyone who moved, cried or blinked."

Within 90 minutes, Hubert had shot 40 people. Twenty-one of them were dead or dying. Nineteen were wounded. And Hubert himself was dead at the hands of a SWAT sharpshooter.

Some observers called it, rightly, the worst one-man massacre in U.S. history. The photographers who converged on the scene agreed: It was a situation they'll never forget.

Says Photographer David Gatley of the Los Angeles Times, "Each photographer has his own story to relate. Few came away without some emotional scars."

Right, police officer assists a bloodied victim away from scene.

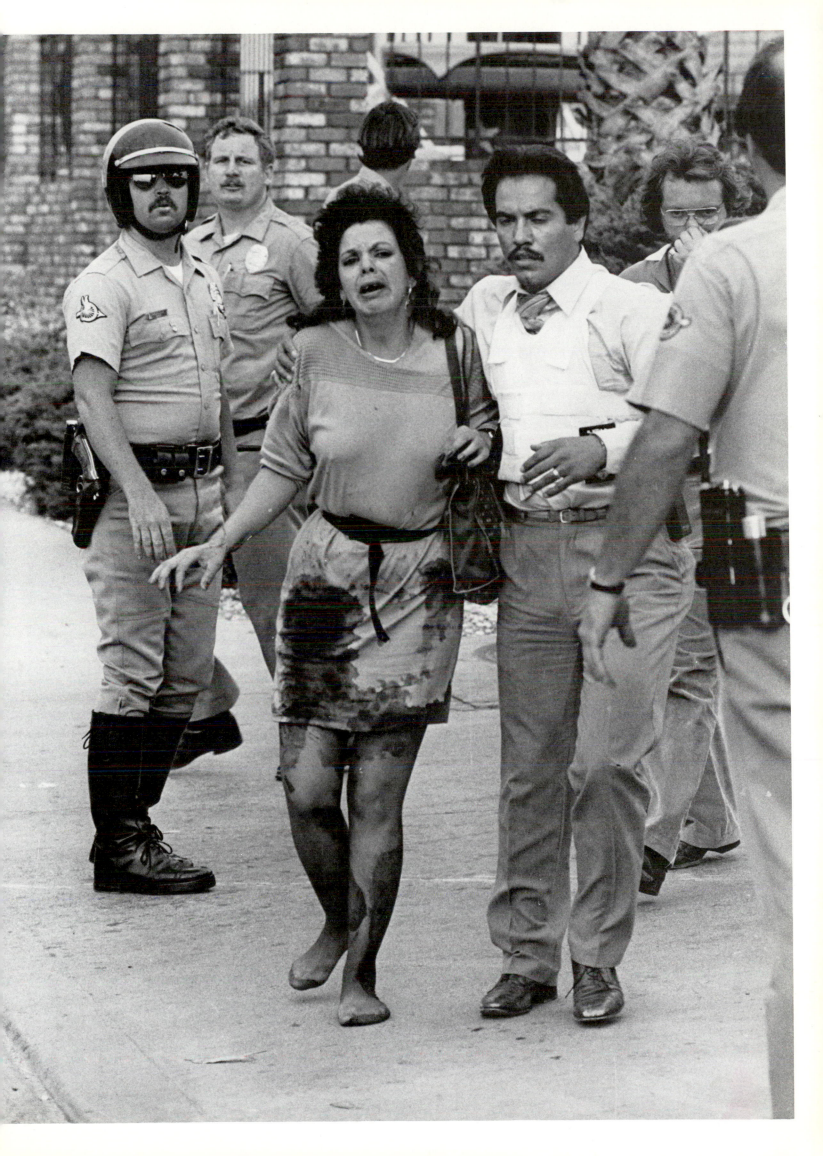

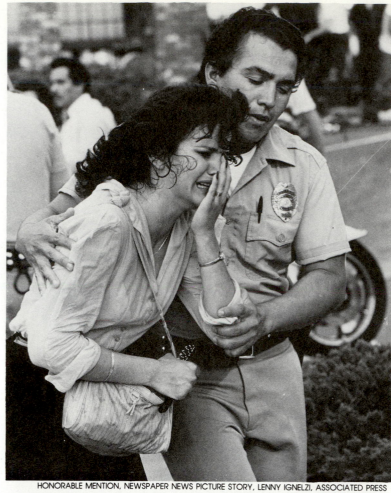

A weeping woman is assisted by a San Diego police officer after the indiscriminate shooting was over.

A stunned and bewildered young woman sits on a curb outside the McDonald's restaurant.

McDonald's massacre

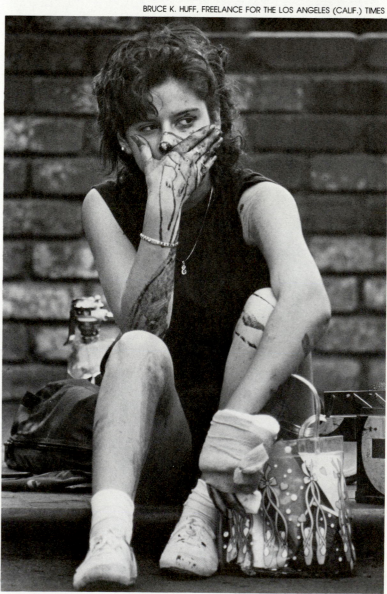

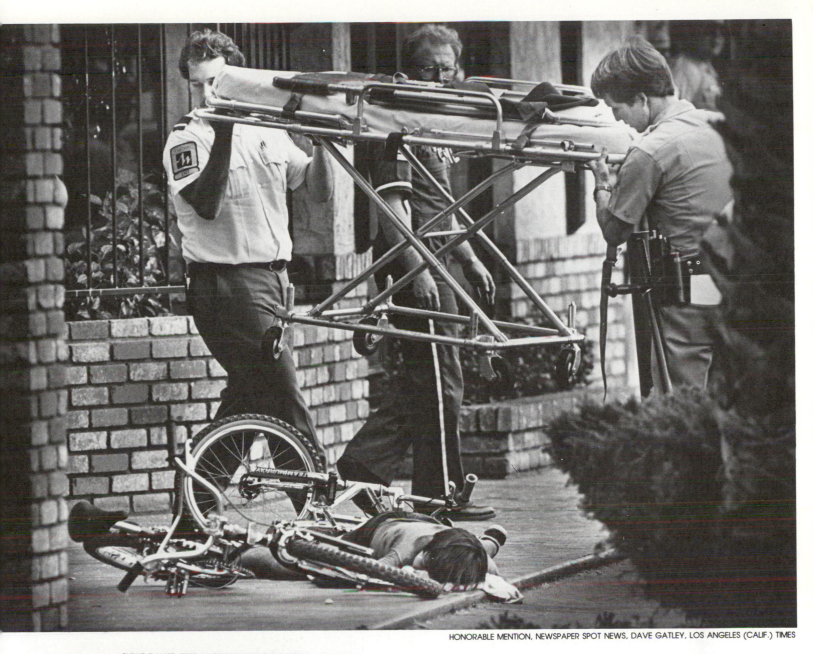

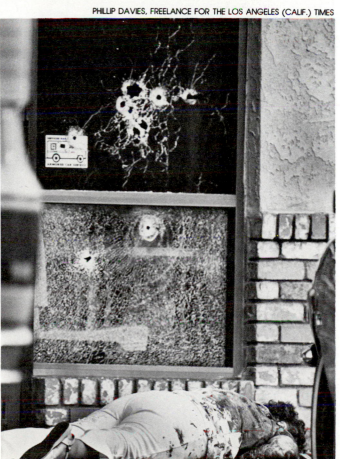

Above, a boy lies dead atop his bicycle as paramedics bring a stretcher to the restaurant.

Left, body of a woman under a bullet-riddled restaurant window.

53

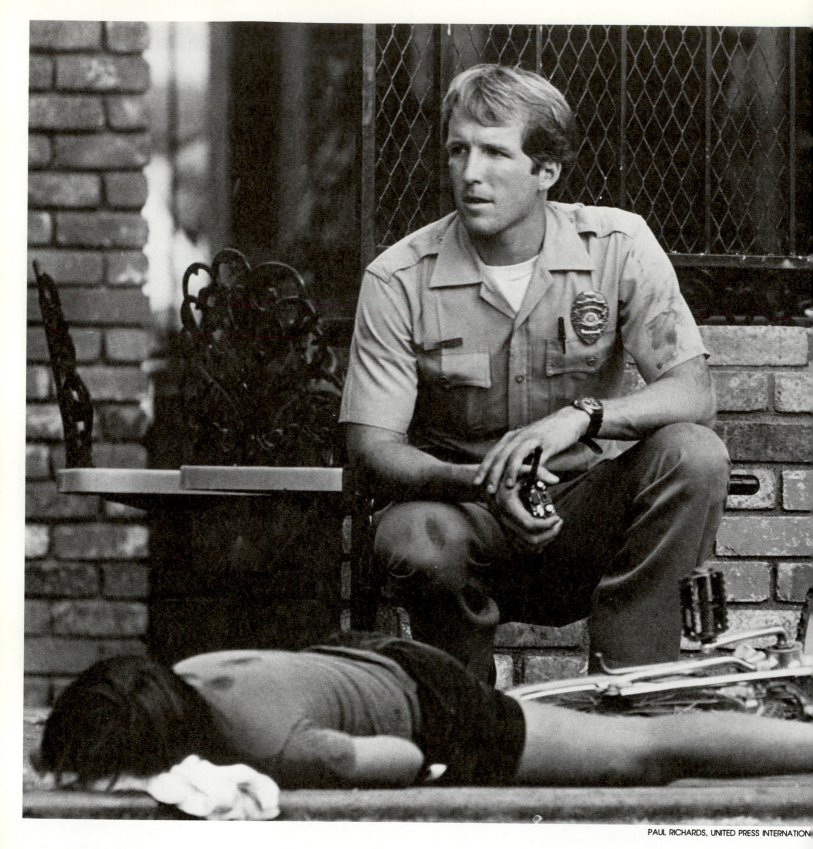

McDonald's massacre

A San Diego police officer kneels over the body of one young massacre victim.

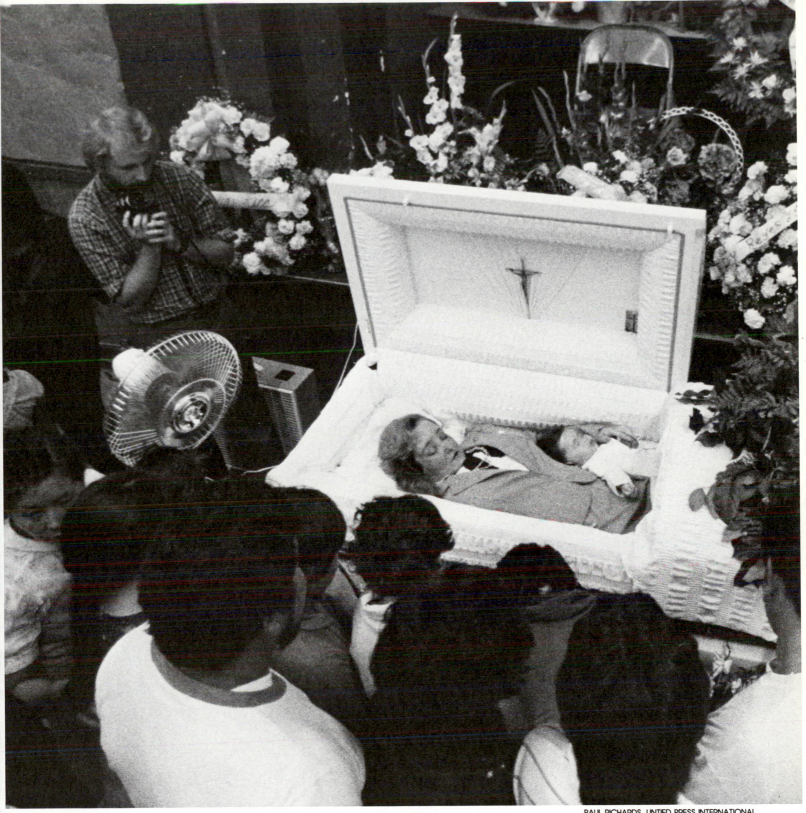

Friends and relatives pay final respects at the funeral of Jackie Wright, 18, and her 8-month-old-son, Carlos, at a wake only blocks away from the restaurant where they were killed.

Schroeder's amazing saga

Late in 1984, a retired Indiana munitions inspector became the second person ever to receive an artificial heart. The medical progress of William Schroeder captured the attention of the world, and a Kentucky freelance photographer — William Strode — recorded the uneven progress of the Schroeder adventure at the Humana Hospital Audubon in Louisville, Ky.

The Associated Press named Schroeder's artificial heart operation among its top ten news stories of the year. Reported the AP, "In the days immediately following his surgery, Schroeder amazed his doctors with his rapid recovery. Then a stroke suffered in his hospital room interrupted his progress, leaving him temporarily paralyzed on one side of his body and affecting his speech and memory."

Amazingly, Schroeder did not die. His recuperation continued; so did Strode's photographic coverage of the event.

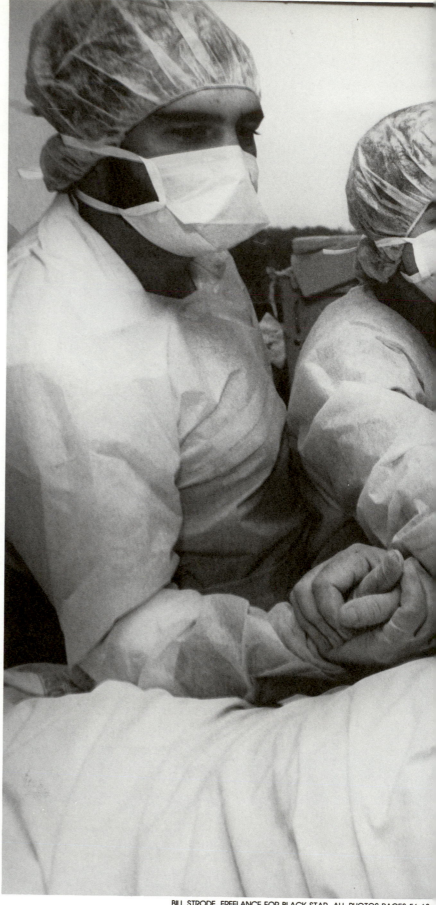

The day after the operation, Schroeder's family visits and feels his new heart for the first time.

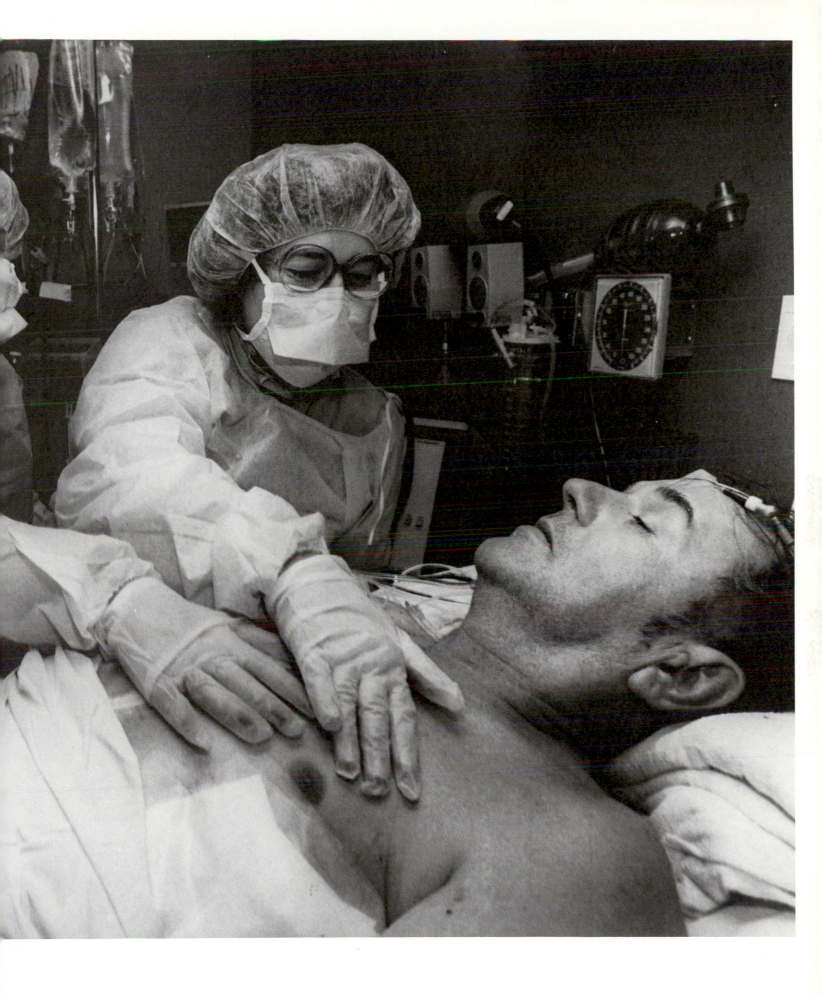

Above, after the operation, Schroeder's physician, Dr. William C. DeVries, tries to unwind.

Preparing for Schroeder's first time out of bed, Dr. DeVries checks to see if all is well.

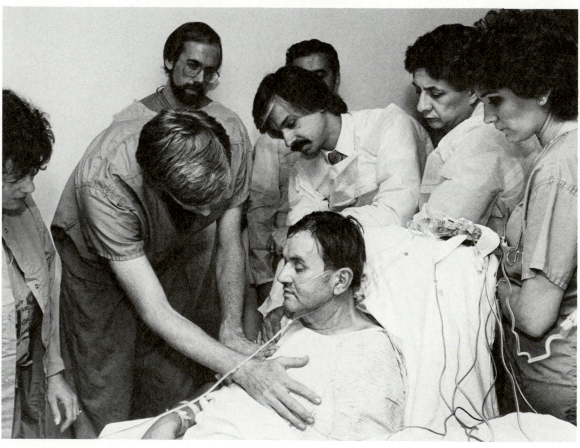

Schroeder's saga

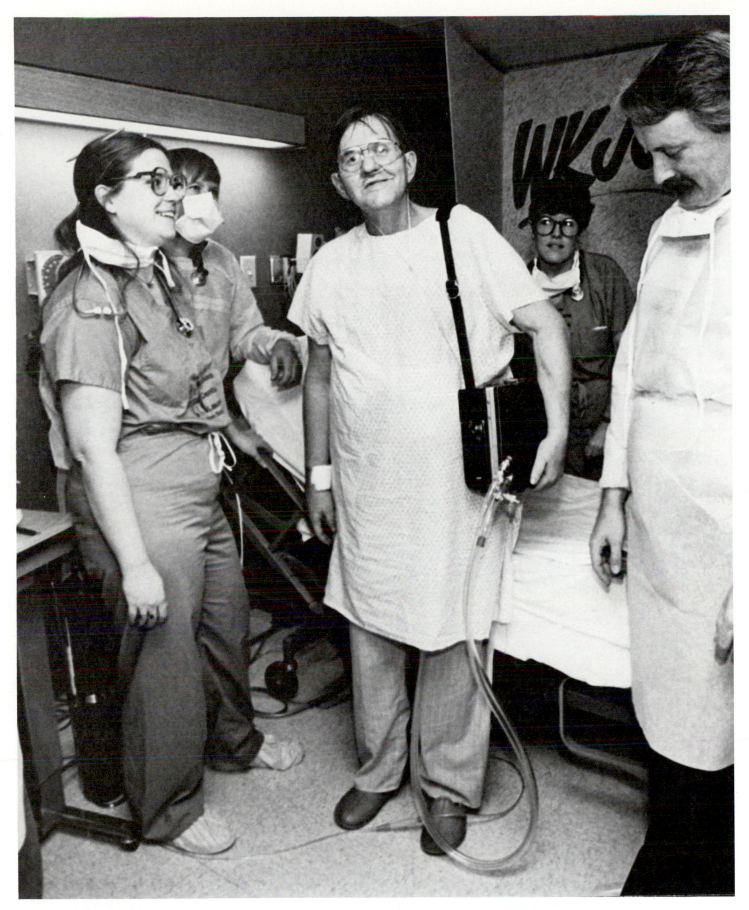

Schroeder's self-confidence is reflected
in his face as he takes his first steps
with his portable "drive."

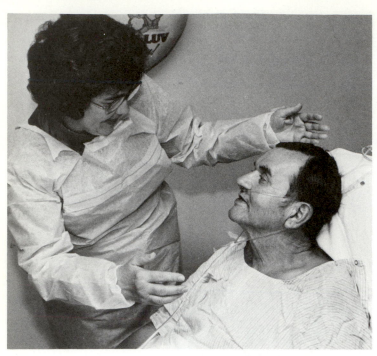

Schroeder's saga

Margaret Schroeder finally can not only see, but also touch and talk with her husband . . .

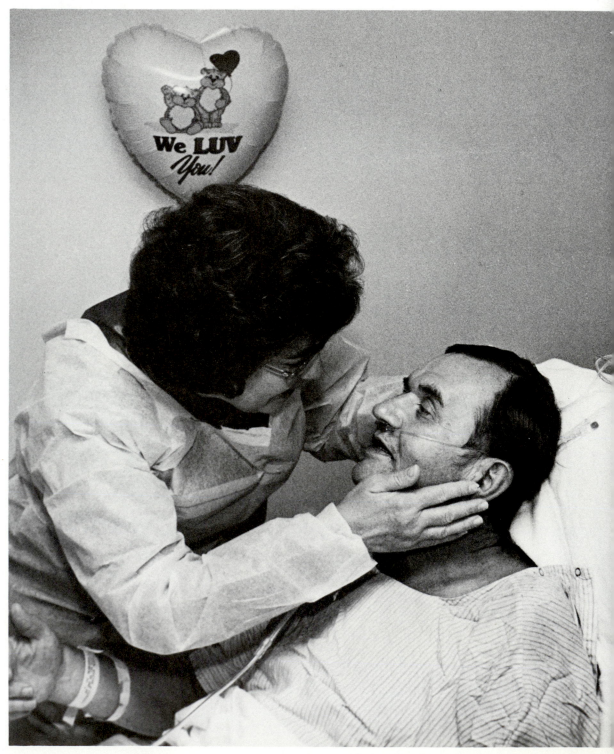

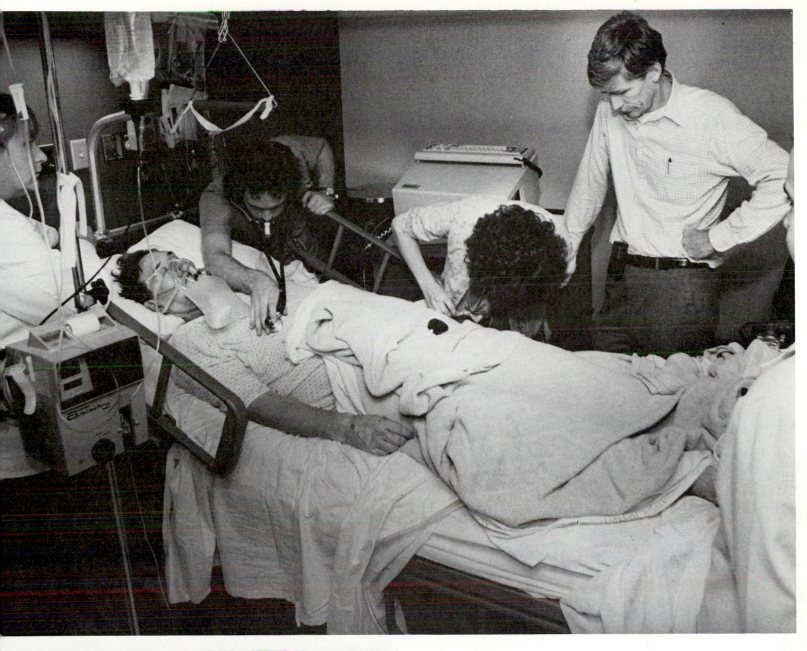

. . . but initial joy turns to despair when Schroeder suffers a stroke.

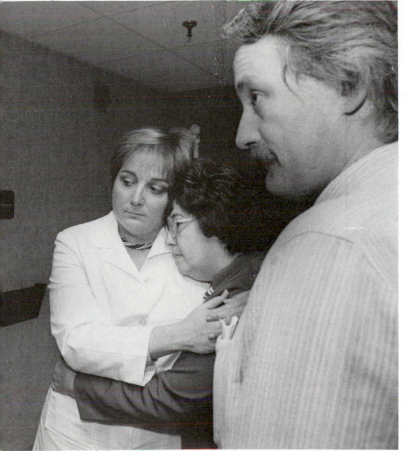

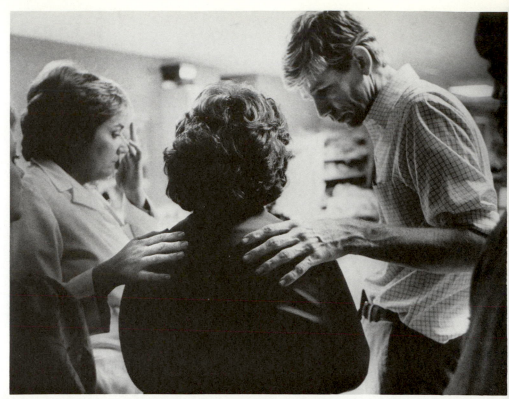

Right, Dr. DeVries and a nurse try to comfort Mrs. Schroeder.

Below, physicians consider their patient's changed condition.

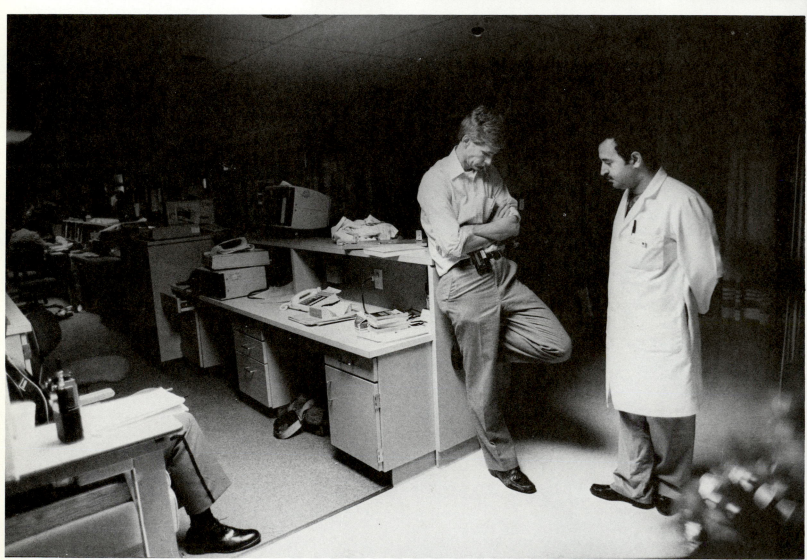

Schroeder's saga

Right, Schroeder fights back from the effects of the stroke. And his amazing saga continued.

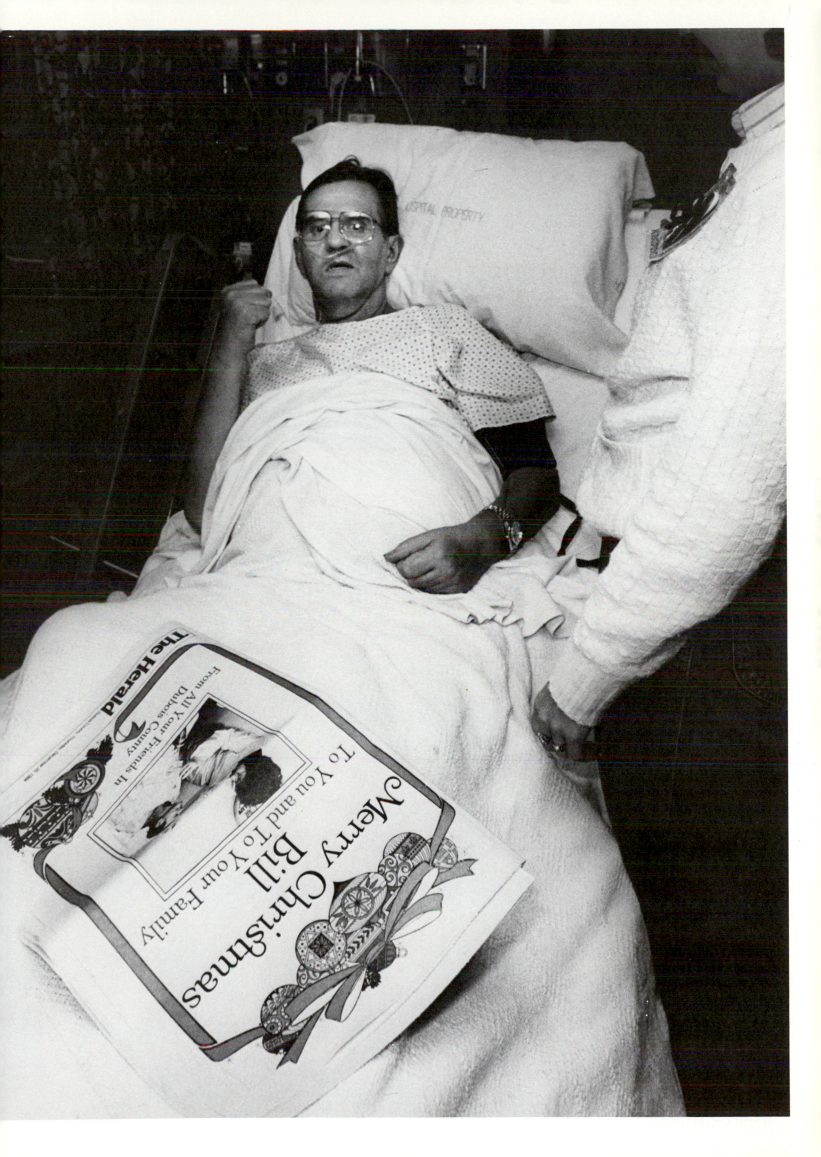

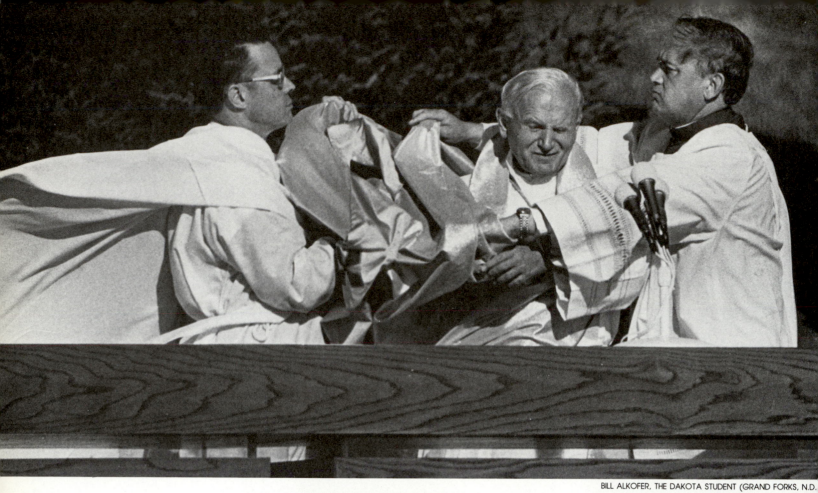

BILL ALKOFER, THE DAKOTA STUDENT (GRAND FORKS, N.D.

JACKIE LORENTZ, GRAND FORKS (N.D.) HERALD

A windblown Pope John Paul II worked his way across Canada early in the fall of 1984. Above, priests struggle with his vestments on a breezy altar near Winnipeg.

Below, a priest punches off a quick exposure as the pope deals with incense.

Canadian Odyssey

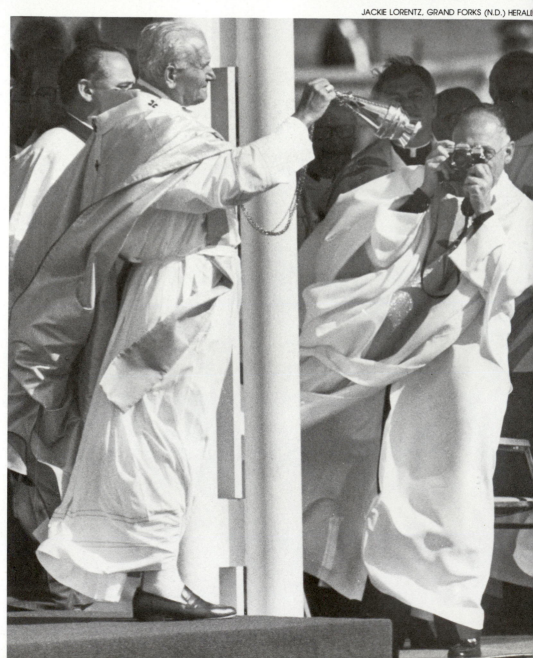

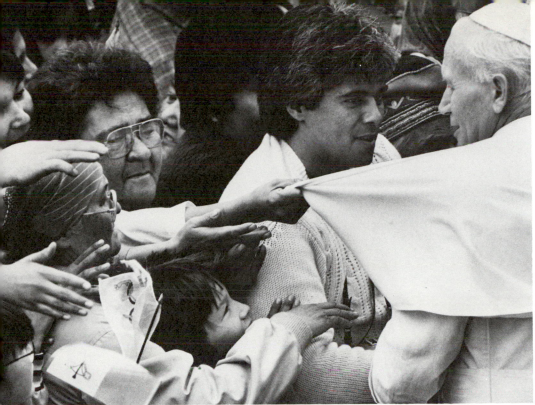

NORMAN W. LONO, THE PHILADELPHIA (PA.) DAILY NEWS

bove, overly enthusiastic Canadians
et, not only the pope's attention, but
 good grip on his clothing.

Below, Popemobile cruises past family
at Flat Rock, Newfoundland, where the
pope was scheduled to bless the fishing
fleet.

ANDY CLARK, REUTERS CANADA

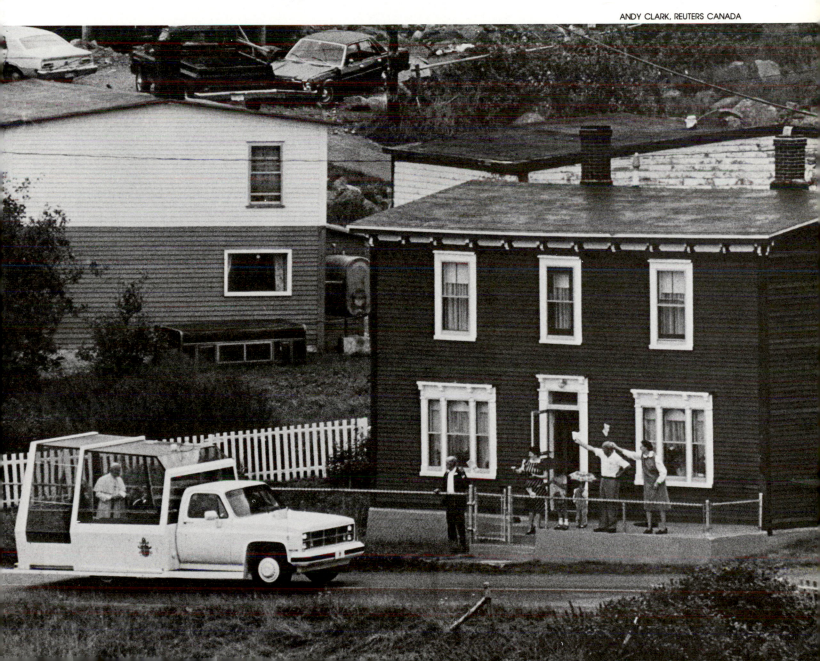

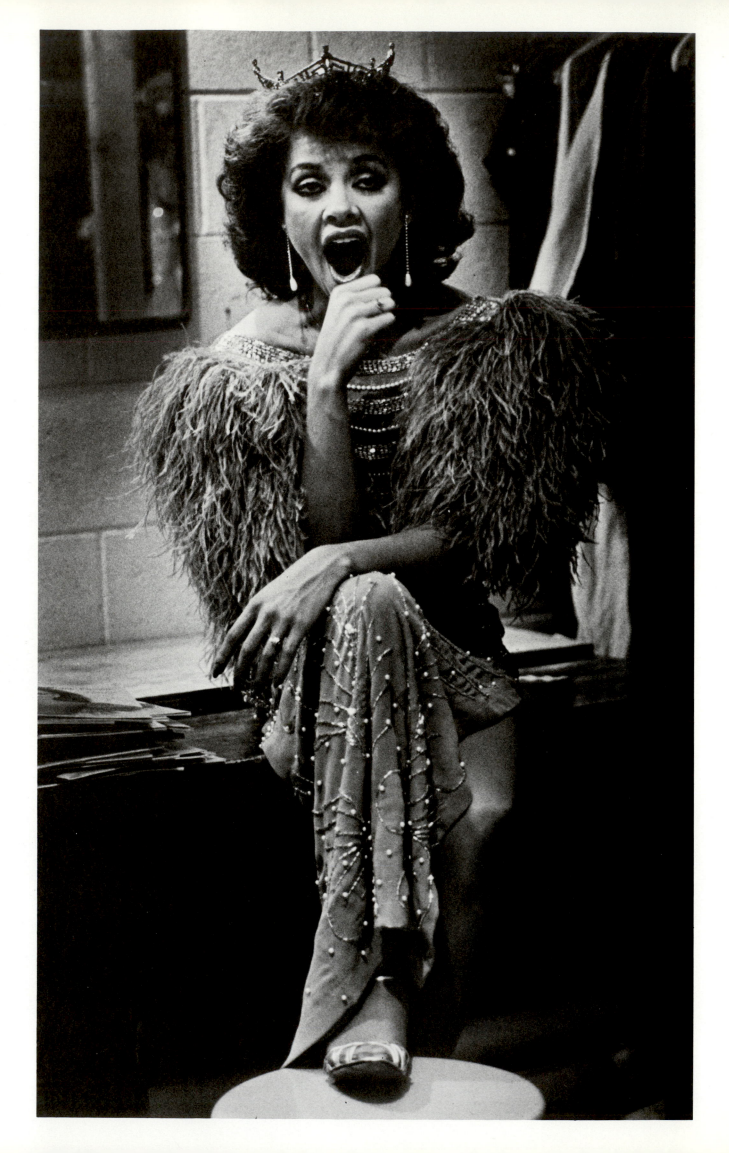

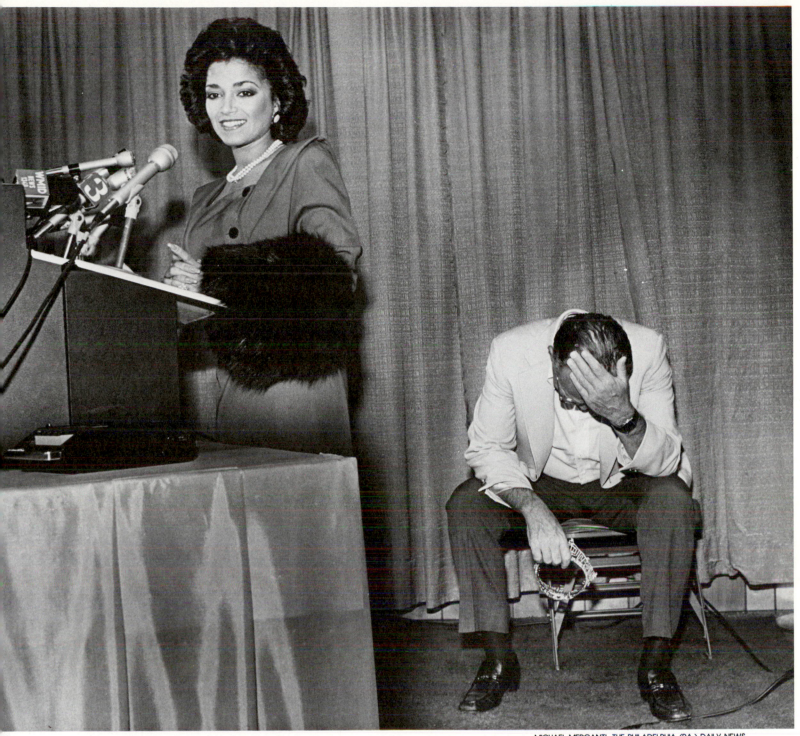

MICHAEL MERCANTI, THE PHILADELPHIA (PA.) DAILY NEWS

During her brief reign as Miss America, Vanessa Williams played the game, appearing at small town pageants, crowning kiddy beauty queens, smiling all the while. But occasionally the strain showed: Tired and coming down with the flu (left), she waits backstage at a Dallas, Texas, high school beauty contest. Then, in July, Miss Williams resigned after sexually explicit pictures of her were published in Penthouse Magazine. In the ensuing turmoil came the decision: Name a replacement. Above, the new queen, Suzette Charles, addresses the press in New York, while the beleagured pageant chairman, Al Marks, holds both his head and the new queen's new crown.

LEFT, APRIL SAUL, THE PHILADELPHIA (PA.) INQUIRER

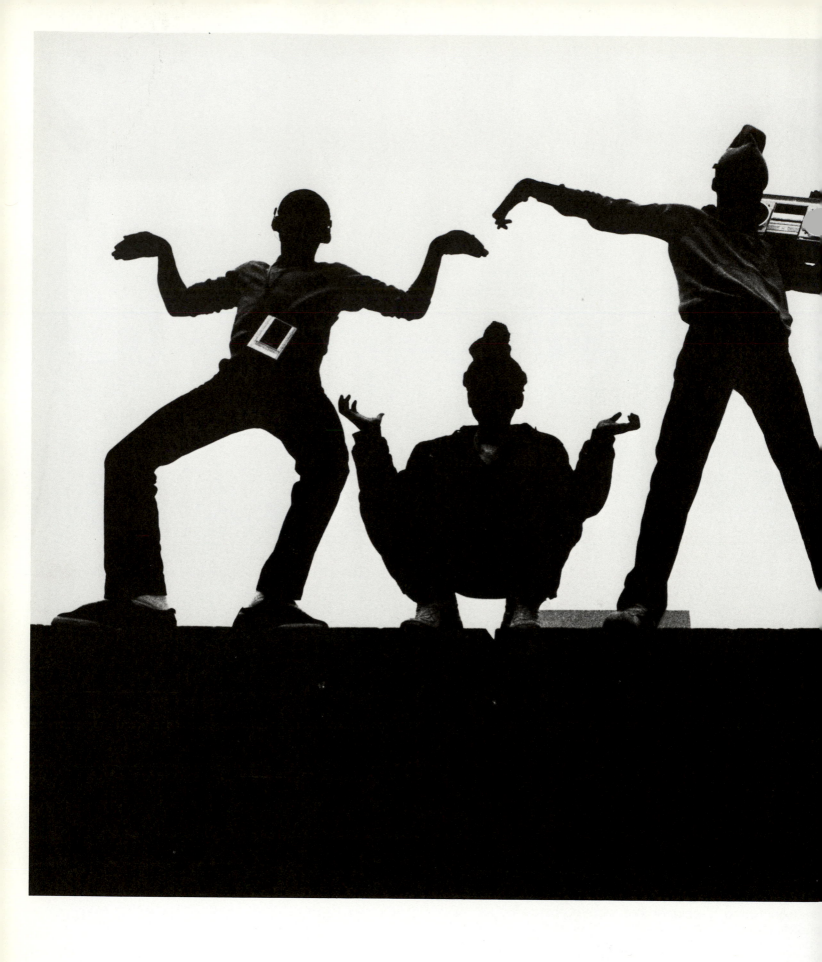

Look, Ma — I'm dancin'

One newspaper feature writer described break dancing as "a wacky style that requires a vivid imagination, nerves of steel, and a limber body." No wonder the male sub-teens across the country claimed it as their own.

Break dancers strut their stuff in Wilmington, Del.

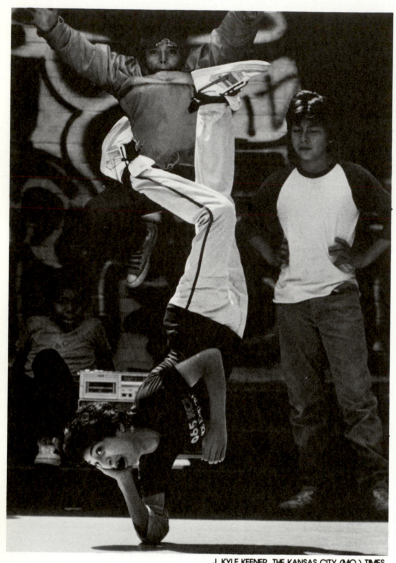

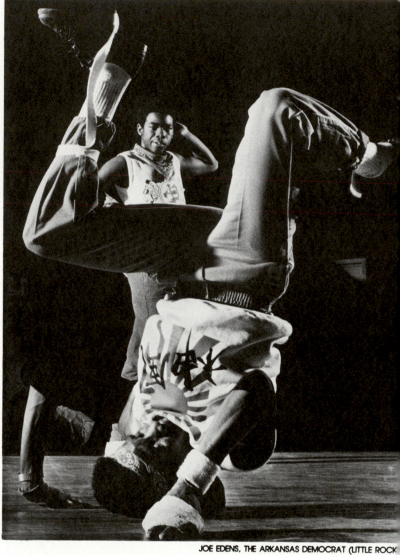

Joe "Crazy Legs" Orozco, 14, does an elbow spin to the satisfaction of other breakers on Kansas City's west side.

In Little Rock, Tony Hubbard (foreground) and Keith Lloyd are partners in a dance team they call "Bubbling Brown Sugar."

Breakin' away

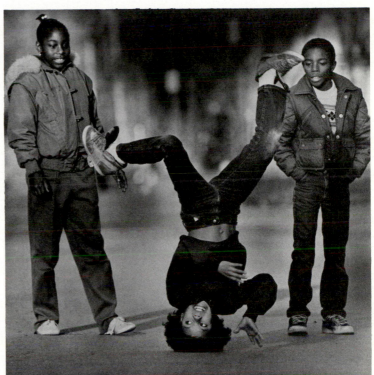

In Utica (above), youngsters dance in the streets during a warm spell in December. A newspaper picture feature of a 15-year-old polio victim changed the life of Eddie Fernandez (left), who went on to tour the United States and Mexico and who danced before President and Mrs. Reagan. "I'm living out a dream," he said

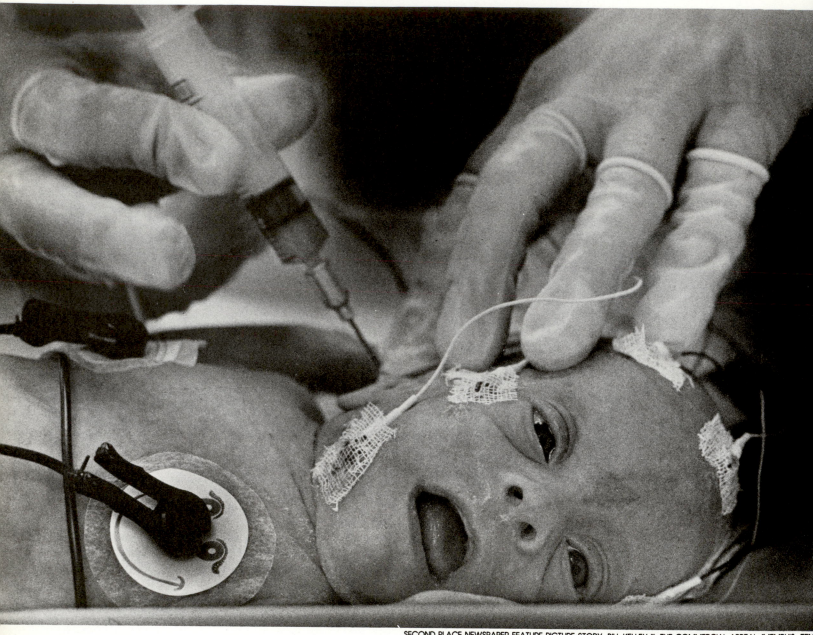

Stephanie's struggle

After Stephanie Hill was born three months prematurely, she developed a problem involving abnormal electrical impulses in her brain. It interfered with her breathing.

And so, for the first three months of her life, Stephanie was hospitalized in the Newborn Prenatal Center in Memphis, Tenn., where she grew from her birth weight of 1 pound, 11 ounces, to her going home weight of 4 pounds, 4 ounces.

Stephanie's parents, Dan and Debbie Hill, came to the hospital nightly, spending the dark hours next to their daughter's incubator.

Right, Mother Debbie Hill said, "The highlight of my evening is getting to hold my creation."

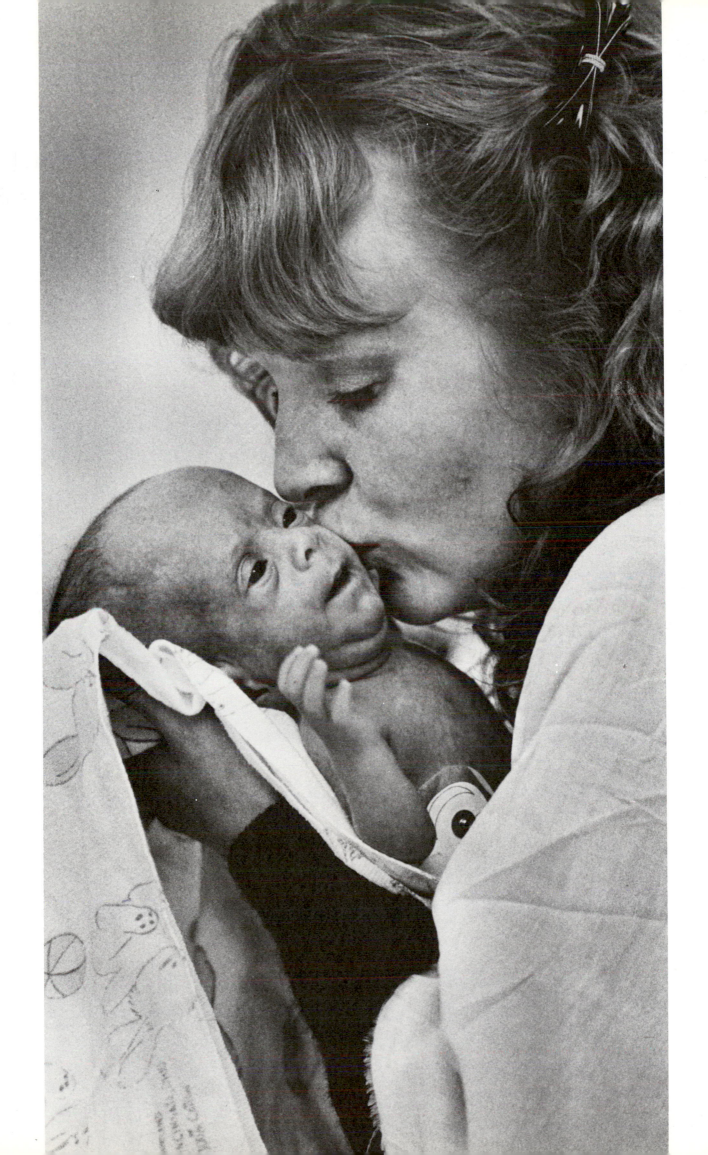

Bad news and long hours take their toll on father Dan. But the nursing staff kept Stephanie in good hands.

Stephanie's struggle

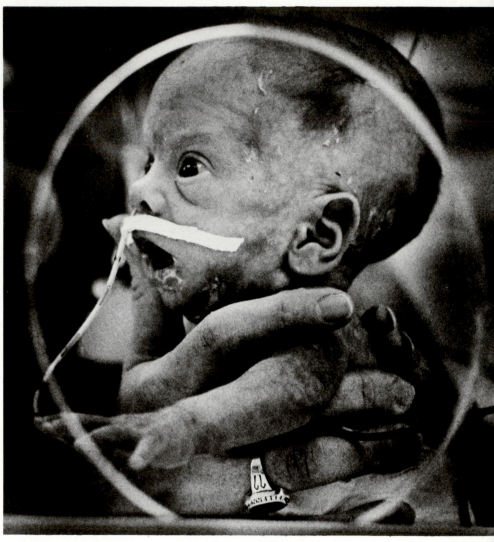

Dan puts his daughter back in her open crib. She graduated from the incubator only when (at 3 pounds, 14 ounces) she could regulate her own body temperature.

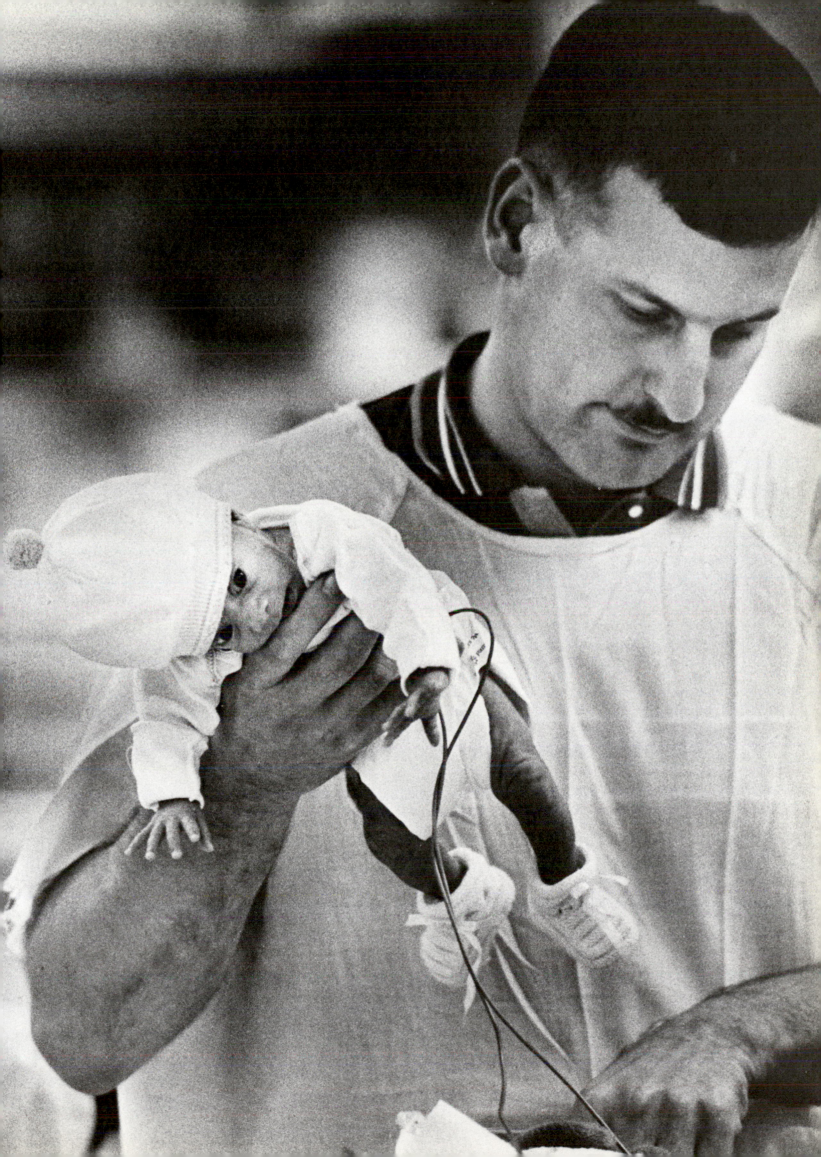

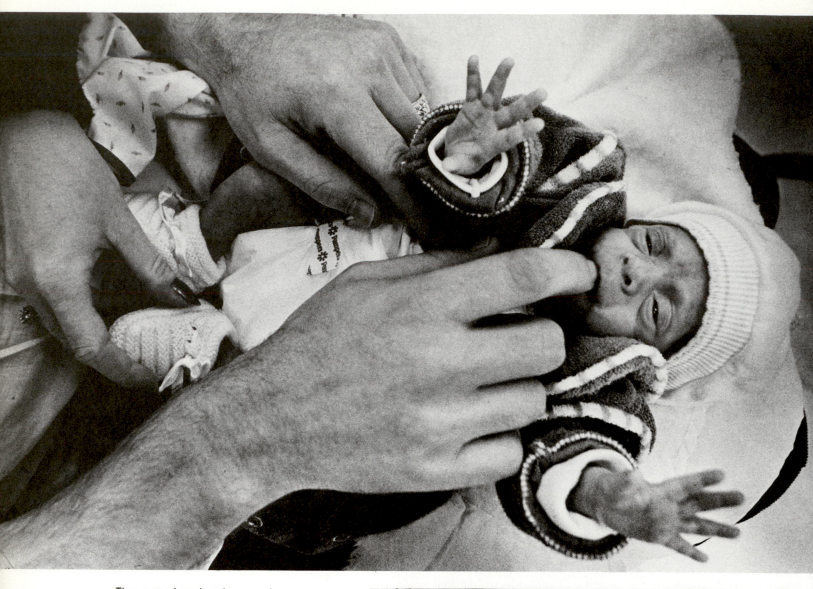

The great going-home day came when Stephanie hit the minimum weight at which babies are released from the center.

Stephanie goes home

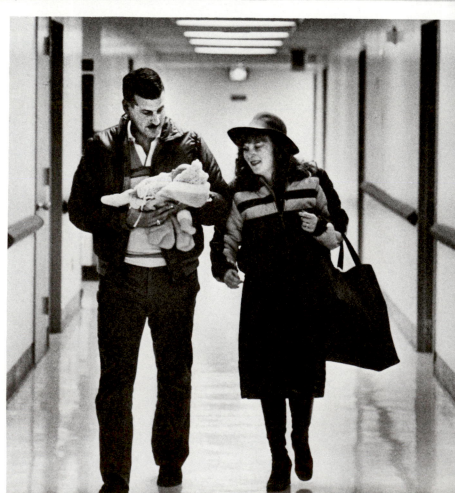

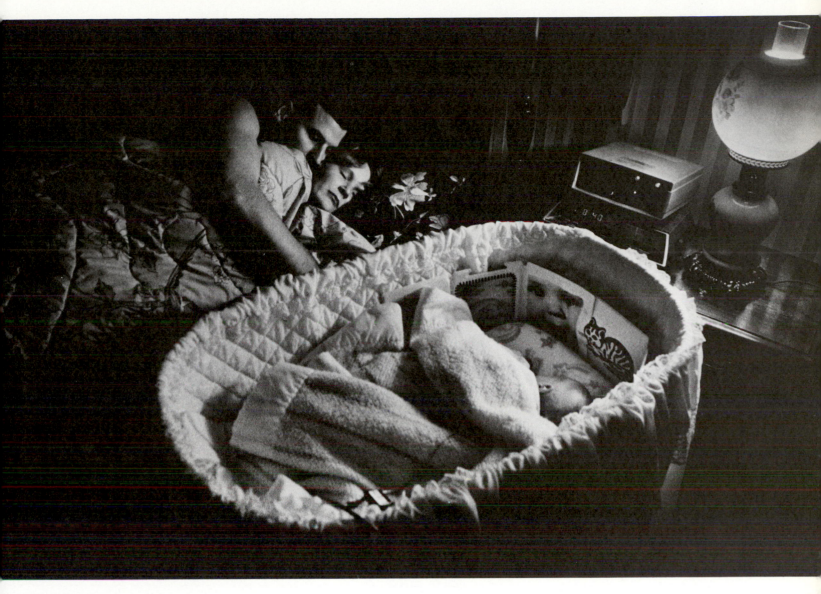

At home, Stephanie is ensconced in her parents' room, where the Hills and a monitor keep watch over the tiny child.

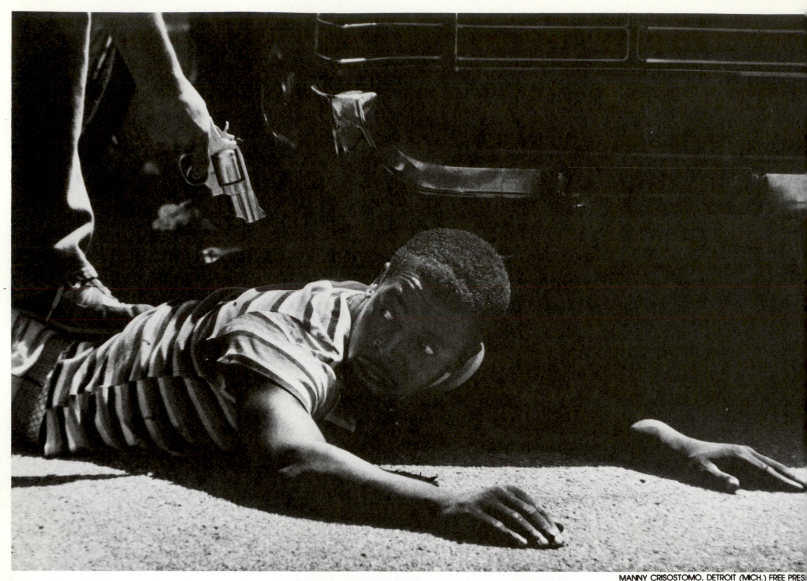

MANNY CRISOSTOMO, DETROIT (MICH.) FREE PRES

PAUL CHINN, LOS ANGELES (CALIF.) HERALD EXAMINE

Above, a suspect in a Detroit drug bust stays down after being nabbed by a narcotics officer. At right, Los Angeles police move in on over-enthusiastic fans after the LA Raiders beat the Seattle Skyhawks for the 1984 AFC championship. Twenty-three persons were arrested.

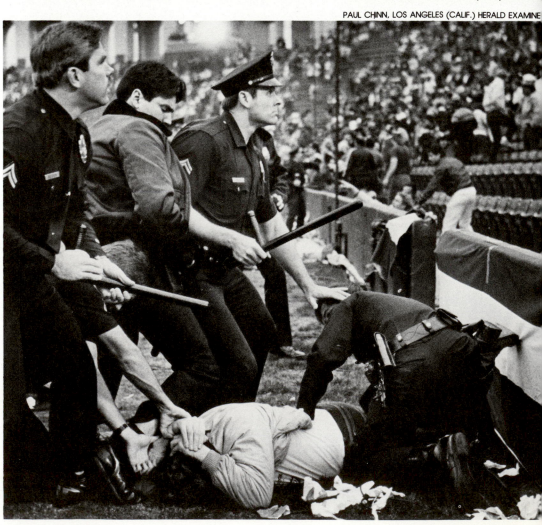

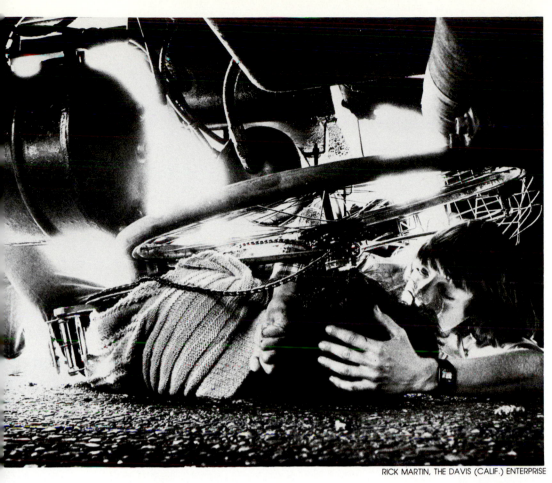

At left, firefighter Karen Schreitmeuller comforts Damber K. Gurung, who was trapped beneath a Davis, Calif., waste removal truck with his bike. Total injuries: scrapes and bruises. Below, a Chicago paramedic, Steve Baumgart, tries to breathe life into a 2-year-old. But he failed. The youngster and five others died in an apartment fire.

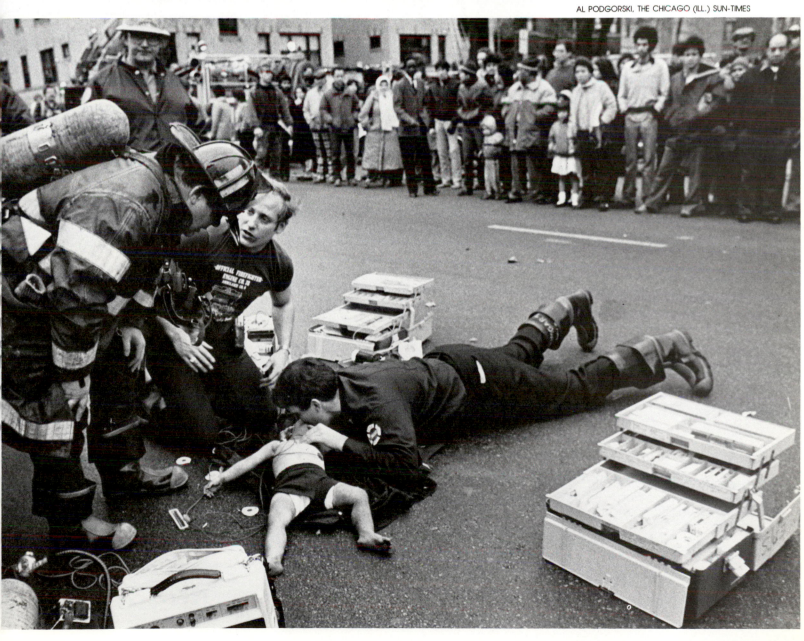

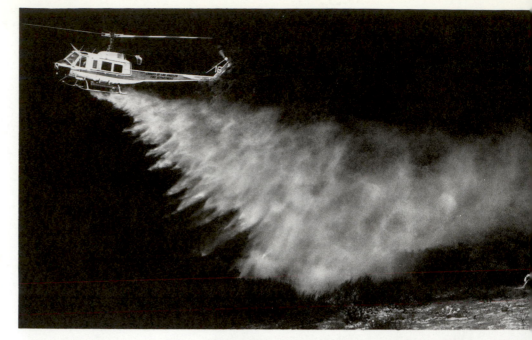

A fire department helicopter dumps water on a brush fire in the canyons near Laguna Niguel, Calif., as a firefighter works on the ground to control the blaze.

BRIAN SMITH, THE REGISTER (SANTA ANA, CALIF.)

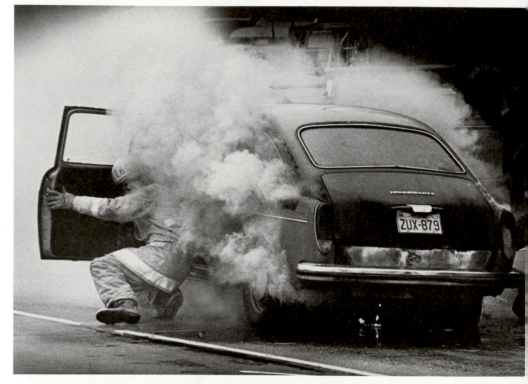

A firefighter in Norfolk, Va., tries to pop the trunk latch on this VW after a fuel line leak caused fire.

TOMMY PRICE, VIRGINIAN PILOT LEDGER-STAR (NORFOLK, VA.)

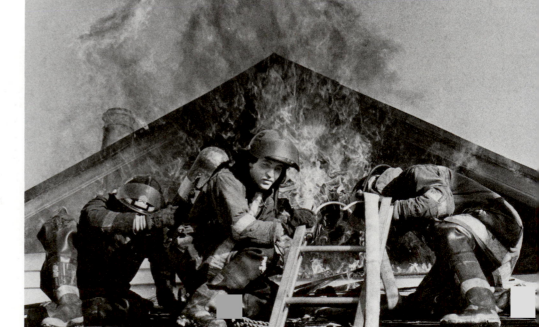

Firefighters in Louisville, Ky., shield themselves from heat and flames as they wait for a line to be passed up to them.

GARY S. CHAPMAN, THE COURIER-JOURNAL & TIMES (LOUISVILLE, KY.)

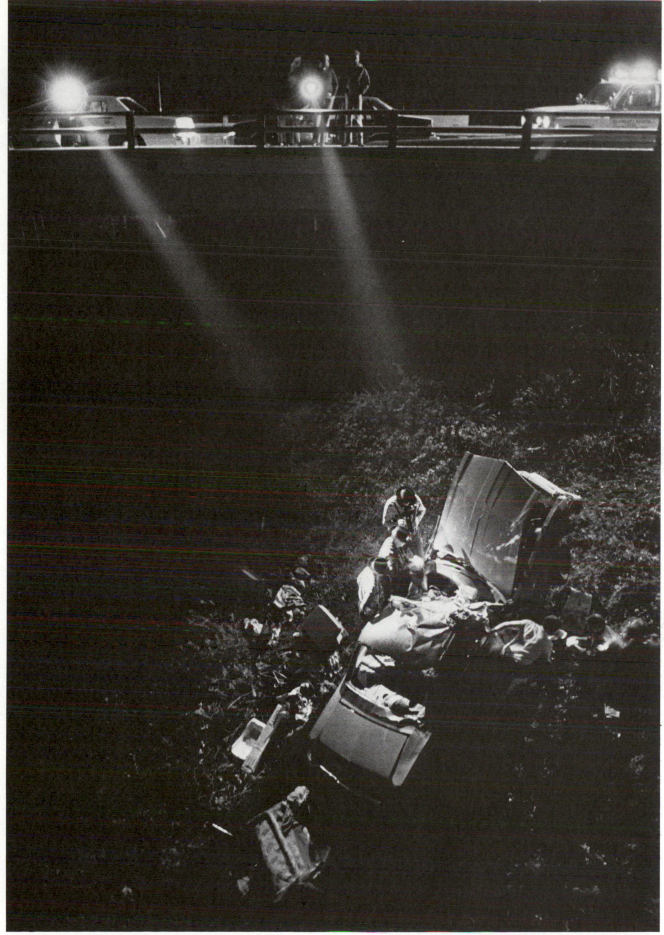

Georgia troopers and Augusta lawmen
search the wreckage of an automobile in
which a 21-year-old woman died after a
high-speed chase.

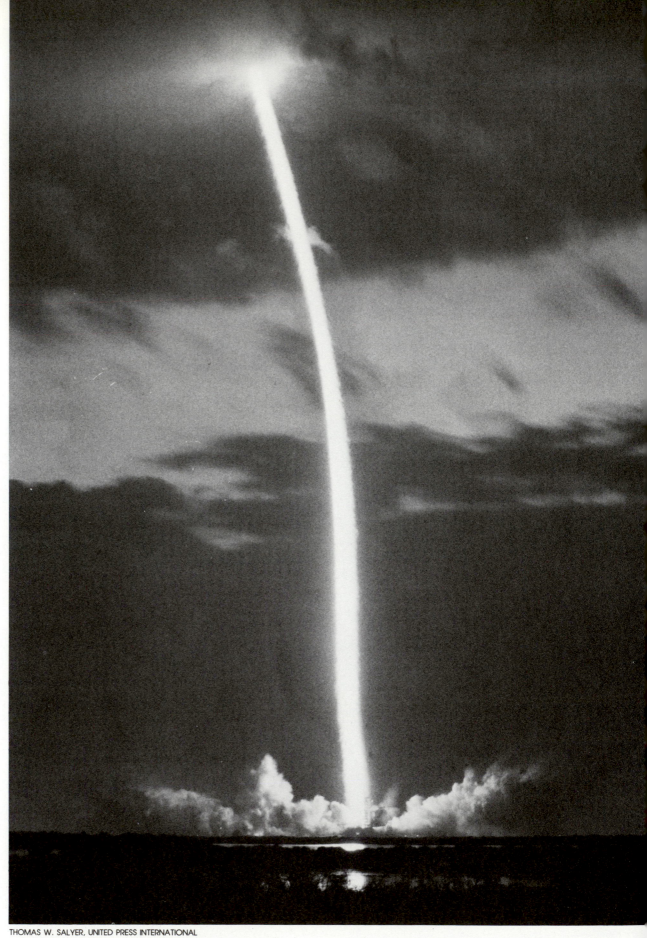

In a time exposure, the space shuttle Challenger pokes a hole through low clouds over the Kennedy Space Center. The 13th launch of a shuttle, it carried a record crew of five men, two women.

At right, three parachutists fall to their deaths after their lines tangled during an exhibition at the Wheat Ridge, Colo., Friendship Festival on Aug. 18. Hundreds of horrified spectators were witnesses.

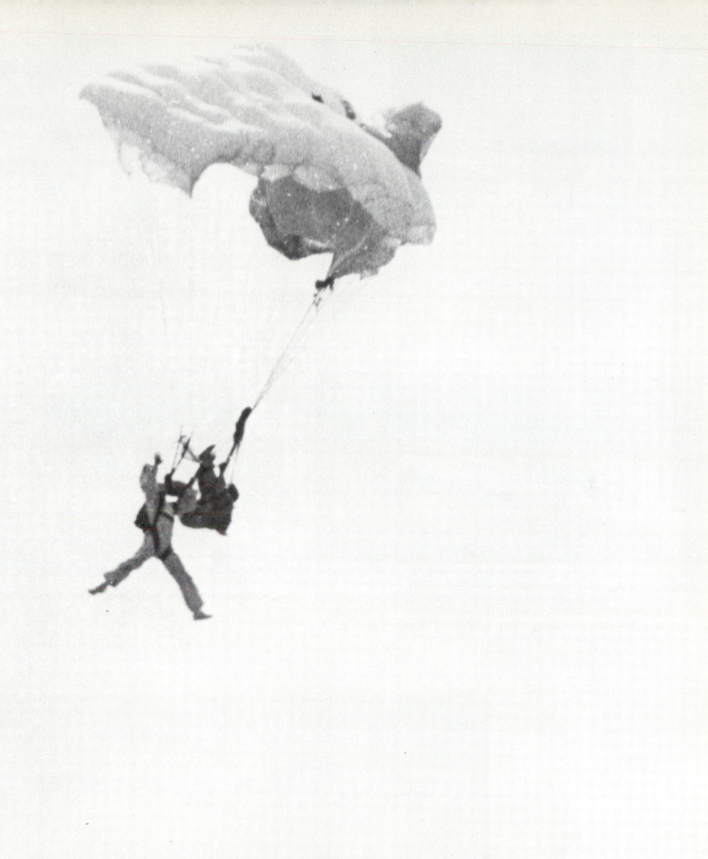

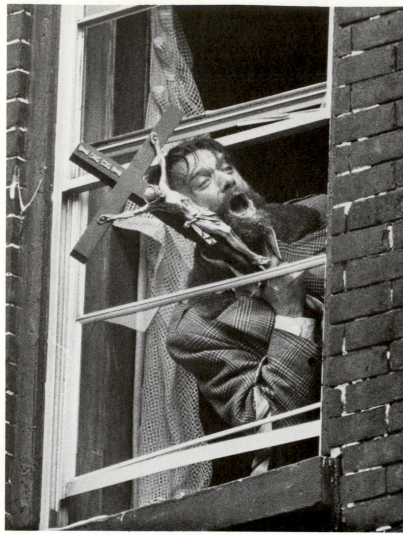

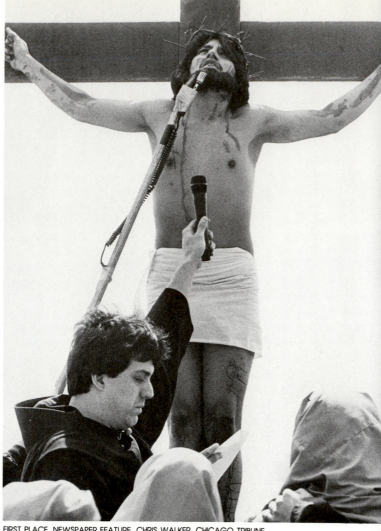

FIRST PLACE, NEWSPAPER SPOT NEWS, MICHAEL LIPACK, NEW YORK DAILY NEWS

FIRST PLACE, NEWSPAPER FEATURE, CHRIS WALKER, CHICAGO TRIBUNE

After throwing several objects through his New York apartment window, Joseph Lawrence yells at passersby. The cross-waving man, who had recently lost his job, was taken by police to a hospital.

Each Good Friday, a dramatization of the stations of the cross is presented in Chicago's Pilsen area. But when microphones went up to record the Passion Play's peak moment, Photographer Chris Walker confessed he was "struck by the absurdity of the scene."

TOMMY PRICE, VIRGINIAN PILOT LEDGER-STAR (NORFOLK, VA.)

A Mexican farm worker, Esteban Rico, was chosen by fellow workers to carry the crucifix in a fiesta mass procession in southwestern Virginia.

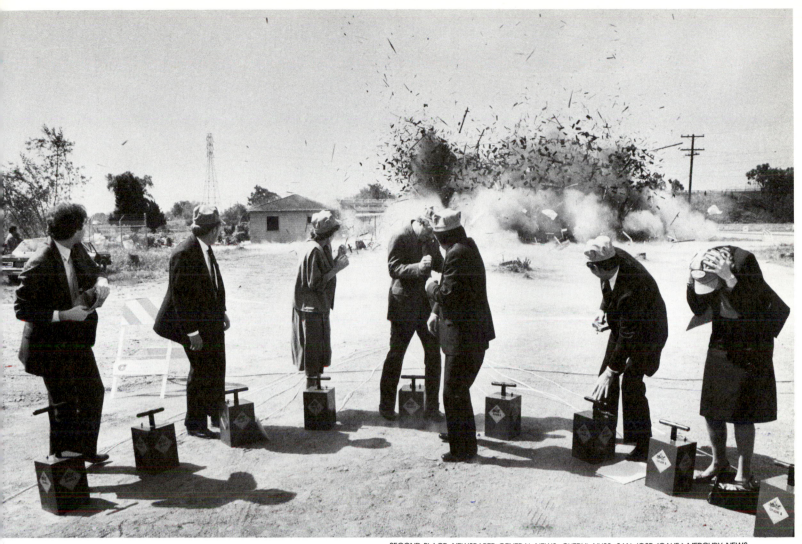

Push those dynamite plungers and now look: City and county officials cooperate (explosively) in a ground-breaking ceremony for a transit line project in California's Santa Clara County.

Below, almost 200 members of Foreign Car Haters of America paid a dime apiece to take a whack at a Japanese auto in a San Francisco parking lot.

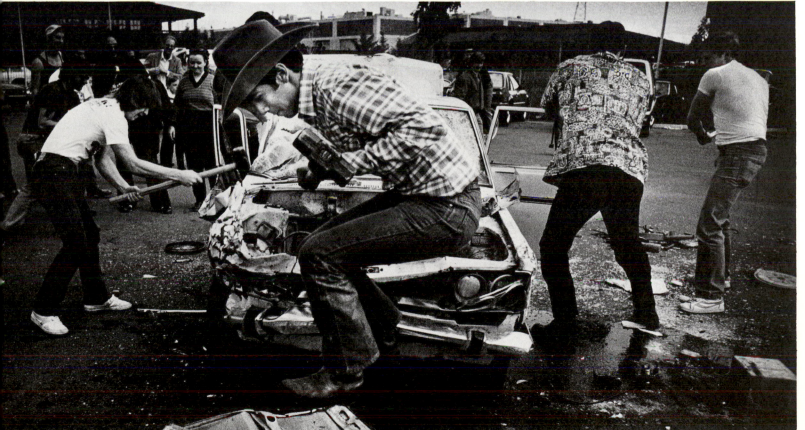

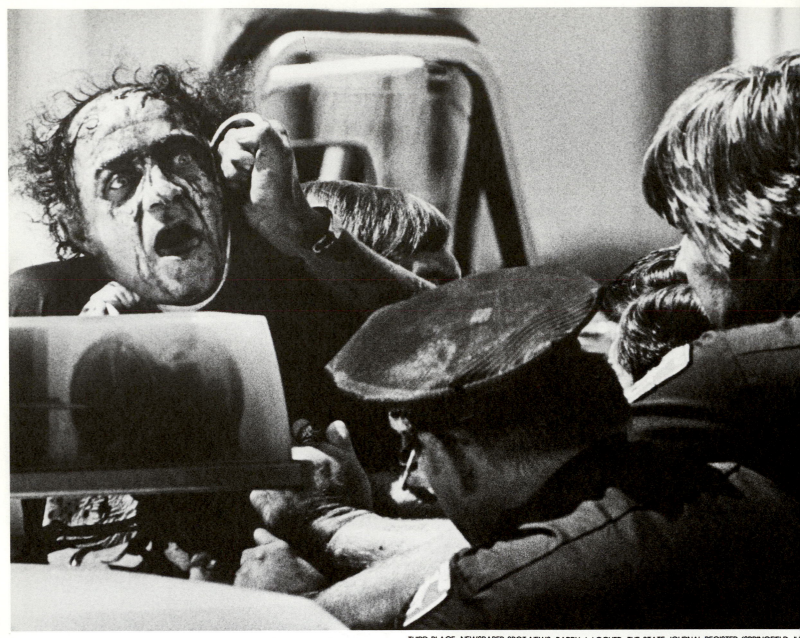

It took seven police officers to subdue a burglary suspect (above) in Springfield, Ill., after he went berserk during his arrest.

No police at all were involved with jumper at right: Eddie Van Halen, lead guitarist of the super rock group Van Halen during show in Inglewood, Calif.

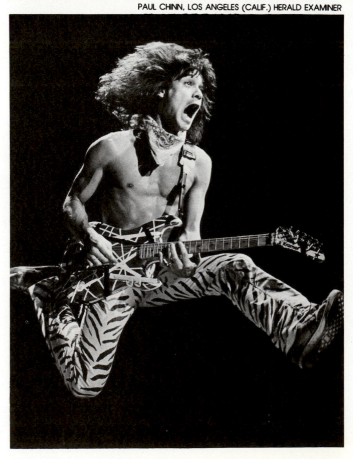

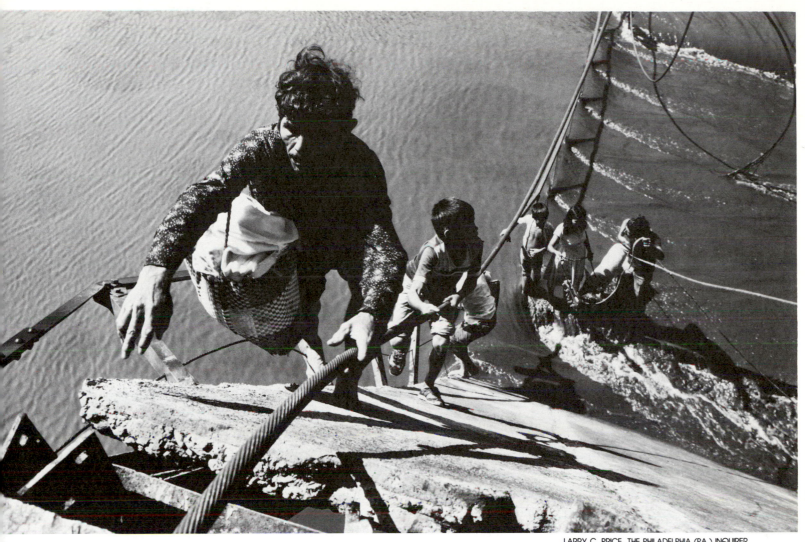

Above, a Salvadoran family fleeing the fighting in Jucuran Province carries a few belongings and their pig. They escaped over remnants of a bridge. Photo was among those for which Photographer Larry C. Price won Pulitzer Prize for feature photography.

Below, an old fishing pier on Florida's Pompano Beach began to collapse as workers repaired it. But the problem went almost unnoticed by folks using the beach.

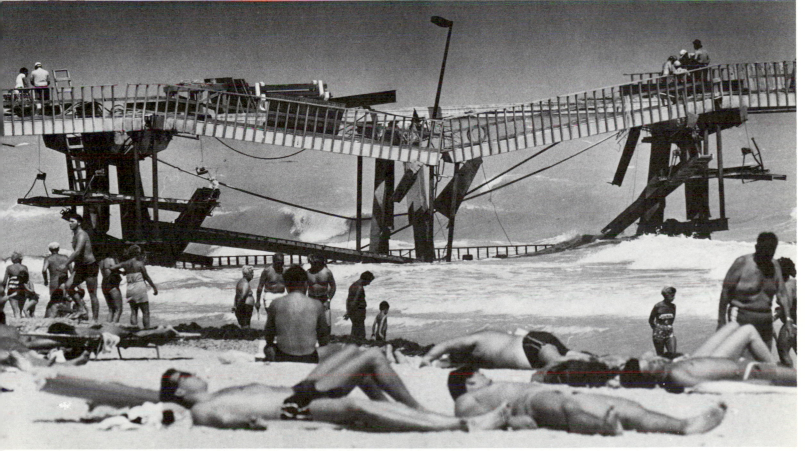

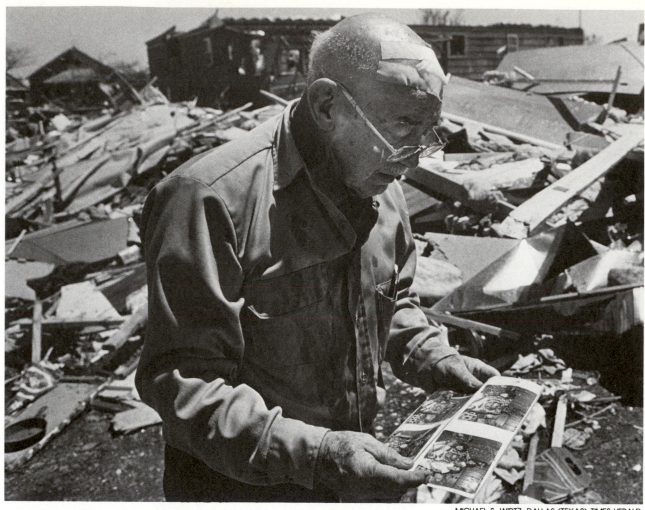

MICHAEL S. WIRTZ, DALLAS (TEXAS) TIMES HERALD

Above, a tornado victim near Dallas, Texas, considers a page from a photo album, one of the few things he salvaged from what had been his home.

Below, firemen show the strain of fighting a swamp blaze that started in a tire dump near the Fort Lauderdale-Hollywood, Fla., airport. The fire burned for 24 hours.

BILL REINKE, THE MIAMI (FLA.) NEWS

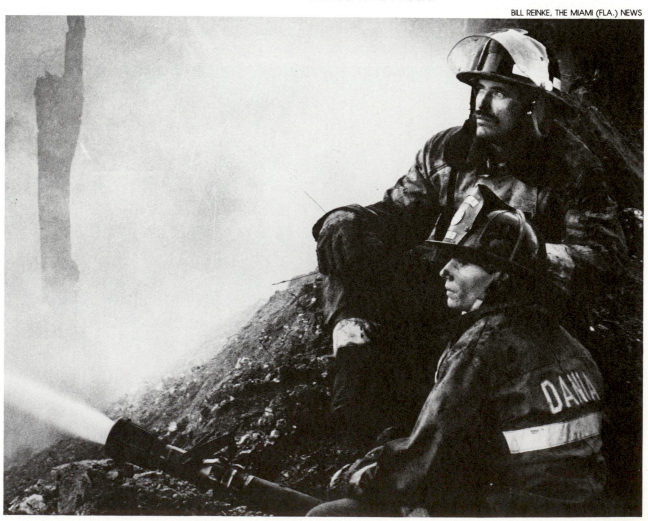

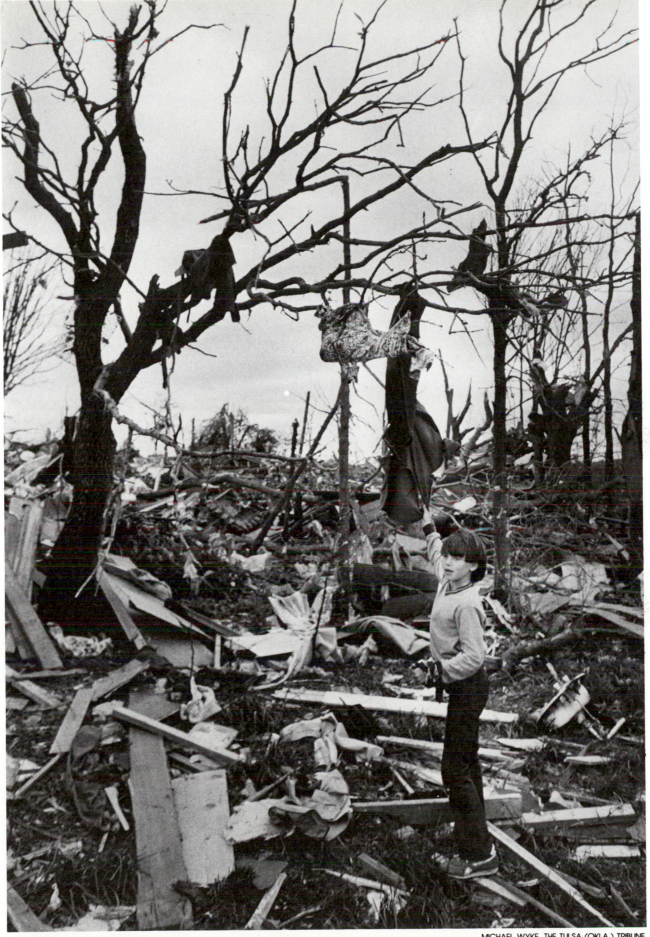

A youngster gathers clothing out of a tree in his front yard after a tornado all but wiped out the small town of Prue, Okla.

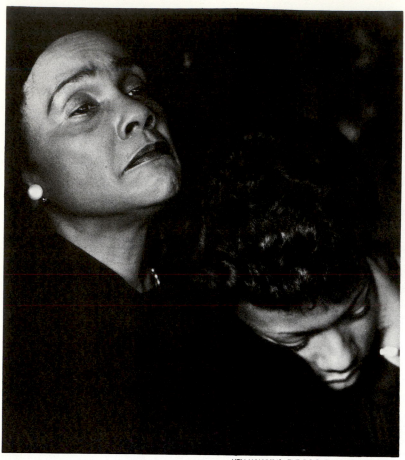

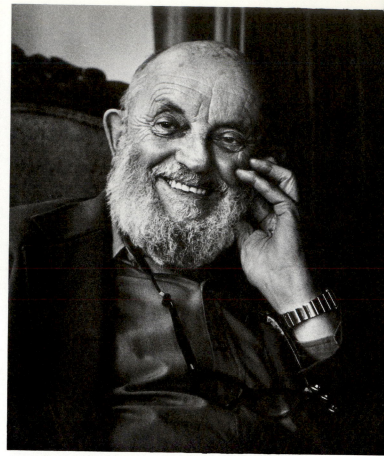

Above, Coretta Scott King and daughter Bernice mourn the death of Martin Luther King, Sr., at graveside service.

Below, Mitch Snyder went on a 66-day hunger strike in a successful attempt to get presidential approval for a grant to support his 800-bed shelter for the homeless in Washington, D.C. - but he almost died in the process.

Above, portrait of photographer Ansel Adams was made shortly before his death in Monterey, Calif., on April 22, 1984.

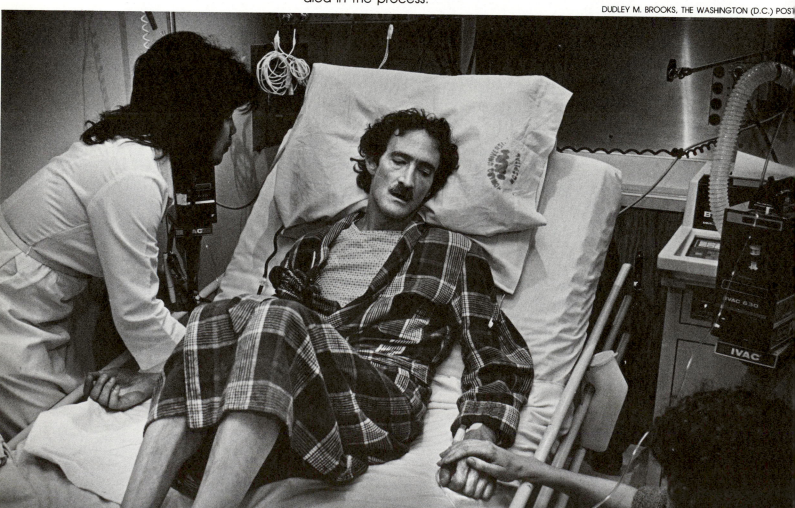

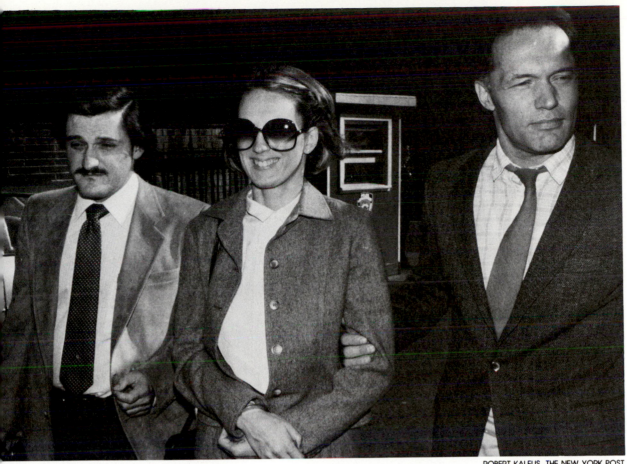

Above, Sheila Devin, the "Mayflower Madam," is escorted by New York detectives after she turned herself in to face charges that she promoted prostitution. The allegations involved a 20-girl, million-dollar sex-for-hire operation.

Below, England's Queen Elizabeth is escorted by Canadian Prime Minister Brian Mulroney during a walkabout following a state dinner for 1,600 persons in her honor at the Winnipeg Convention Center.

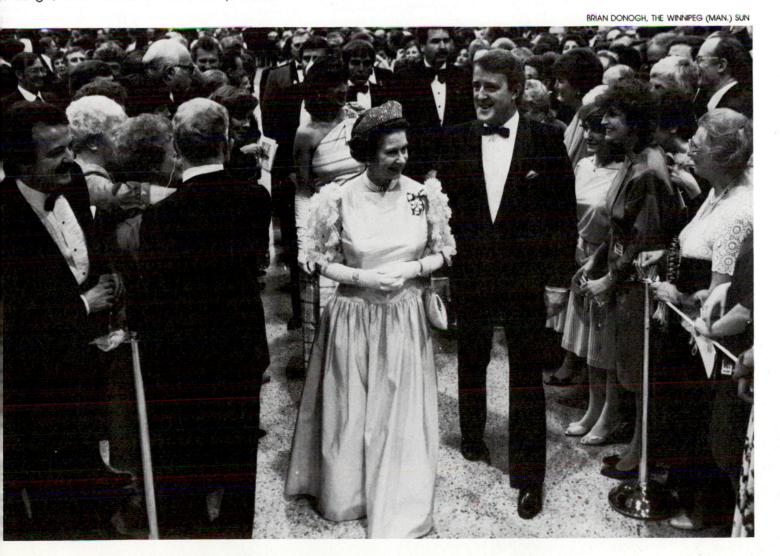

CHARLES FOX, THE PITTSBURGH (PA.) PRE

Tough times, still

There's been no economic recovery for laid-off steelworkers like trio (above) in Monongahela River Valley near Pittsburgh. In 1979, United States Steel facilities there employed 28,000 persons; five years later fewer than 6,000 were still on the job.

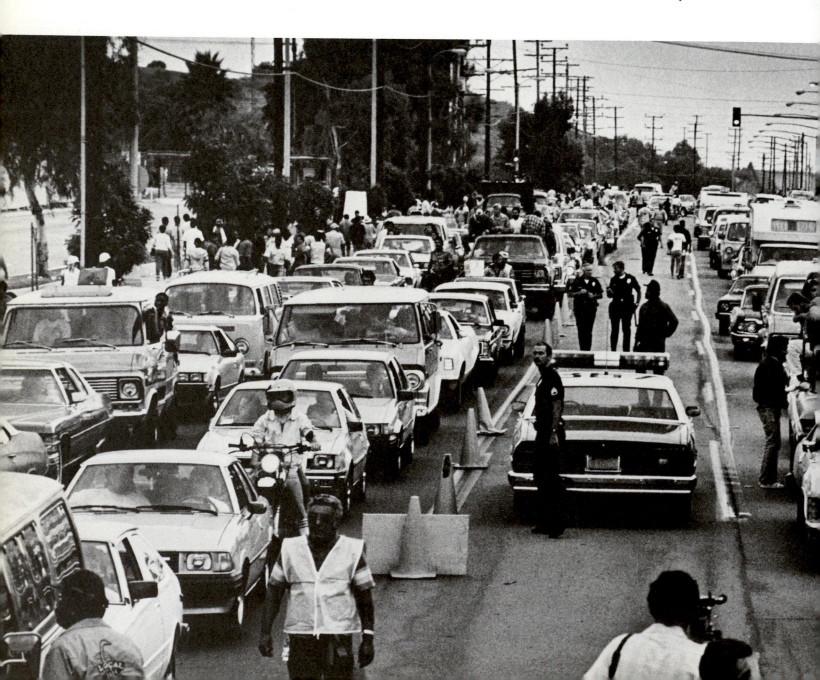

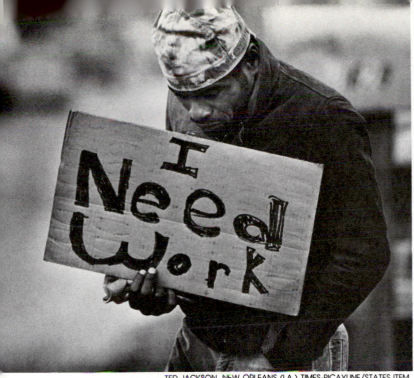

Above, Jack Harper, a 35-year-old New Orleans longshoreman, stands on a street corner just before Christmas to make a desperate plea. Below, thousands of people camp on the streets for three days to get applications for 350 openings on the docks in San Pedro and Long Beach, Calif.

Above, Clifford and Dawn Chester sleep in an abandoned house in Philadelphia, Pa. Unemployed, they were among 4,000 newly poor without homes, displaced by a stagnant economy. Below, Linda Reese and her 4-year-old son heckle non-striking workers during a shift change at Clifton, Ariz., copper plant.

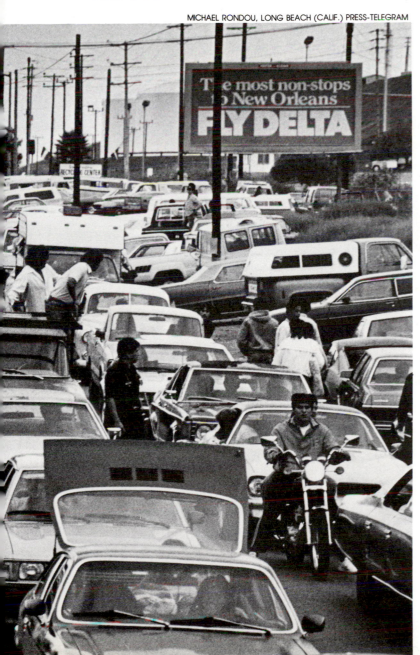

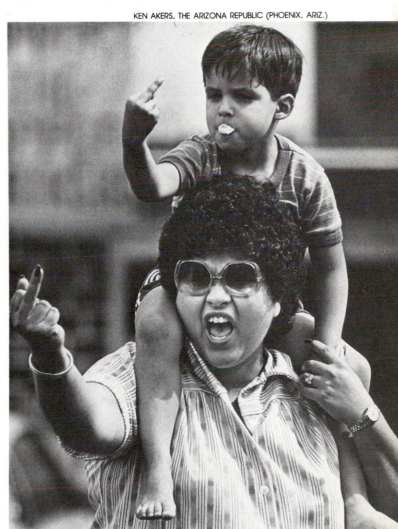

Right, John and Juanita plan their next move after a home owner told them they couldn't rent from him. Below, the family checks out one more rental dwelling.

FIRST PLACE, NEWSPAPER FEATURE PICTURE STORY, GENARO MOLINA, SAN JOSE (CALIF.) MERCURY NEWS

The search goes on . . .

John Martinez and Juanita Recendez have seven children and no place to live. The whole family has its roots in San Jose, Calif., and their search for housing centers there.

To save money, they stay with friends and in shelters. John is a security guard; Juanita is a homemaker. Their youngsters range in age from 2 to 15 years.

And they cannot find a place to rent.

Left, John holds list of houses that are potential homes. Below, Juanita and son John, 15, peek inside a house as the elder John waits for their verdict.

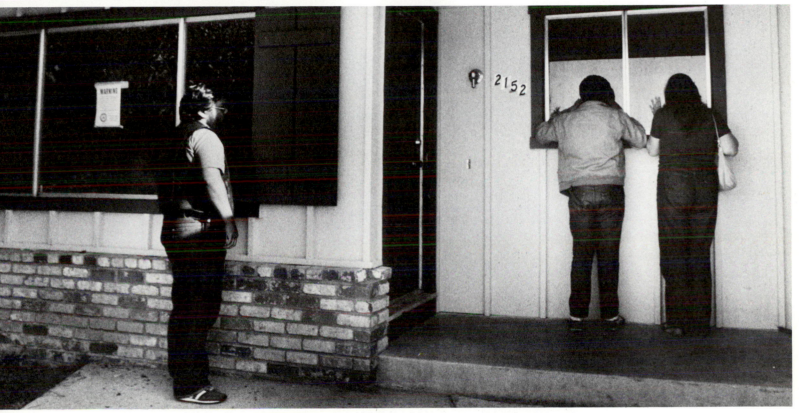

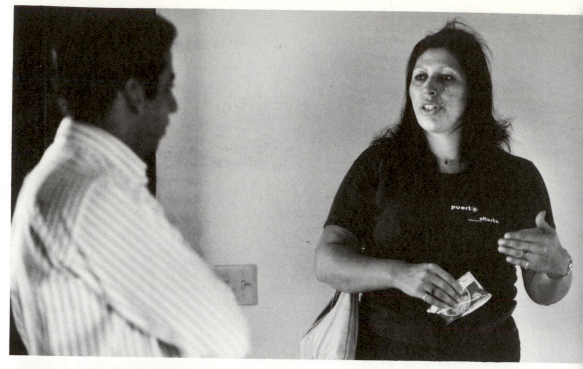

Home hunt

In this sequence, Juanita talks with landlord Bob Dhillion, trying to convince him they're honest and would keep up the payments. But the size of the family weighs against her plea; Dhillion decides against renting to them.

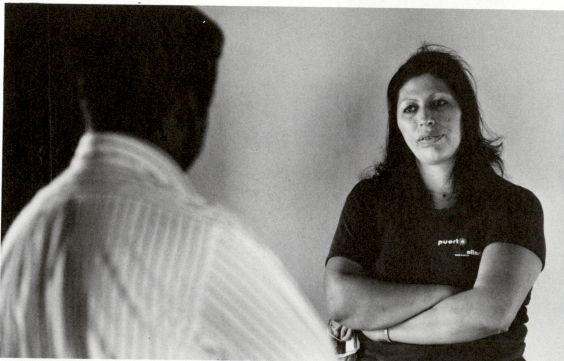

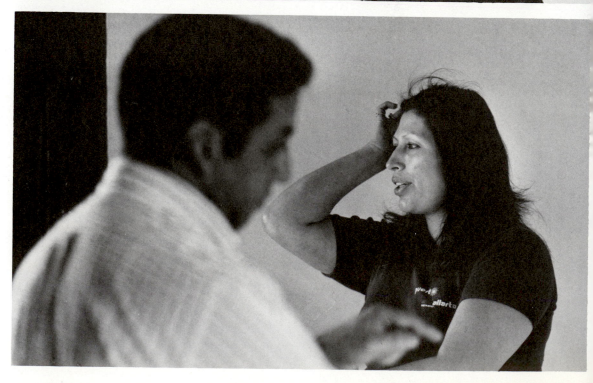

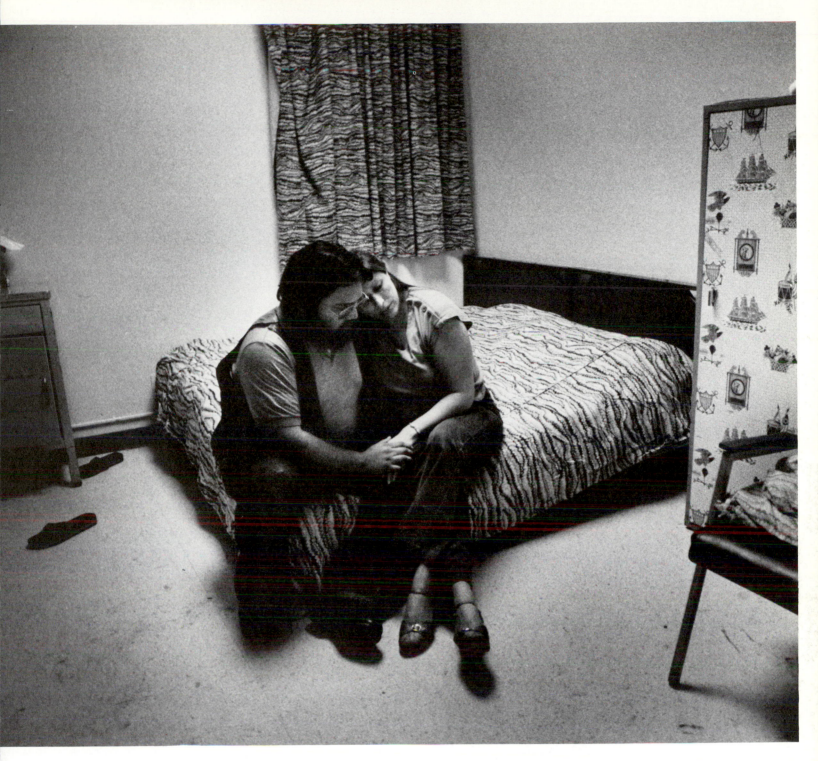

Back at the shelter for homeless
families, John and Juanita comfort
each other.

THOM SLATER, THE DAILY PRESS (NEWPORT NEWS, VA.)

Snow . . .

Above, Larry Easter of Newport News, Va., walks through a 6-inch snowfall to look for a job. His rationale: "The stores probably wouldn't have too many customers." Right, when Photographer Thomas Ondrey was caught in a fall of huge flakes in a downtown parking lot, he knew his search for a weather shot had ended.

THOMAS ONDREY, THE PITTSBURGH (PA.) PRESS

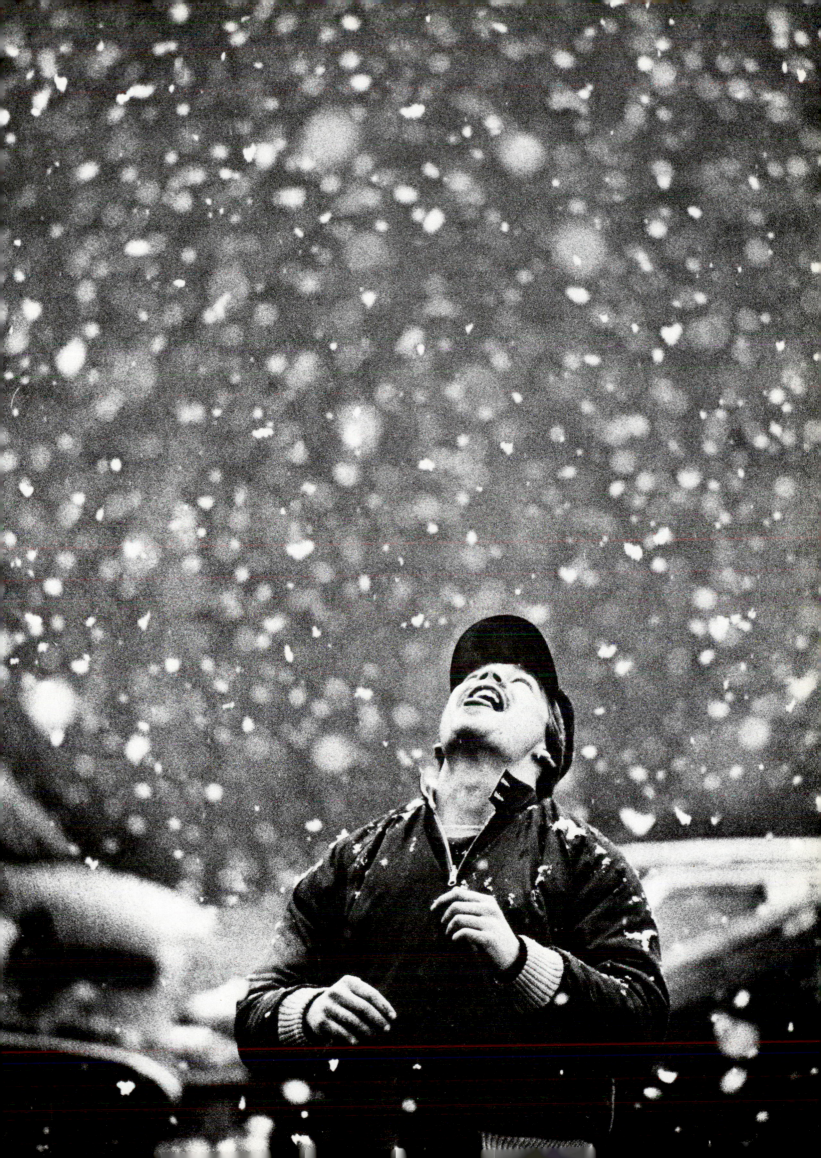

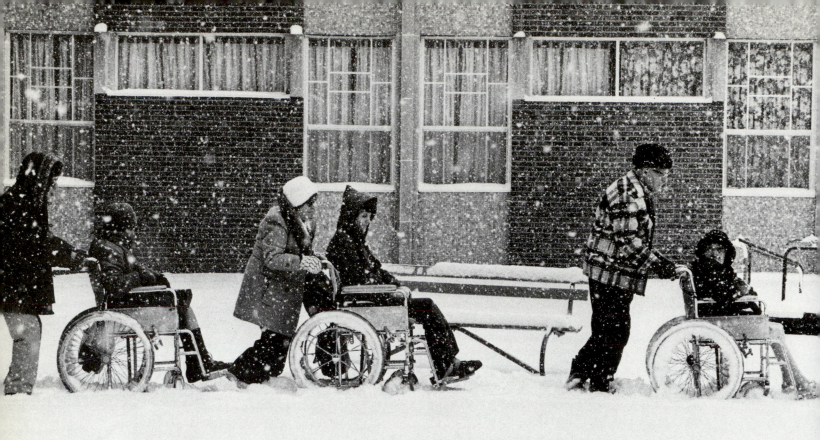

AL PODGORSKI, THE CHICAGO (ILL.) SUN-TIMES

. . . **and more snow**

Above, family members and patients in development center in Bloomington, Ill., wheel physically disabled residents to morning mass. Below, an unemployed man wanders across the White House South Ellipse in Washington during heavy weather.

Right, an honor guard at Fort Logan National Cemetery in Denver, Colo., endures blizzard conditions to honor Lt. Col. Kenneth Crabtree, killed by an apparent terrorist bomb in a war-torn corner of Africa.

FRANK JOHNSTON, THE WASHINGTON (D.C.) POST

RIGHT, BILL WUNSCH, THE DENVER (COLO.) POST

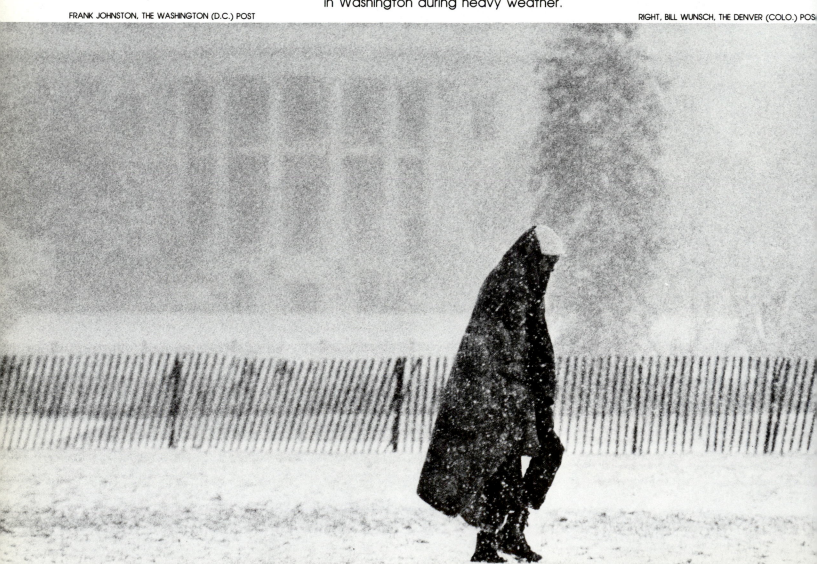

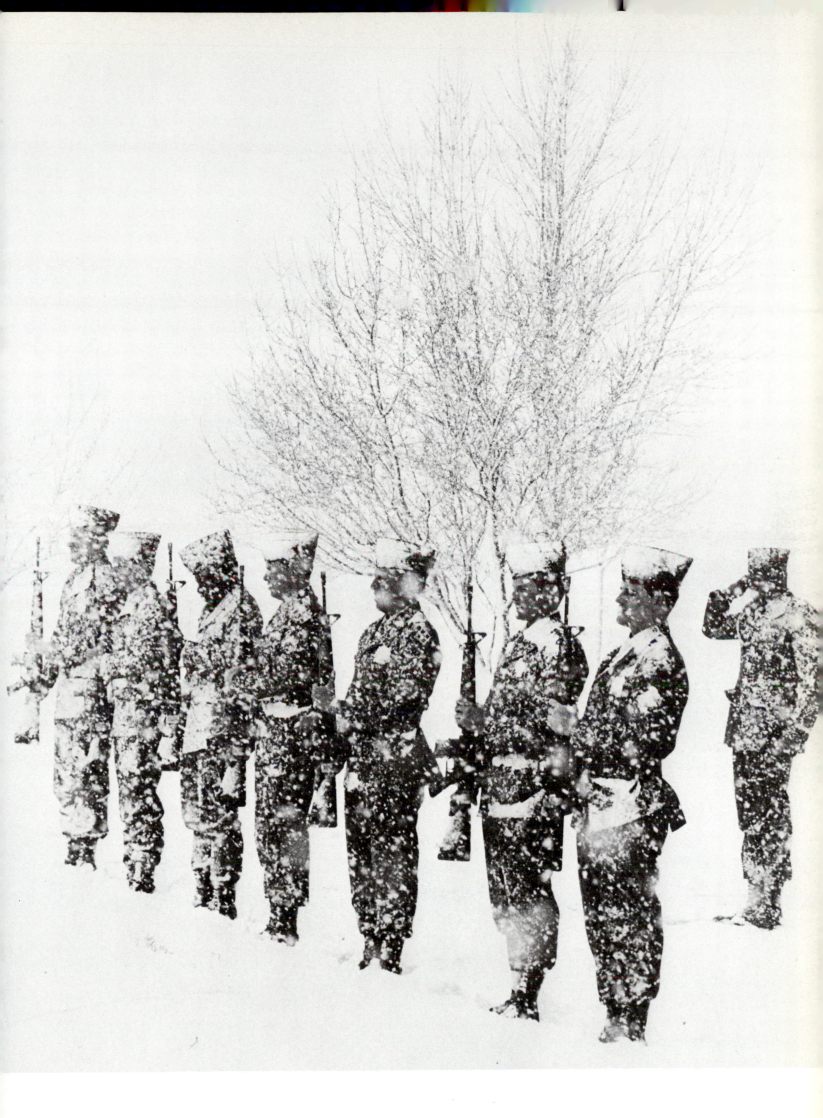

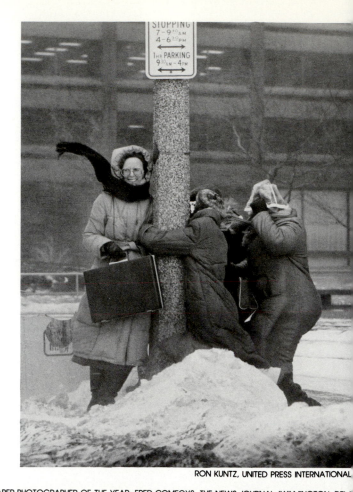

Don't let go

Right, winds off Lake Erie make walking hazardous in Cleveland, Ohio; utility pole provides an anchor for this trio. Below, Wilmington, Del., businessman attaches himself to a tree during windiest (60 MPH) day of the year.

RON KUNTZ, UNITED PRESS INTERNATIONAL

NEWSPAPER PHOTOGRAPHER OF THE YEAR, FRED COMEGYS, THE NEWS-JOURNAL (WILMINGTON, DEL.)

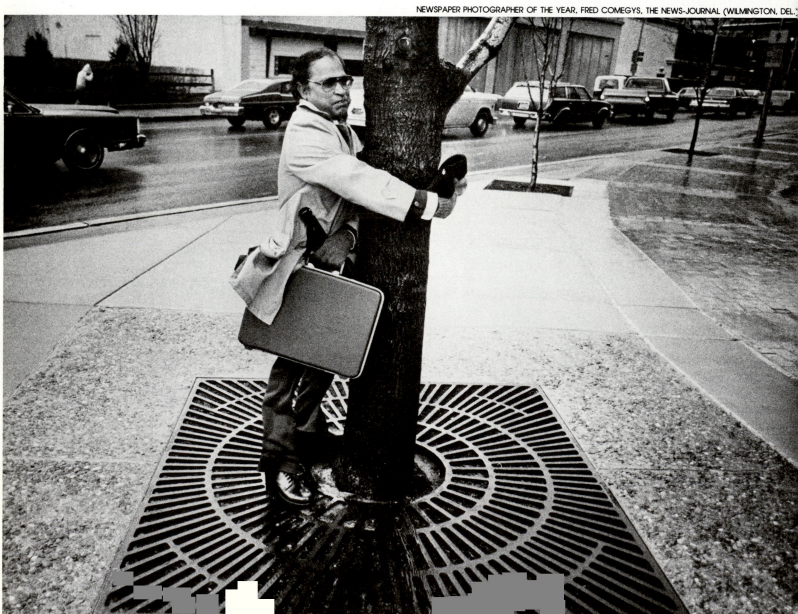

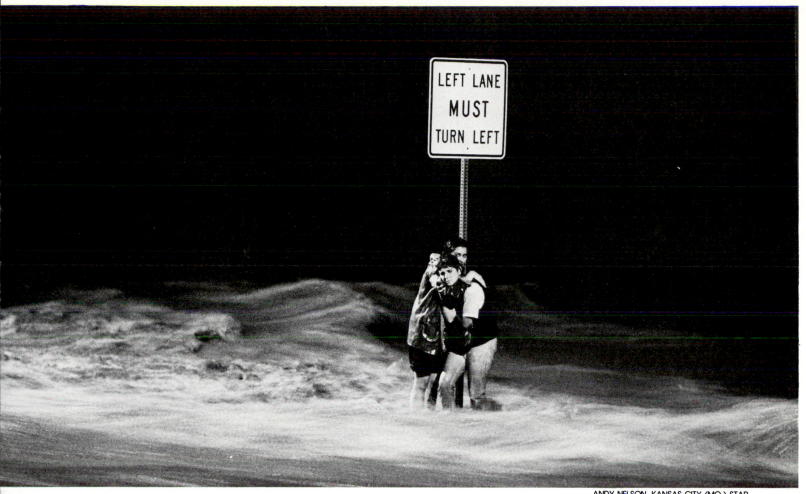

Above, a pair of Kansas City, Mo., teenagers spent eight hours clinging to a street sign after floodwaters swept them two blocks down a suburban street. An armored personnel truck was used to rescue them. Below, a St. Louis, Mo., pedestrian has no intention of making a right turn; she just wants sanctuary from the cold, wind, and snow.

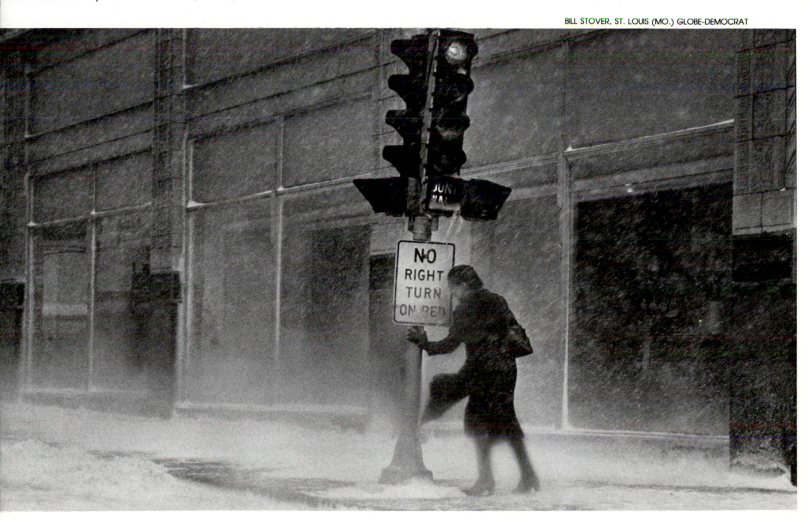

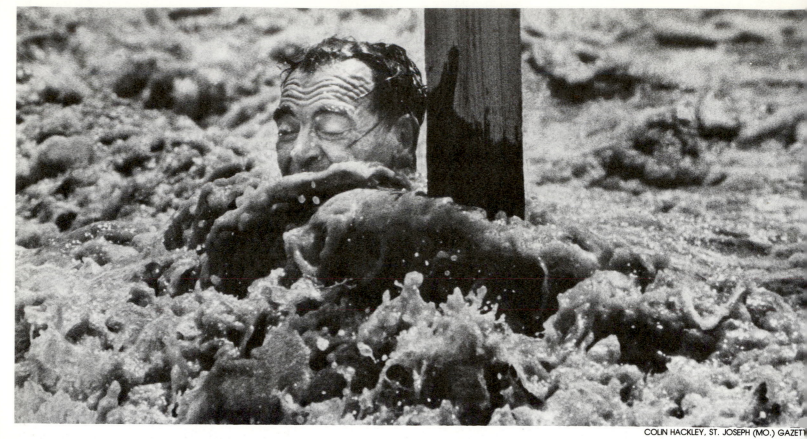

Wet and wild

Above, Charles Drier fights floodwaters after being swept away from a rope he and others had been using to reach a boy stranded by the flood-swollen Platte River at Tracey, Mo. Both Drier and the boy were rescued. Below, firefighters at Miami, Fla., try to save occupant of a car that plunged from a bridge. But he was pronounced dead at the scene.

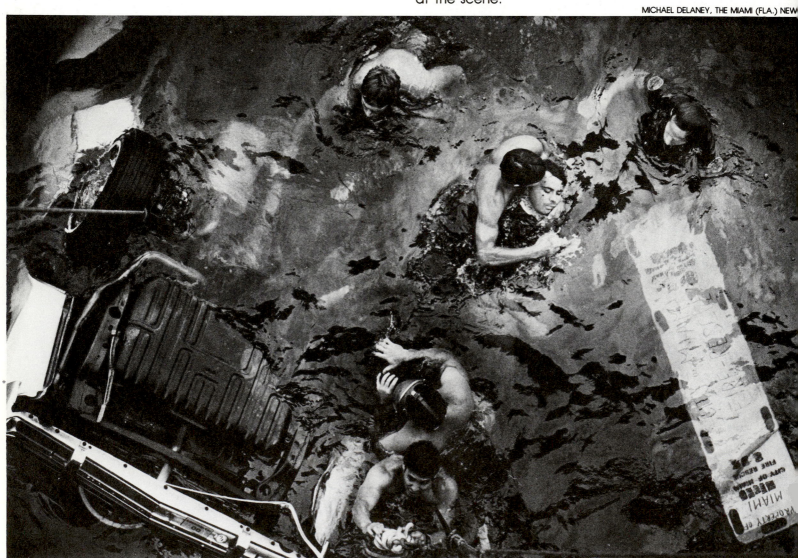

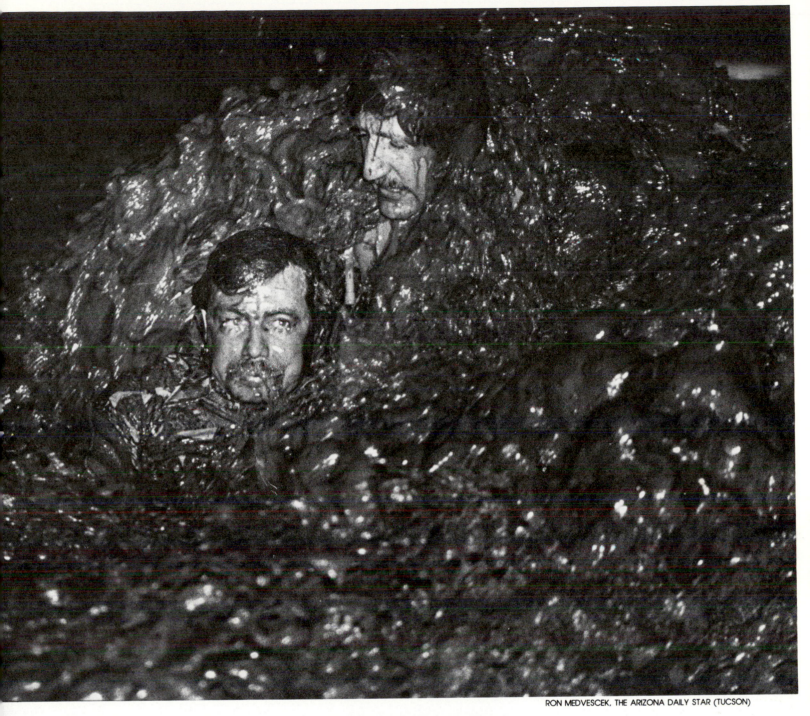

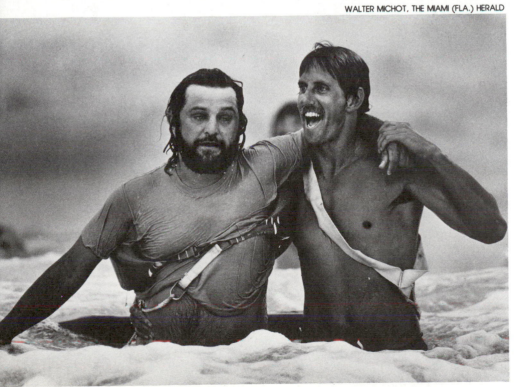

Above, Kelly Buttle (left) waited 90 desperate minutes for rescue from floodwaters in an Arizona wash. By the time Richard Kunz reached him, Buttle had slipped below the surface. Kunz spotted an elbow, dragged Buttle up. Although his body temperature dropped to 84 degrees during the ordeal, Buttle recovered.

Left, Ralph Murray is pulled safely to shore by lifeguard Brian Kearney at Fort Lauderdale, Fla., after his fishing boat sank. Murray and two companions bobbed at sea for nearly three hours before being rescued. Said Photographer Walter Michot, "I'll never forget the expressions on these faces."

Right, in Delaware, members of the Pagans motorcycle gang attend graveside rites for a brother who was gunned down by FBI in Ohio.

Below, sunbather finds solitude in cemetery at Block Island, R.I.

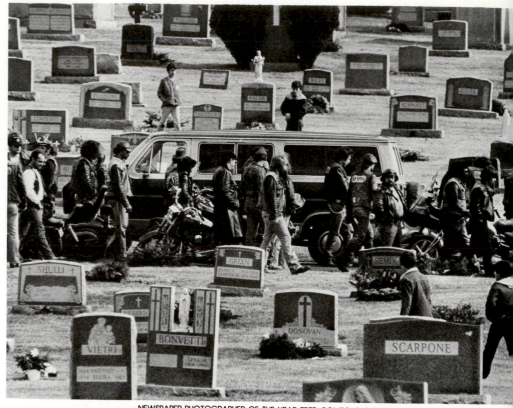

NEWSPAPER PHOTOGRAPHER OF THE YEAR FRED COMEGYS, THE NEWS-JOURNAL (WILMINGTON, DEL

HONORABLE MENTION, NEWSPAPER FEATURE, CHIP GAMERTSFELDER, FREELANCE, BLOCK ISLAND, R.

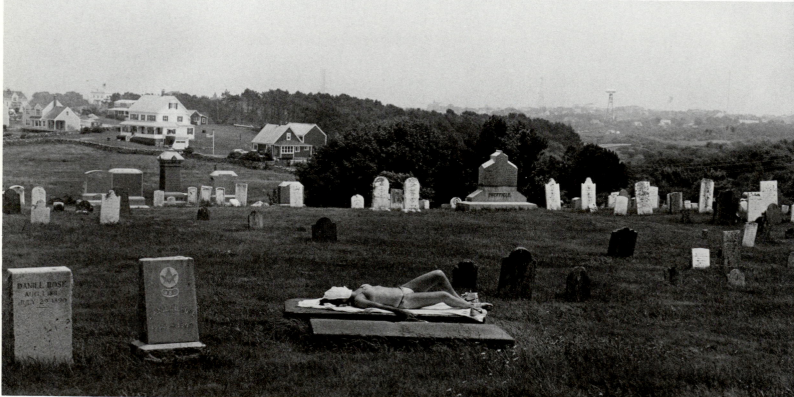

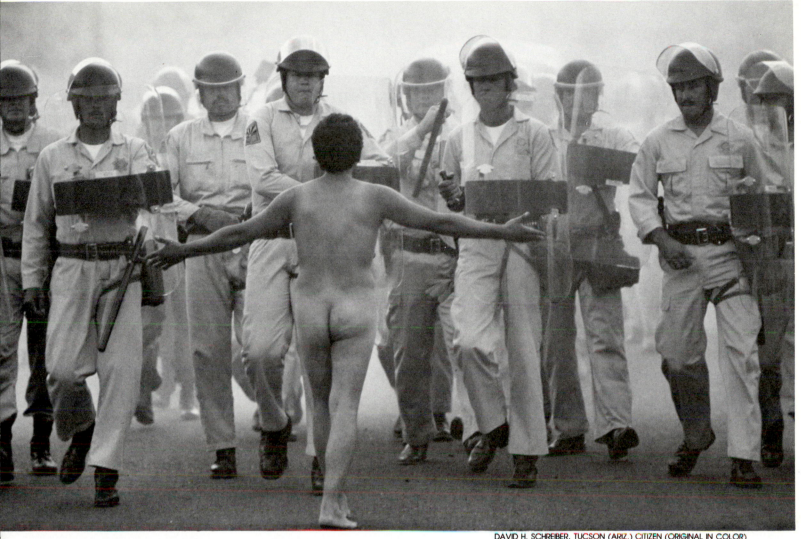

Above, a striking miner surrenders at Clifton, Ariz. After Robert Andazola ripped off his clothes, officers arrested him for unlawful assembly and indecent exposure.

Below left, resident in nature camp near San Jose, Calif., enjoys scenic trek through Santa Cruz mountains.

Below, a visitor to Dallas, Texas, during Republican National Convention seeks relief for his daughter.

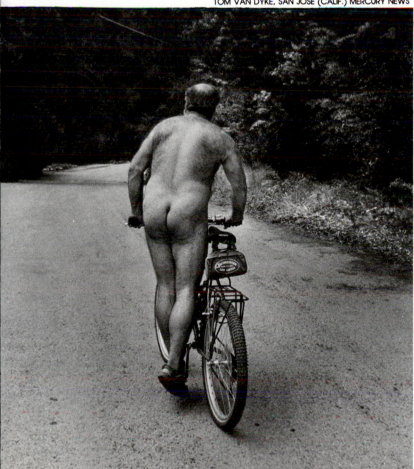

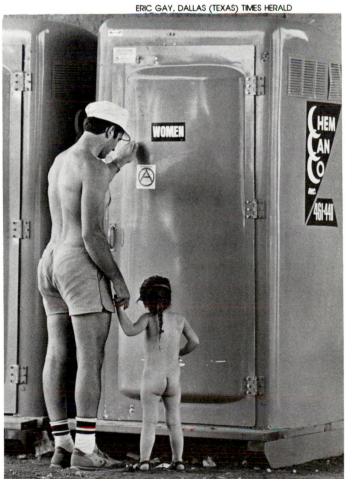

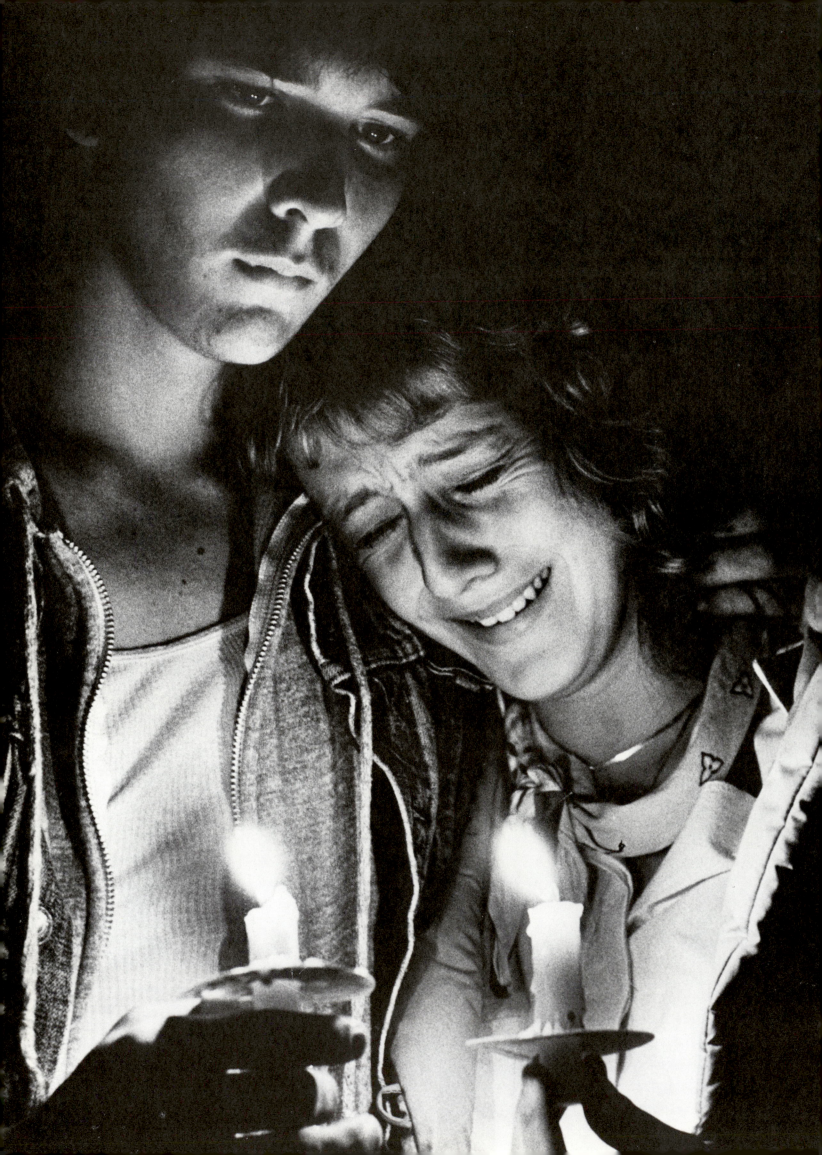

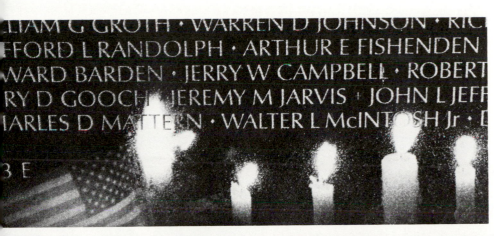

eft, at a candlelight vigil for those still listed as missing in action, Michael Salatto, 18, and Kathi ggers, 16, weep for a war they are too young to remember.

Left, candles and a flag are reflected on the black granite wall of the memorial. Below, war memorabilia decorates the base of the newly-dedicated statue.

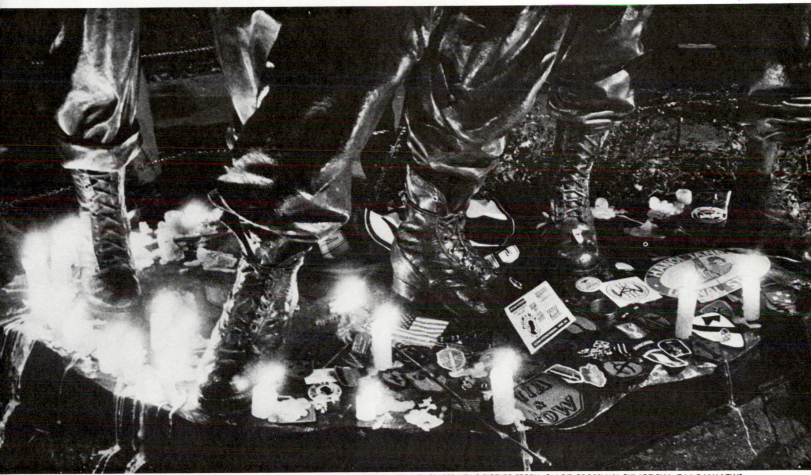

FIRST PLACE, NEWSPAPER NEWS PICTURE STORY, G. LOIE GROSSMAN, PHILADELPHIA (PA.) DAILY NEWS

The longest war

Veterans Day Weekend 1984: In Washington, D.C., a statue of three soldiers, "Three Fighting Men," is dedicated at the Vietnam Veterans Memorial. And once more, veterans and Americans with long memories come to commemorate a poignant monument to a long and unhappy conflict.

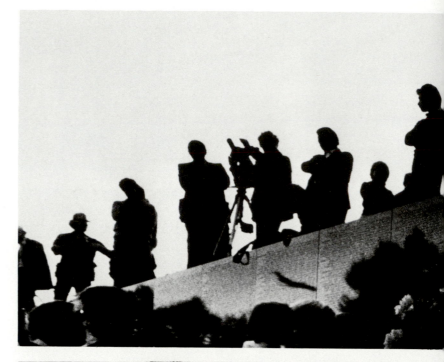

The longest war

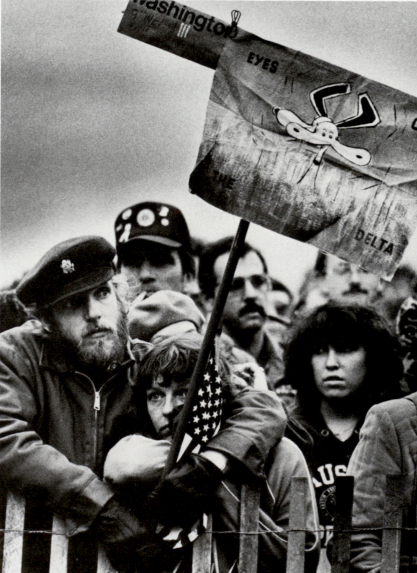

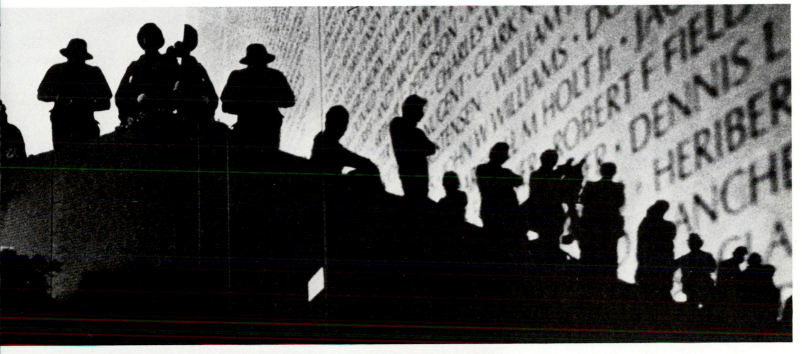

Above, some veterans gather on grass above the black granite slabs of the memorial. Left, a veteran and his wife hold back their emotions.

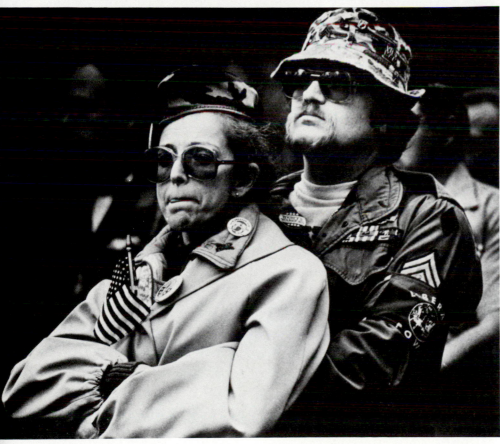

Left, Phil and Kathy Isasi came from East Islip, N.Y., to participate.

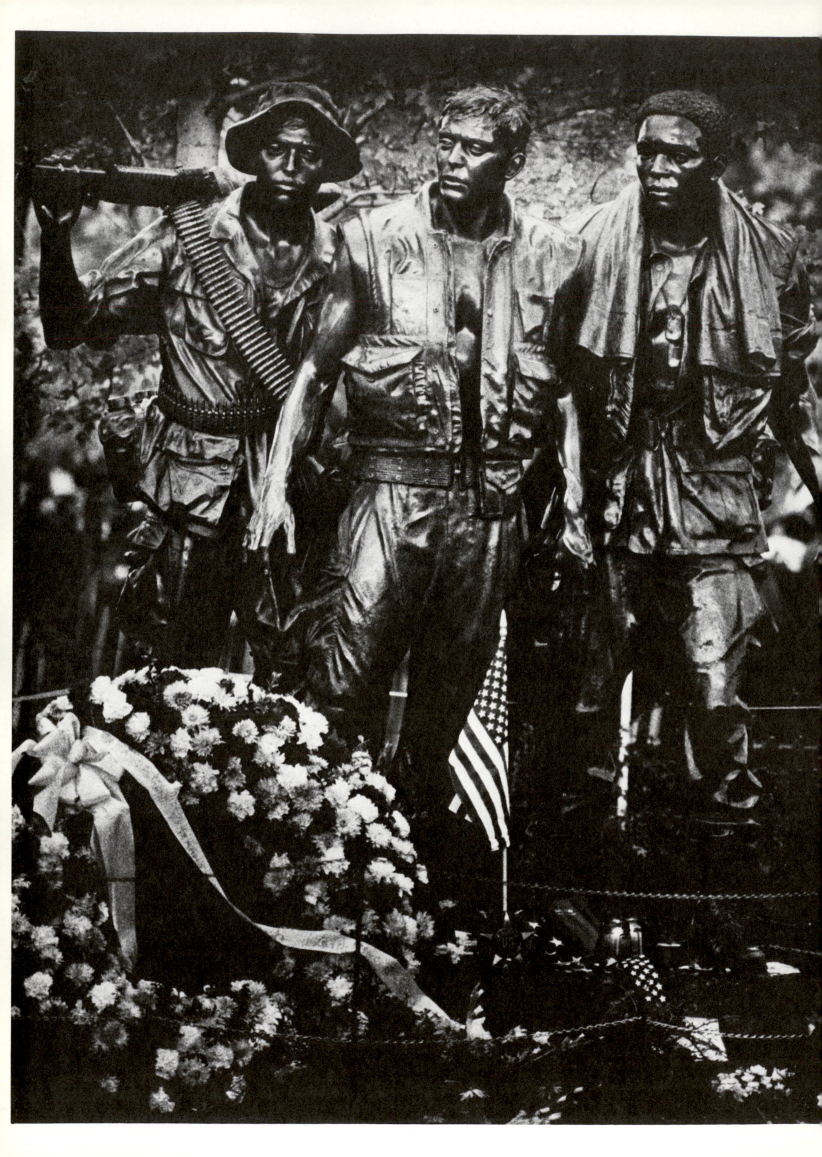

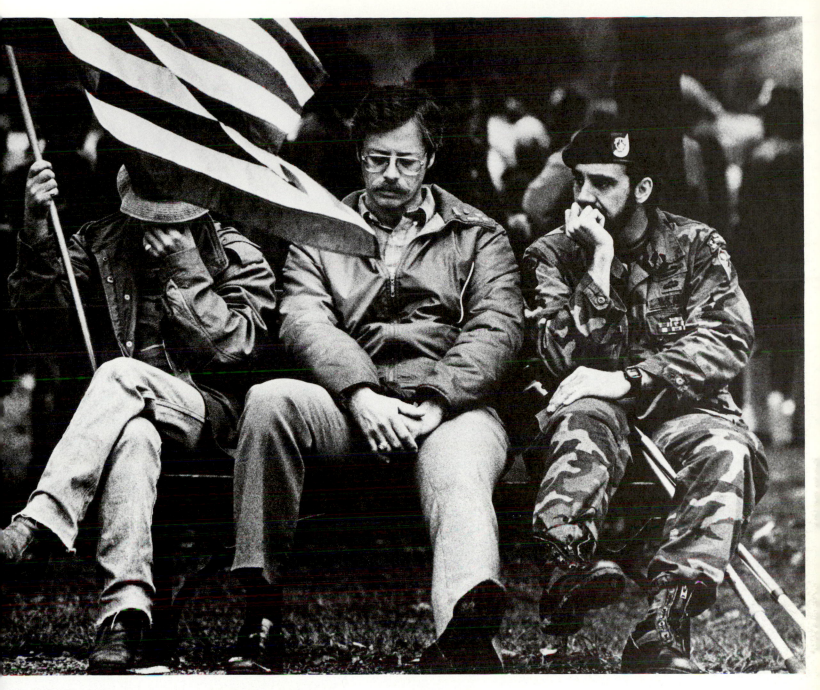

Left, statue by Frederick Hart was commissioned as a compromise to those who thought original memorial wall was not enough. Above, a trio of Vietnam vets — Thomas Dill (with flag) of Falls Church, Va., and Ford Burgess and Tom Titus (with crutches) both from Idaho — listen to the dedicatory music.

The longest war

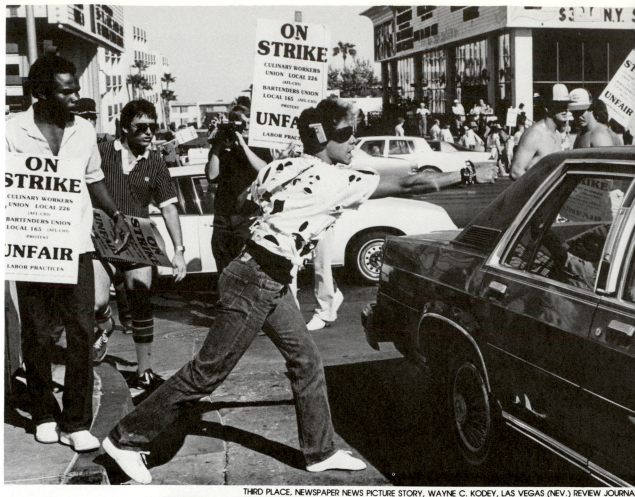

Imperilled picketer

A strike of culinary workers in Las Vegas, Nev., was three days old when Photographer Wayne C. Kodey staked out at Caesar's Palace, where he pictured picketers trying to keep drivers (above) from entering the hotel parking lot. But when one car kept moving through the crowd, picketer Jim Turner, a striking waiter, didn't move quickly enough. He starts to go down in two-photo sequence at right.

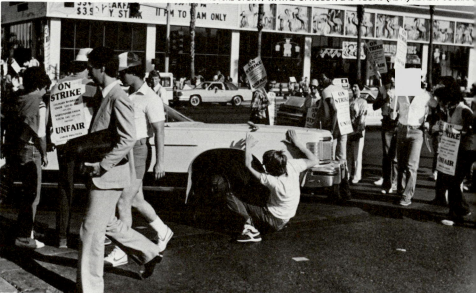

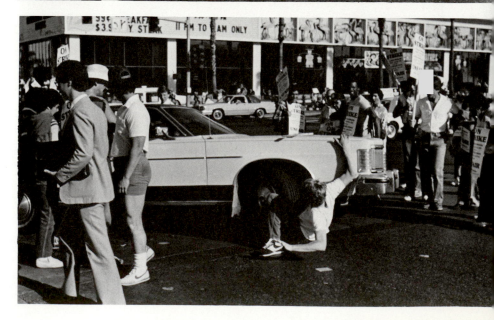

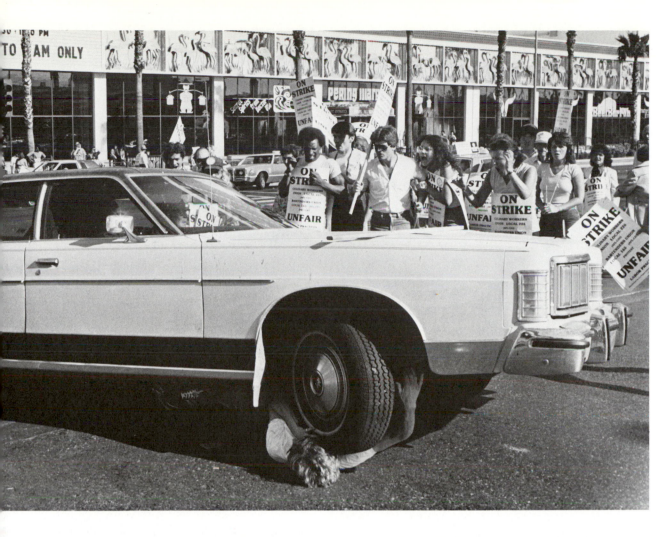

Above, picketer Turner bears full weight of auto at this point. Says Photographer Kodey, "The driver didn't realize he'd run over a person ..."

Below, paramedics load Turner for a trip to the hospital, where he was treated for a broken pelvis and shoulder. In background, police keep order among picketers.

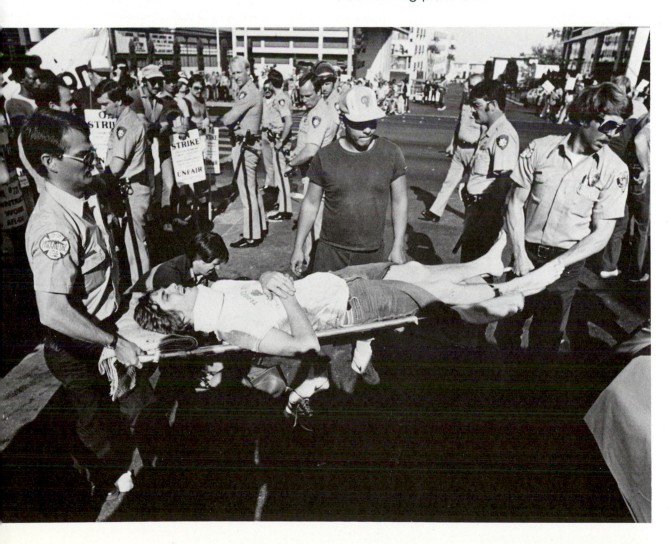

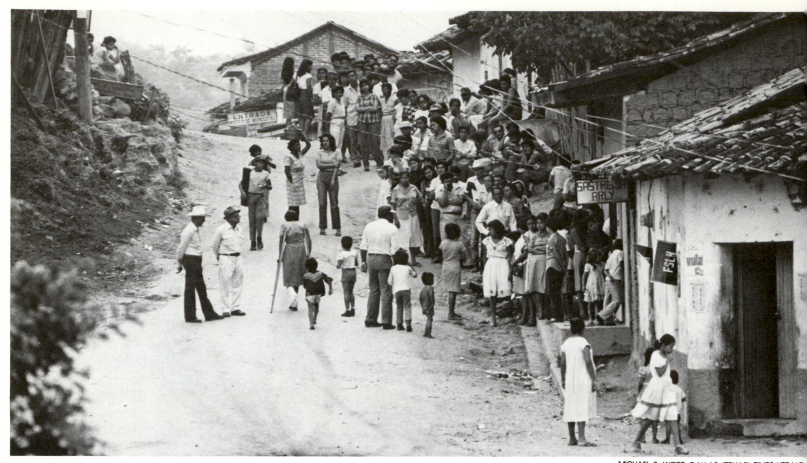

Above, people in a small Nicaraguan town line up to vote in the first national election in 10 years. Reported The Chicago Tribune: "The assured outcome of the election left many voters and observers with little enthusiasm for the contest."

Below, woman in the small mountain town of La Palma, El Salvador, displays a white flag from her bullet-pocked home. It signalled her hope for peace during talks between guerrillas and Salvadoran President Jose Napoleon Duarte.

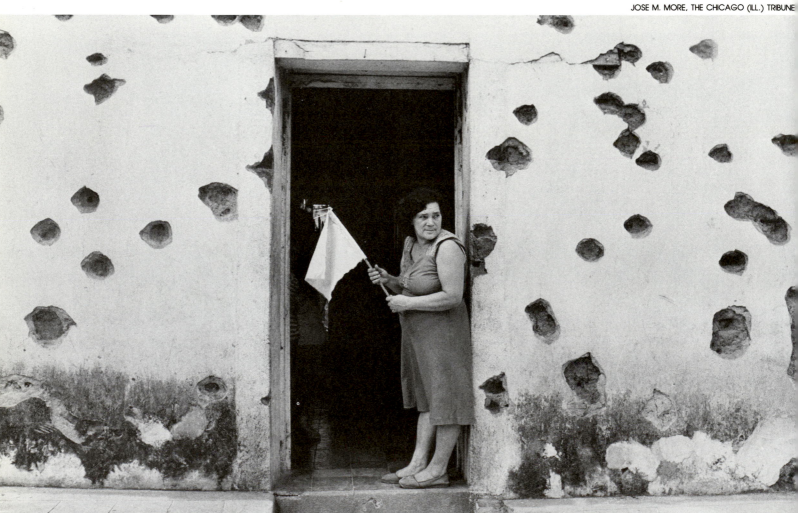

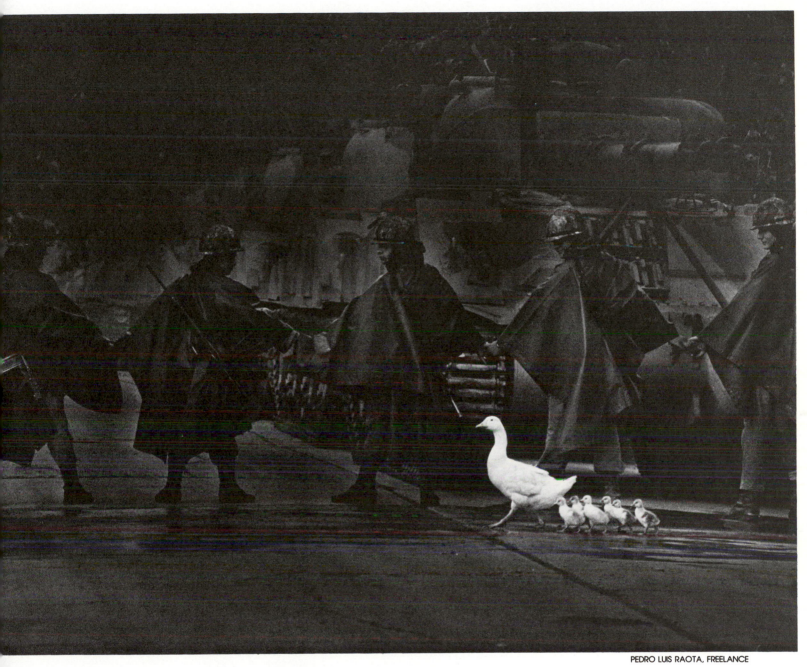

Near Buenos Aires, Argentina, soldiers join hands to make sure a duck and her ducklings can pass by without risk from tanks.

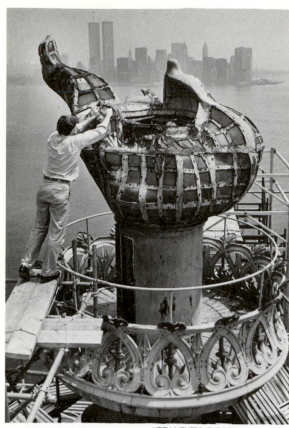

After 99 years, "the Lady" got a face lift to the tune of $39 million. Hopes were that the restored Statue of Liberty would be re-opened to the public by July 4, 1985 — the year the monument's centennial was to be celebrated. Above, John Robbins of the National Park Service tapes glass on the statue's torch. Right, scaffolding enfolds Lady Liberty as restoration work continues.

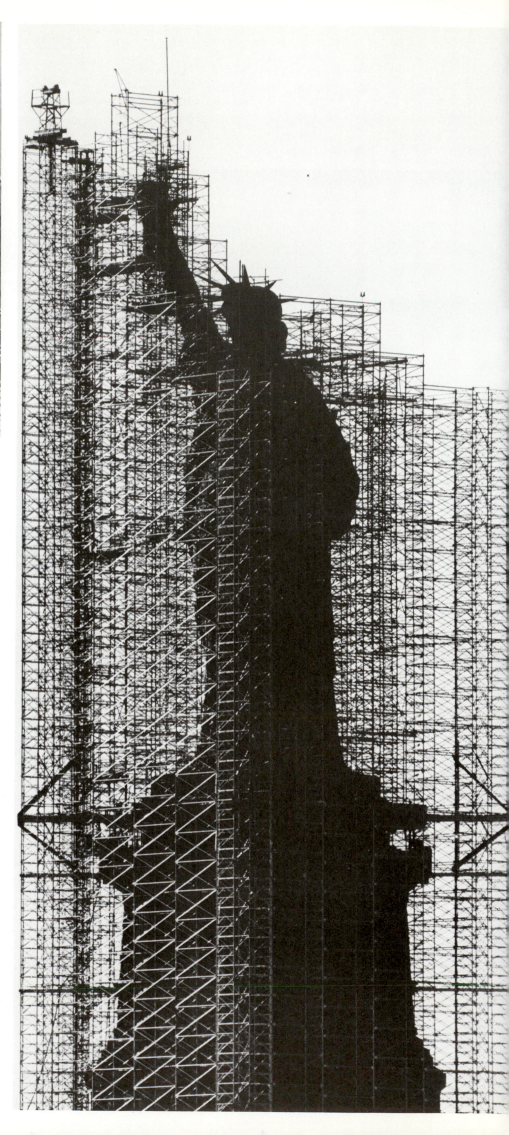

Dave McMillen lost his dual tires in Lewiston, Ida., when the wheel studs broke; after that, it was a simple matter of waiting for help.

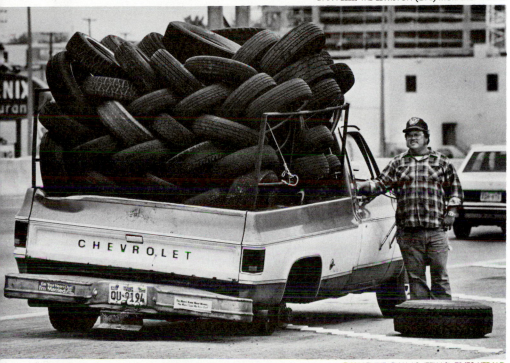

John Morgan dropped a wheel on one of Dallas's busiest freeways; again, watch and wait.

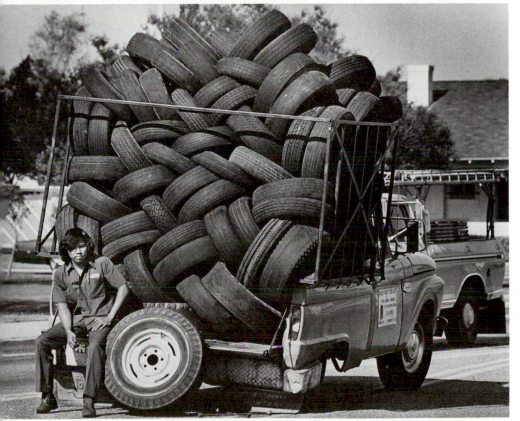

In Phoenix, Ariz., Ros Ramos practices the virtue of patience in the presence of a flat tire and the absence of a jack.

Above, the Maltese freighter *Eldia,* grounded on Nauset Beach on Cape Cod, drew more than 30,000 curious people. Some 140,000 gallons of fuel had to be removed before the ship could be refloated.

Below, smoke pours from the 630-foot tanker *Puerto Rican* as tiny firefighting vessel sprays water amidships. Officials suspected a bomb caused an explosion aboard the petrochemical tanker 25 miles west of California's Golden Gate, creating a blaze that killed a crewman.

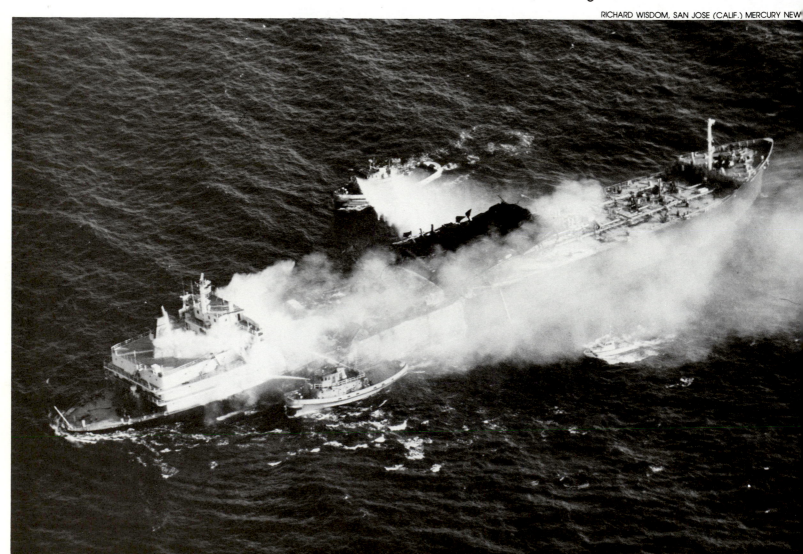

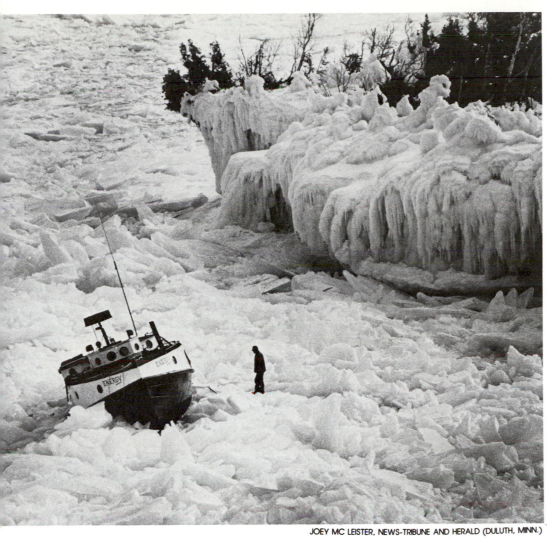

Left, the fishing boat *Energy* was dumped into ice floes by wicked and shifting winter winds on Lake Superior near Duluth, Minn. Coast Guardsmen freed the craft in a few hours.

Below, the best-known beached freighter of 1984: the *Mercedes,* which spent four months cozied up to the sea wall of a Palm Beach, Fla., socialite. Eventually, the ship was towed to Ft. Lauderdale, where it was sunk and serves as an artificial reef.

JOEY MC LEISTER, NEWS-TRIBUNE AND HERALD (DULUTH, MINN.)

DON PREISLER, THE PALM BEACH (FLA.) POST

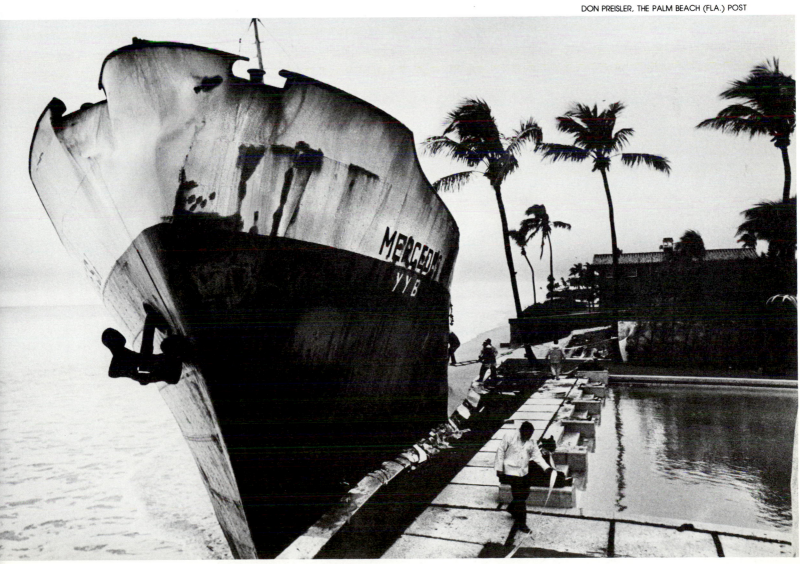

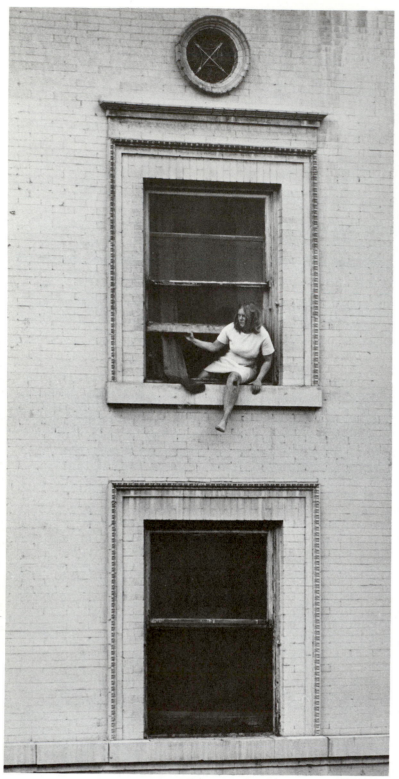

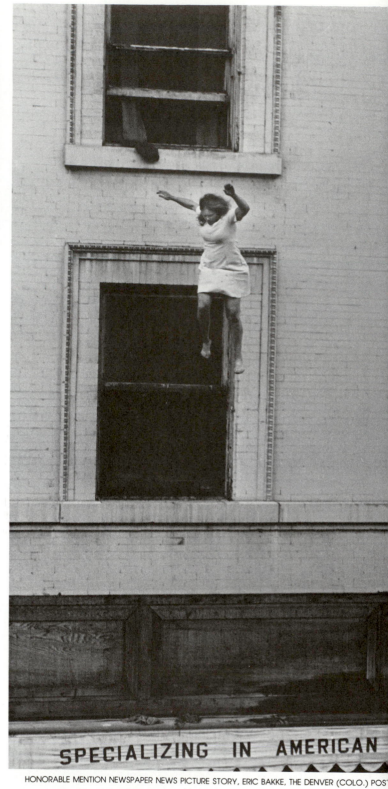

Near miss

In October 1984, Loretta Savage edged her way out of a third story apartment window in Denver, Colo., and plunged downward onto passers-by Lane Jones and Peggy Pfeffer. The apparent suicide attempt failed, but left Savage in serious condition.

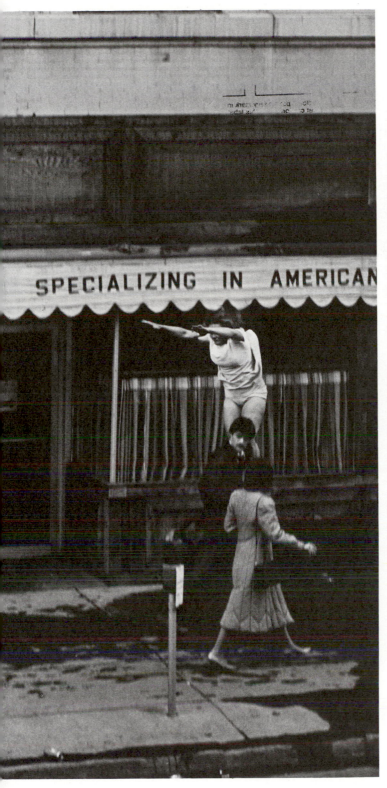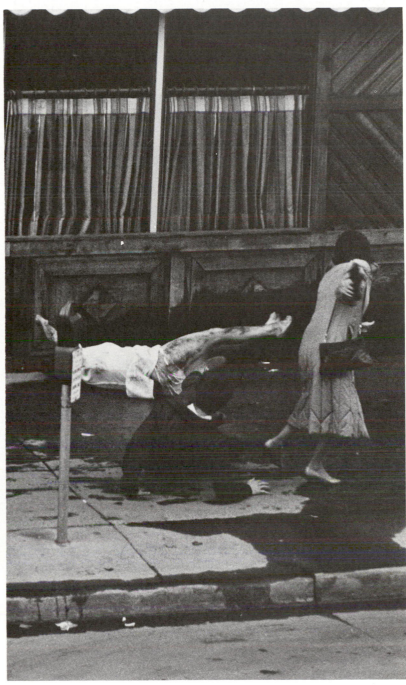

Conductor Don Schurr (left) takes fares, aids riders. Below, passengers get off at San Bruno, one of many stops between San Francisco and San Jose.

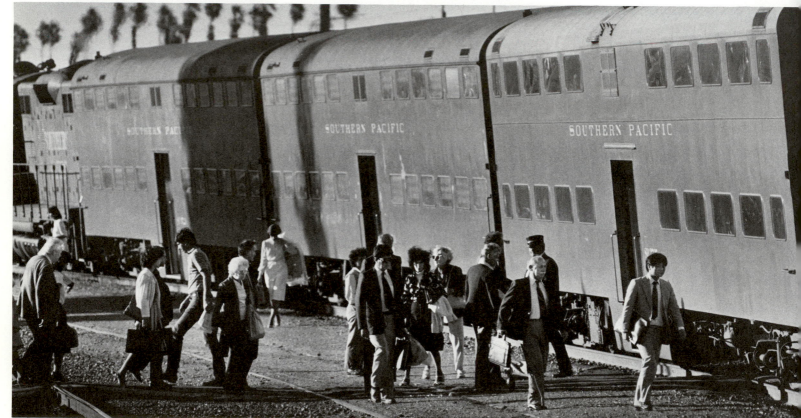

B·o·o·a·a·r·r·rd!

The coach cars are vintage 1950. The train h
been running daily on the San Francisco-San
Jose route for the last 100 years.

It's part of the Southern Pacific-Caltrans
Peninsula Line that carries thousands of
commuters, all refugees from rush-hour traffic
on the Bay Shore Freeway. On weekdays,
there are 26 trains and about 16,000
passengers

There's talk of retiring some of the older
passenger cars in favor of new Japanese
models. And they want to spruce up 27 of the
line's stations, too. End of an era? Probably, bu
the camaraderie of this West Coast commute
train will undoubtedly continue.

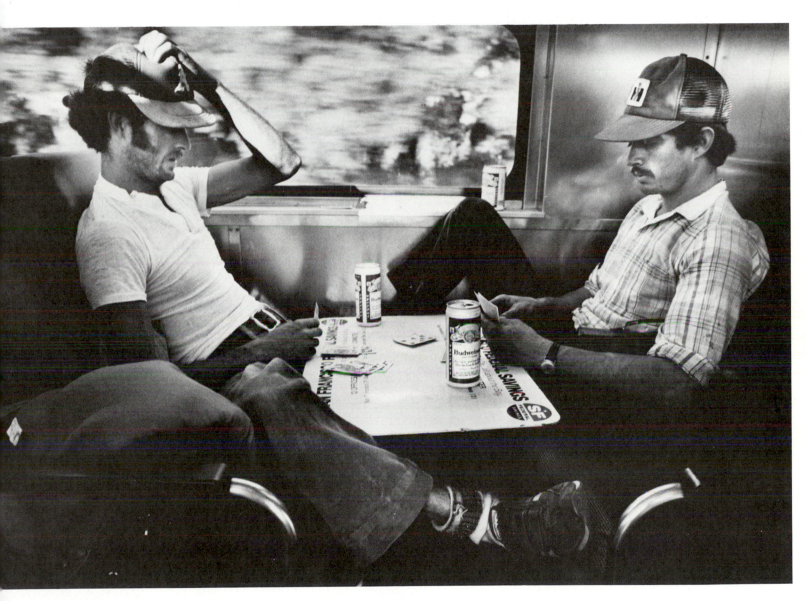

Two passengers play one more card
game in — how many millions? — as
the scenery blurs past their window.

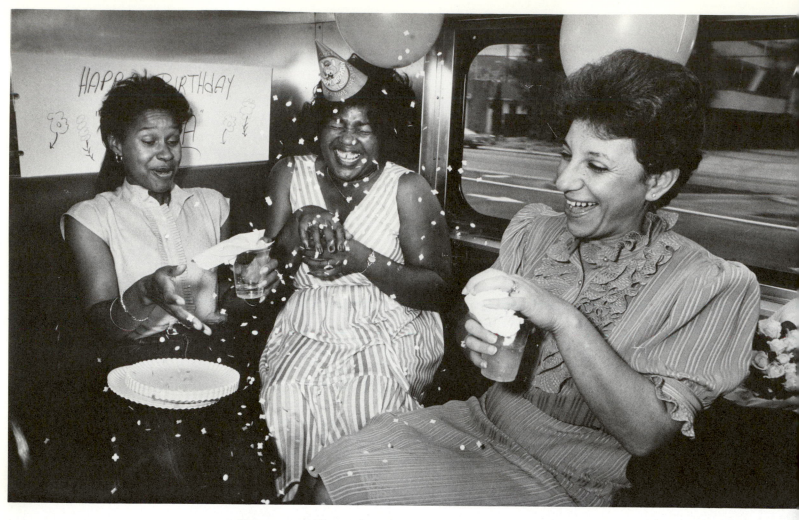

Commuter train

Above, Johnnie Keels (left) and Lila Bridgeman throw a birthday party for their friend, Clara Jackson (right). Below, Frank Flynn (left) and Phil Tisley peer out windows on their way to San Francisco.

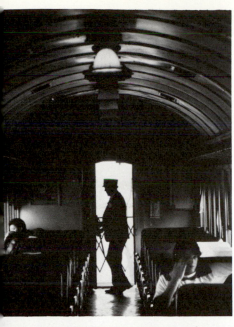

Left, conductor Art Huvari opens a door in one of the 1920-era cars. He's been with the Southern Pacific for 44 years. Below, a woman streaks down a station platform, intent on catching the train to San Francisco.

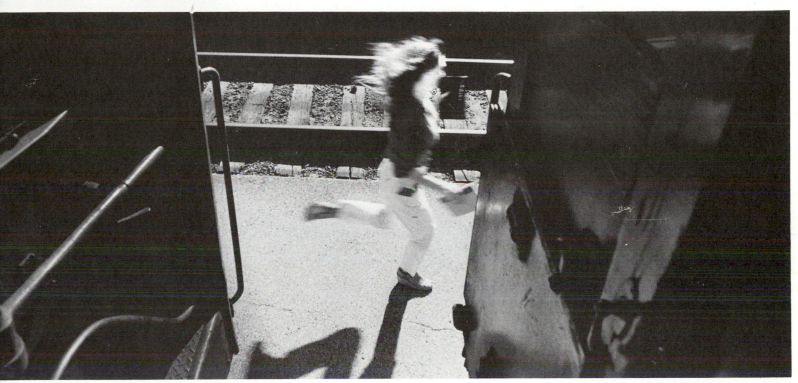

Above, photo illustration was used
with a story reporting the trend
toward fishing as a cash crop

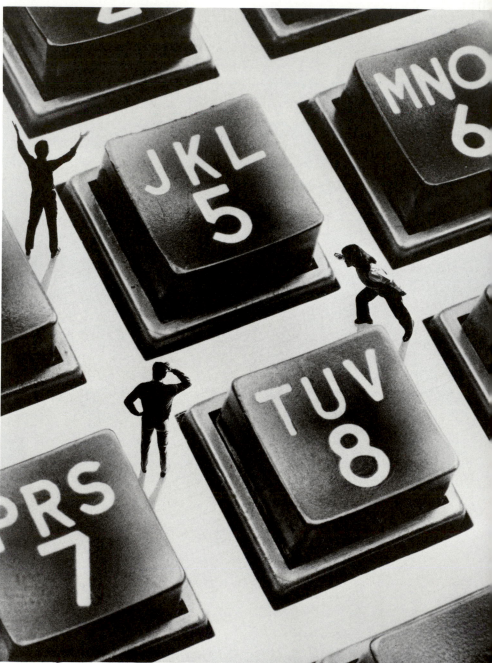

To illustrate a story dealing with high-tech telephones,
Photographer Gary S. Chapman started with a close
photo of a phone, added prints of people, spotting in
shadows and re-shooting entire composite on 4x5.

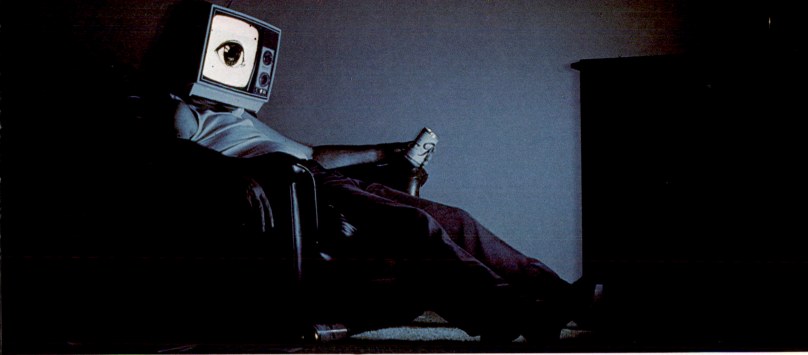

FIRST PLACE NEWSPAPER EDITORIAL ILLUSTRATION, PETER HALEY, THE JOURNAL-AMERICAN (BELLEVUE, WASH.)

Above, the big eye watching the big eye ran without cutlines to illustrate a story headlined, "Why we watch so much television."

Below, to illustrate a story headlined "Scars of child abuse," Photographer Danielle Pallatto combined the figure of a child with a sketch drawn by a girl who had been sexually abused by a neighbor.

THIRD PLACE NEWSPAPER EDITORIAL ILLUSTRATION, DANIELLE PALLOTTO, THE JOURNAL (ROCKVILLE, MD.)

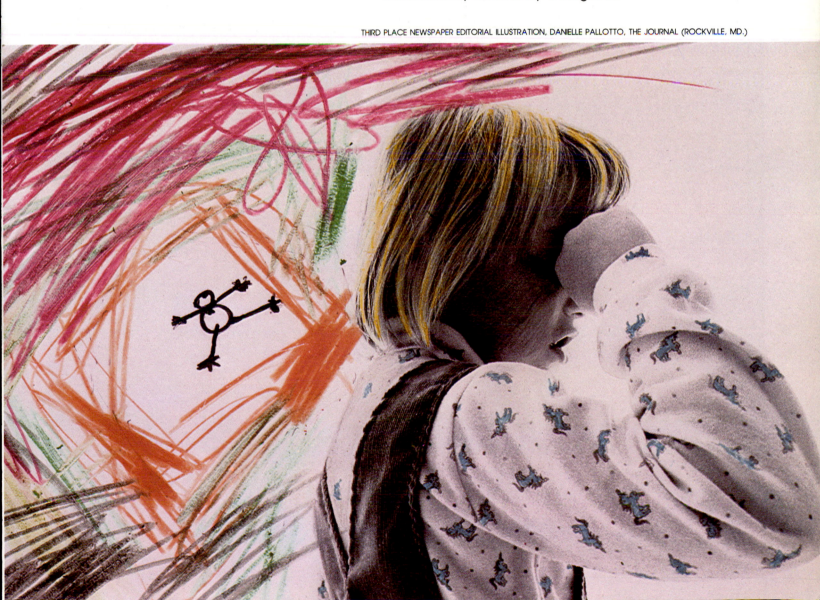

In March 1984 the Chicago Tribune reported:
"Neon-colored fashions are bursting into the
spotlight . . ." like the glowing designs of David
Rainey's multicolored acrylic necklace, bracelets,
and earrings.

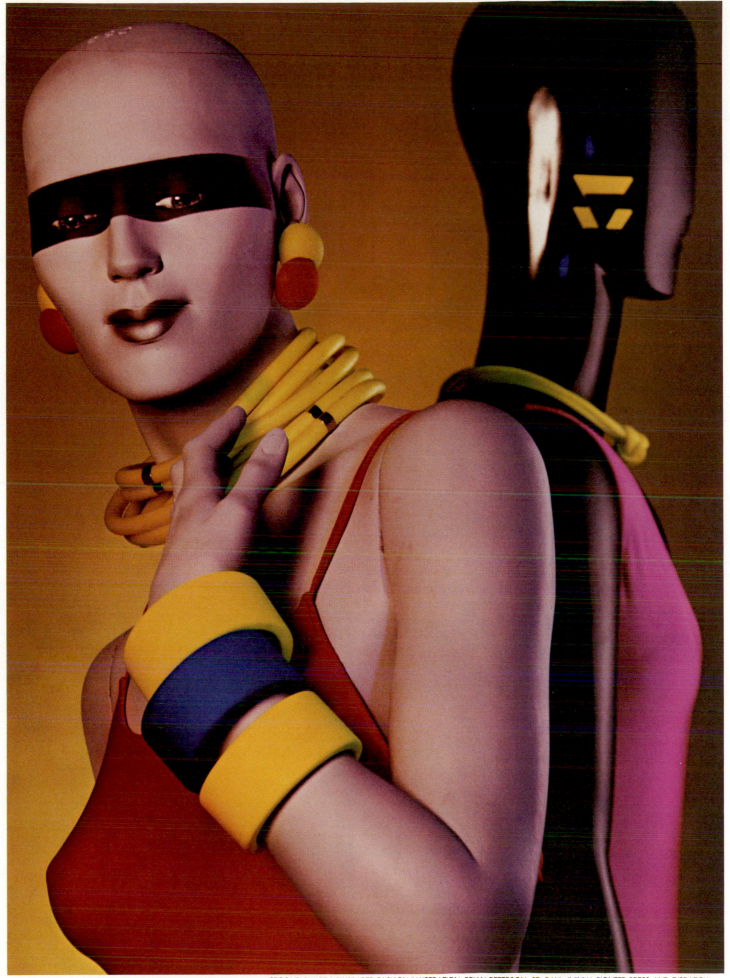

SECOND PLACE NEWSPAPER FASHION ILLUSTRATION, BRIAN PETERSON, ST. PAUL (MINN.) PIONEER PRESS AND DISPATCH

Accessories were featured in this illustration made
on location in St. Paul, Minn., for fall fashion section.

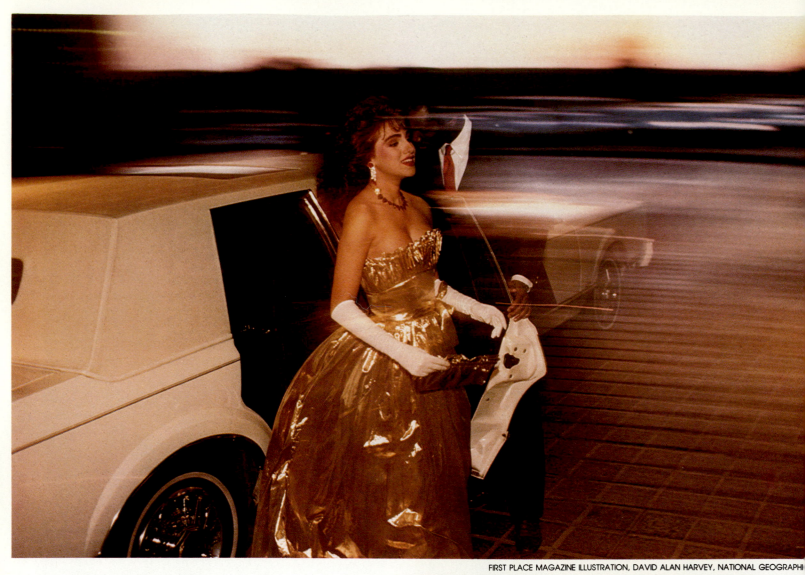

FIRST PLACE MAGAZINE ILLUSTRATION, DAVID ALAN HARVEY, NATIONAL GEOGRAPHI

THIRD PLACE NEWSPAPER FASHION ILLUSTRATION, MARK B. SLUDER, THE CHARLOTTE (N.C.) OBSERVE

Above, making a grand exit from a limousine, a Dallas model in a gold lamé gown swirls through a silken night.

Right, Photographer Mark B. Sluder used his own belt buckle and jeans to make this photograph.

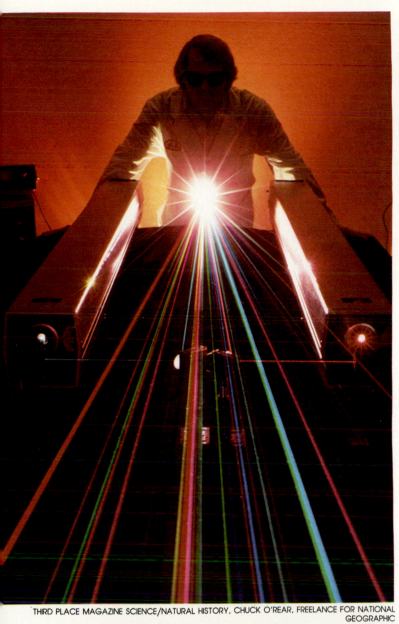

Above, a lettuce plant is grown hydroponically; a way, said Photographer Marna G. Clarke, to treat yourself to green vegetables in the dead of winter.

Left, a rainbow of colors from krypton and argon laser beams are split by diffraction grating in a laser lab.

Below, a cad-cam computer model helps determine stress on the Statue of Liberty.

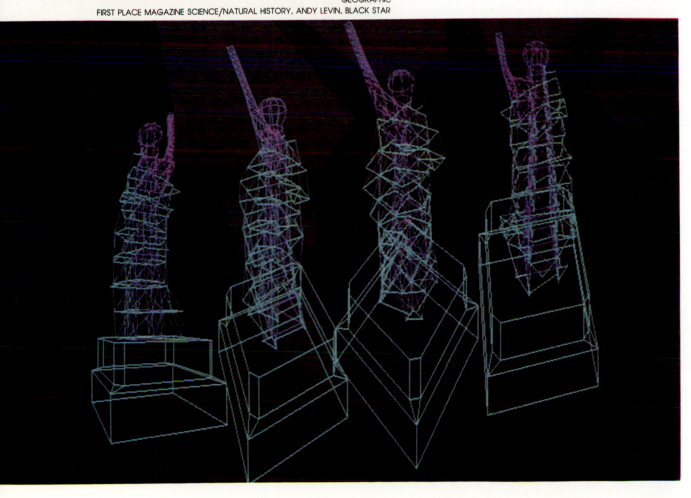

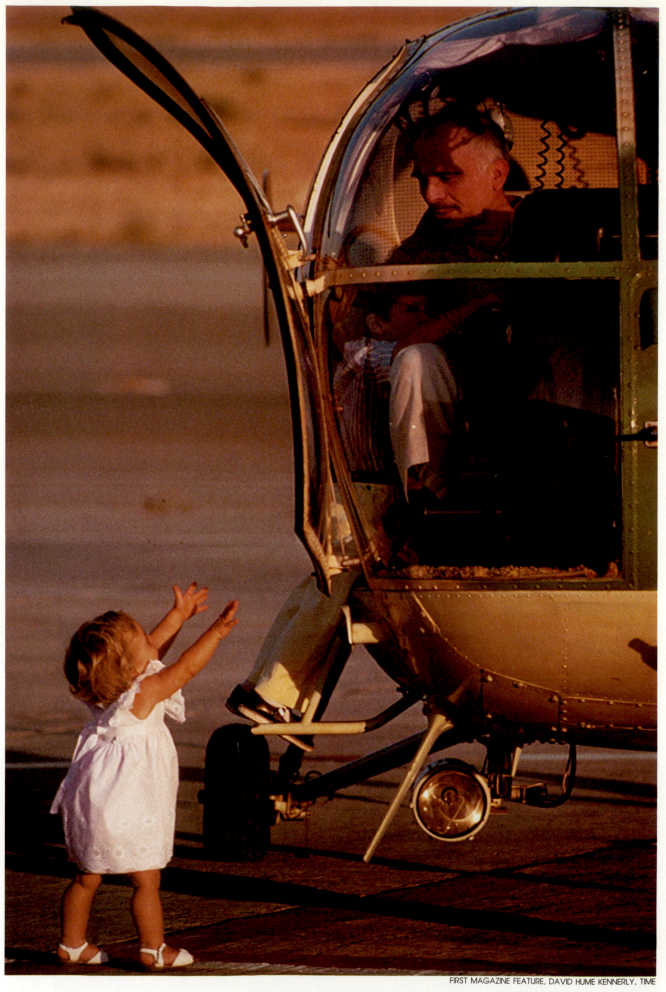

Like any daughter anywhere, Princess Iman lifts her arms
to her father: Jordan's King Hussein, at Amman Airport.

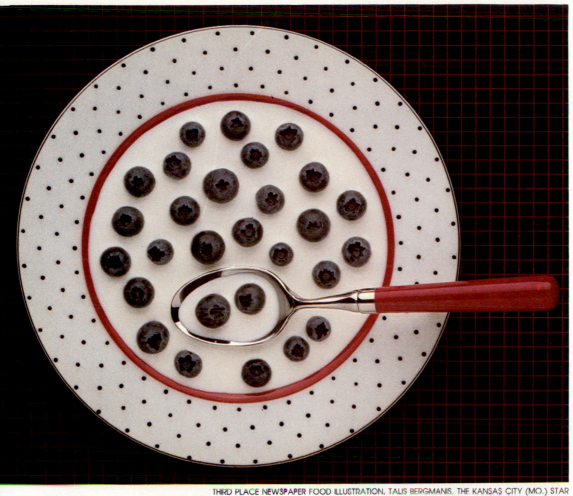

THIRD PLACE NEWSPAPER FOOD ILLUSTRATION, TALIS BERGMANIS, THE KANSAS CITY (MO.) STAR

FIRST PLACE NEWSPAPER FOOD ILLUSTRATION, MICHAEL J. BRYANT, SAN JOSE (CALIF.) MERCURY NEWS

Photographer Talis Bergmanis, assigned to illustrate story on blueberries, went through china departments of several stores before he found the right dish.

When Photographer Michael J. Bryant needed to illustrate a story on bottled water, he found it necessary to use glycerin to write the magic word ... water wouldn't hold.

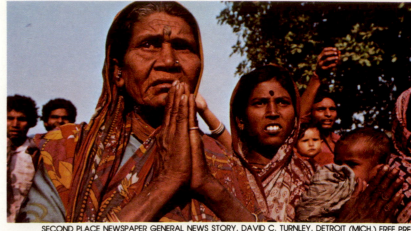

Below, honor guard tows gun carriage bearing the prime minister's body as spectators (right) react.

SECOND PLACE NEWSPAPER GENERAL NEWS STORY, DAVID C. TURNLEY, DETROIT (MICH.) FREE PRESS

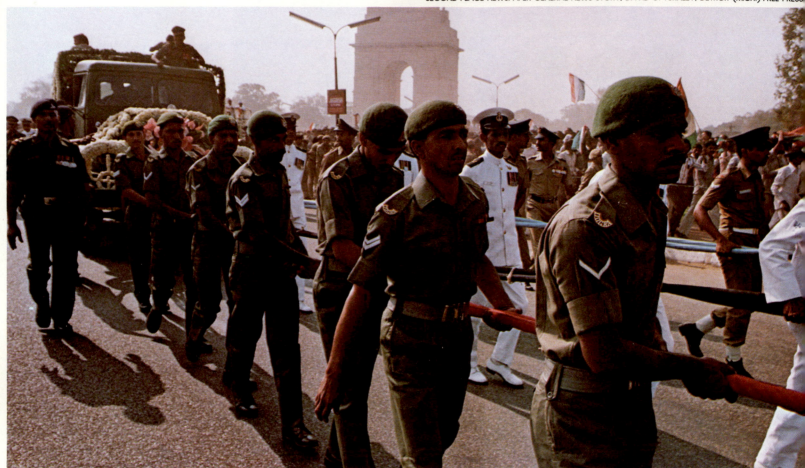

Gandhi: assassination victim

On a bright autumn morning, the last day of October 1984, India's Prime Minister Indira Gandhi was assassinated by two members of her security guard, identified as Sikhs.

The daughter of India's first prime minister, Jawaharlal Nehru, she had dominated India for most of 18 years. Gandhi's death triggered the worst violence in India since 1947; more than a thousand persons were killed in anti-Sikh riots. A scant 12 hours after her death, Gandhi's son, Rajiv Gandhi, was named her successor.

At the time of the assassination, Photographer David C. Turnley of the Detroit (Mich.) Free

Press was vacationing in Paris. He was sent to cover the funeral.

Reported Turnley: "Journalists were packed in army trucks which preceded by about one mile the gun carriage carrying Gandhi's body. Frustrated by the bad vantage point, I jumped out of the truck and ran back to a position alongside Gandhi's body, where I worked unmolested by security the entire route."

Turnley's work received a citation from the Overseas Press Club for photo reporting abroad.

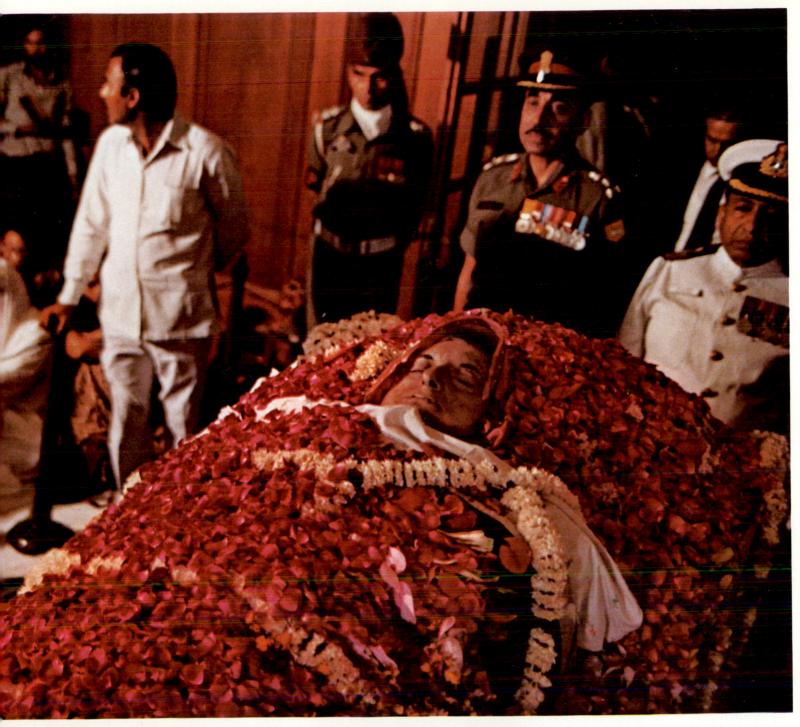

Above, Gandhi's bier is surrounded by officials and military officers.

Left, New Delhians strain for position during funeral procession.

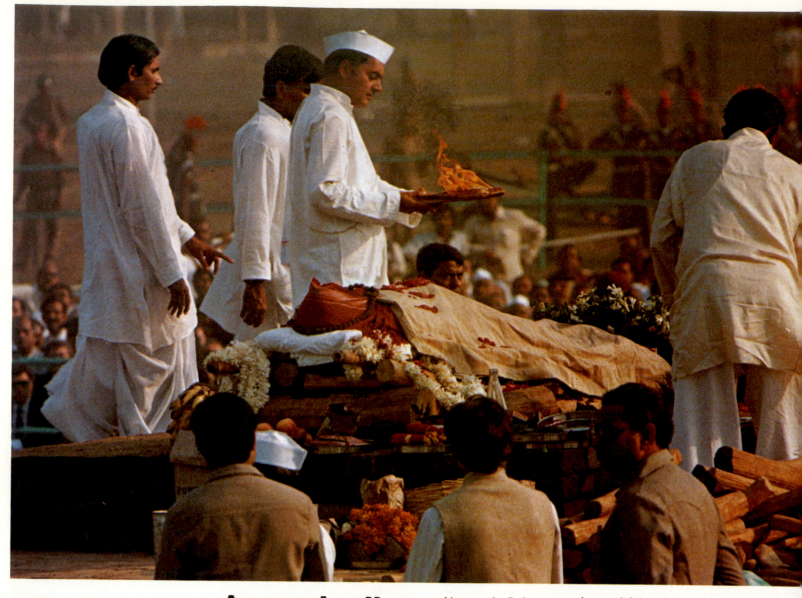

Assassination

Above, India's new prime minister, Rajiv Gandhi, prepares to cremate his mother's body.

Below, mourners at the site of Gandhi's cremation.

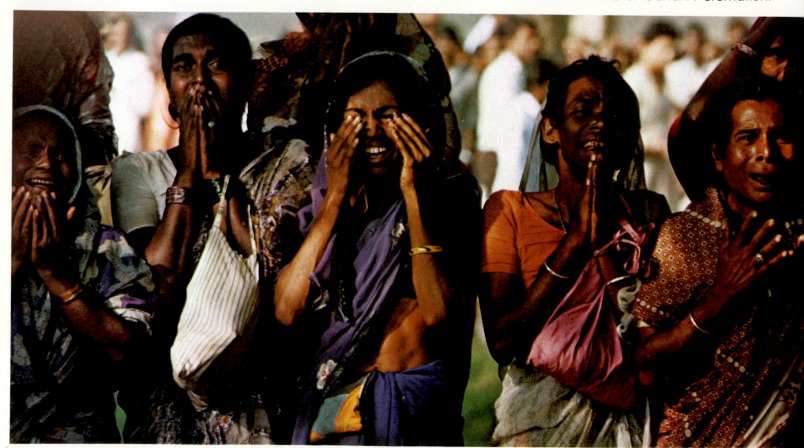

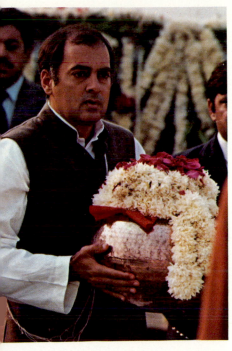

Left, Prime Minister Rajiv Gandhi collects his mother's ashes.

Below, guards are alert for continuing violence.

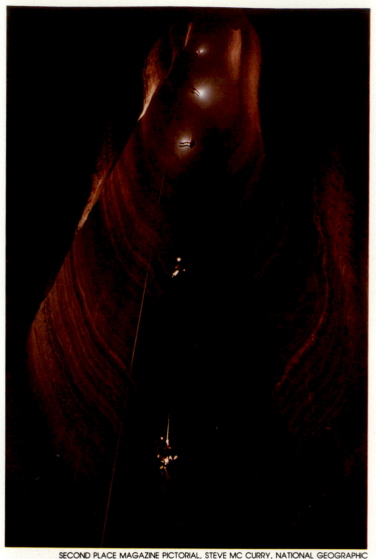

Left, a subject flashes a strobe intermittently as he rappels 600 feet into Fantastic Pit in Georgia, the deepest pit cave in the United States.

Below, before the beginning of the monsoon, cruel winds sear the arid plains of western India, and women seek shelter in the lee of a tree.

Right, Photographer Georg Gerster calls it "Texas scrollwork:" patterns formed in a cotton field by deep disking, which is done to protect young plants from the wind.

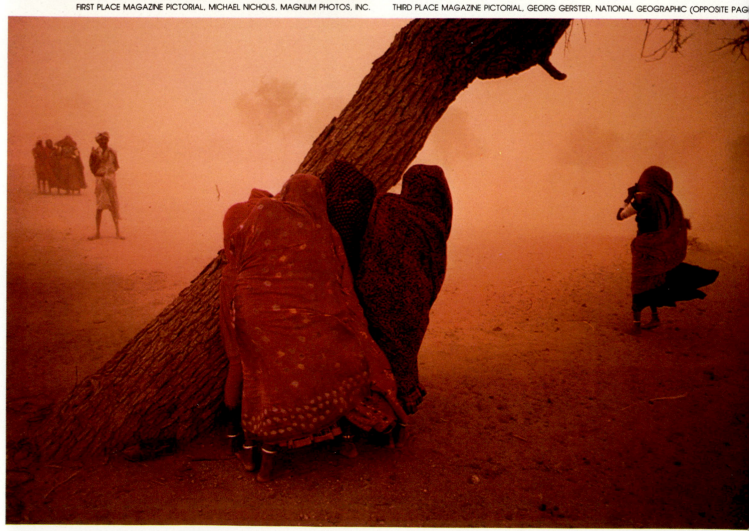

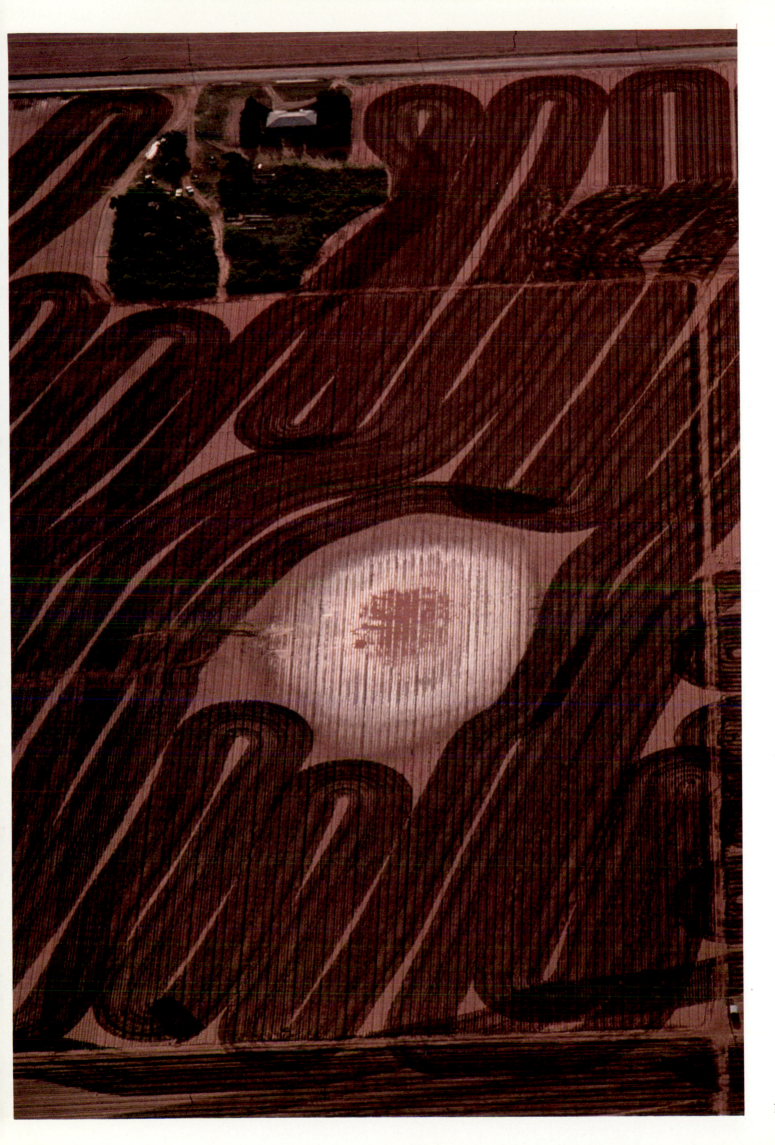

141

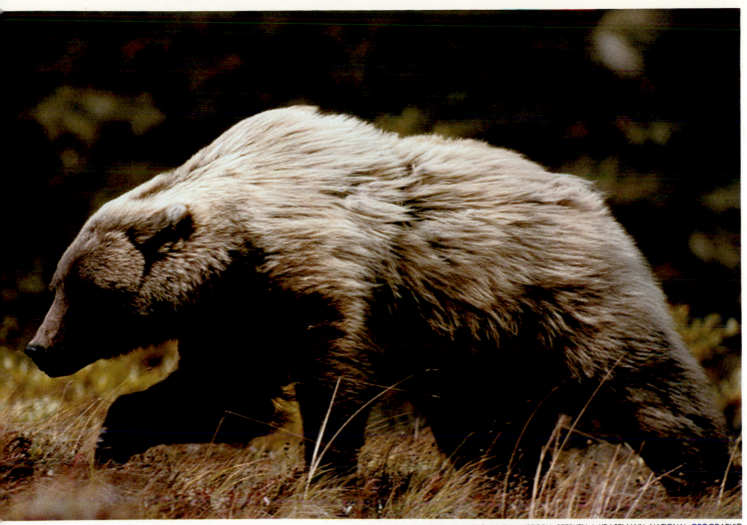

bove, a grizzly on the tundra of the Alaska Range,
alking into the wind to scent any possibility of food.

ght, a Saskatchewan grain elevator gleams in the late
fternoon sun.

eft, a Type 57 Bugatti — symbol of the golden age of
utomobiles.

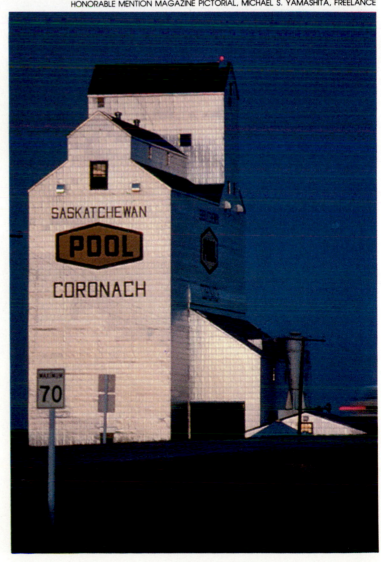

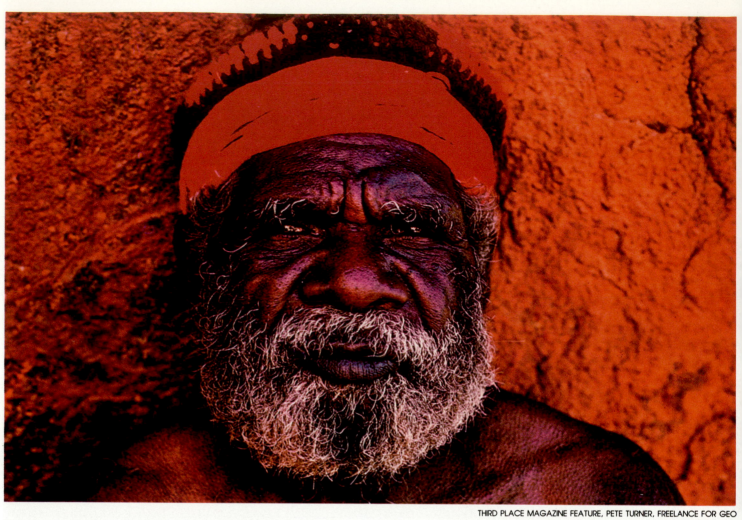

Above, Australian aborigines have lived around Ayers Rock for 30,000 years. They are its official owners.

THIRD PLACE MAGAZINE FEATURE, PETE TURNER, FREELANCE FOR GEO

Below, an Indian tailor salvages his rusty, antique (but essential) sewing machine from his village shop after a flash monsoon flood in Porbandar.

HONORABLE MENTION MAGAZINE FEATURE, STEVE MC CURRY, NATIONAL GEOGRAPHIC

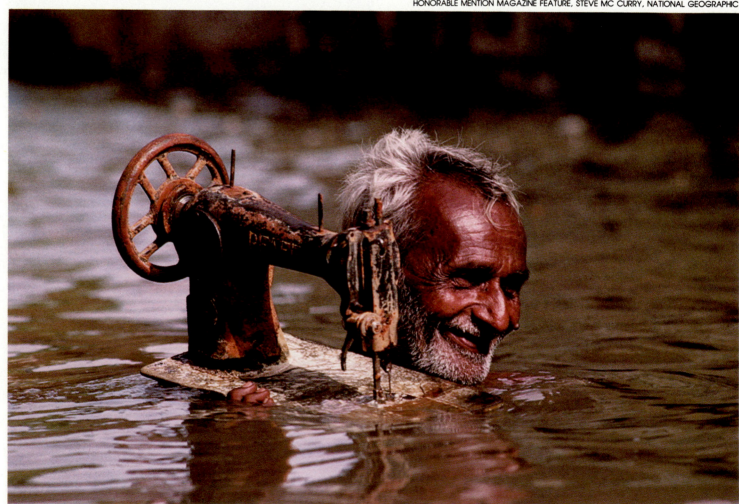

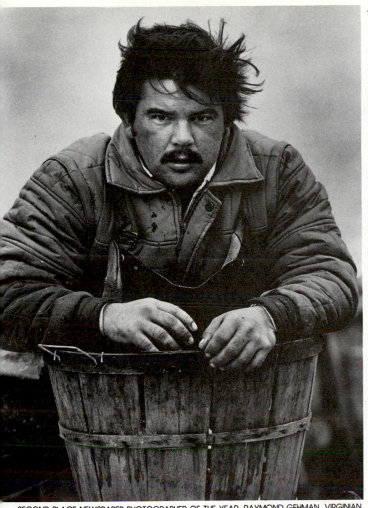

SECOND PLACE NEWSPAPER PHOTOGRAPHER OF THE YEAR, RAYMOND GEHMAN, VIRGINIAN
PILOT-LEDGER STAR (NORFOLK)

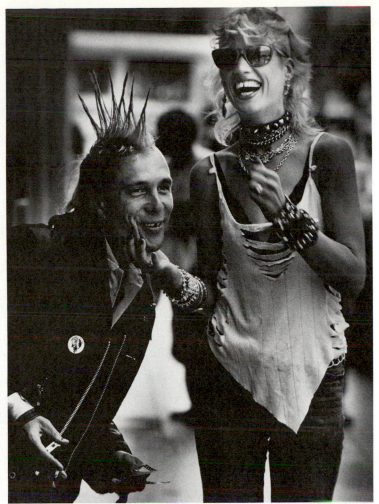

THIRD PLACE NEWSPAPER PHOTOGRAPHER OF THE YEAR, GARY PARKER, SAN JOSE (CALIF.)
MERCURY NEWS

bove, Jesse James West, a
Gloucester (Va.) Guineaman, brings
n a basket of fish after a morning's
vork.

Below, Photographer Fred Comegys's
portrait of a tattooed man.

Above, a pair of residents of the
Haight-Ashbury section of San
Francisco clown for the camera.

NEWSPAPER PHOTOGRAPHER OF THE YEAR, FRED COMEGYS, THE NEWS-JOURNAL (WILMINGTON, DEL.)

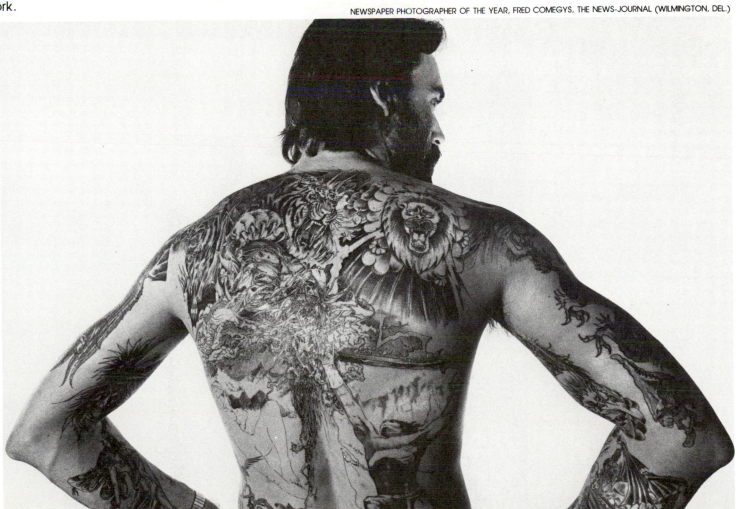

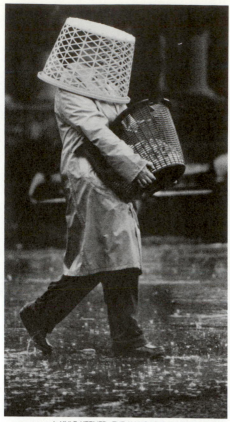

In downtown Kansas City, Mo., a woman uses a spare laundry basket to shield herself during thunderstorm.

At the University of Illinois, Naval ROTC Midshipman Patrick Bingham makes sure his shine stays shiny.

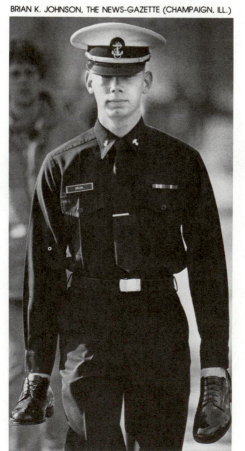

In San Angelo, Texas, drummer does what comes naturally after banging away down 16-block homecoming parade route.

In Louisville, Ky., kindergartner Patrick Bingham shows how things happen during a solar eclipse.

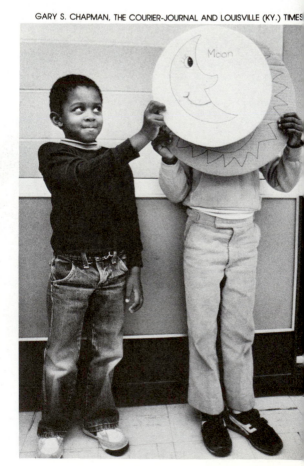

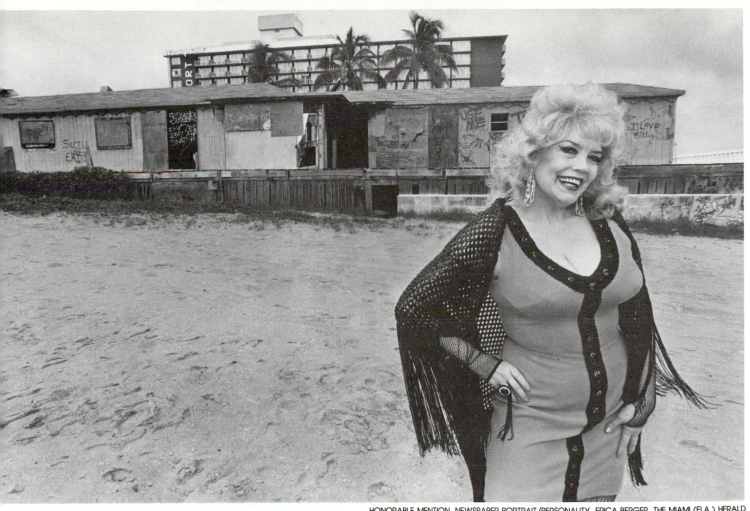

HONORABLE MENTION, NEWSPAPER PORTRAIT/PERSONALITY, ERICA BERGER, THE MIAMI (FLA.) HERALD

n the 1950s, Evelyn "Treasure Chest" West, above, was a stripper who insured her 45½-inch bust for $50,000. These days she works as a night club comedienne.

New York City subways (below) usually get a bad press. But on Halloween, one passenger, at least, got into the spirit of the occasion.

SECOND PLACE NEWSPAPER FEATURE PICTURE, FRANK O. JACOBS III, TODAY'S SUNBEAM (SALEM, N.J.)

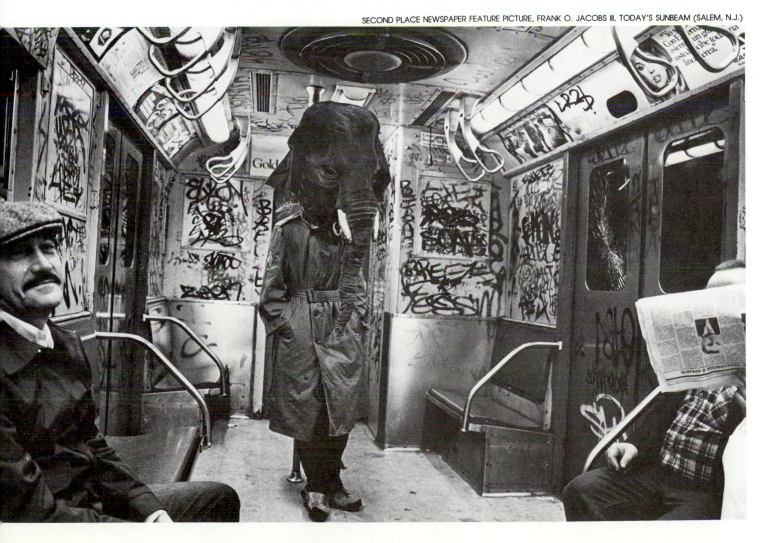

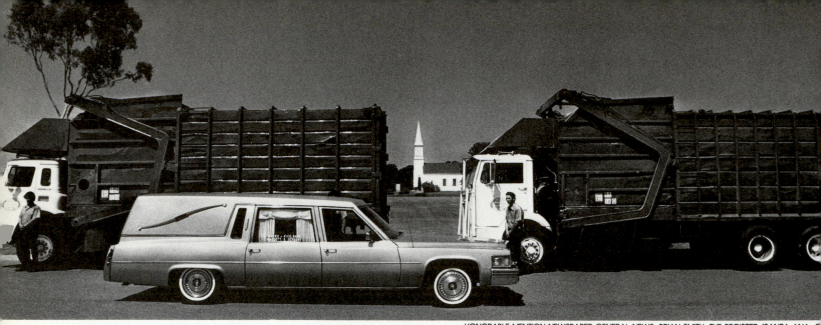

HONORABLE MENTION NEWSPAPER GENERAL NEWS, BRIAN SMITH, THE REGISTER (SANTA ANA, C

HONORABLE MENTION NEWSPAPER FEATURE PICTURE, JED KIRSCHBAUM, THE BALTIMORE (MD.

Above, an honor guard of garbage trucks was on hand at Forest Hills to pay respects during funeral of Cosmo Taormina, founder of the Anaheim, Calif., Disposal Company. Right, what do you do when the Baltimore Zoo's giraffe, Angel, has a baby but they won't let mother and child outside? You get what you can, where you can.

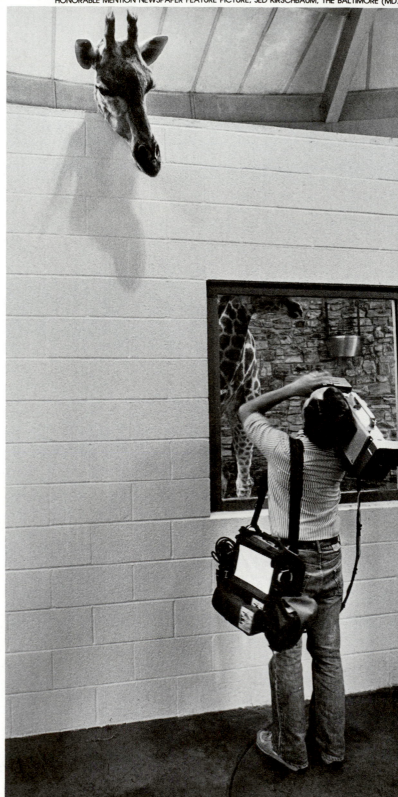

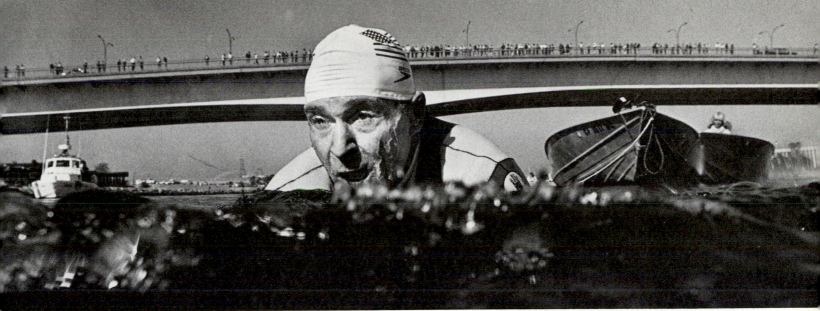

Above, fitness buff Jack LaLanne comes up for air while pulling 70 small boats a mile in 2½ hours in Queensway Bay, Long Beach, Calif. The occasion: LaLanne's 70th birthday. And he did it with wrists and ankles shackled. LaLanne's conclusion: ''Toughest thing was the last 100 yards.''

Below, when 16 Chicago kids came down with symptoms of food poisoning, they were taken to several area hospitals. The media converged on the first ''victim'' emerging under his own power. Says Photographer Robert A. Reeder, ''. . . made me think of Andy Warhol's quote about everyone being famous for 15 minutes during his life . . .''

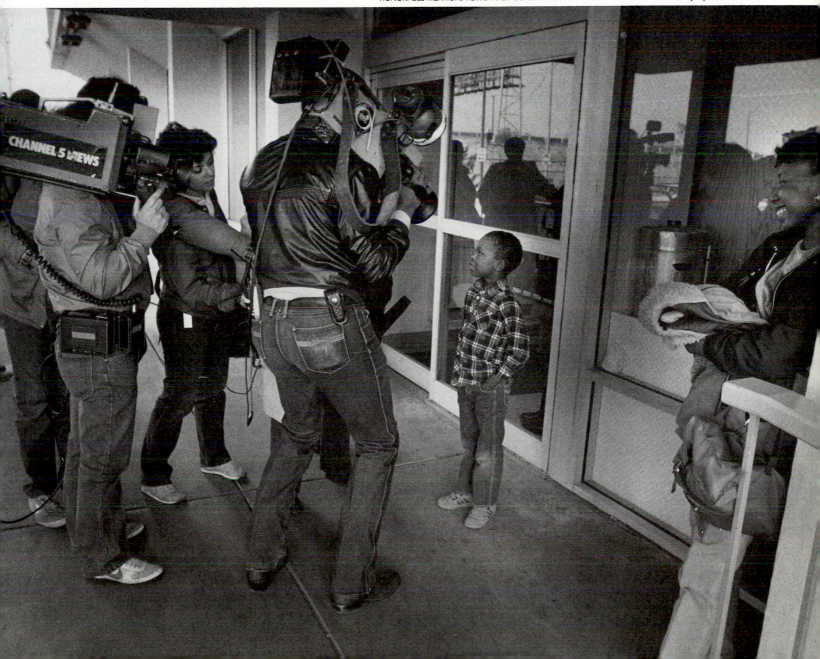

Right, portraits of his predecessors look down on Wyoming County (N.Y.) Judge John Conable as he contemplates his coming retirement. Below, these women were among 2,000 baptized in one day at The Church of God in Christ — Temple of Prayer for All People, in Newport News, VA.

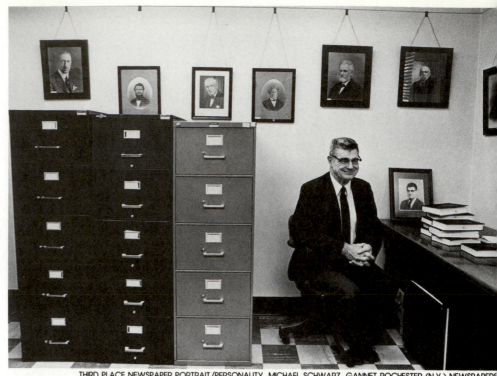

THIRD PLACE NEWSPAPER PORTRAIT/PERSONALITY, MICHAEL SCHWARZ, GANNET ROCHESTER (N.Y.) NEWSPAPERS

SECOND PLACE NEWSPAPER PHOTOGRAPHER OF THE YEAR, RAYMOND GEHMAN, VIRGINIAN PILOT-LEDGER STAR (NORFOLK, VA

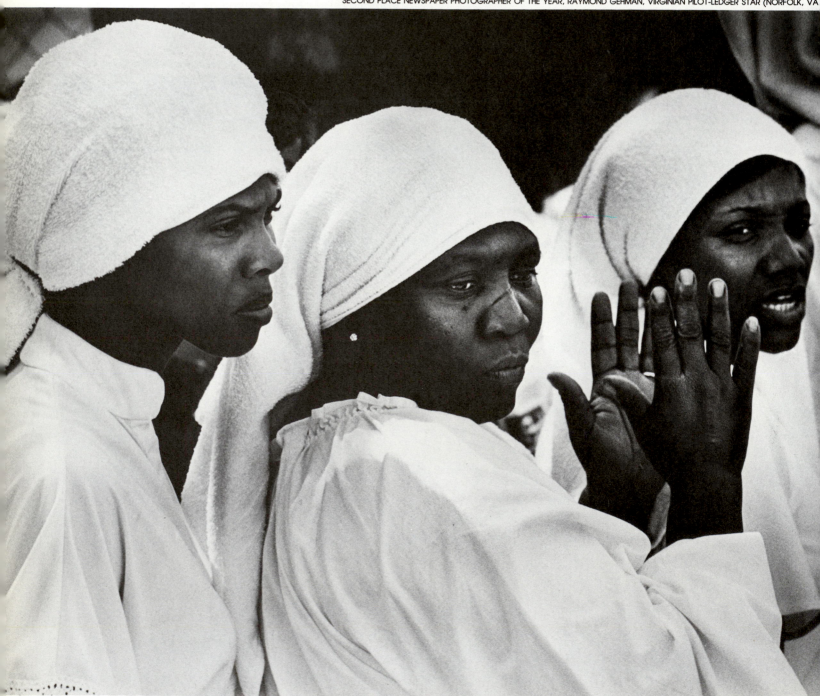

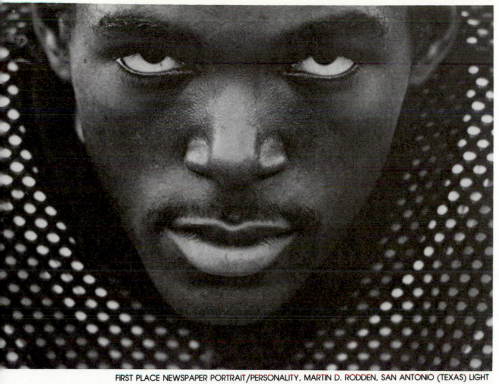

Left, San Antonio, Texas, high school football player of the year, Ternell Washington, excels both on gridiron and in the classroom. Below, in Virginia, Natalie Caddell contemplates life without her husband, who died after surgery in which, a jury decided, the doctor was negligent.

FIRST PLACE NEWSPAPER PORTRAIT/PERSONALITY, MARTIN D. RODDEN, SAN ANTONIO (TEXAS) LIGHT

SECOND PLACE NEWSPAPER PORTRAIT/PERSONALITY, RAYMOND GEHMAN, VIRGINIAN PILOT-LEDGER STAR (NORFOLK, VA.)

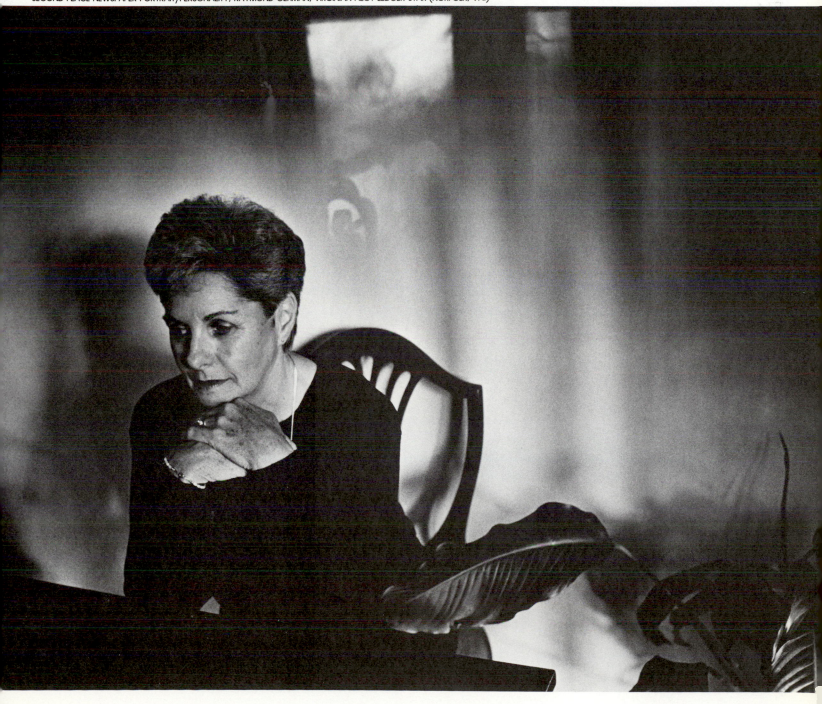

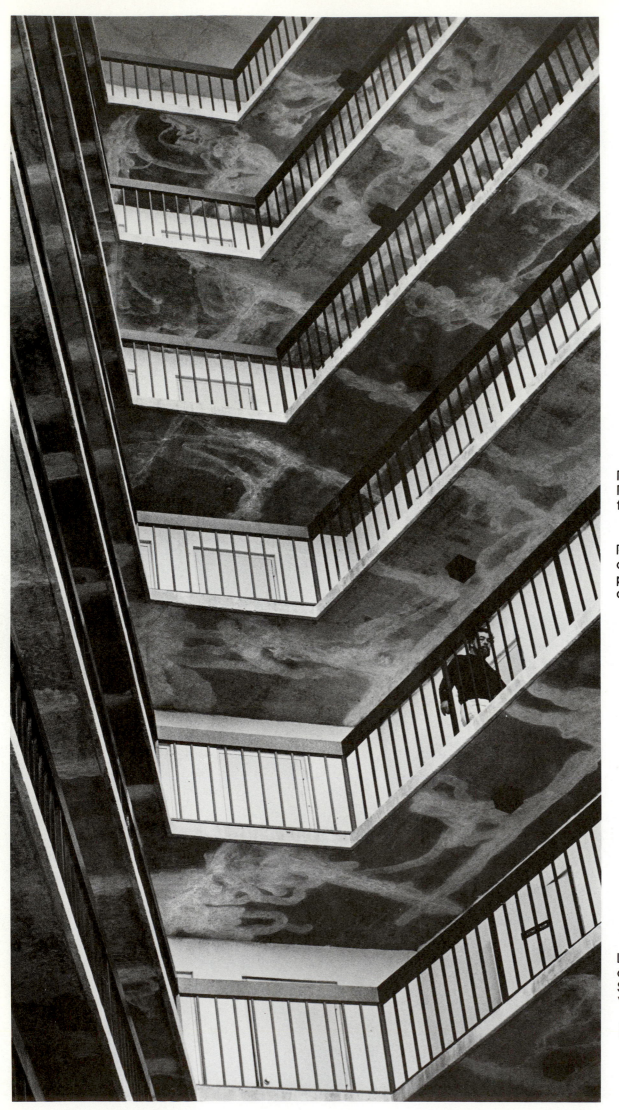

Right, freelance artist Chris Reynolds chalks out new logo for a Pittsburgh athletic club

Right, the photographer's assignment was a cocktail party, but he concentrated on an art exhibit instead.

Left, a pattern of 20th-century living: Photographer Stephen Crowley calls it ''Condo geometry.''

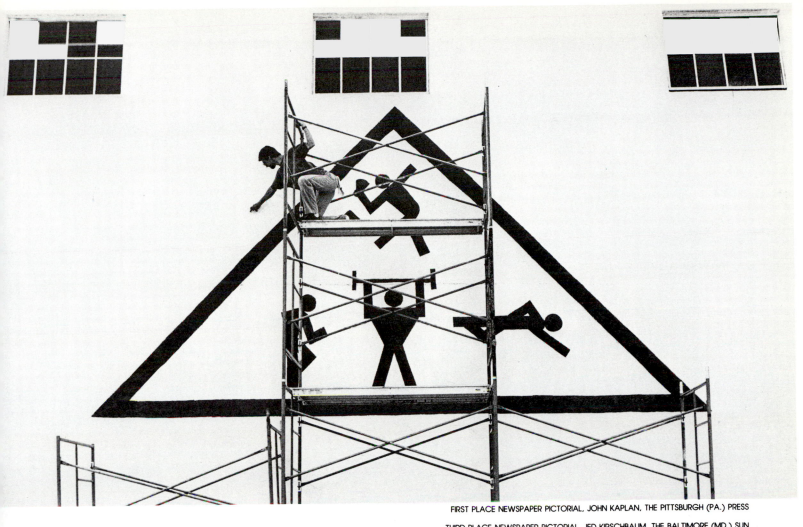

FIRST PLACE NEWSPAPER PICTORIAL, JOHN KAPLAN, THE PITTSBURGH (PA.) PRESS

THIRD PLACE NEWSPAPER PICTORIAL, JED KIRSCHBAUM, THE BALTIMORE (MD.) SUN

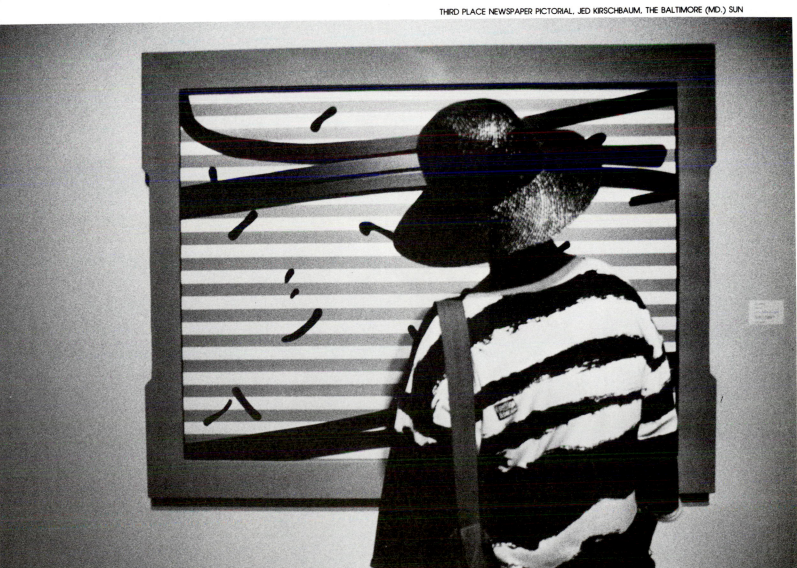

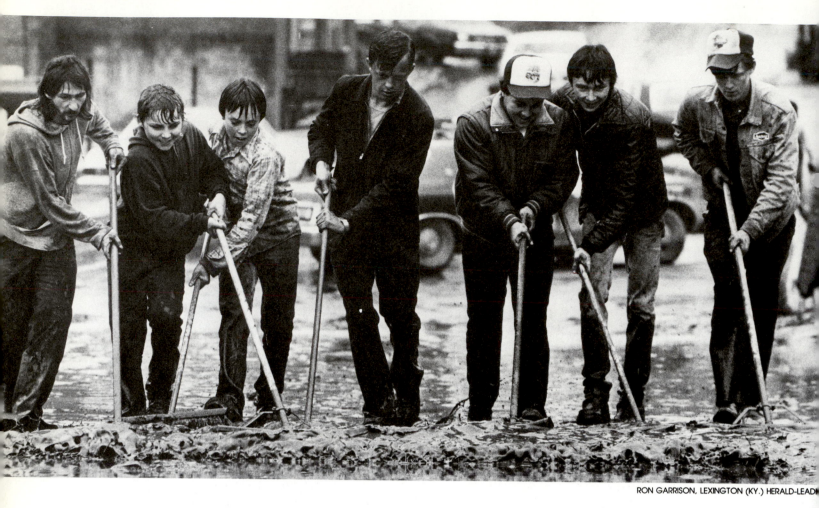

RON GARRISON, LEXINGTON (KY.) HERALD-LEAD

Above, volunteers in Hazard, Ky., use squeegees (and one broom) to push mud into a storm sewer after the main street was flooded by rising waters from the North Fork of the Kentucky River. Below, crew of painters takes a lunch break. They're working on the Lewis and Clark Bridge over the Columbia River at Longview, Wash.

KURT WILSON, THE DAILY NEWS (LONGVIEW, WASH.

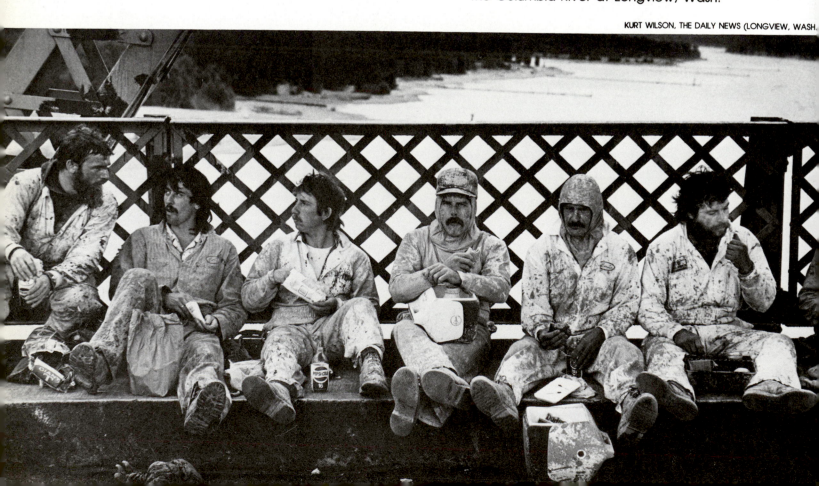

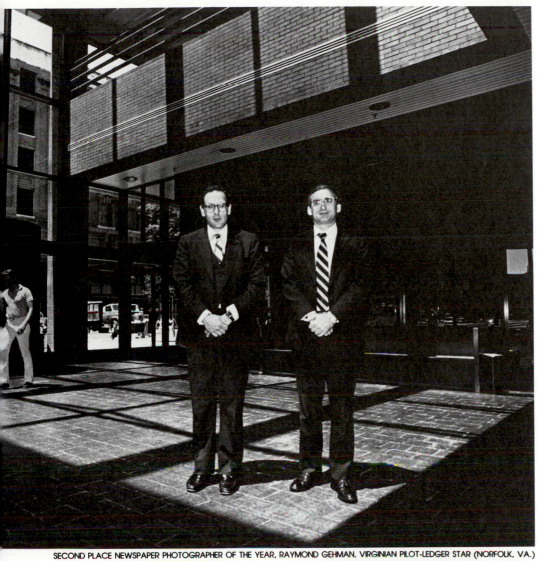

Left, attorneys in a Norfolk, Va., firm pose in the lobby of their office building. Below, members of the Slim 'n' Trim Club usually swim in the buff at a boys' club in Pawtucket, R.I., but they wrapped up for a group portrait.

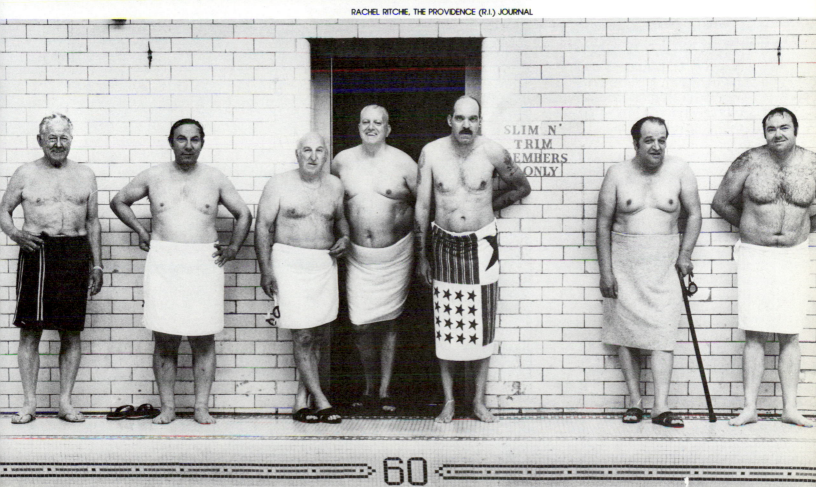

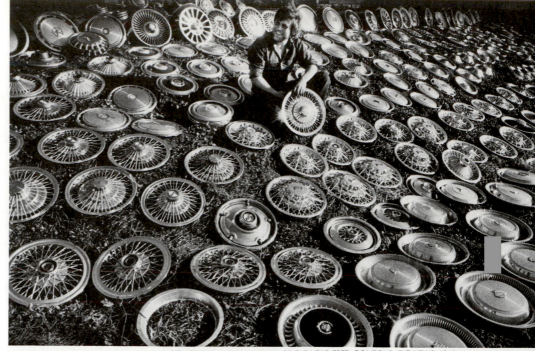

Jerry Naylor's hubcap business picks up during the pothole season. It takes him two hours to spread out his 1,500-piece stock at a Wilmington, Del., highway intersection.

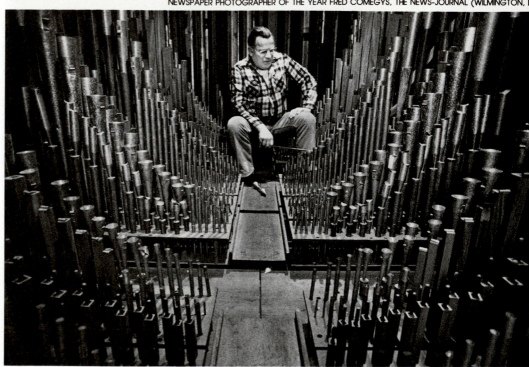

Robert Hickey tunes the organ in St. Michael's Church in Rochester, N.Y. He has 95 regular customers and 35 others who call him when their music goes flat.

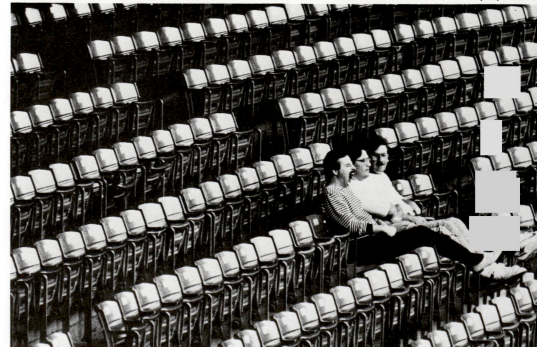

Just how bad was attendance at Pittsburgh Pirates baseball games in 1984? Well, the club kept sinking further into depths of the National League Eastern Division and the fans, well . . .

un in Little Rock: Librarian at the
niversity of Arkansas sets out books
 dry after a water pipe burst,
ooding top floors of the library.
stimated damage: $500,000.

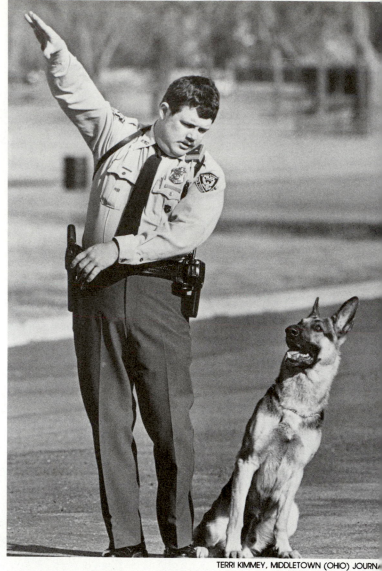

Right, training session between Middletown, Ohio, police officer and his four-legged partner is a study in diagonals. Below, trainer Gene Poole gets his llama's ears-laid-back attention in Raleigh, N.C.

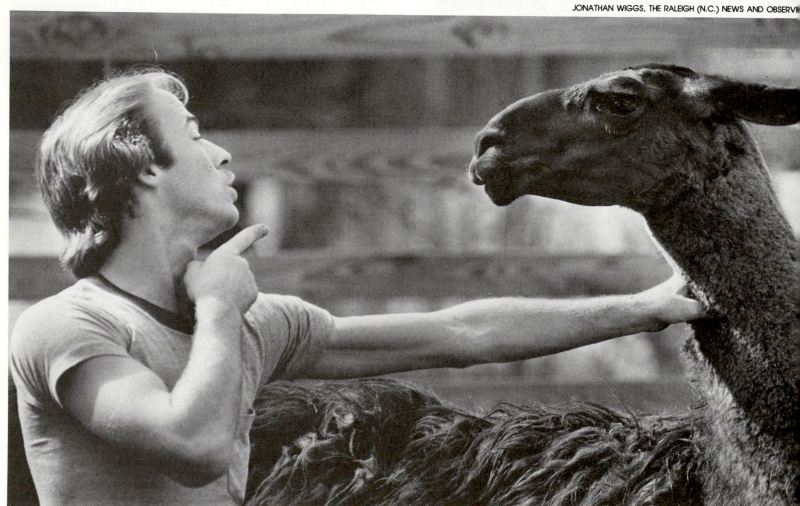

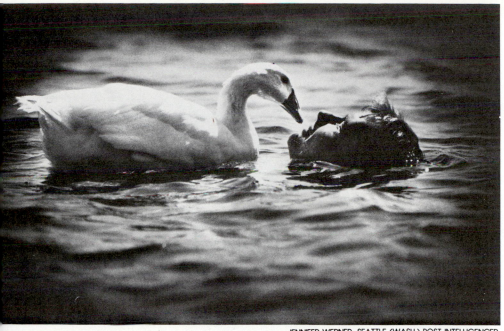

JENNIFER WERNER, SEATTLE (WASH.) POST-INTELLIGENCER

Rick Wall, 6th-grade teacher in Seattle, Wash., hatched Lucy the Goose as a class project. Now they have a mother-daughter relationship.

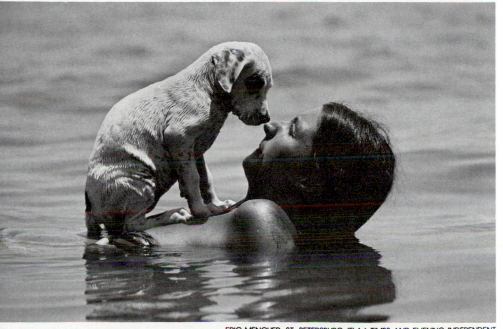

ERIC MENCHER, ST. PETERSBURG (FLA.) TIMES AND EVENING INDEPENDENT

Swimmer at St. Petersburg, Fla., gets her pup's soggy but undivided attention.

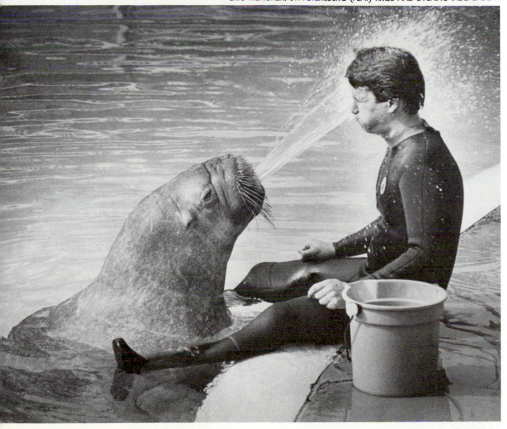

Flo the walrus is being trained to squirt water. Handler Jim Timon is the squirtee.

BARBARA S. MARTIN, LOS ANGELES (CALIF.) TIMES

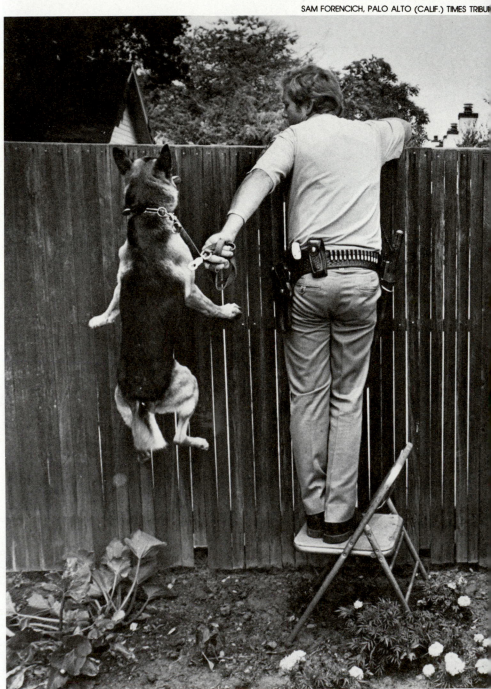

Argentine nuns, says Photographer Pedro Luis Raota, "use a little ingenuity" to overcome an obstacle.

As Deputy Sheriff John Mattes looks for a burglary suspect in Palo Alto, Calif., his partner Bogie gets in on the action, too.

PEDRO LUIS RAOTA, FREELANCE, BUENOS AIRES, ARGENTIN

SAM FORENCICH, PALO ALTO (CALIF.) TIMES TRIBUI

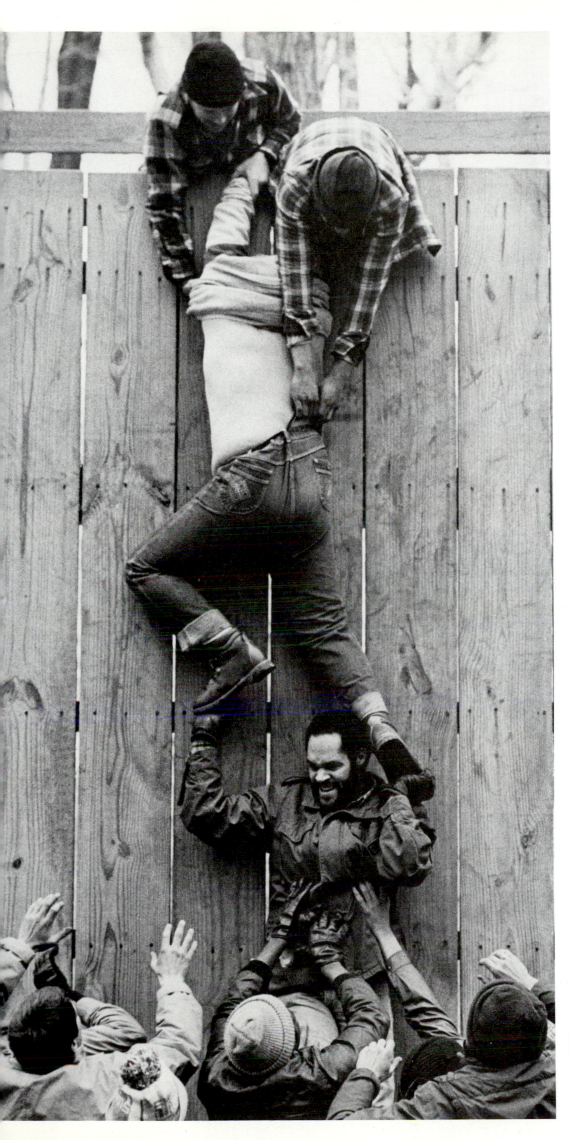

With a little help from his friends, Rory scales a 14-foot wall. It's part of a "Wilderness challenge" camping trip for Cleveland, Ohio, inner-city boys.

LOIS BERNSTEIN, FREELANCE FOR CLEVELAND (OHIO) PLAIN DEALER

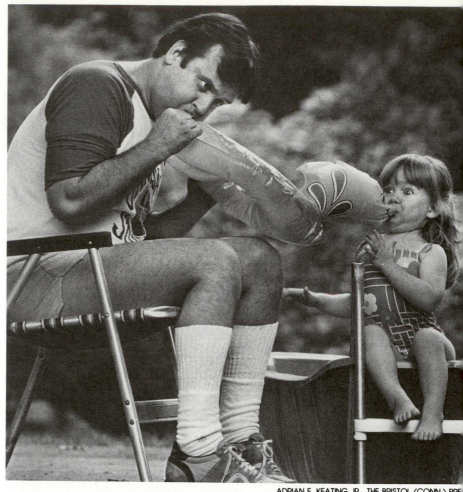

Right, George O'Hara and daughter Casey huff and puff on Casey's rubber ducky in Bristol, Conn. Below, Randy Grossert and daughter Jenae take a juice break at a Renaissance fair in Kansas City, Mo.

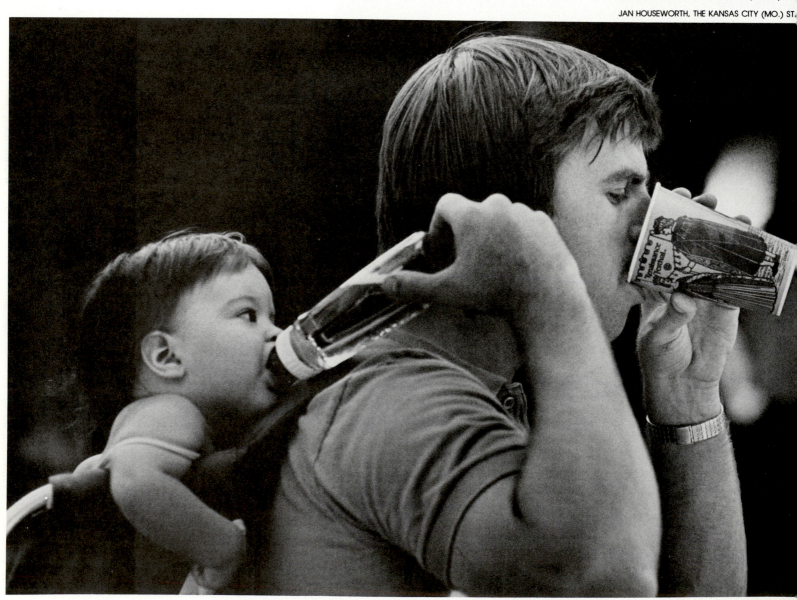

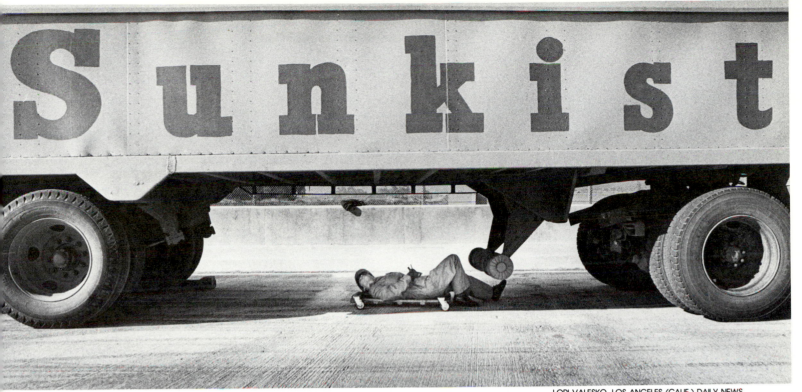

Above, an inspector for the California Highway Patrol checks the underside of an 18-wheeler during a surprise roadside inspection.

Below, Kenn Kallenberger gets a worm's-eye view of his lawnmower during a grassy pit stop in Bremerton, Wash.

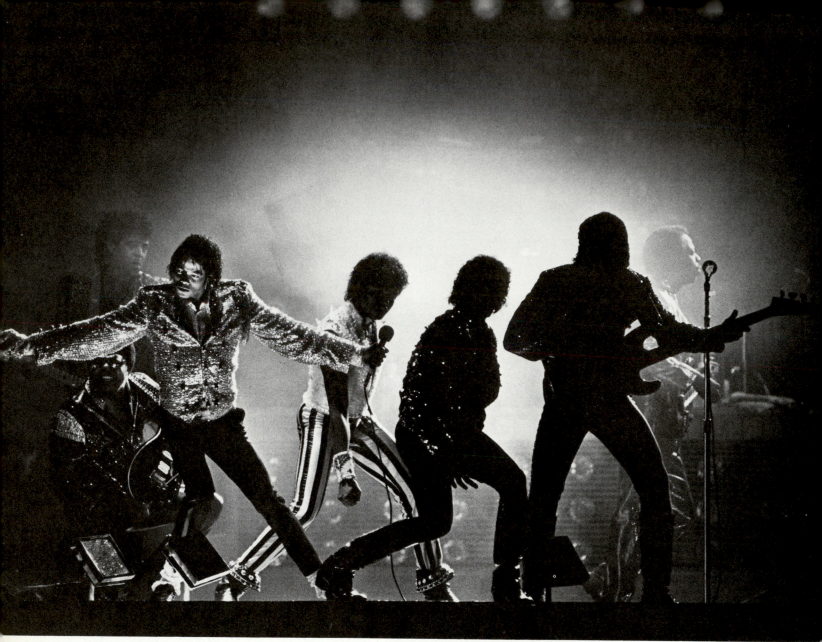

Superstar Michael Jackson's Victory Tour began in controversy, ended in triumph. Above, Jackson and his brothers perform "Wanna Be Starting Something" in Washington, D.C.'s, Kennedy Stadium. Below, Jackson on stage in the University of Tennessee's Neyland Stadium in Knoxville.

HRH Michael . . .

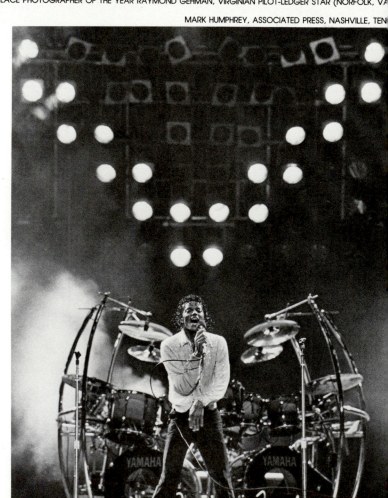

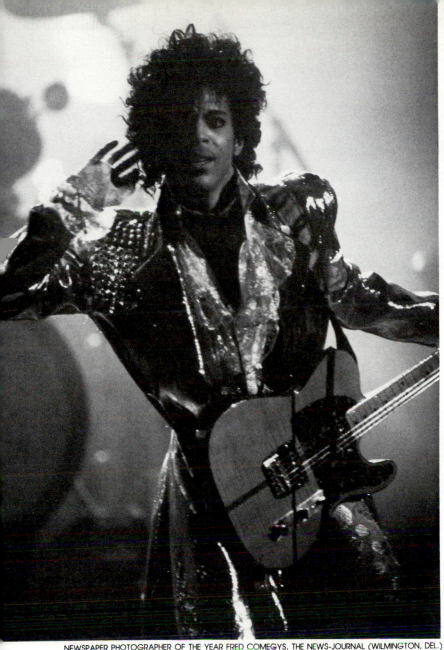

Rock sensation Prince made news during his "Purple Rain" tour of the nation.

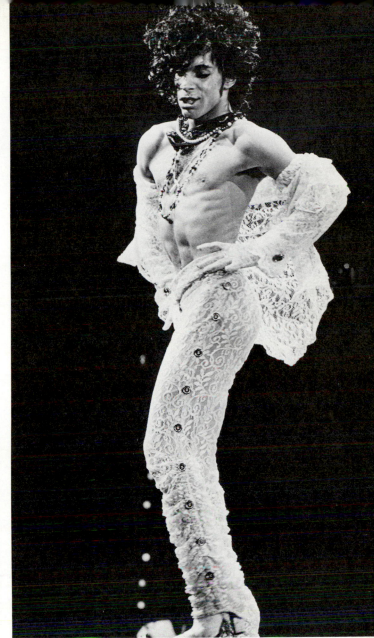

In Chicago, Prince strips and gyrates while, reported one writer, "his young audiences go wild."

. . . and the Prince

Even living mobiles hanging around the City Center don't excite this blasé New Yorker, who's apparently waiting for someting *really* unusual to happen. Members of Japan's modern dance team Sankai Juku rehearse outdoors for their New York debut.

Saeko Ichinohe is a Japanese dancer who visited Rochester, N.Y., schools to demonstrate her blend of Japanese and contemporary dance.

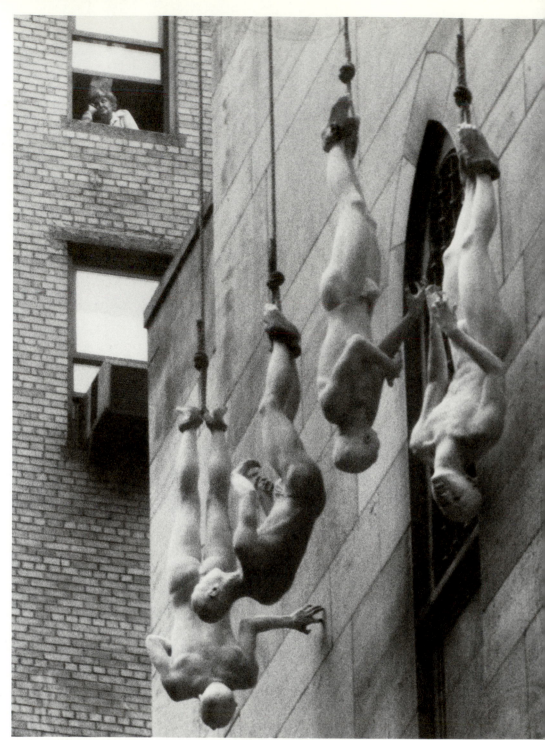

THIRD PLACE NEWSPAPER FEATURE PICTURE, MEL FINKELSTEIN, NEW YORK DAILY NEW

ANNE LENNOX, GANNETT ROCHESTER (N.Y.) NEWSPAPE

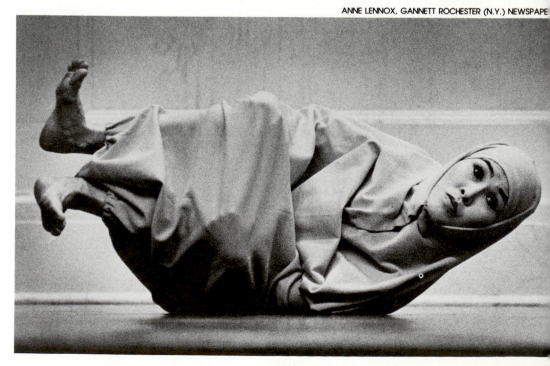

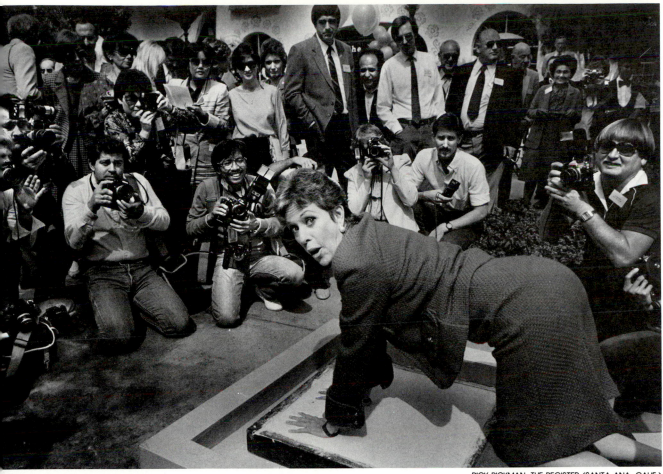

Above, it was a media circus when comedienne Carol Burnett went for immortality at the Movieland Wax Museum in Buena Park. Says Photographer Rick Rickman, "Everyone was trying to get her attention . . . I yelled at the top of my voice, 'Carol, I've got your best angle'." When she reacted, Rickman knew he had his picture.

Below, rock artist Bruce Springsteen soaks his head from a tub of ice water during one of three shows he did during July heat in Chicago.

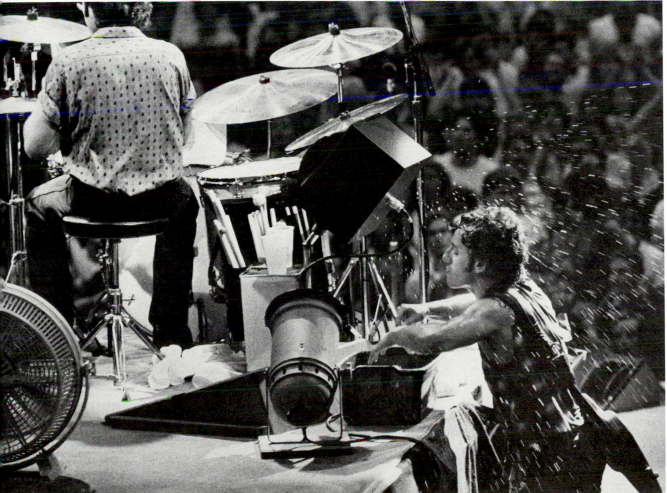

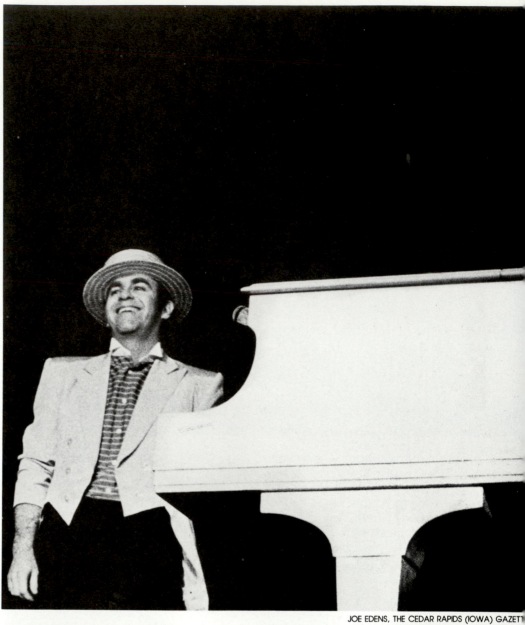

Elton John in concert in Iowa City. Says Photographer Joe Edens, "He said this was to be his last American tour. We'll see."

JOE EDENS, THE CEDAR RAPIDS (IOWA) GAZETT

AKIRA SUWA, THE PHILADELPHIA (PA.) INQUIRE

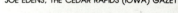

Looking natural, Clara Peller of "Where's the beef?" fame, displays the talent that initially attracted Wendy's ad campaign director.

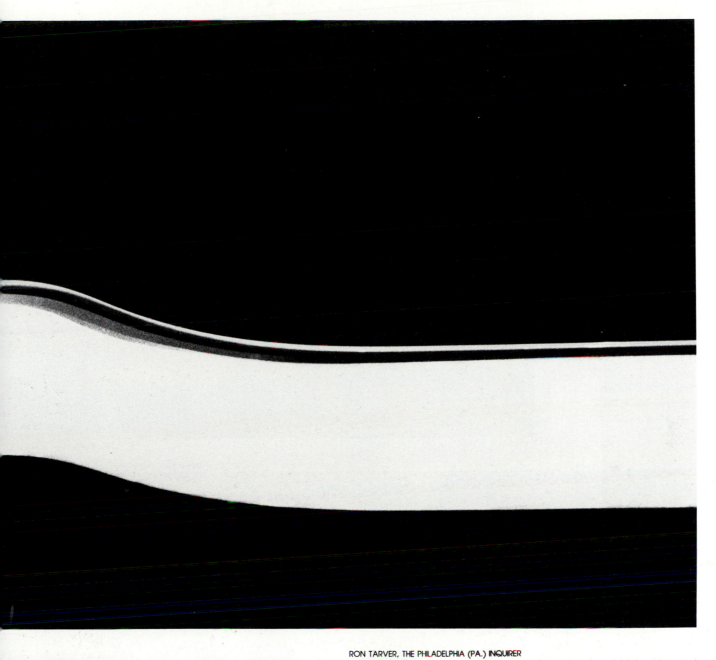

RON TARVER, THE PHILADELPHIA (PA.) INQUIRER

Hundreds of kids showed up when Mr. T appeared at a Philadelphia bookstore to autograph his autobiography.

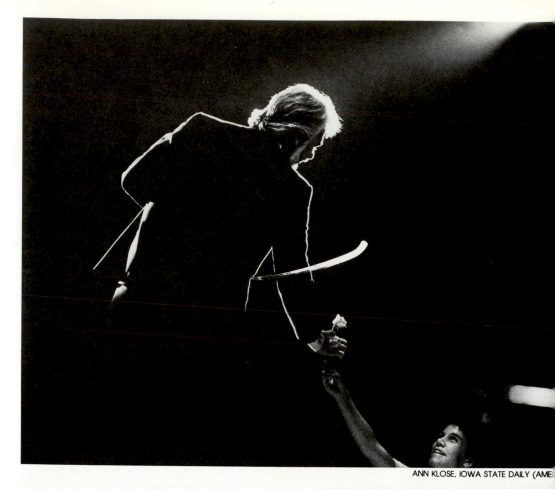

Right, country singer Kenny Rogers gets a rose from a fan during an appearance in Ames, Iowa. Below, rock superstar Cyndi Lauper delivers to her fans at a concert at Millersville, Pa., University.

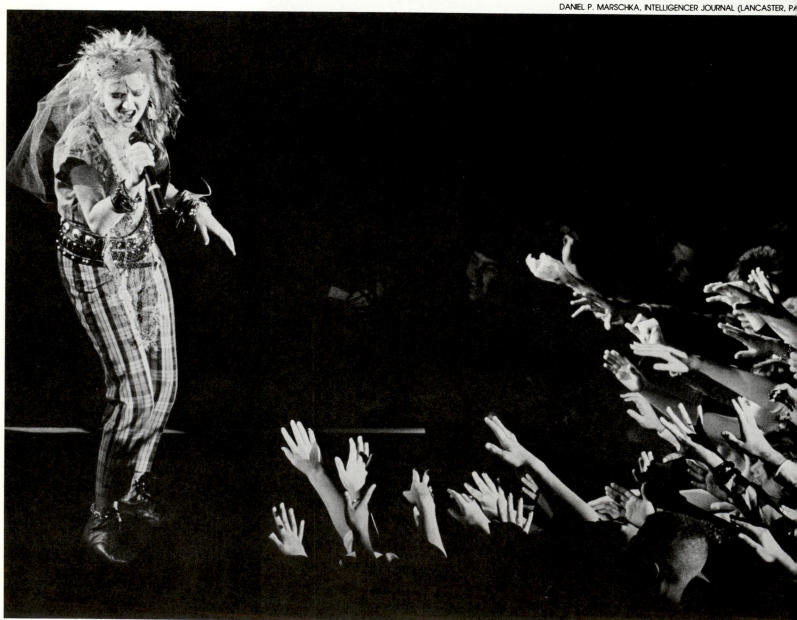

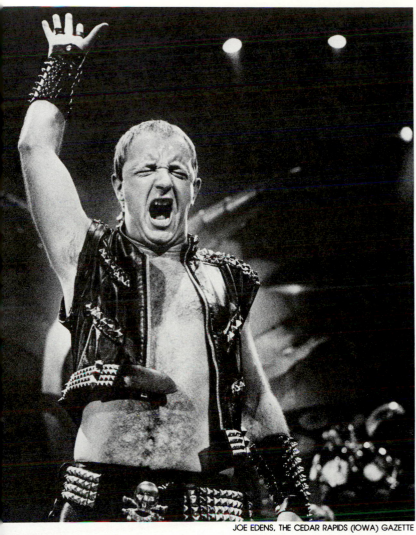

JOE EDENS, THE CEDAR RAPIDS (IOWA) GAZETTE

MARK HUMPHREY, ASSOCIATED PRESS, NASHVILLE, TENN.

ANDY STARNES, THE PITTSBURG (PA.) PRESS

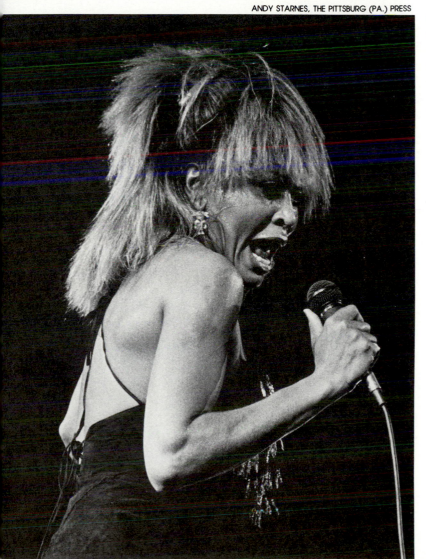

Upper left, vocalist Rob Halford of the British quintet Judas Priest plays to thousands of teenagers in Cedar Rapids, Iowa. Above, country singer Waylon Jennings tapes a television special at the Tennessee Performing Arts Center in Nashville. Left, Tina Turner sings at sold-out concert in Pittsburgh's Civic Arena.

PEDRO LUIS RAOTA, FREELANCE, BUENOS AIRES, ARGENTINA

Above, street musician in Buenos Aires plays for children who, says Photographer Pedro Luis Raota, "watch without understanding the things of this world." Left, in Dallas, actor Mickey Rooney has World Series on television before dressing for his starring role in "Sugar Babies."

HONORABLE MENTION NEWSPAPER PORTRAIT/PERSONALITY, MICHAEL S. WIRTZ, DALLAS (TEXAS) TIMES HERALD

When Robert Keith Williams refused to smile for the photographer, the mother of the stubborn, poker-faced one-year-old took matters into her own hands.

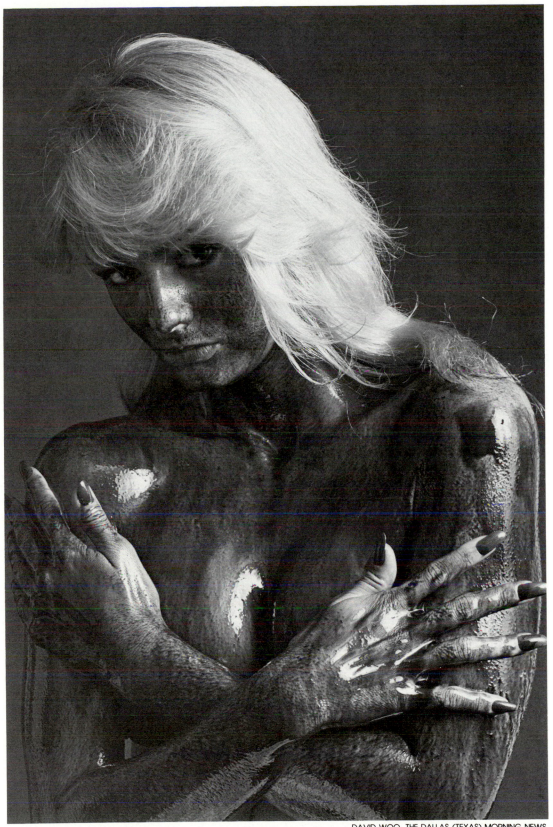

Oil-covered blonde is one of 75 models used in production of book titled "Texas Women." Says Photographer David Woo, "I drained the oil from my car the day before the shoot."

Below, print showing Israel's Moshe Efrati Kol Demama Dance Company was made from three consecutive frame of exposures made during their appearance in Los Angele

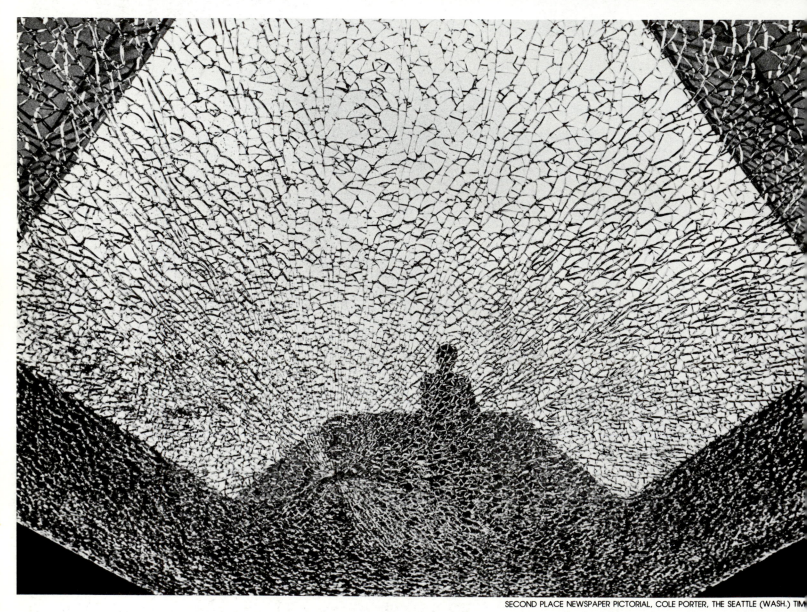

Above, worker at the Seattle aquarium peers down through shattered glass of a fish tank after vandals threw a rock and broke the $10,000 piece of glass.

Right, Delaware old-timer takes it easy as he waits for arrival of his morning paper.

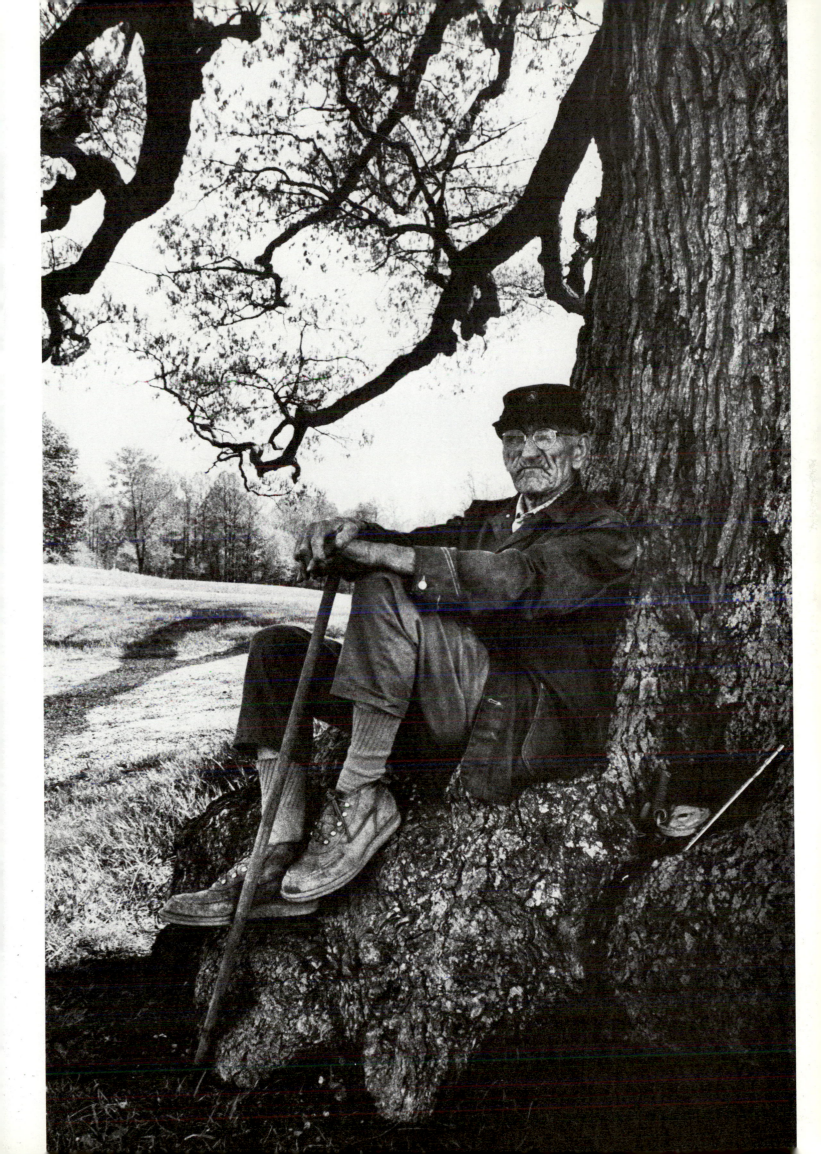

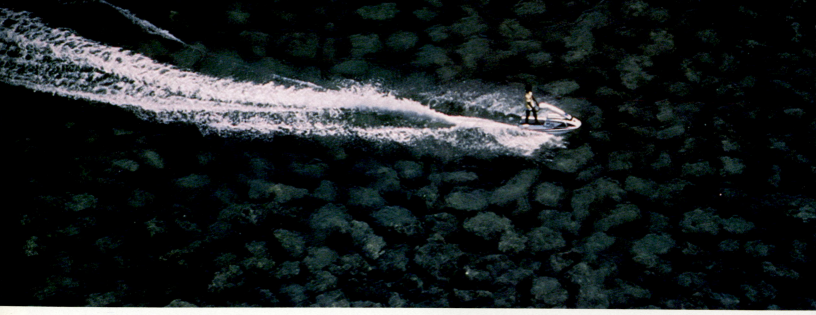

Above, jet-skiing tourists at the beaches of Montego Bay.

Right, a young swimmer in a river near Ocho Rios.

Jamaica:
Hard times, high hopes

The National Geographic went to Jamaica, and, in January 1985, reported:

" 'Come back to Jamaica ... Come back to the way things used to be.'

"This slogan on American television won the island a dramactic increase in tourists. But the reality of Jamaica is not that simple.

"Many things stay the same: the beauty, the warmth of Jamaica's people, the splendid beaches. But Jamaica, ever-changing as it works out its destiny, is not the way it used to be."

Left, stretching on the shore at Hellshire Beach.

Left, sunrise in Port Maria.

Below, Teresa Montcrieffe cools out in the waters of Dunn's River Falls.

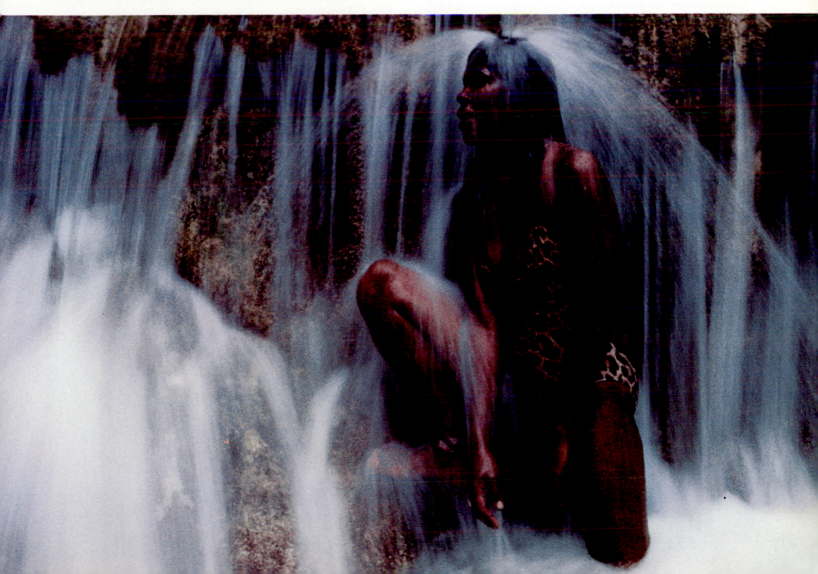

Sean Conry, 12, gets a close look at a metal sculpture at a Kansas City, Mo., art fair

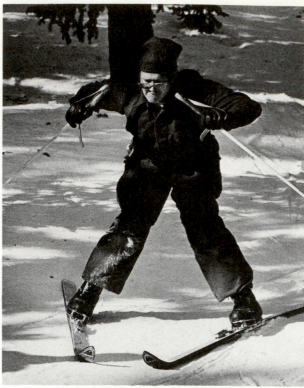

For this Marine involved in a winter survival course on Colorado's Squaw Peak, skis were just one more challenge to be faced.

Under that camouflage head covering is Dan Baker, California's wild turkey-calling champion.

Dancer Diane Downes photographed a dancer before the curtain went up at a dress rehearsal of the Louisville, Ky., Ballet corps.

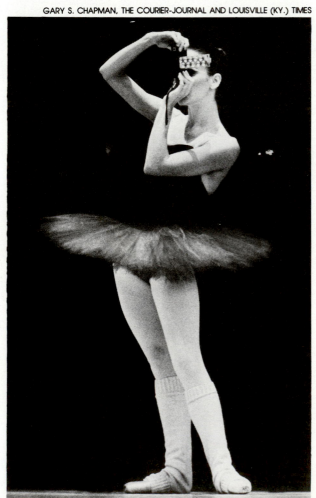

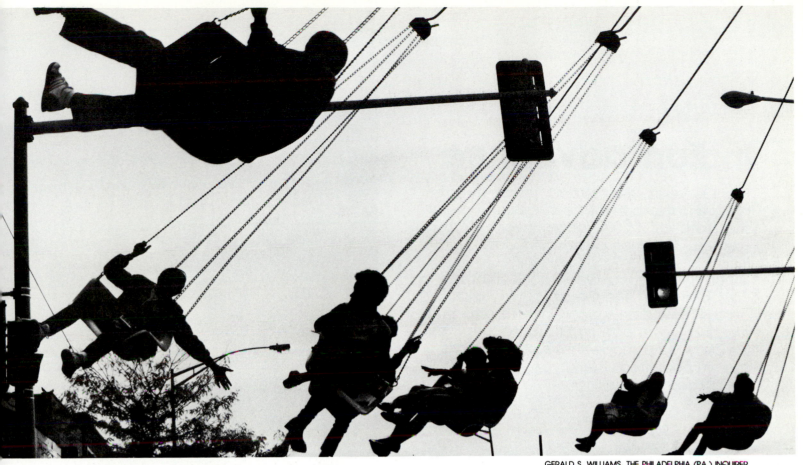

Above, kids are strung out through street traffic lights on a swing ride at the annual autumn Germantown Festival in Philadelphia, Pa.

Below, Kris Kringer, a 15-year-old employee at Water Boggan in Clarksville, Ind., knows how to cool off on a summer afternoon.

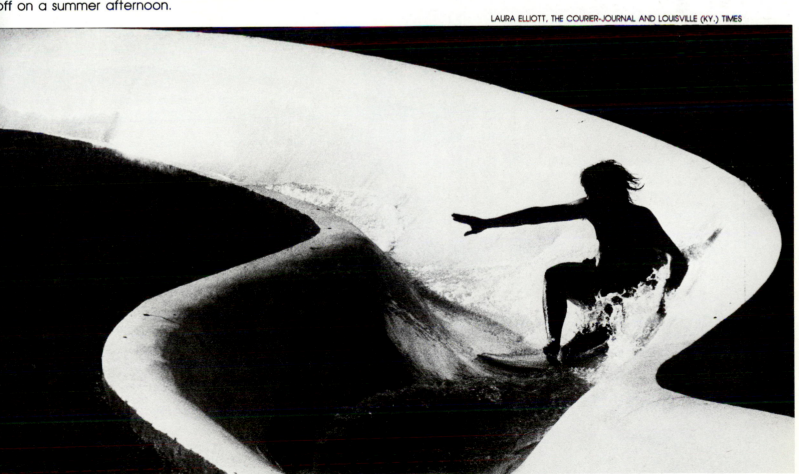

Indian adventure

For 130 years, the railroad has been an indispensable part of life in India. Consider the statistics: 11,000 locomotives, 1.6 million workers, 10 million passengers daily.

When the National Geographic sent author Paul Theroux ("The Great Railway Bazaar") across the Indian subcontinent by train, the trip also was made by Photographer Steve McCurry, who made these photographs on the railroads from the Khyber Pass to Bangladesh.

Right, a venerable steam engine chugs past the Taj Mahal.

Below, a portrait of the depot as village: Howrah station serves Calcutta and embraces a community. The sleepy sprawl anywhere, beggars beg, mothers suckle infants.

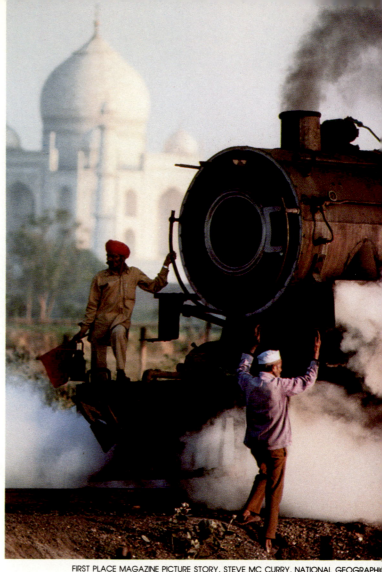

FIRST PLACE MAGAZINE PICTURE STORY, STEVE MC CURRY, NATIONAL GEOGRAPHIC

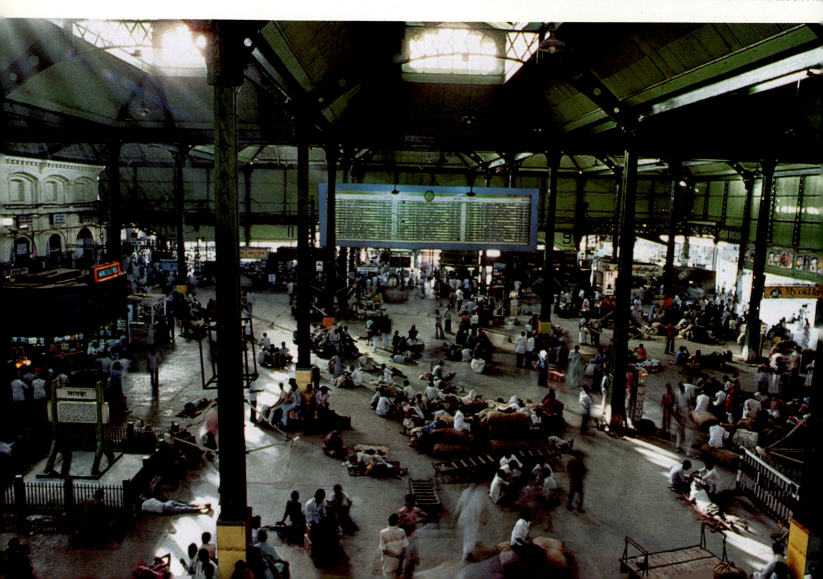

Right, although railroad officials mount occasional crackdowns against non-paying passengers, these farmers see nothing wrong in grabbing a free ride on a branch line to Calcutta to take their hay to market.

Below, washerwomen beat clothes on rocks in the Yamuna River as a train thunders toward Agra on a double-decked bridge.

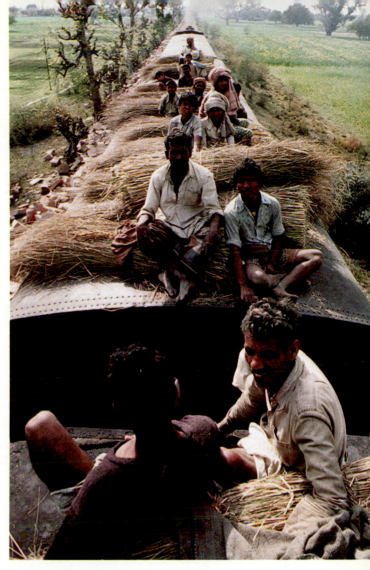

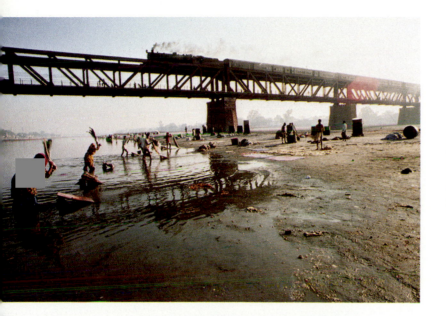

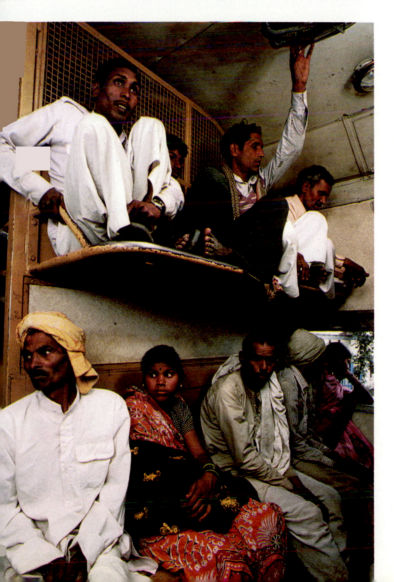

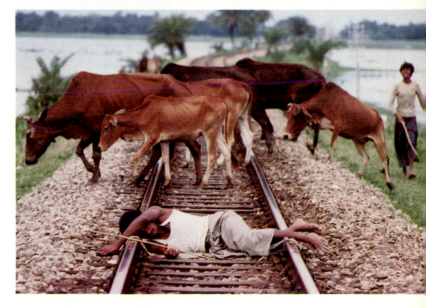

Above, near Chittabonga a Bangladeshi snoozes on the only available dry spot — the tracks — while a shepherd nudges his cattle away from monsoon floods.

Left, People's Express means a lot of people crammed into little space. Indian railroads carry some 3.7 billion passengers a year.

Right, in Victor, Colo., a youngster practices wheelies on a fog-bound deserted street.

Below, 16-year-old John Haradon takes a soda break before a weathered sign advertising a different kind of drink.

JEFFERY MOREHEAD, COLORADO SPRINGS (COLO.) SU

STEPHEN A. SMEDLEY, THE PEORIA (ILL.) JOURNAL STA

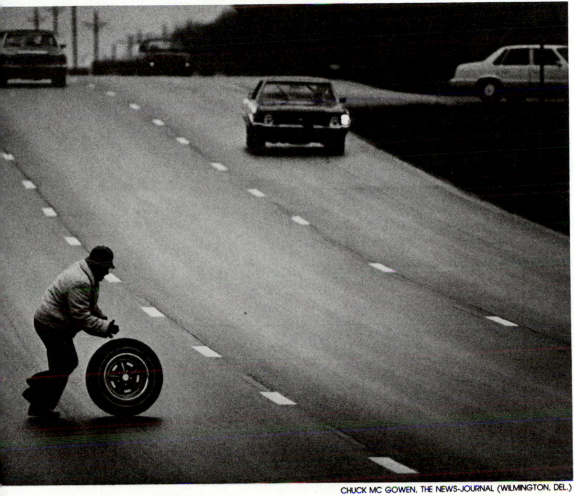

Left, on one wheel and a lot of guts, a motorist tries to to cross the busy DuPont Highway near Wilmington, Del.

Below, add four sleds to a quartet of Amish boys, string them out on Snake Hill Road in Lancaster (Pa.) County, and the picture editor will approve.

CHUCK MC GOWEN, THE NEWS-JOURNAL (WILMINGTON, DEL.)

DANIEL P. MARSCHKA, INTELLIGENCER JOURNAL (LANCASTER, PA.)

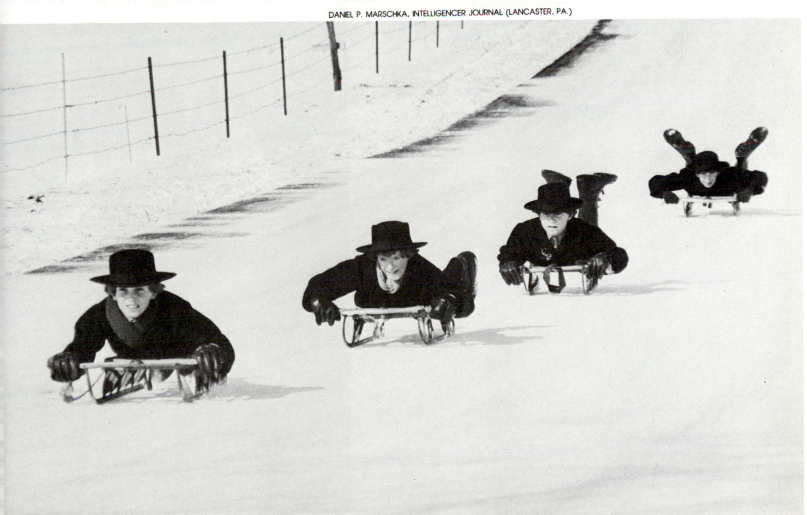

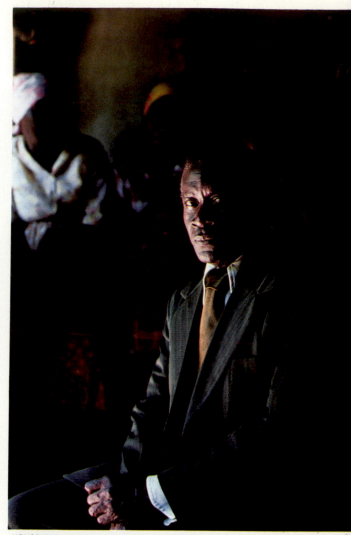

Right, portrait of Col. Collin L.G. Harris, leader of the "Maroons," a Jamaican political faction.

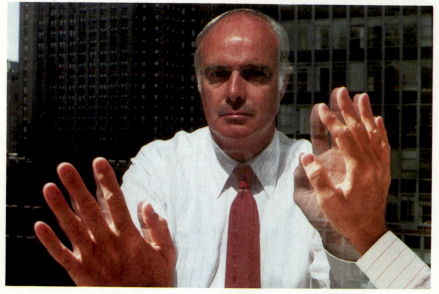

HONORABLE MENTION, MAGAZINE PORTRAIT/PERSONALITY, GEORGE LANGE, FREELANCE

HONORABLE MENTION, MAGAZINE PORTRAIT/PERSONALITY, DAVID BURNETT, CONTACT FOR TIME

THIRD PLACE MAGAZINE PORTRAIT/PERSONALITY, BILL HAYWARD, FORTUNE MAGAZINE

Above, a window-reflected image of Ron Daniel, president of a large consulting firm, was used with story titled, "McKinsey & Company looks at itself."

Right, portrait of media magnate Rupert Murdoch was made in a New York City entryway.

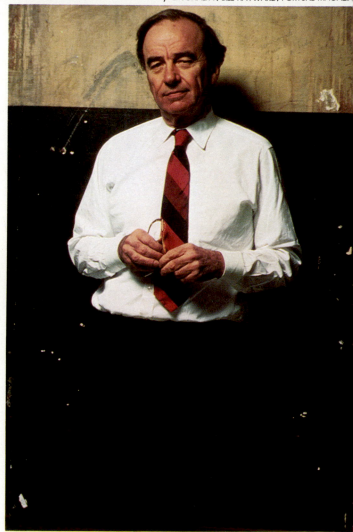

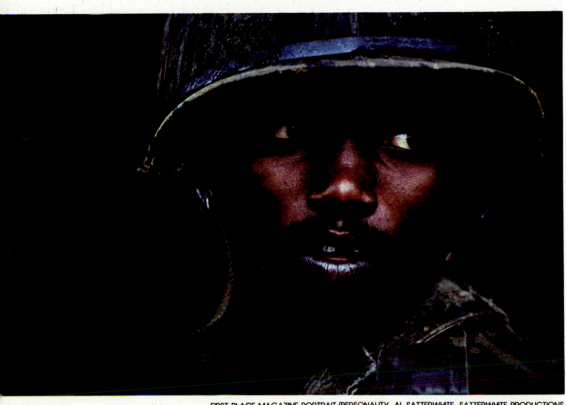

FIRST PLACE MAGAZINE PORTRAIT/PERSONALITY, AL SATTERWHITE, SATTERWHITE PRODUCTIONS

Singapore soldier.

After taking final religious vows, Sister Elizabeth shares her joy with her mother, through the screen that will separate them for life.

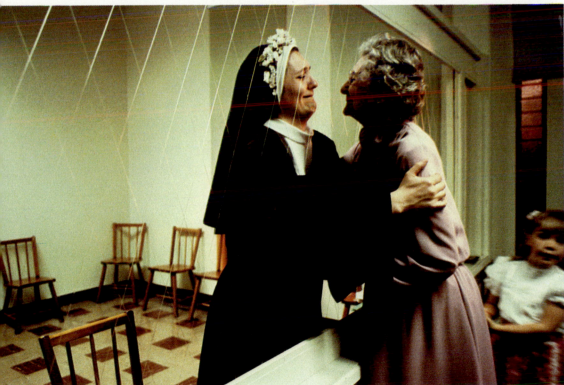

SECOND PLACE MAGAZINE FEATURE, ROSANNE OLSON, FREELANCE FOR GEO

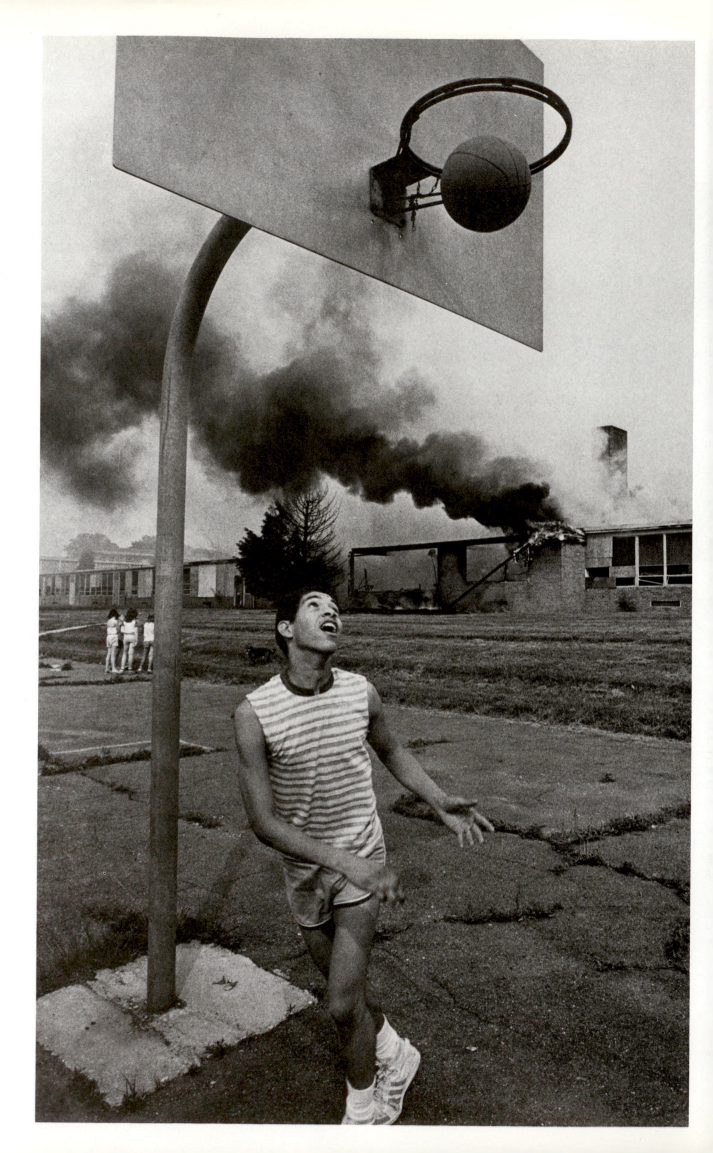

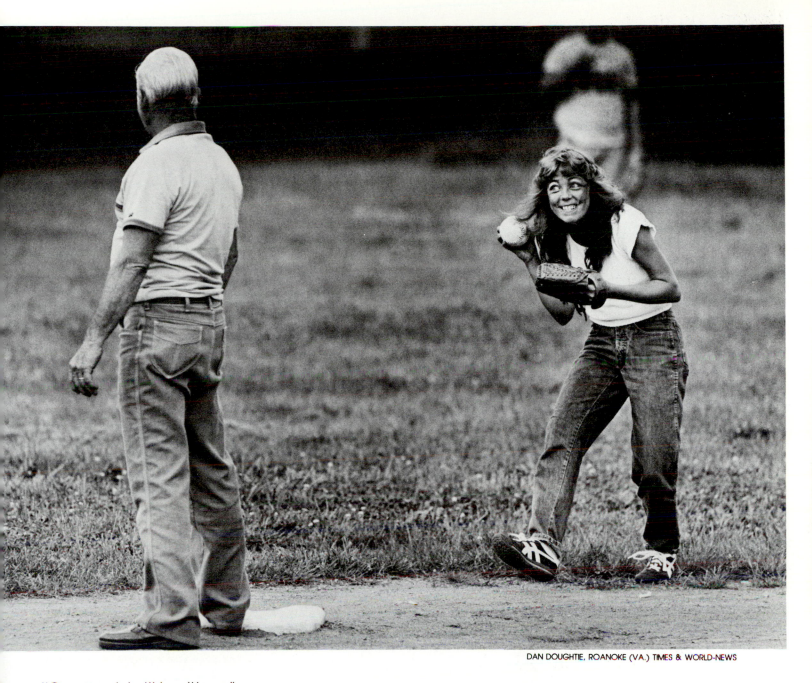

bove, "Gonna getcha!" is written all
ver Donna Williams's face as she
dvances on nonchalant base runner
ron Ferguson during a company
cnic in Roanoke, Va. Reports
otographer Dan Doughtie, "The
ame (and the score) was forgotten
soon as the hot dogs were ready."

ft, life and basketball goes on for
ung Michael Gordon as a vacant
ementary school in Wilmington, Del.,
rns.

This sporting life

A survey recently disclosed that sporting
events make up at least one-third of the
assignments the average American
photojournalist gets these days.

How well those assignments have been filled
will be apparent in the following pages.

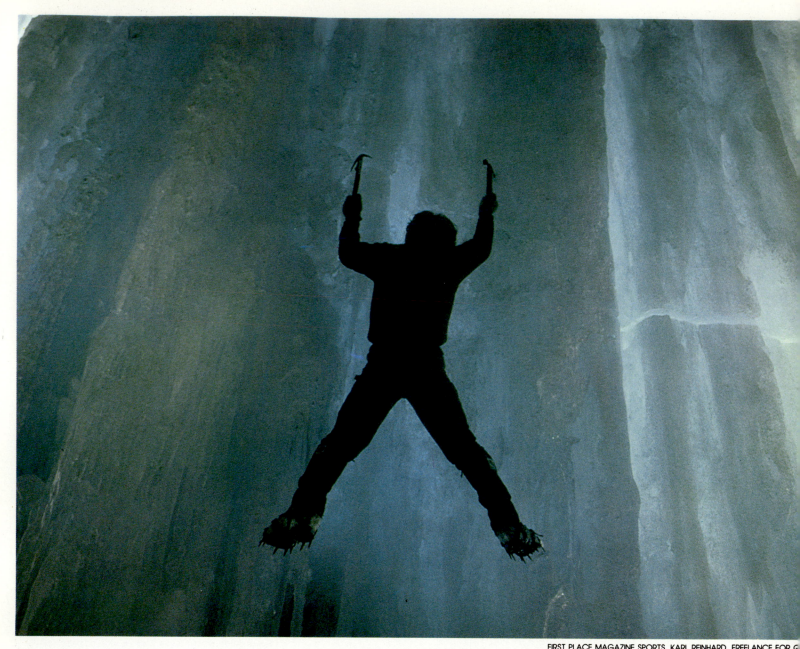

FIRST PLACE MAGAZINE SPORTS, KARL REINHARD, FREELANCE FOR G

Above, in one of the most unusual sporting activities extant, an ice climber in Patagonia is spread-eagled against a frozen waterfall.

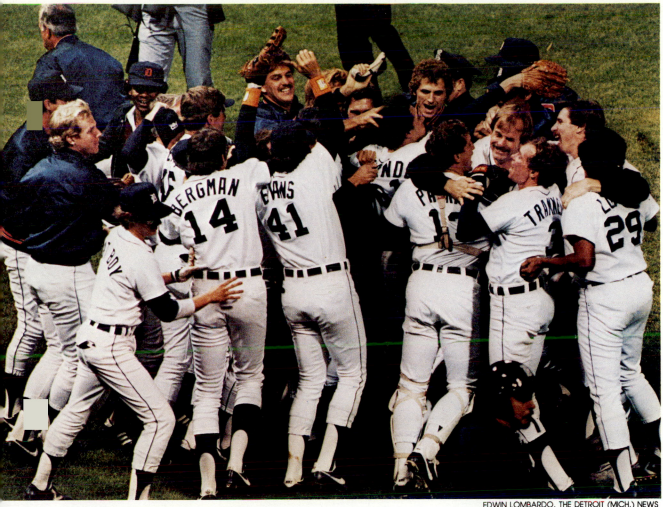

EDWIN LOMBARDO, THE DETROIT (MICH.) NEWS

bove, members of the Detroit Tigers let go after inning the American League East title from the ilwaukee Brewers. The win led to the World Series — nd the world championship — for the Tigers.

Below, in Barcelona, Spain, site of a soccer game between arch-rival teams from Barcelona and Madrid, supporters of the Barca Club show their colors.

HONORABLE MENTION MAGAZINE SPORTS, STEPHANIE MAZE, FREELANCE FOR NATIONAL GEOGRAPHIC

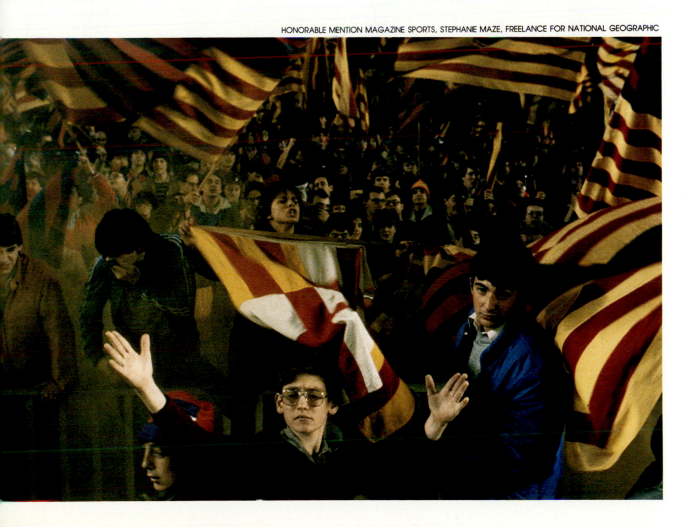

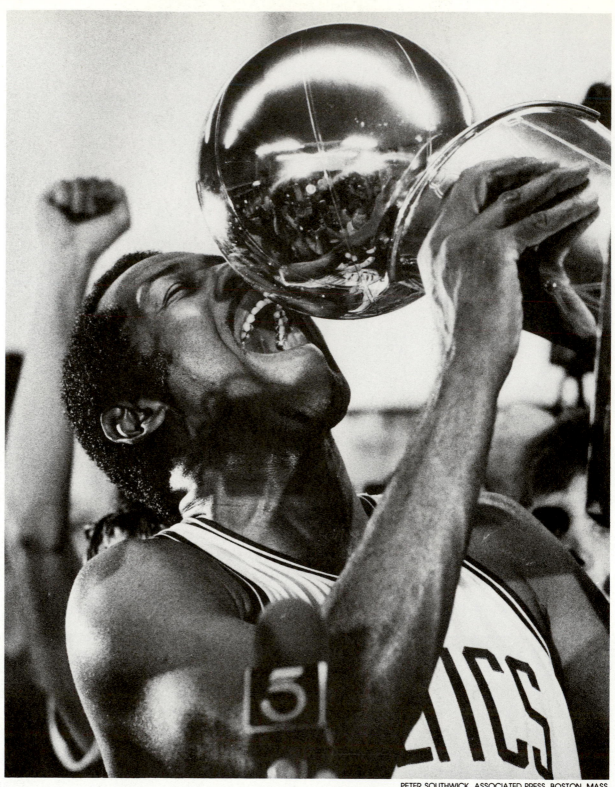

PETER SOUTHWICK, ASSOCIATED PRESS, BOSTON, MASS.

Above, Boston Celtic M.L. Carr kisses the National Basketball Assn. trophy after his team beat the Los Angeles Lakers for the Celtics' 15th NBA championship. Right, shortly thereafter, the whole city of Boston turned out (300,000 strong) to join Celtic guard Quinn Buckner in the classic "We're Number One" routine.

RIGHT, JIM MAHONEY, THE BOSTON, (MASS.) HERAL

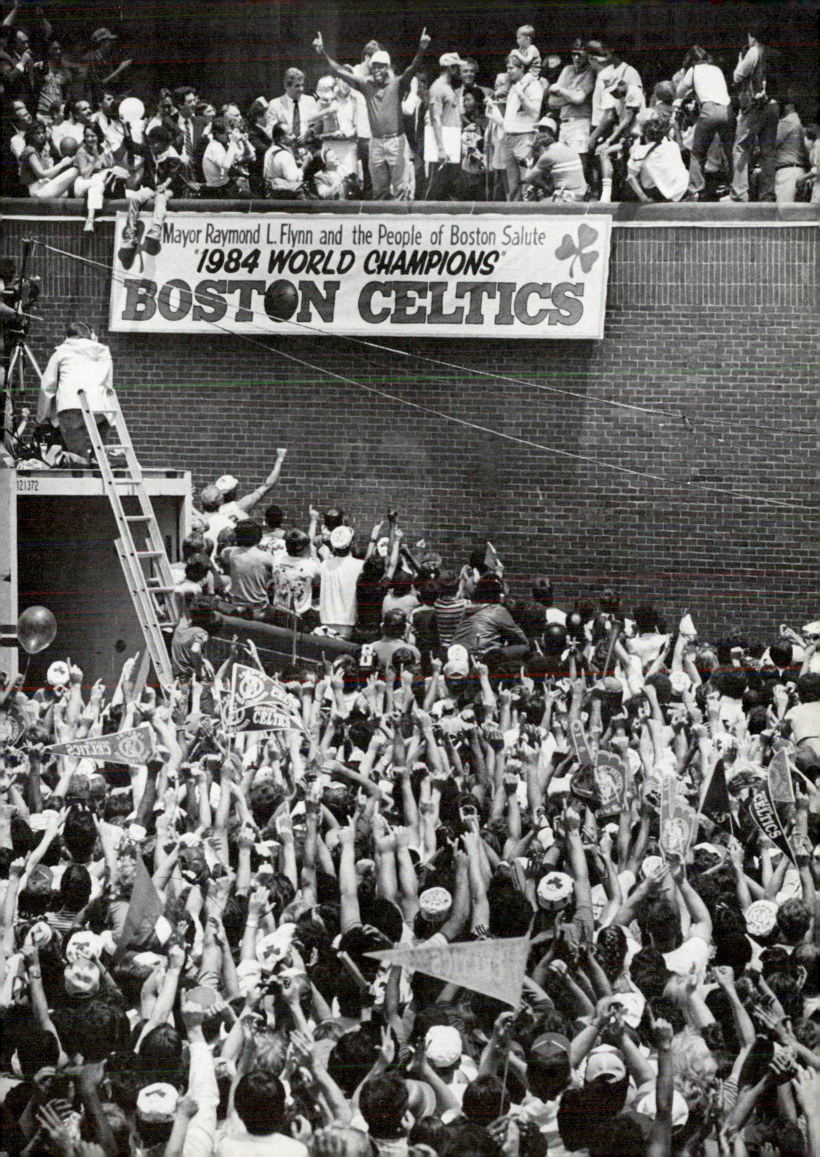

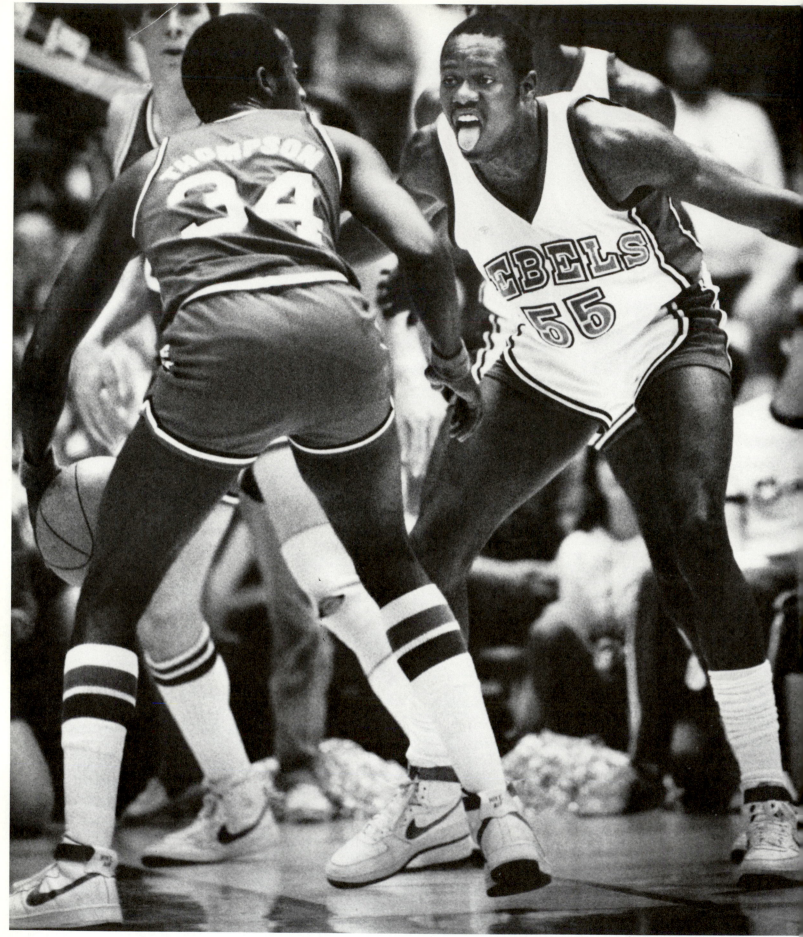

CHRISTINE COTTER, LOS ANGELES (CALIF.) TIME

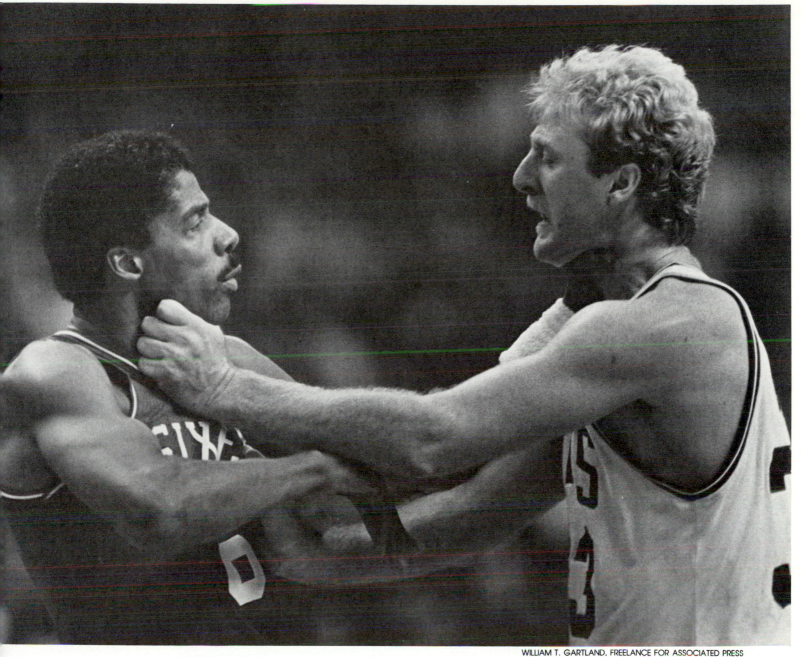

eft, Joe Flowers was probably practicing total defense
when he stuck his tongue out during the 1984 Pacific Coast
Athletic Assn. championship game between Flowers'
University of Nevada Las Vegas Rebels and Fresno State.
Despite Flowers' histrionic efforts, Fresno State won 51-49.
Above, things got beyond the face-making stage when
Philadelphia 76er Julius Erving (left) and Boston Celtic Larry
Bird took a hands-on approach that cleared both benches
in the Boston Garden early in November. (Who won?
Oh ... the Celtics.)

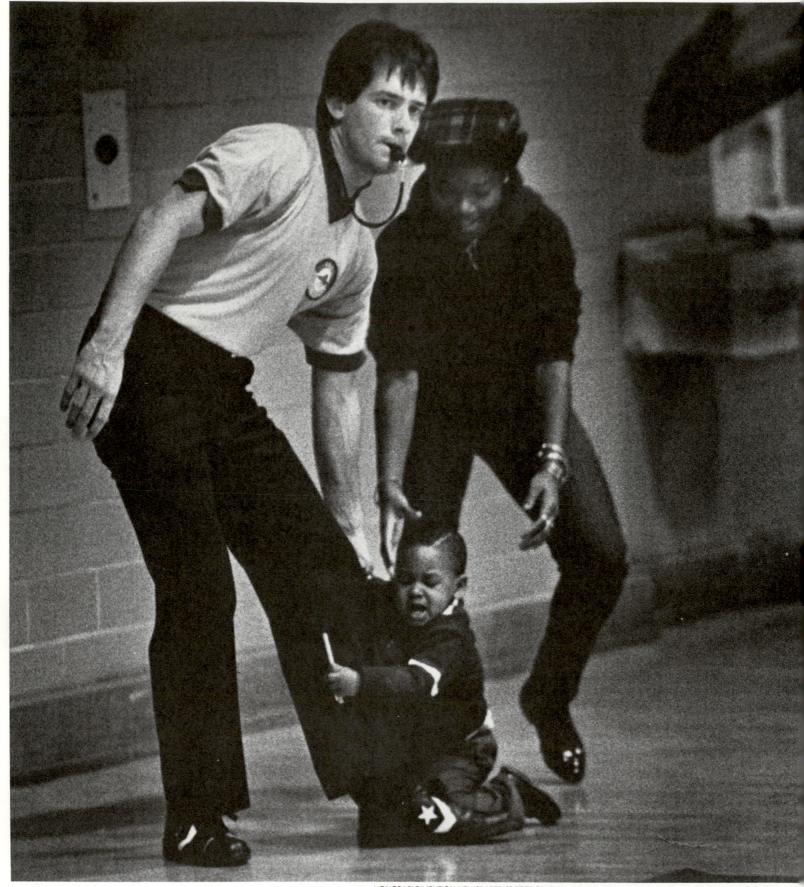

HONORABLE MENTION NEWSPAPER SPORTS FEATURE, TOMMY PRICE, VIRGINIAN PILOT-LEDGER STAR (NORFOLK, VA

No, 17-month-old Lorenzo Bunch wasn't protesting ref Fred Daughtrey's call (above); he was just looking for sanctuary during a Norfolk high school basketball game until his mother could rescue him. Right, Georgetown's Pat Ewing shows how it's done during 1984 NCAA semifinals in Seattle. Georgetown dumped Kentucky, went on to beat Houston for all the marbles.

RIGHT, HONORABLE MENTION NEWSPAPER SPORTS ACTION, HARLEY SOLTES, THE SEATTLE (WASH.) TIM

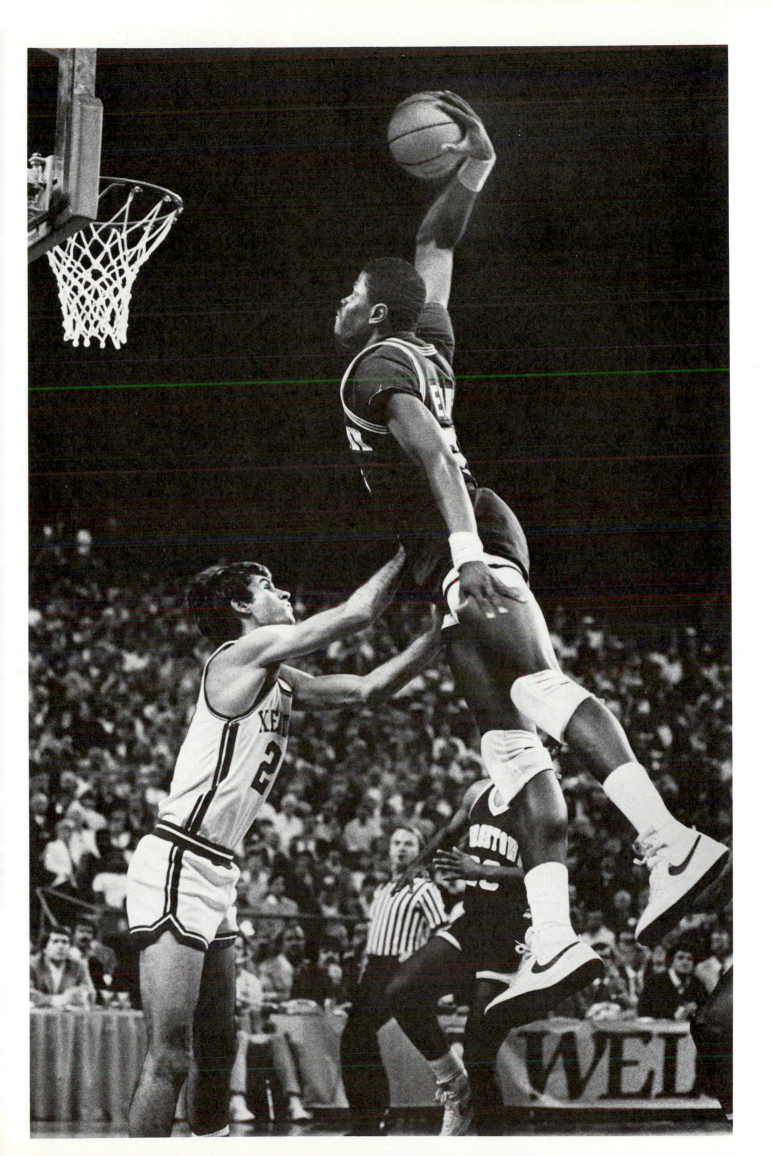

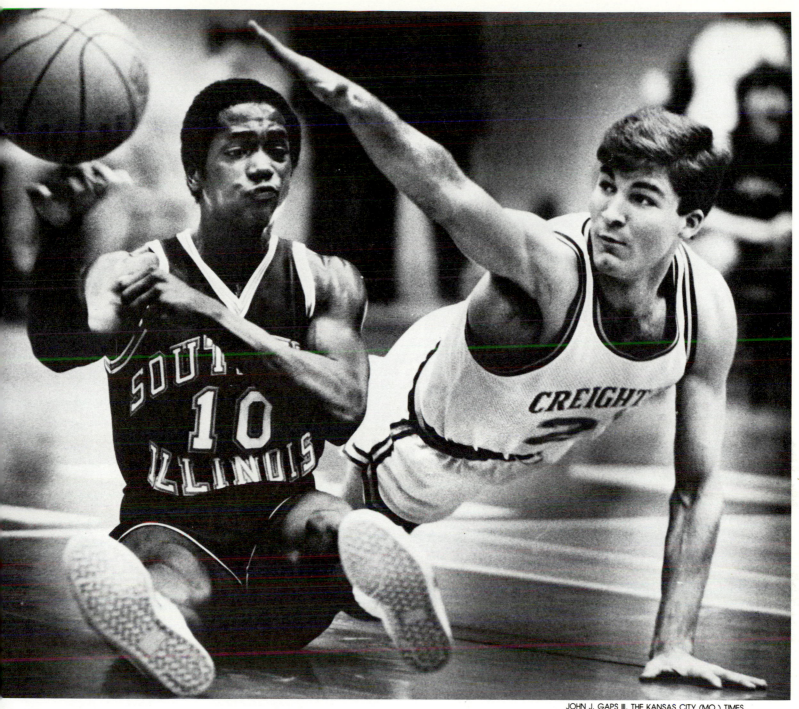

eft, San Jose's Bobby Evans fouls University of
California-Irvine's Jerome Lee while attempting to
teal. San Jose lost. Above, no foul at all when
Gary Swain (right) of Omaha, Nebr.'s Creighton
niversity puts the pressure on Roy Birch, Southern
nois University forward, during Creighton's
vinning effort.

Kentucky boy

American colleges began hearing about a 7-foot, 4-inch German basketball player — and the recruiting war began. And Gunther Behnke was indeed a good prospect; he played on top German club teams and had performed creditably.

When the University of Kentucky announced Behnke would join its team, alumni and fans were delighted. And interest was intense. As a result, the Courier-Journal and Louisville Times sent a photographer and reporter to Germany. Assignment: introduce Behnke to Kentucky.

A special four-page section was produced and published a week before Behnke arrived on campus. Says Photographer Michael Hayman, "The story told of both positive and negative evaluations of Behnke, leaving it uncertain as to whether he could make the Kentucky team. There were also hints that he lacked dedication to basketball necessary to make it in bigtime U.S. competition."

Playing for a laugh from his mother, Behnke dwarfs a doorway.

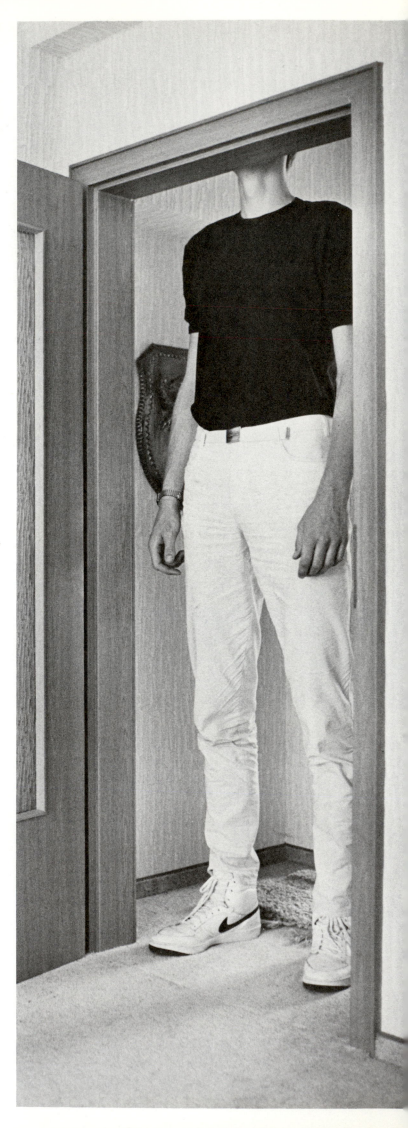

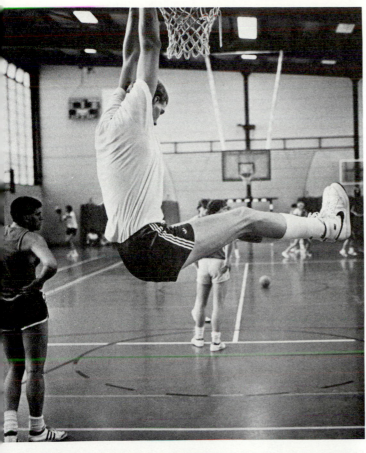

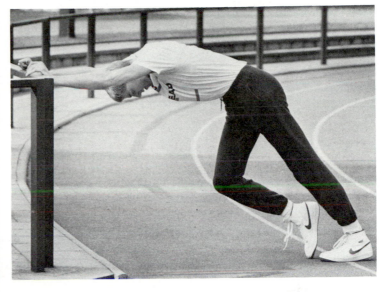

Behnke spent his days in a gymnasium in Pulheim, West Germany (a suburb of Cologne), keeping in shape for his American debut.

Below, Behnke accommodates his size to normal kitchen heights.

Above, he spends a quiet morning with his father and mother.

Below, the German basketball prospect with his steady girlfriend.

ehnke, all alone amidst a crowd on a sidewalk in owntown Cologne. (Photographer Hayman reports e aftermath to the Gunther Behnke story: ''One eek after Behnke arrived in Kentucky, he gave up nd went home. Reason: He was homesick.'')

Kentucky boy (farewell)

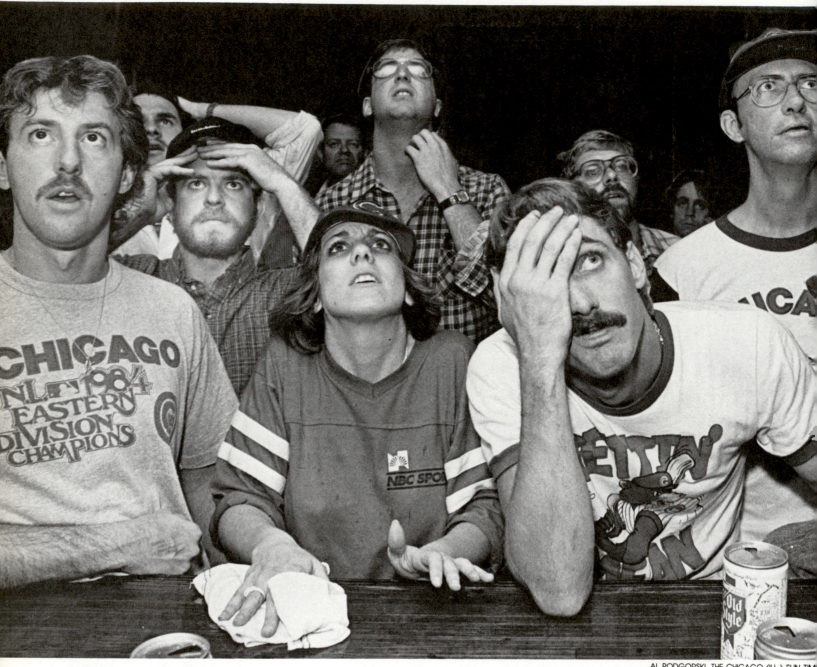

AL PODGORSKI, THE CHICAGO (ILL.) SUN-TIM

No cutlines needed

Above, Chicago Cubs fans in Murphy's Bleacher Bar watch the final and disastrous National League playoff game with the San Diego Padres. Photographer Al Podgorski says he was making celebration pictures until the fifth inning. The fans' expressions had been mirrored earlier in the season by Manager Jim Frey (center at right) and Cubs coaches as the watched a line drive foul in a game the Cubs lost — to the Padres.

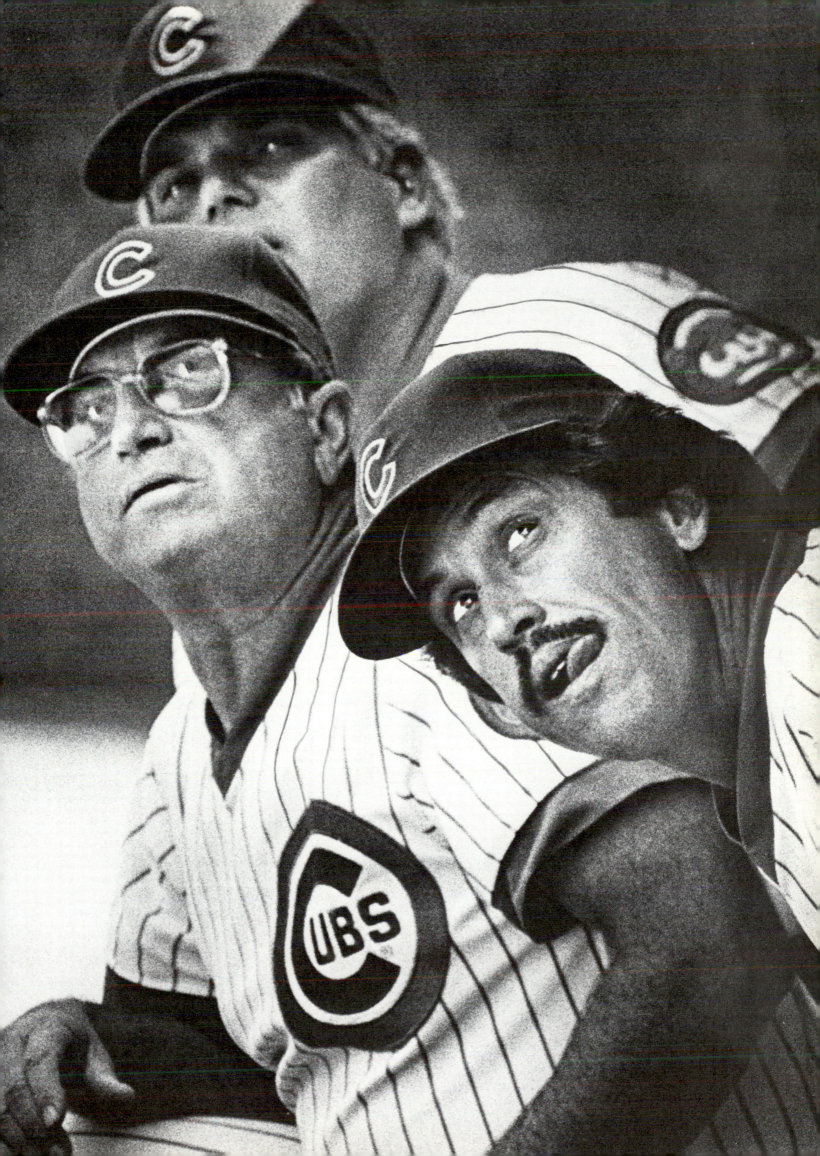

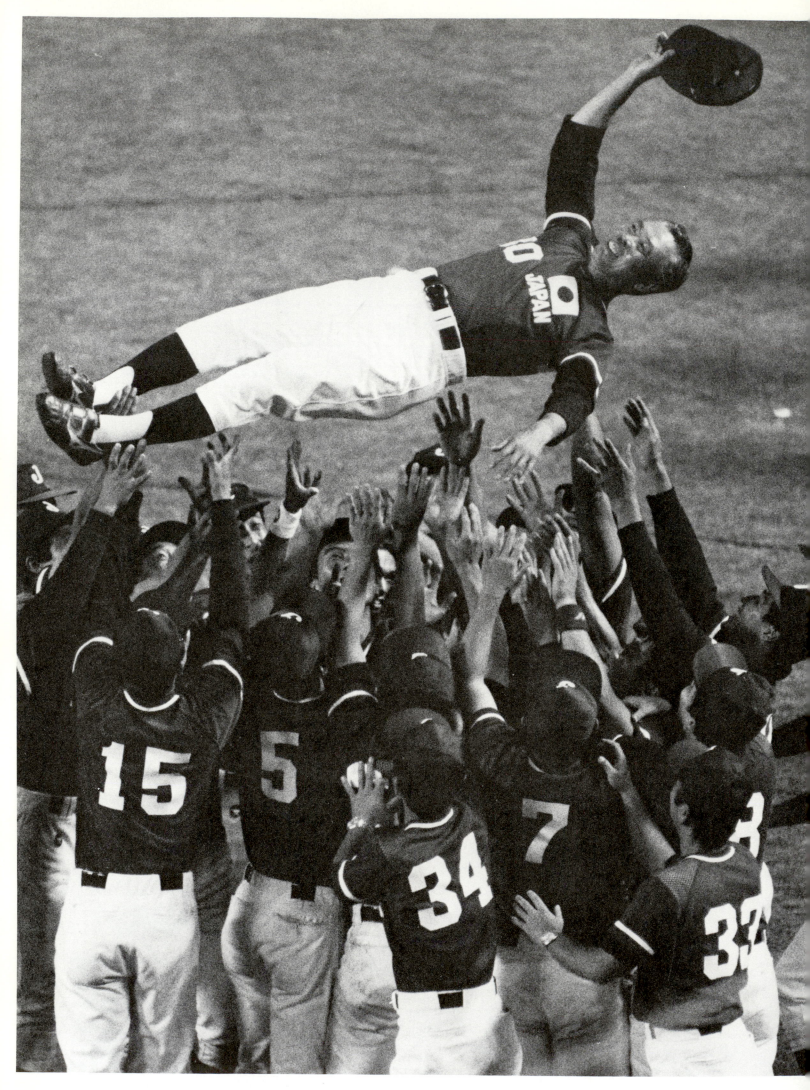

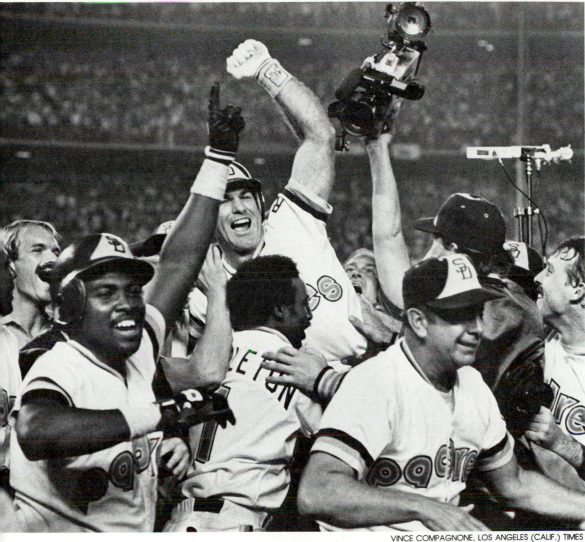

Steve Garvey is carried across home plate by his San Diego Padre team members after he hit the game-winning home run in bottom of the ninth to beat the Chicago Cubs 7-5 in the fourth game of the National League playoffs. Padres went on to win the playoffs, but lost the series to the Detroit Tigers.

eft, manager of the apanese Olympic baseball team, Reiichi Matsunaga, is tossed backward by jubilant team members after they beat the United States at the Summer Olympic games.

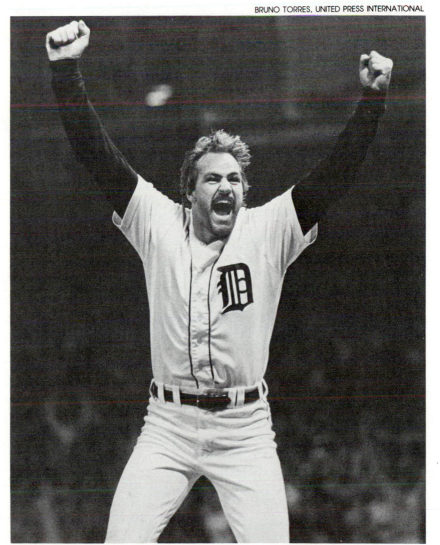

Kirk Gibson of the Detroit Tigers was the batting star of the World Series. Here he celebrates his second home run of the fifth and final game of Series.

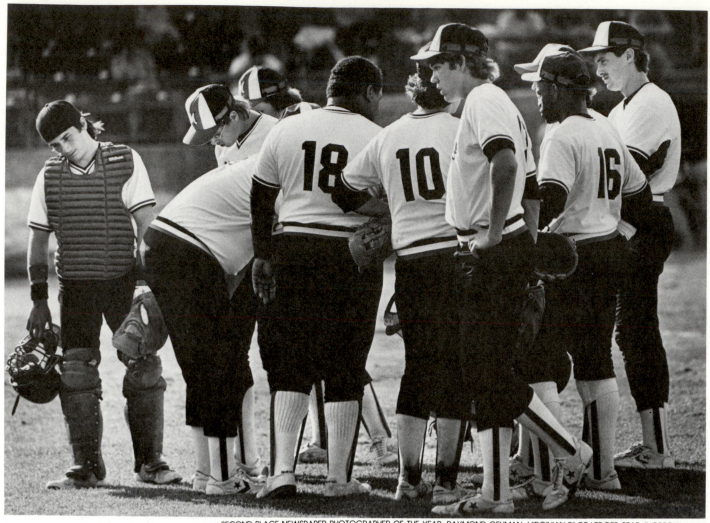

Above, catcher Wesley Morrell missed a tag, and the winning run scored. Now he and his teammates from Manor High School, Portsmouth, Va., are trying to adjust to the loss.

Below, Giant Jack Clark's diving form is neither pretty nor effective as Dodgers catcher Steve Yeager applies the tag. Still, the Giants won this early game, 4-3.

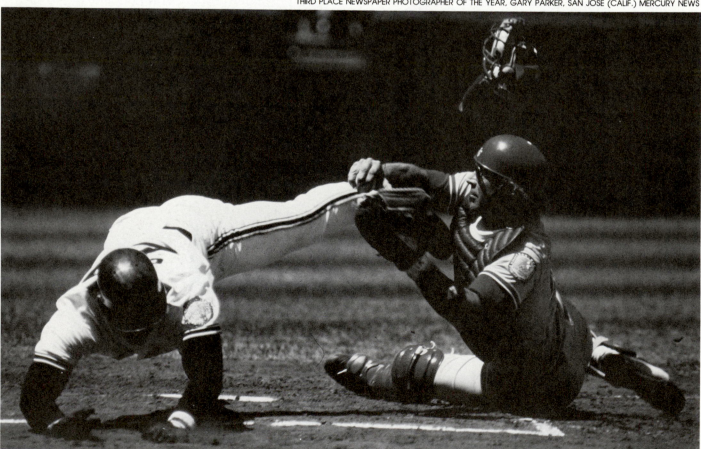

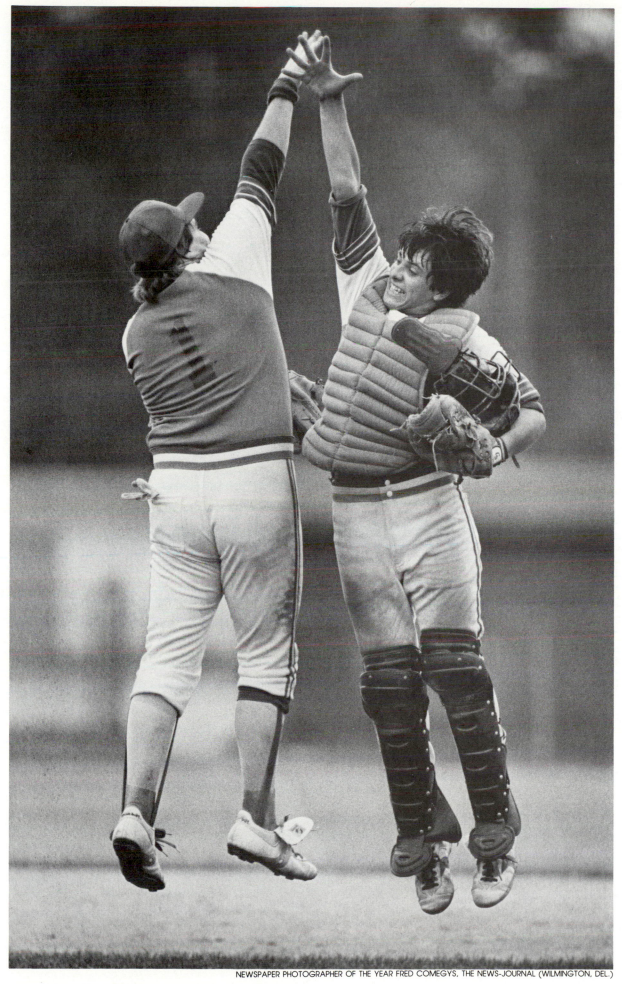

NEWSPAPER PHOTOGRAPHER OF THE YEAR FRED COMEGYS, THE NEWS-JOURNAL (WILMINGTON, DEL.)

Little League catcher and pitcher take to the air after winning Eastern Regional baseball game.

THIRD PLACE NEWSPAPER SPORTS FEATURE PICTURE, ANDY STARNES, THE PITTSBURGH (PA.) PRES

TOMMY PRICE, VIRGINIAN PILOT-LEDGER STAR (NORFOLK, VA.)

bove, early August workout creates athletic patterns
a Virginia high school practice field.

ft, Pitt football team runs steps at the University of
ttsburgh stadium in a conditioning drill. (Did it help?
ey lost their first four games.)

211

Right, Purdue fullback Marty Scott barrels over Ryan Jackson, Virginia defensive player. Action came during 1984 Peach Bowl which the University of Virginia won, 27-24.

Below, Washington Redskins linebacker Peter Cronan celebrates the Redskins' 24-21 victory over the San Francisco 49rs that sent them to the 1984 Super Bowl, while an over-zealous fan who rushed onto the field is restrained.

SECOND PLACE NEWSPAPER PHOTOGRAPHER OF THE YEAR, RAYMOND GEHMAN, VIRGINIAN PILOT-LEDGER STAR (NORFOLK, VA.) (BOTH PHOTO

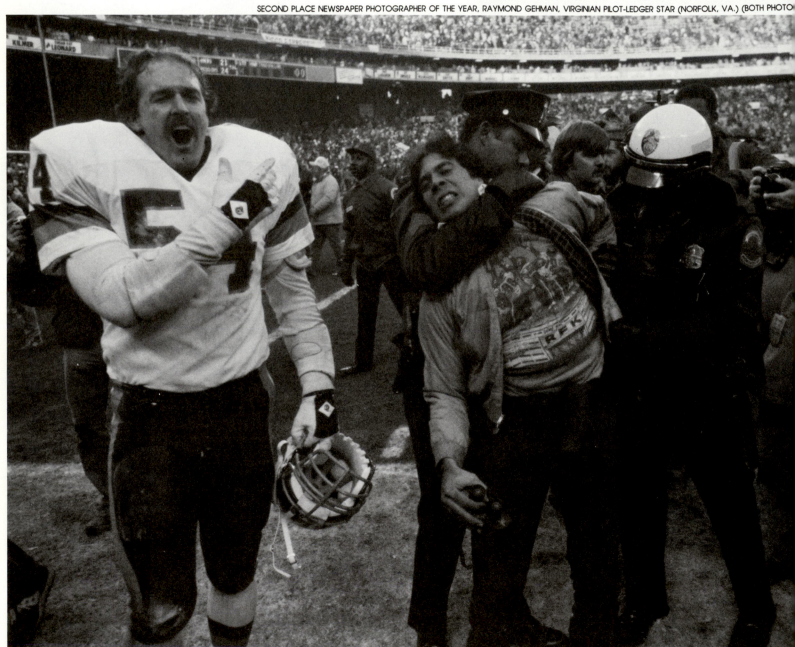

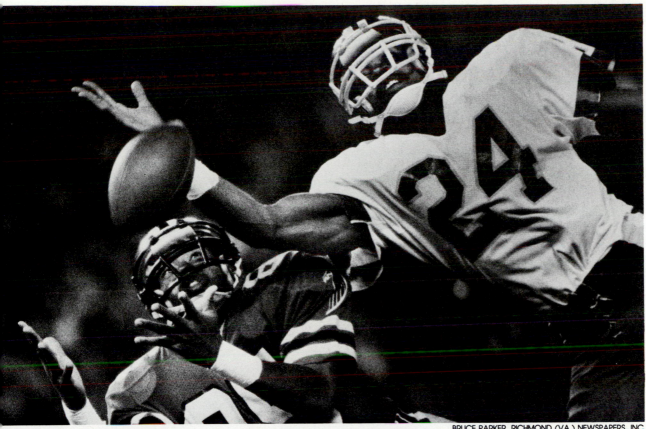

Above, the Washington Redskins' Anthony Washington (at right) keeps a touchdown pass away from Alfred Jackson of the Atlanta Falcons.

Left, like a human wall, the San Francisco 49rs offensive line keeps the Minnesota Vikings locked up.

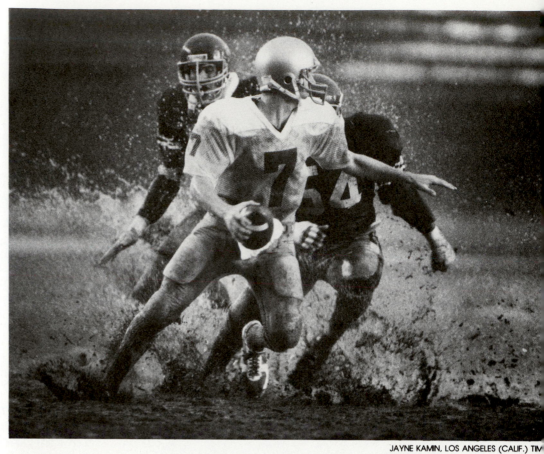

No, it's not water polo: Notre Dame quarterback Steve Beuerlein splashes through Lake Coliseum in Los Angeles with USC linebackers Duane Bicket and Neil Hope in soggy pursuit. The Irish won.

They wondered if Brigham Young University quarterback Robbie Bosco could play under pressure. Then came the big plays by Bosco, including this one: He shakes off an attempted sack by a San Diego State defender to complete his pass and win the game, 34-3.

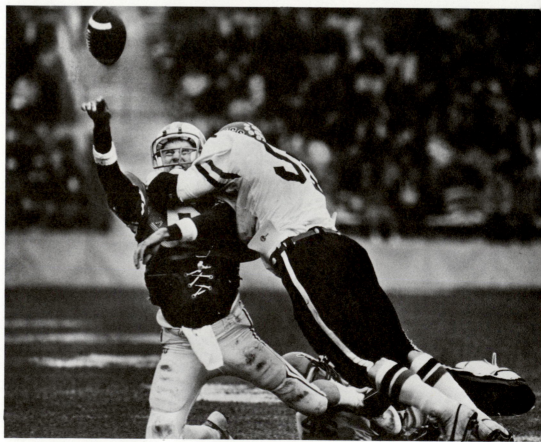

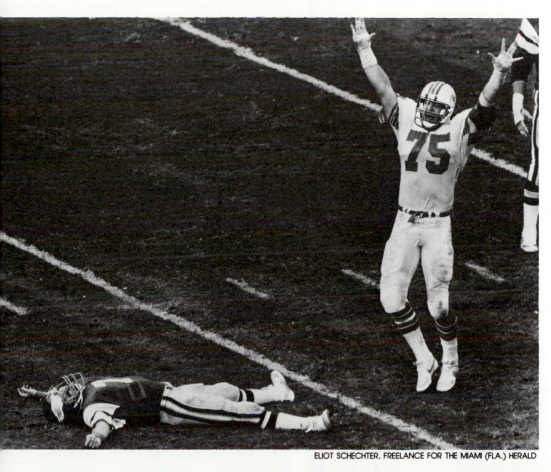

With one minute and 52 seconds left in a Miami Dolphins-Philadelphia Eagles game, Eagles quarterback Ron Jaworski tried a field goal. When it was blocked by Dolphins Doug Betters (75), Jaworski collapsed in disbelief. It was a 24-23 win for the Dolphins.

ELIOT SCHECHTER, FREELANCE FOR THE MIAMI (FLA.) HERALD

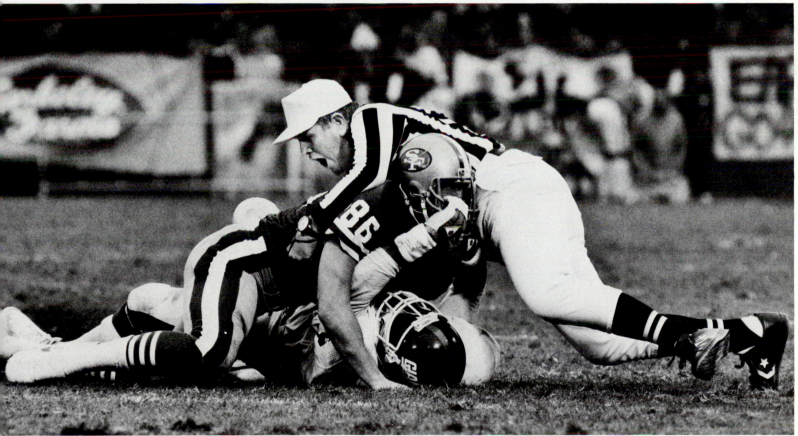

GARY J. REYES, DAILY REPUBLIC (FAIRFIELD, CALIF.)

ine judge Jack Johnson became part of the action as e tried to break up a fight between San Francisco 49r ohn Frank (86) and N.Y. Giants linebacker Lawrence aylor. Action came during the NFL playoff game. The 9rs took it, 21-10.

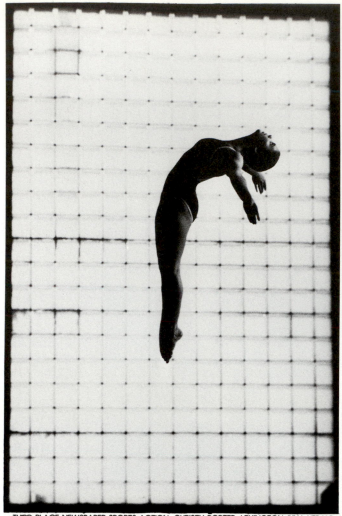

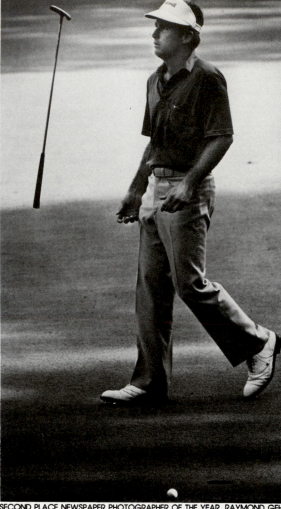

Above, in Kentucky, Jessamine County diver Julie Jelf makes last dive in high school competition. She placed 3rd.

Below, Geoff Courtnall of Boston Bruins goes head first against Philadelphia Flyers who won 4-3.

Above, Curtis Strange conside his putter after missing putt in Anheuser Busch golf classic.

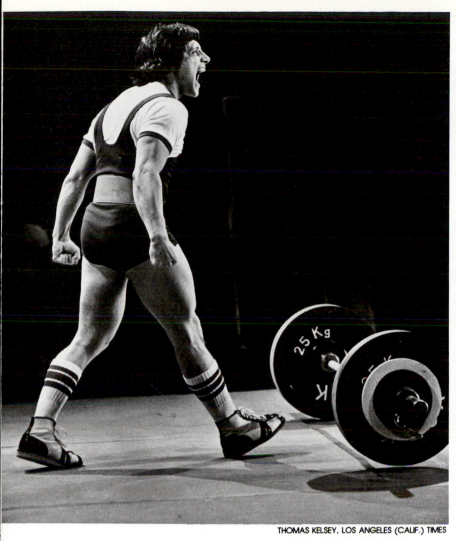

THOMAS KELSEY, LOS ANGELES (CALIF.) TIMES

TOMMY PRICE, VIRGINIAN PILOT-LEDGER STAR (NORFOLK, VA.)

Above, Hometowner Donny Warner, York, Pa., screams to crowd after placing second in U.S. Weightlifting championships.

Below, Mova Garlisi, British Columbia, wins her class at Mid-America Weightlifting Championship with lift of 110 kilos.

Above, Virginian high school wrestler Lew White spends a quiet moment before a match in which he pinned his opponent.

JON LANGHAM, PIONEER PRESS (MELROSE PARK, ILL.)

JIM GENSHEIMER, SAN JOSE (CALIF.) MERCURY NEWS

Above, in May 1984, Swale carried Laffit Pincay Jr. to his first Kentucky Derby win in 10 years. A few weeks later, Swale was dead.

Below, moment of truth for bulldogger Mike Swearingen of East Bethany, N.Y., comes during rodeo in Holland, Mass.

NANCY PALMIERI, THE MORNING UNION (SPRINGFIELD, MASS.)

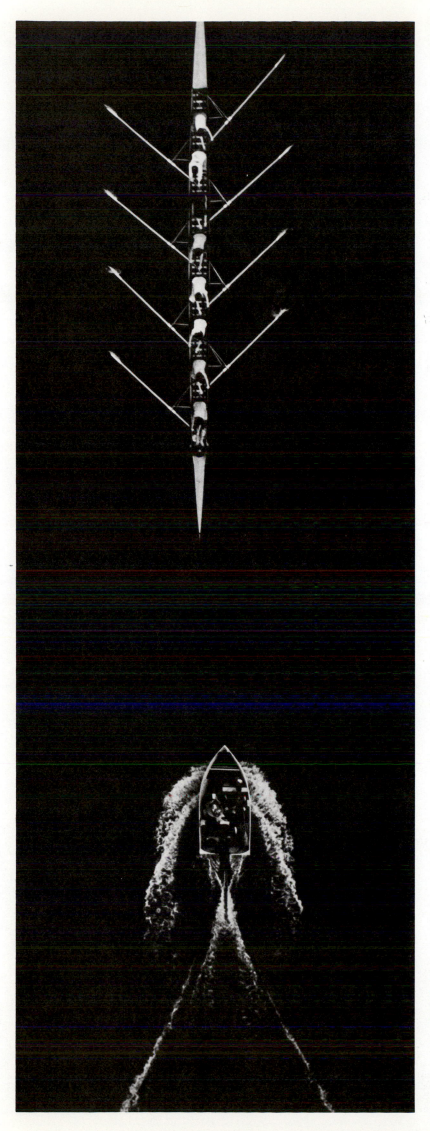

Coach's launch trails the sculling crew of the Los Gatos Rowing Club on Lexington Harbor in California.

TOM VAN DYKE, SAN JOSE (CALIF.) MERCURY NEWS

Right, corner kick brought high-flying action to this New Jersey high school soccer game. That's Burlington City goalie Matt Baker (center) thwarting a play by Moorestown attackers.

Below, in Connecticut, Norwalk High School lacrosse player Paul Prescott (10) works his way around a thicket of McMahon players. Norwalk won.

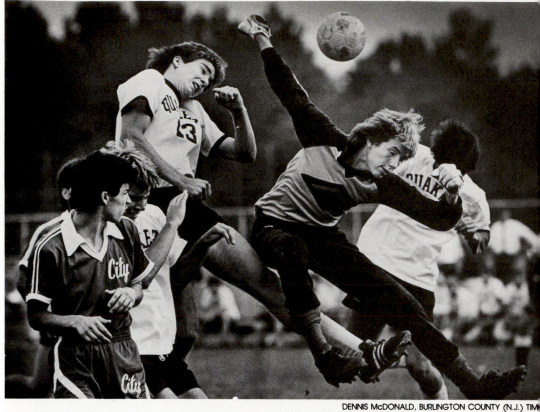

DENNIS McDONALD, BURLINGTON COUNTY (N.J.) TIM

GLENN OSMUNDSON, THE ADVOCATE (STAMFORD, CONN

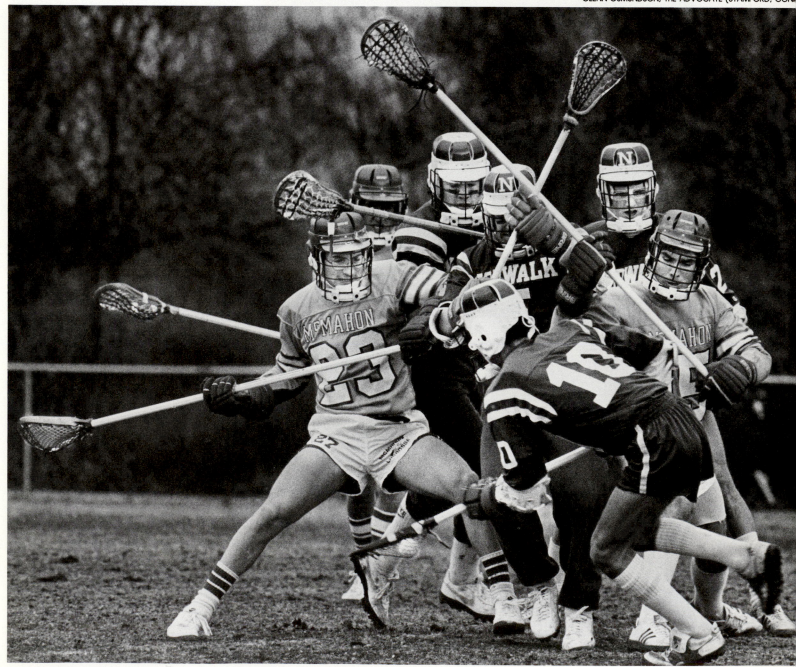

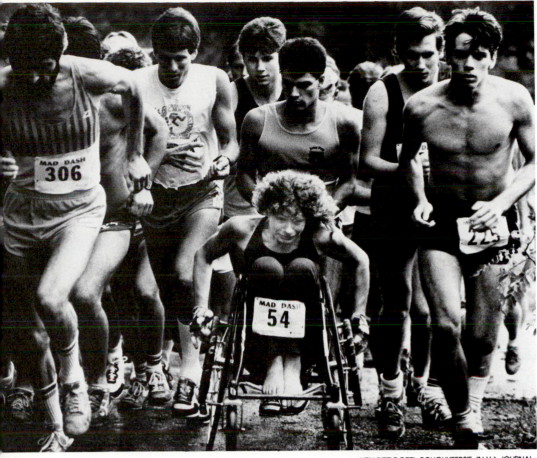

bove, making her own room, Natalie acon pushes off in the 15-kilo Mad ash at Rhinebeck, N.Y. She finished 7th out of 185 runners . . . and won e wheelchair class.

Below, 21-foot dory heads for sky during National Lifeguard championships at San Clemente, Calif. This team won the dory event — by one (horizontal) boat length.

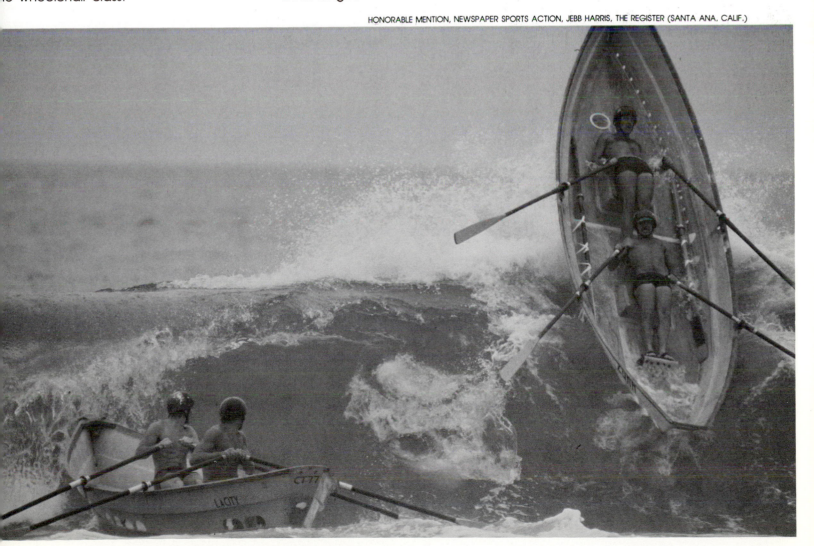

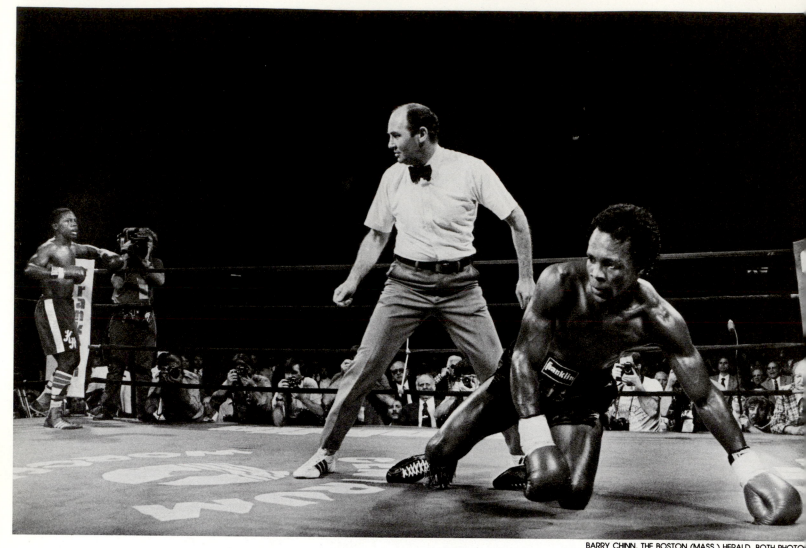

That's all, Folks

Above, Sugar Ray Leonard struggles to his feet as opponent Kevin Howard retreats to a neutral corner. The fight was supposed to have been a warmup for Leonard's comeback from retirement.

Right, Sugar Ray raises weary arms in victory after Howard was declared a TKO. Right after this fight in Worcester, Mass., Leonard made the surprise announcement that he would retire again — and for good.

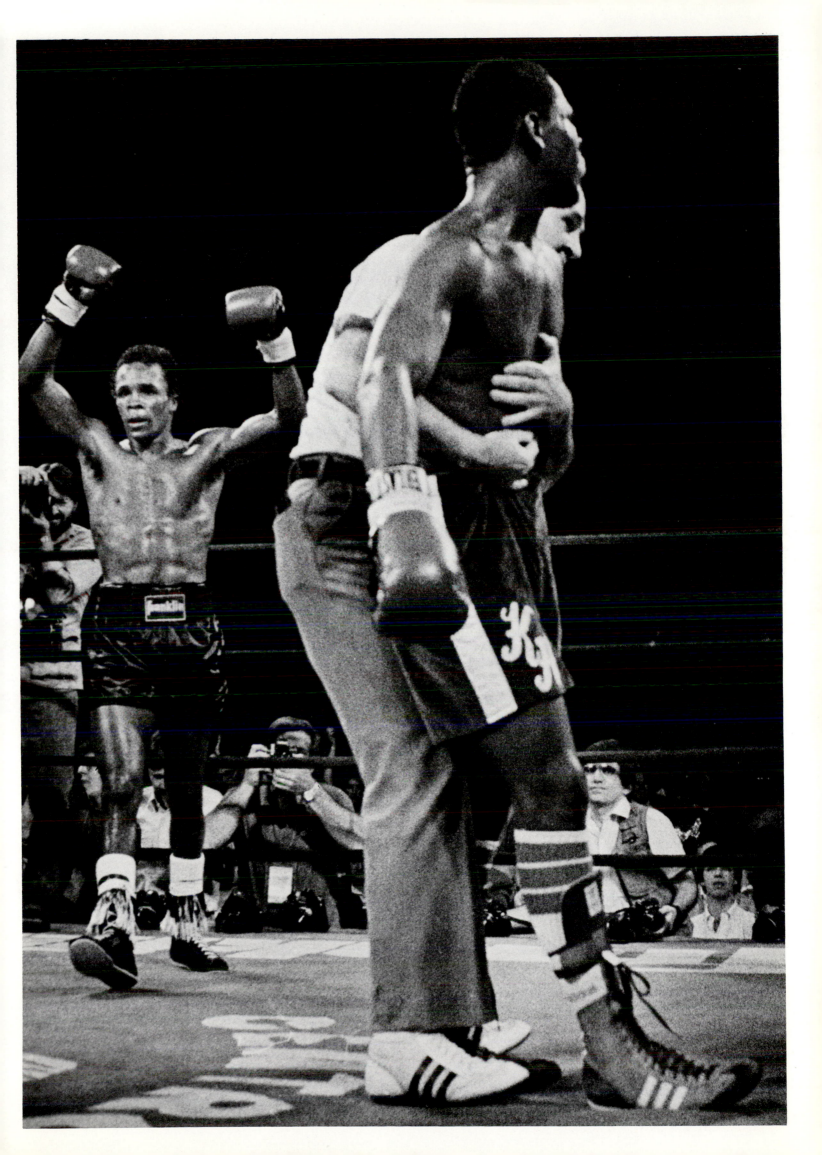

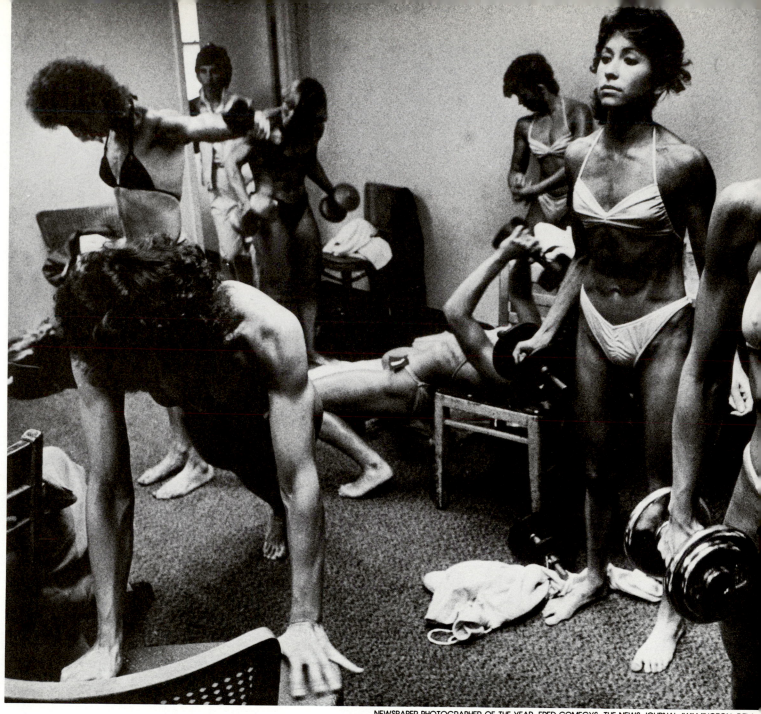

Above, body building competitors pump up backstage before their public appearance.

Bar belles

Women's body building is a skyrocketing sport in which competitors display a combination of power, grace and beauty.

And competition has grown right along with the sport; for several years now, the Delaware State Body Building Championships have included a women's division. Nine competed in the spring of 1984.

Pumping up and putting on oil —
all part of looking good for the
judging.

Above, Shirley Wintren strains with weights to give her muscles the maximum workout.

Right, the moment of truth comes as muscle girls make their final poses.

Bar belles

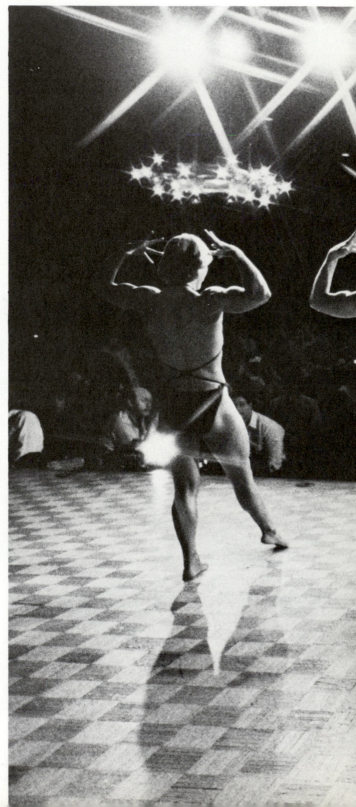

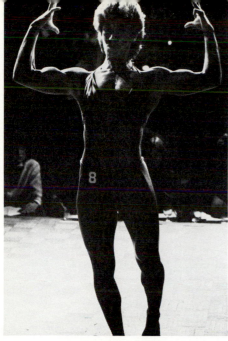
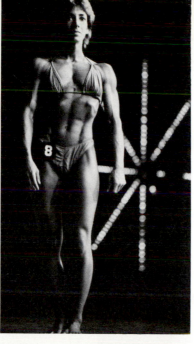

Here's how Ann Taylor looked during competition. She was the eventual winner of the women's body building championship.

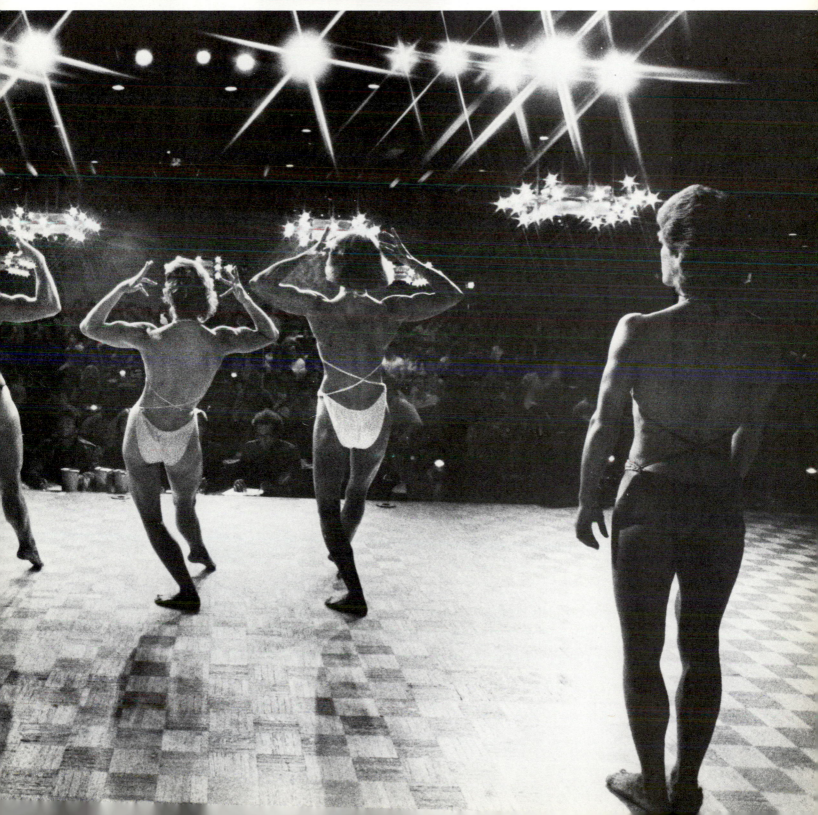

Right, Pee Wee hockey players are too small to go onto the ice the usual way. They can't jump over the boards, so coaches lift them on and off the ice.

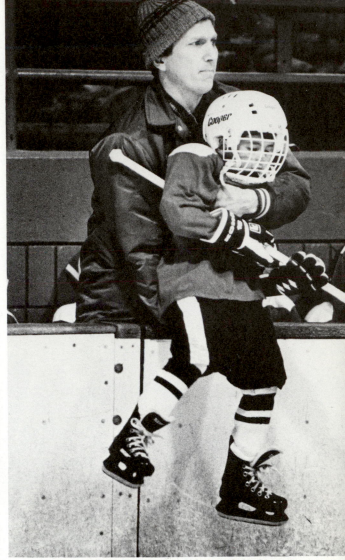

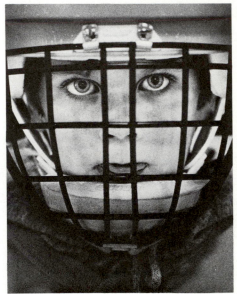

Above, Gale Self, a 6-year-old hockey player. Says Photographer Paul Brown, "The innocent eyes conceal a killer instinct on the ice."

Junior puck jockeys

There are other sports for little guys besides Little League baseball, especially in the northern climes.

That's why hockey gets big attention among small fry (and their parents) in Alaska, where weather conditions are more favorable to hockey than just about any other sport.

And they start Alaskan kids early . . . like these five-and six-year-olds.

Right, hockey mom Linda O'Sullivan cheers on the team and her 6-year-old son.

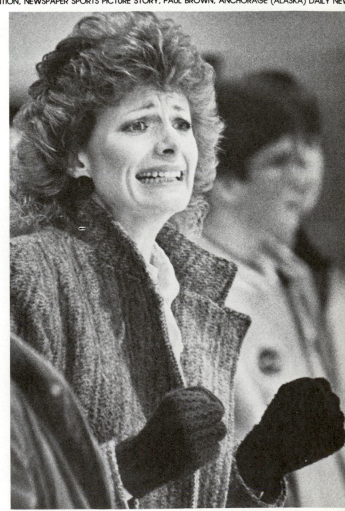

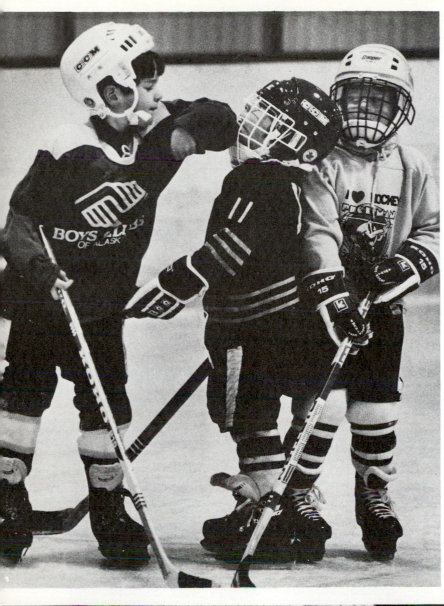

Left, Sean Boyd takes a shot to the head during a league game.

Below, Sean has his helmet removed by his parents after the game, while his 20-month-old brother, Ryan, gets familiar with the equipment.

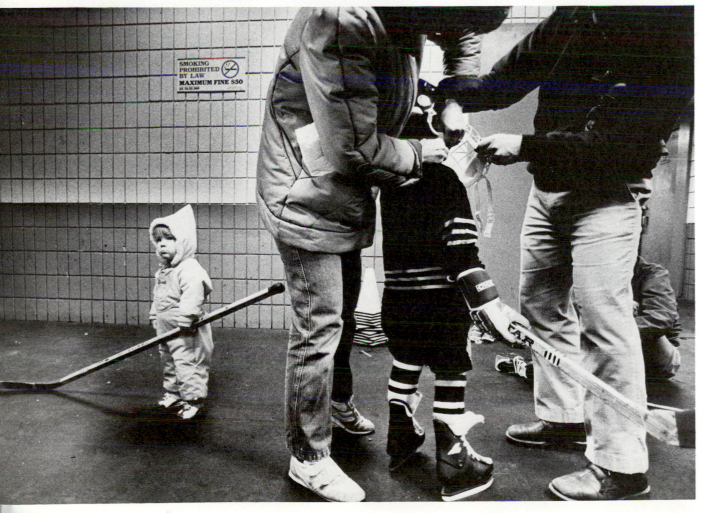

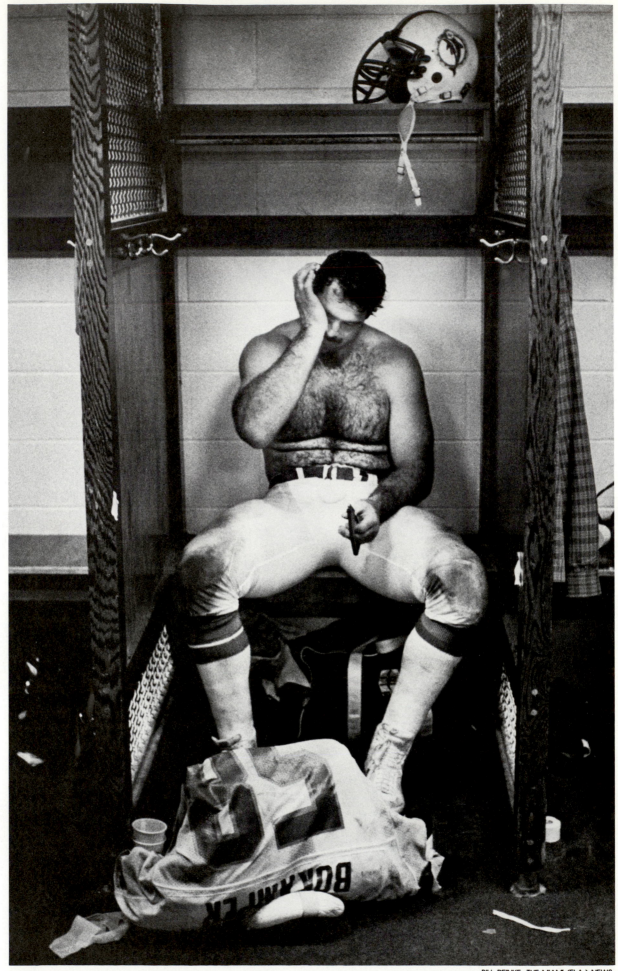

The dream of an unbeaten season ended, Kim Bokamper, defensive end for the Miami Dolphins, considers the team's first loss (after 11 wins) to San Diego.

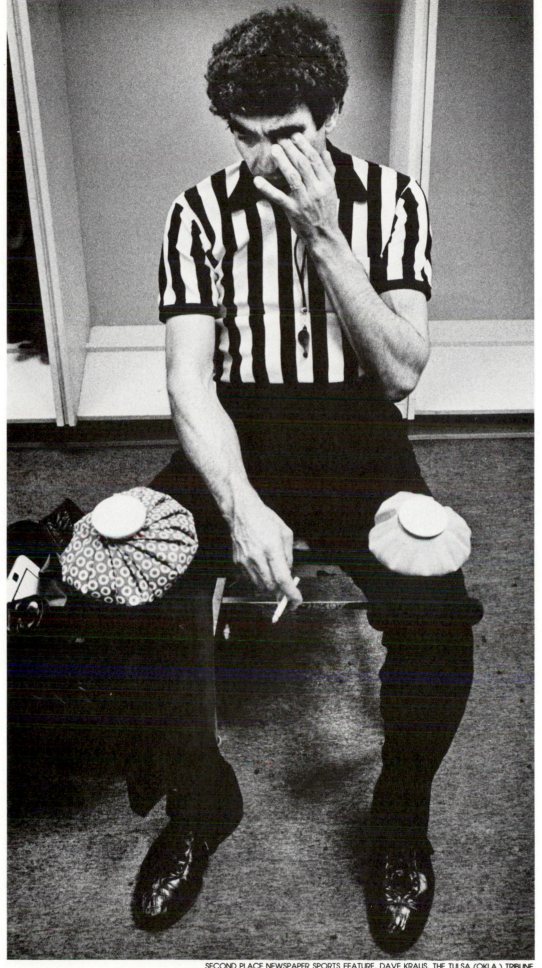

SECOND PLACE NEWSPAPER SPORTS FEATURE, DAVE KRAUS, THE TULSA (OKLA.) TRIBUNE

In Tulsa, Okla., basketball referee John Dabrow spends a moment alone during halftime of a college game. After three operations on his knees, Dabrow must ice them down often.

'Just one more . . .'
That sweet old POY refrain

By Jack Belich
Photo Editor
St. Petersburg (Fla.) Times
& Evening Independent

First impressions are lasting impressions, they say.

After my first look at the room where the 20,000-plus entries in the 42nd Pictures of the Year competition were stacked as high as the ceiling, I was properly impressed.

If not really impressed, then I must have been overwhelmed. At this point, I thought I understood just how big a job lay ahead. But you really can't understand the judges' job until you do it yourself.

Simply put, it is a task of monumental proportions.

Five days would seem to be enough time to do a creditable job. Five days — to someone who has never witnessed the judging — might even seem like too much time. Perhaps they are building in extra time, so they can take a couple of hours off for lunch; and then wrap it up by 5 p.m. or so — just in time to party every night.

Those who think those thoughts obviously have not met Ken Kobre and Carol Cullen.

Ken, who functions as the POY director, and Carol, the person who keeps it all running smoothly, have learned all about judges. And all about how time slips away.

And so, Ken and Carol have put together a Master Plan. Simply put, it calls for us judges to do the judging — first and foremost. Everything else is secondary: like eating lunch, like going to the bathroom, like calling your office to check in, like — well, you get the idea.

Those of you who are street photographers know all about "Just one more." Usually, you're talking about just one more photo.

Ken and Carol know all about "Just one more," too.

As we started to wade through the flood of photos, we lost track of time — and of precisely where we were in the actual categories. After we'd finish one category, Ken would say, "Just one more." At 7 p.m., when we thought it was time to knock off for the day, Ken would give us those now famous words, "Just one more."

But he never told us just how many more categories we had to go. Late one night, we tried to pin him down. "Surely we've judged all the categories by now," I said. "Surely it's time to get some much-needed sleep."

But it wasn't time to quit for the day. Stacks of photos still had to be judged. We had time for "just one more," Ken told us.

And so it went, hour after hour, day after day, category after category. There was always just one more category that we had to judge.

The judging itself was difficult, although no more so than the average daily work of a typical photo editor. During the course of the judging we saw — and talked about the relative merits of — many, many good photographs.

The decisions we made as judges were simple — to keep it in, or to throw it out.

We also saw an overabundance of bad photos — which any first-year photojournalism student would know were not going to make the final cut. In fact, we saw a considerable number of photos so obviously out of step with the rest of the competition that it was embarrassing. I am referring to terrible, really amateur, print quality; poorly mounted prints, slipping off the mount board, with bubbles under the print; developer-stained prints; poorly cropped prints; story boards that were poorly edited, and so on.

All the technical faults, I think, could easily be overcome with just a little care and attention to detail. Overcoming the inability to edit your own contest entries is a bit more of a problem.

Most photographers have a battle with themselves over editing their own material. Sometimes that photo you worked hardest to get turns out not to be the best photo.

And there is the rub. You worked hard for that shot. You risked life and limb by leaning out of the helicopter for just the right angle, or you climbed the fire department truck ladder some 90 feet into the air, looking for just the right perspective.

And by gosh, you're determined to enter that photo in the POY. It is the most prestigious competition in our business. And it serves your ego to enter that shot.

But it doesn't really serve you, the photographer.

I know how tough it is to edit down a 10-photo story board to six or seven key photos — but that type of editing discipline is truly necessary if you want to win.

Keep it simple — tell the story, by all means — but keep it simple.

Again and again during our judging sessions, we judges talked about how much better certain stories would have looked if the photographer had exercised his or her editing discipline. How uncluttered the revised story would have been! Over and over, we questioned why a certain photo — the weak sister of the story — was left in to clutter and spoil.

In virtually every case, the questioned photo that had been left in was not needed to tell the story. Many times we found not one, but two and sometimes three unnecessary photos. And every time, the photo had spoiled the story.

These five judges spent five days evaluating more than 8,000 photographs submitted by 1,500 photographers in the 42nd Pictures of the Year Contest. In the foreground: Alice Rose George, picture editor of Fortune Magazine. Her male counterparts, from left: Robert L. Kerns, coordinator of visual communication in the Mass Communications Department of the University of South Florida, Tampa; Wally McNamee, staff photographer for Newsweek Magazine; Jack Belich, photo editor for the St. Petersburg (Fla.) Times & Evening Independent, and Barth Falkenberg, senior staff photographer for the Christian Science Monitor.

Enough said about tight editing. Let's now talk about impact. Spell it IMPACT.

Webster's tells us impact is "to hit with force" and "the power of an event, idea (or maybe a photo?) to produce changes, move the feelings, etc."

Impact, it should be noted here, plays a very big part of getting the judges' attention — and in winning photo contests.

Without impact, we judges have a tendency to take only a quick look at the image, and then it's on to the next photo. In a contest such as the POY, where you have so many entries, I would guess that with a routine photo we would spend no more than a second or two in taking that all-important first look. Think about that, folks — no more than a second or two.

If an entry doesn't have impact — it's out.

After we made one or two complete passes through all the entries, we usually ended up with somewhere between six and 35 finalists. At this point, we then made very slow and deliberate passes through the survivors in search of that one outstanding photo worthy of a first place award.

During this final period of judging in each category, the judges either spoke in favor of or against a particular entry. Eventually we got it down to the best six or seven photos. We then only had to decide the order of the finalists.

And finally, several days after we first arrived at the University of Missouri, we had our winners. Culled from the multitude of entries, these winners withstood the rigors of the week — as had the judges — and can stand tall at being named the very best.

As for Ken and Carol, they too can stand tall. Their Master Plan worked. The judges did indeed judge — even if we couldn't always take a break when we wanted to.

But sometimes I still wake up in the middle of the night to hear Ken and Carol saying, "Just one more." But I know there isn't any more judging to be done.

Until next year.

The winners

Newspaper division

WINNERS

SPOT NEWS:
First — Michael Lipack, New York Daily News, "Cry for help"
Second — J.R. Erickson, freelance, "Skydiving tragedy"
Third — Barry J. Locher, The State Journal-Register (Springfield, Ill.), "Crazed burglary suspect"
Honorable mention — David Gatley, Los Angeles (Calif.) Times, "The McDonald's mass slaying"
Honorable mention — Bob Ivins, The San Diego (Calif.) Union, "Wounded boy at McDonald's"

GENERAL NEWS:
First — Paul Kitagaki, Jr., San Francisco (Calif.) Examiner, "Foreign car smashing"
Second — Cheryl Nuss, San Jose (Calif.) Mercury News, "Groundbreaking ceremony"
Third — Leo Hetzel, Press-Telegram (Long Beach, Calif.) "Birthday swim"
Honorable mention — Robert A. Reeder, Chicago (Ill.) Sun-Times, "Fifteen seconds of stardom"
Honorable mention — Brian Smith, The Register (Santa Ana, Calif.), "Funeral for a garbage man"

CAMPAIGN '84:
First — Mike Franklin, The San Diego (Calif.) Union-Tribune, "Just one more peek for Ronnie"
Second — Jim Curley, Columbia (Mo.) Daily Tribune, "Udder admiration"
Third — David Woo, The Dallas (Texas) Morning News, "Run, Jesse, run"
Honorable mention — Pat McDonogh, The Courier-Journal and Louisville (Ky.) Times, "Mondale declines"
Honorable mention — Michael S. Green, The Detroit (Mich.) News, "Spin, Jesse, spin"

FEATURE PICTURE:
First — Chris Walker, The Chicago (Ill.) Tribune, "Media event"
Second — Frank Jacobs III, Today's Sunbeam (Salem, N.J.) "Halloweenaphant"
Third — Mel Finkelstein, New York Daily News, "The suspense is real"
Honorable mention — Jed Kirschbaum, The Baltimore (Md.) Sun, "On the outside looking in"
Honorable mention — Chip Gamertsfelder, freelance, "Sunbather on Block Island"

SPORTS ACTION:
First — Bruce Chambers, Long Beach (Calif.) Press-Telegram, "Decker's dream takes a tumble"
Second — Bruce Parker, Richmond (Va.) Newspapers, Inc., "Battle for a bomb"
Third — Christy Porter, Lexington (Ky.) Herald-Leader, "Final dive"
Honorable mention — Jebb Harris, The Register (Santa Ana, Calif.), "Racing the violent sea"
Honorable mention — Harley Soltes, The Seattle (Wash.) Times, "Pat Ewing Flies"

SPORTS FEATURE:
First — Lennox McLendon, Associated Press, "Victory"
Second — Dave Kraus, The Tulsa (Okla.) Tribune, "Referee's recuperation"
Third — John Starnes, The Pittsburgh (Pa.) Press, "Pit stop"
Honorable mention — Tommy Price, Virginian Pilot-Ledger Star (Norfolk, Va.), "Referee's dilemma"

PORTRAIT PERSONALITY:
First — Martin D. Rodden, San Antonio (Texas) Light, "A serious man"
Second — Raymond Gehman, The Virginian Pilot-Ledger Star (Norfolk, Va.), "Facing life without him"

Third — Michael Schwarz, Gannett Rochester (N.Y.) Newspapers, "Judge's last days"
Honorable mention — Erica Berger, The Miami (Fla.) Herald, "Evelyn 'Treasure Chest' West"
Honorable mention — Michael S. Wirtz, Dallas (Texas) Times Herald, "Mickey"

PICTORIAL:
First — John Kaplan, The Pittsburgh (Pa.) Press, "Art in action"
Second — Cole Porter, The Seattle (Wash.) Times, "Shattered"
Third — Jed Kirschbaum, The Baltimore (Md.) Sun, untitled
Honorable mention — Stephen Crowley, The Miami (Fla.) Herald, "Condo geometry"

FOOD ILLUSTRATION:
First — Michael J. Bryant, San Jose (Calif.) Mercury News, "Bottled water"
Second — Gary S. Chapman, The Courier-Journal and Louisville (Ky.) Times, "Fish farming"
Third — Talis Bergmanis, The Kansas City (Mo.) Star, "Blueberries and cream"
Honorable mention — Jan Houseworth, The Kansas City (Mo.) Star, "Bottled vinegars"
Honorable mention — Brian Smith, The Register (Santa Ana, Calif.), "The onion: other foods pale in comparison"

FASHION ILLUSTRATION:
First — Bob Fila, Chicago (Ill.) Tribune, "Day glo jewelry"
Second — Brian Peterson, St. Paul (Minn.) Pioneer Press and Dispatch, "Accessories"
Third — Mark B. Sluder, The Charlotte (N.C.) Observer, "Western buckle"
Honorable mention — Dan Sheehan, The Florida Times-Union (Jacksonville) "Jellies"
Honorable mention — Gary Parker, San Jose (Calif.) Mercury News, "Spam cocktail dress."

EDITORIAL ILLUSTRATION:
First — Peter Haley, The Journal-American (Bellevue, Wash.), "TV addiction"
Second — Gary S. Chapman, The Courier-Journal and Louisville (Ky.) Times, "Telephone maze"
Third — Danielle Pallotto, The Journal (Rockville, Md.) "Scars of child abuse"
Honorable mention — Stephen Haines, Providence (R.I.) Journal, "American summer"
Honorable mention — Michael J. Bryant, San Jose (Calif.) Mercury News, "Sending the kid to camp"

NEWS PICTURE STORY:
First — G. Loie Grossmann, Philadelphia (Pa.) Daily News, "The longest war"
Second — David C. Turnley, Detroit (Mich.) Free Press, "Gandhi's funeral"
Third — Wayne C. Kodey, Las Vegas (Nev.) Review Journal, "Strike picketer being run over"
Honorable mention — Lenny Ignelzi, Associated Press, "McDonald's massacre"
Honorable mention — Eric Bakke, The Denver (Colo.) Post, "Death wish"

FEATURE PICTURE STORY:
First — Genaro Molina, San Jose (Calif.) Mercury News, "In search of housing"
Second — Bill Kelley III, The Commercial Appeal (Memphis, Tenn.), "Stephanie's struggle"
Third — Jim Gensheimer, San Jose (Calif.) Mercury News, "Commuter train"
Honorable mention — Betty Udesen, The Seattle (Wash.) Times, "A small town Christmas"
Honorable mention — Sam Mircovich, freelance for The Torrance (Calif.) Daily News, "Repairing a broken wing"
Honorable mention — Jimi Lott, The Seattle (Wash.) Times, "The Doukhobors"

SPORTS PICTURE STORY:
First — Brian Smith, The Register (Santa Ana, Calif.), "USA gymnastic team's golden upset."
Second — Bruce Chambers, Long Beach (Calif.) Press-Telegram, "Decker's dream takes a tumble"
Third — Michael Hayman, The Courier-Journal and Louisville (Ky.) Times, "German basketball recruit"
Honorable mention — Keith Meyers, The New York Times, "Only you, Mary Lou — gold medal"
Honorable mention — Paul Brown, Anchorage (Alaska) Daily News, "Pee wee hockey"

CAMPAIGN '84 PICTURE STORY:
First — Judy Griesedieck, San Jose (Calif.) Mercury News, "Gary Hart — creating an image"
Second — David Peterson, The Des Moines (Iowa) Register, "Dreams never die"
Third — Michael S. Green, The Detroit (Mich.) News, "I like Walter"
Honorable Mention — Bryan Moss, Rocky Mountain News (Denver, Colo.), "Racing from one photo opportunity to another"

SELF-PRODUCED PUBLISHED PICTURE STORY:
First — John Metzger, Ithaca (N.Y.) Journal, "In tragedy's wake"

Magazine division

NEWS DOCUMENTARY:
First — David Burnett, Contact Press Images for Time, "Ethiopia's plight"
Second — David Burnett, Contact Press Images for Time, "Child's burden"
Third — David Burnett, Contact Press Images for Time, "Drought victim"
Honorable mention — John Isaac, United Nations, "Children had forgotten how to eat"
Honorable mention — Michael O'Brien, freelance for Life, "Seal harvesters"

CAMPAIGN '84:
First — P.F. Bentley, Time, "The empty room"
Second — P.F. Bentley, Time, "Lonely on the road"
Third — Chick Harrity, U.S. News and World Report, "All the accessories"
Honorable mention — Peter Turnley, Newsweek, "Teardrops of pride"

FEATURE:
First — David Hume Kennerly, Time, "Hussein"
Second — Rosanne Olson, freelance for GEO, "Sister

Magazine winners (cont'd)

Elizabeth and Mom"

Third — Pete Turner, freelance for GEO, "Aborigine"

Honorable mention — Steve McCurry, National Geographic, "Afghan refugee family"

SPORTS:

First — Karl Reinhard, freelance for GEO, "Ice climber"

Second — Steven E. Sutton, Duomo Photography, Inc., "Mary Lou Retton — 1984 Olympics"

Third — Tobey Sanford, freelance for Life, "An archer to the very core"

Honorable mention — Stephanie Maze, freelance for National Geographic, "Viva Barca"

Honorable mention — Neil Leifer, Time, "Daley's throw"

PORTRAIT PERSONALITY:

First — Al Satterwhite, Satterwhite Productions, "Singapore soldier"

Second — James Stanfield, National Geographic, "Godiva's Lady Sandra"

Third — Bill Hayward, Fortune Magazine, "Rupert Murdoch"

Honorable mention — George Lange, freelance, "Ron Daniel"

Honorable mention — Joseph McNally, Wheeler Pictures (freelance for Life), "Golden girl"

Honorable mention — David Burnett, Contact Press Images for Time, "Col. Harris"

PICTORIAL:

First — Michael Nichols, Magnum Photos, Inc., for

Rolling Stone, "Ladder to nowhere"

Second — Steve McCurry, National Geographic, "Pre-monsoon dust storm"

Third — Georg Gerster, National Georgraphic, "Texas scrollwork"

SCIENCE/NATURAL HISTORY:

First — Andy Levin, Black Star, "The lady gets a new look"

Second — Steven J. Krasemann, National Geographic, "Grizzly"

Third — Chuck O'Rear, freelance for National Geographic, "Rainbow spectrum of laser beams"

ILLUSTRATION:

First — David Alan Harvey, National Geographic, "Dallas"

Second — Marna G. Clarke, freelance for The Hartford (Conn.) Courant, "Hydroponic lettuce"

Third — Mark Hanauer, freelance for GEO, "Type 57"

PICTURE STORY:

First — Steve McCurry, National Geographic, "By rail across the Indian subcontinent"

Second — David Burnett, Contact Press Images for National Geographic, "Jamaica"

Third — David Burnett, Contact Press Images for National Geographic, "Ethiopian famine"

Honorable mention — David Doubilet, National Geographic, "Izu Oceanic Park"

Honorable mention — Andy Levin, Black Star, "The lady gets a new look"

Editing awards

BEST USE OF PHOTOGRAPHS BY A NEWSPAPER UNDER 30,000:
Journal Tribune (Biddeford, Me.)

BEST USE OF PHOTOGRAPHS BY A NEWSPAPER OVER 30,000:
The Register (Santa Ana, Calif.)

NEWSPAPER PICTURE EDITOR AWARD:
Kristin Snipes, Sacramento (Calif.) Bee

NEWSPAPER MAGAZINE PICTURE EDITOR AWARD:
First — Bill Marr, The Philadelphia (Pa.) Inquirer
Honorable mention — Arnie Brown, The Des Moines (Iowa) Register

BEST USE OF PHOTOGRAPHS BY A MAGAZINE:
First — Life
Honorable mention — International Wildlife

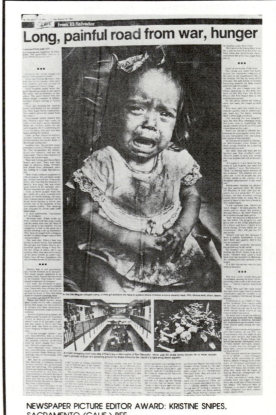

NEWSPAPER PICTURE EDITOR AWARD: KRISTINE SNIPES, SACRAMENTO (CALIF.) BEE

BEST USE OF PHOTOGRAPHS BY A NEWSPAPER UNDER 30,000:
JOURNAL TRIBUNE (BIDDEFORD, ME.)

BEST USE OF PHOTOGRAPHS BY A NEWSPAPER OVER 30,000:
THE REGISTER (SANTA ANA, CALIF)

BEST USE OF PHOTOGRAPHS BY A MAGAZINE:
LIFE

NEWSPAPER MAGAZINE PICTURE EDITOR AWARD:
BILL MARR, THE PHILADELPHIA (PA.) INQUIRER

Index to Photographers